WOMEN of ABSTRACT EXPRESSIONISM

WOMEN of ABSTRACT EXPRESSIONISM

EDITED BY JOAN MARTER

INTRODUCTION BY
GWEN F. CHANZIT, EXHIBITION CURATOR

DENVER ART MUSEUM

IN ASSOCIATION WITH
YALE UNIVERSITY PRESS
NEW HAVEN AND LONDON

Published on the occasion of the exhibition *Women of Abstract Expressionism,* organized by the Denver Art Museum

Denver Art Museum, June–September 2016
Mint Museum, Charlotte, North Carolina, October–January 2017
Palm Springs Art Museum, February–May 2017
Whitechapel Gallery, London, June–September 2017

Women of Abstract Expressionism is organized by the Denver Art Museum. It is generously funded by Merle Chambers; the Henry Luce Foundation; the National Endowment for the Arts: the Ponzio family; U.S. Bank; Christie's; Barbara Bridges; DAM Contemporaries, a support group of the Denver Art Museum; the Joan Mitchell Foundation; the Dedalus Foundation; Bette MacDonald; the Deborah Remington Charitable Trust for the Visual Arts; the donors to the Annual Fund Leadership Campaign; and the citizens who support the Scientific and Cultural Facilities District (SCFD). We regret the omission of sponsors confirmed after February 15, 2016.

Denver Art Museum
Director of Publications: Laura Caruso
Curatorial Assistant: Renée B. Miller

Yale University Press
Publisher, Art and Architecture: Patricia Fidler
Editor, Art and Architecture: Katherine Boller
Production Manager: Mary Mayer

Designed by Rita Jules, Miko McGinty Inc.
Set in Benton Sans type by Tina Henderson
Printed in China through Oceanic Graphic International, Inc.

Library of Congress Control Number: 2015948690
ISBN 978-0-300-20842-9 (hardcover); 978-0914738-62-6 (paperback)
A catalogue record for this book is available from the British Library.

This paper meets the requirements of ANSI/NISO Z39.48-1992 (Permanence of Paper).

10 9 8 7 6 5 4 3 2 1

Frontispiece: Jay DeFeo, *Incision,* 1958–61 (detail of cat. 6)
Page 5: Helen Frankenthaler, *Jacob's Ladder,* 1957 (detail of cat. 17)
Cover illustration: Elaine de Kooning, *Bullfight*, 1959 (detail of cat. 11)

Denver Art Museum
100 W. 14th Avenue Parkway
Denver, Colorado 80204
denverartmuseum.org

Yale University Press
PO Box 209040
New Haven, Connecticut 06520-9040
yalebooks.com/art

CONTENTS

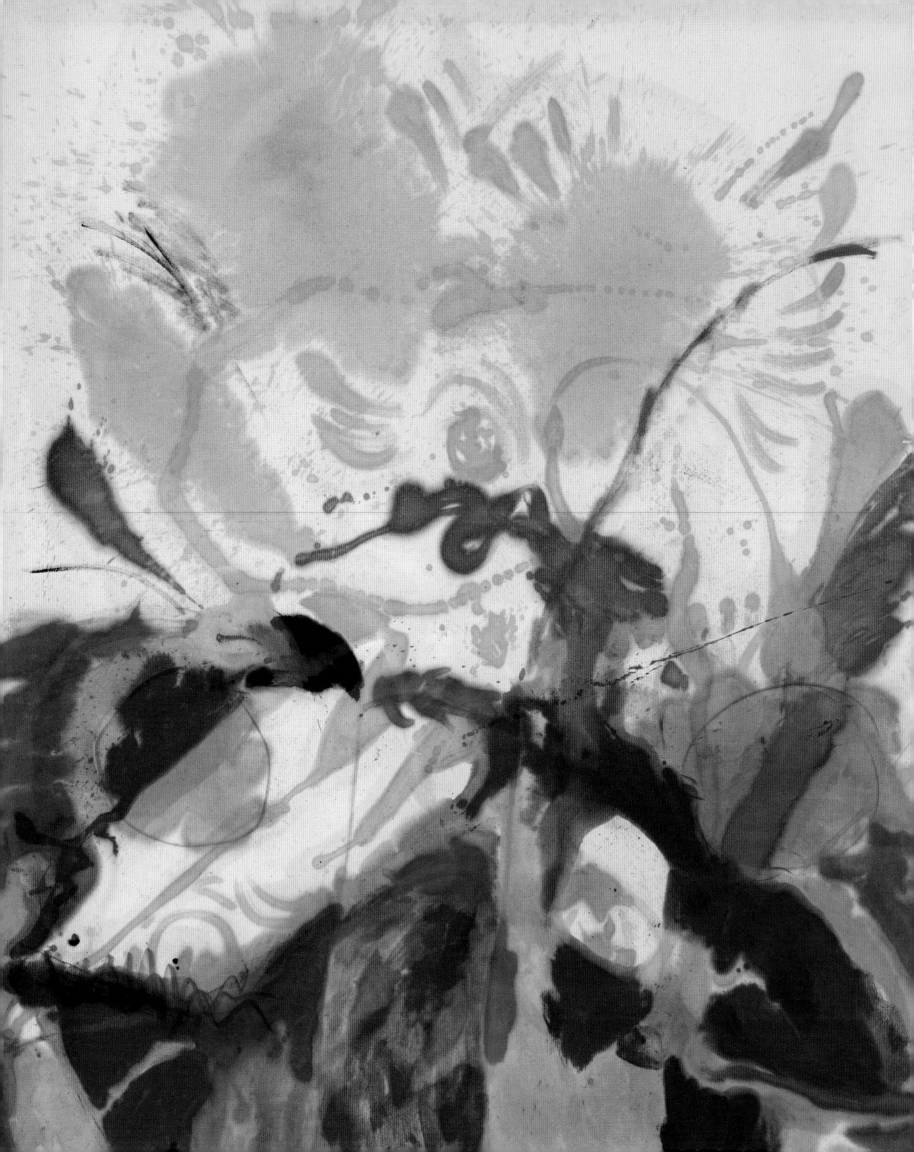

Women of Abstract Expressionism, organized by the Denver Art Museum, is the first major museum exhibition to present the work of female painters who came of age artistically in the heady avant-garde milieu of late 1940s and 1950s America. These painters took full part in classes and exhibitions on both the East and West coasts within the circles of artists who became known as Abstract Expressionists, yet their participation has been underreported and their canvases undervalued. This exhibition and book will show these gestural painters in a new light and serve to both challenge and correct the prevailing canon of Abstract Expressionism.

Major support from Merle Chambers enabled curatorial research and the publication of this catalogue. We are also grateful to the Henry Luce Foundation, the National Endowment for the Arts, the Ponzio family, U.S. Bank, Christie's, the Joan Mitchell Foundation, the Dedalus Foundation, Bette MacDonald, and the Deborah Remington Charitable Trust for the Visual Arts for their generous contributions to the project. Additionally, we would like to thank Barbara Bridges and DAM Contemporaries, a support group of the Denver Art Museum, for their contributions to the documentary film produced for the exhibition.

I am deeply grateful to generous institutional colleagues who lent paintings to the exhibition: Doreen Bolger, director, the Baltimore Museum of Art; Rod Bigelow, executive director, Crystal Bridges Museum of American Art; Barbara O'Brien, executive director, Kemper Museum of Contemporary Art; Michael Govan, CEO and Wallis Annenberg Director, Los Angeles County Museum of Art; William J. Chiego, director, McNay Art Museum; Sabine Eckmann, William T. Kemper Director and chief curator, Mildred Lane Kemper Art Museum; Glenn D. Lowry, director, Museum of Modern Art; Susan Fisher Sterling, Alice West Director, National Museum of Women in the Arts; Lori Fogarty, director and CEO, Oakland Museum of California; Neal Benezra, Helen and Charles Schwab Director, San Francisco Museum of Modern Art; Charles R. Loving, director, Snite Museum of Art, University of Notre Dame; Brian Trimble, interim director, University Art Museum at California State University, Long Beach; and Adam D. Weinberg, Alice Pratt Brown Director, Whitney Museum of American Art.

We are also indebted to Margaret Mathews-Berenson, curator, Deborah Remington Charitable Trust for the Visual Arts; Elizabeth Smith, executive director, Helen Frankenthaler Foundation; Leah Levy, director and trustee, The Jay DeFeo Trust; and Christa Blatchford, CEO, Kira Osti, collections manager, and Laura Morris, archivist, Joan Mitchell Foundation.

Special thanks go to Art Enterprises, Ltd.; Judith Godwin; Susan and David Kalt; Thomas McCormick and Janis Kanter; Barbara Nino; Craig Ponzio; Christopher Schwabacher; Jennifer and David Stockman; and Brenda Webster. I also want to acknowledge and thank several additional lenders who wish to remain anonymous. Finally, I am delighted to partner with President and CEO Kathleen V. Jameson at the Mint Museum and JoAnn McGrath Executive Director Elizabeth Armstrong at the Palm Springs Art Museum in presenting this important exhibition.

This exhibition project supports the mission of the Denver Art Museum to highlight personal creativity among broad segments of society, to identify and encourage individual and unique perspectives, and to show the work of exceptional artists. This catalogue will be the permanent record of *Women of Abstract Expressionism.* With a new understanding of Abstract Expressionism and of the contributions of women, we fully expect this project to have a lasting impact on the field.

Christoph Heinrich
Frederick and Jan Mayer Director
Denver Art Museum

ACKNOWLEDGMENTS

It is a pleasure to acknowledge the many people who contributed to *Women of Abstract Expressionism.* I have enjoyed the help and cooperation of independent scholars, individuals working within institutions, and the represented artists and their families.

The idea for this exhibition came in 2008, when I saw the noteworthy exhibition *Action/Abstraction,* organized by Norman Kleeblatt at the Jewish Museum in New York, and wondered about some of the "outlier" artists who today remain at the fringes of art historical accounts of Abstract Expressionism, but who were active participants at the time. I especially thought about some female Abstract Expressionists who have received scant mention in mainstream texts, whose paintings challenge the male-centric definition of the movement.

From the beginning, I looked to bring on an East Coast partner, and I found such a person in Joan Marter, who had done the only exhibition on this subject, in 1997. Joan was pleased to revisit the subject on a broader scale, and I thank her for her partnership; this catalogue speaks to her expertise.

Evaluating more than one hundred potential artists for inclusion was a huge task, and project assistant Jesse Laird Ortega's research and communication have been crucial. She also wrote the excellent chronology printed in this volume. Curatorial assistant Renée Miller undertook many aspects of exhibition management and took the lead in securing image rights and photography.

The informative essays by scholars Robert Hobbs, Ellen Landau, Susan Landauer, and Joan Marter enrich this publication. Irving Sandler's generous interview is especially appreciated. I also thank Aliza Edelman for researching the biographies included in this volume.

There are not sufficient accolades for the Denver Art Museum's director of publications, Laura Caruso, who managed every aspect of this volume before we turned the book over to Yale University Press, including editorial oversight, fact-checking, project management, and coordination with Yale.

I give enormous thanks to Merle Chambers and Hugh Grant for their friendship and support of this multiyear project. I also thank Craig Ponzio for his special support and belief in this exhibition. Tom McCormick has been a good-natured advocate from the project's earliest stages, generously providing expertise, introductions, and archival material. Mark Borghi is another ally whose expertise enriched this project. Dean Sobel, director of the Clyfford Still Museum, is always willing to share his knowledge, and I am lucky to have him right next door. I also welcome Rebecca Hart to the Denver Art Museum as Polly and Mark Addison Curator of Modern and Contemporary Art, and I look forward to her input.

Denver Art Museum staff contributed immensely. I appreciate the professionalism of Sarah Cucinella-McDaniel, Heather Haldeman, and Lori Iliff, who proactively accomplished all registrarial responsibilities, including loan management, communication with venues, and shipping and insurance. Jill Desmond and Kara Kudzma kept the exhibition project on task. Exhibition designer Ben Griswold and experience and interpretation specialists Danielle St. Peter and Melora McDermott-Lewis made insightful and valuable contributions to the visitor experience in the exhibition. I also thank Alison Bowman and Arpie Chucovich in Development; Katie Ross in Marketing; Jeff Wells in Photography; and Kristy Bassuener, Shadia Lemus, and the rest of the team in Communications. Alex Dreas, Anna Estes, Claire Roseland Hoag, Erin Kirkland, Zoe Larkins, Kaitlin Maestas, and Alison Ricketson provided project assistance.

Frederick and Jan Mayer Director Christoph Heinrich's enthusiasm and advocacy enabled this project to develop and to come to fruition. I greatly appreciate his scholarly and administrative support.

Artists Mary Abbott, Sonia Gechtoff, and Judith Godwin have been wonderful participants. Their interviews, included in a short film that the museum has produced, were not only helpful for this project but will serve as a source of information for scholars for years to come. Christopher and Hannelore Schwabacher, Brenda Webster, and Susannah and Miles Kelly shared stories of Abstract Expressionist artists who also happened to be mothers, making our understanding of these artists that much more real. I very much appreciate Helen Harrison's lively account of Lee Krasner and her work in the Pollock-Krasner studio, where Krasner painted for many more years than did her more-famous husband. Many thanks go to Andrea Torrice for creating the outstanding film to accompany the exhibition, along with her on-site team of Bill Turnley, Alex Corn, Travis Conklin, and Leonard Levy.

All the lenders to this exhibition, both private and institutional, have my sincere gratitude for the trust

they placed in this project. This exhibition would not be possible without the outstanding works they put under our stewardship.

I appreciate the helpfulness of Howard Agriesti, Susie Alldredge, René Paul Barilleaux, Peter Becker, Madelyn Berezov, Christa Blatchford, Michael Borghi, Rebeka Ceravolo, Maria Coltharp, Mag Dimond, Charles Duncan, Joan Eckels, Amaranth Ehrenhalt, David Eichholtz, Lilly Fenichel, Stuart Friedman, Kris Graves, Loretta Howard, David Keaton, Nathan Kernan, Nathan Kerr, Leah Levy, Edvard Lieber, Collette Loll, Michael Luyckx, Margaret Mathews-Berenson, Sherry Maurer, Laura Morris, Steven Nash, Barbara Nino, William O'Connor, Kira Osti, Christopher Scoates, Anita Shapolsky, Elizabeth Smith, Miriam Smith, Gary Snyder, Rex Stevens, Jennifer Stockman, Annette Stott, Alicia Thomas, and Cynthia Weisfield.

Finally, I look forward to collaborating with President and CEO Kathleen V. Jameson and Senior Curator Jonathan Stuhlman at the Mint Museum, and JoAnn McGrath Executive Director Elizabeth Armstrong and Donna and Cargill MacMillan, Jr., Director of Art Daniell Cornell at the Palm Springs Art Museum. I thank them for joining with us in presenting *Women of Abstract Expressionism*.

Gwen F. Chanzit
Curator

For more than a decade, I have intended to expand upon the exhibition *Women and Abstract Expressionism, Painting and Sculpture, 1945–1959,* which I curated in 1997. This exhibition, which featured seven women artists, was organized at Baruch College, City University of New York, and also shown at the Guild Hall Museum in East Hampton. Thanks to the Denver Art Museum and curator Gwen Chanzit, a more thorough study of the women of the Abstract Expressionist era has come to fruition. This fully illustrated publication features essays by leading scholars on Abstract Expressionism, a useful chronology, and informative artists' biographies and selected readings.

With pleasure I thank my collaborators on this publication. My esteemed colleagues Ellen G. Landau and Robert Hobbs have written original, insightful essays for this book. Both have been recognized for their many contributions to scholarship on the New York School, and for this book, they have offered new ideas and a refreshing new "take" on this period. Susan Landauer has added considerably to the history of Abstract Expressionism with her essay on women artists on the West Coast. Readers will learn the importance of artists such as Clyfford Still, who taught Bay Area artists, and the distinctive circumstances of this artistic environment.

Special thanks go to Irving Sandler—among the leading authorities on Abstract Expressionist painters, The Club, the co-op galleries, and key events of the period—whom I had the privilege of interviewing in his home in 2013. An edited transcript appears in this volume.

This publication includes biographies of the artists included in the exhibition, along with those of others who were actively working as abstract artists in the late 1940s through 1950s. Aliza Edelman unearthed material on some unrecognized women artists from the Abstract Expressionist era and documented articles and reviews of their work. My hope is that these biographies will spur further research and lead to more opportunities for recognition for all these artists. Jesse Laird Ortega, project assistant at the Denver Art Museum, has been crucial to this undertaking in myriad ways, and her chronology is a thoroughly researched account of the exhibitions and personal events that shaped the lives of women artists from the 1940s to 1960.

My acknowledgments extend to the staff of the Watson Library of the Metropolitan Museum of Art. For help with some key information in my research I would like to thank Helen Harrison, director of the Pollock-Krasner House in East Hampton, and Ellen G. Landau. I extend special gratitude to my excellent co-editor of the *Woman's Art Journal,* Margaret Barlow, who has been essential to all of my writing projects for many years. Abundant gratitude goes to Laura Caruso, director of publications at the Denver Art Museum, for her professionalism and her unwavering commitment to this publication. Finally, I offer my sincere thanks to Patricia Fidler, Katherine Boller, Tamara Schechter, Mary Mayer, and Heidi Downey at Yale University Press for their painstaking efforts in producing this volume.

Joan Marter
Editor and Project Co-Organizer

INTRODUCTION TO THE EXHIBITION

GWEN F. CHANZIT

When I start [painting] I don't know what's going to happen. . . . When you're dancing,
you don't stop to think: now I'll take a step . . . you allow it to flow.
—Elaine de Kooning

Elaine de Kooning's description of process speaks to critic Harold Rosenberg's legendary account of Abstract Expressionist painting: its genesis comes from an "event" and is a "result of this encounter."[1] A host of female artists from the late 1940s and 1950s similarly approached a canvas. Yet ever since Abstract Expressionism came on the scene, only a handful of artists have defined the whole movement in textbook accounts. As with other past art movements, these individuals are predominantly male; in this case, not only are they male, but their maleness, their heroic *machismo* spirit, has become a defining characteristic of the expansive, gestural paintings of Abstract Expressionism. Some recent studies have suggested an expanded definition of the movement, yet no major museum exhibition has focused on the role of women associated with Abstract Expressionism.[2]

This exhibition seeks to celebrate the special contributions of women to Abstract Expressionism as a means of understanding its broader parameters. Canvases by women painters show the expressive freedom of direct gesture and process at the heart of Abstract Expressionism, which often includes a new sense of scale, allover treatment, and surface (or just below surface) emphasis. Yet we find in the diverse works of female painters that there are additional qualities not typically associated with the movement, as I will outline later in this introduction.

Some may question a gender-based focus today, when we profess to value art and criticism that put female artists on equal footing with men. That was emphatically *not* the case in the 1950s, and art histories of the movement continue the gender bias. Current market values still undervalue canvases by female painters in comparison to male contemporaries. Projects such as this one provide an essential correction to what is by any measure an unequal accounting of women's contributions.

If there is a silver lining to be found, it may be that it was partly a consequence of gender inequality during the 1950s that some female artists found Abstract Expressionist painting liberating, even if some made sure their signatures did not peg them as female.[3] Given the diminished societal role of women at the time, a canvas might be the sole platform for a woman's autonomy.

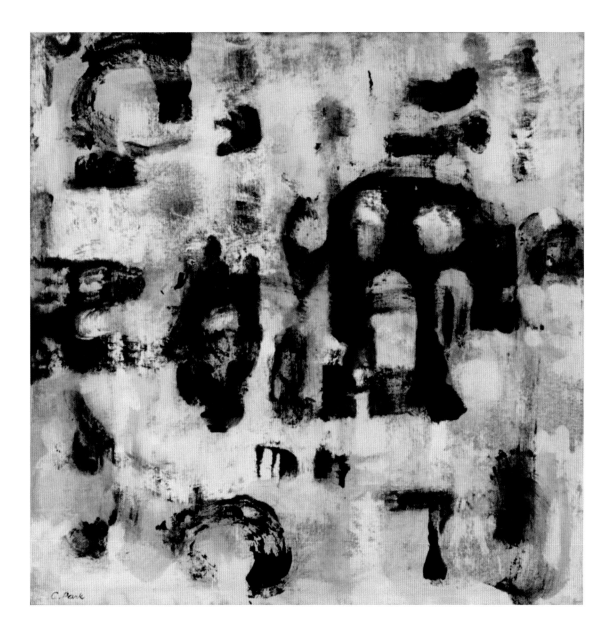

C. Park

FIG. 1. Charlotte Park, *#12*, 1952. Oil paint on canvas, 37 × 37 in. (93.98 × 93.98 cm). The Parrish Art Museum, Water Mill, N.Y., Gift of the artist, 2003.1.

Of the forty-plus women who might have qualified for inclusion in this exhibition based on style, artistic and social circles, and geographical location (both East and West coasts, and more specifically, New York and San Francisco), the twelve selected artists stand in for the many who worked within the late 1940s and 1950s art world: Mary Abbott, Jay DeFeo, Elaine de Kooning, Perle Fine, Helen Frankenthaler, Sonia Gechtoff, Judith Godwin, Grace Hartigan, Lee Krasner, Joan Mitchell, Deborah Remington, and Ethel Schwabacher. Limiting the number allows the exhibition to show several major works by each artist, providing a more in-depth understanding of her work. In this way, the exhibition highlights a variety of *individuals* who were active in avant-garde artistic circles on the East Coast and in the Bay Area.

This publication enables us to enlarge the discourse beyond what is possible in a gallery setting. The illustrations, biographies, and chronology underscore the breadth of activity undertaken by women artists of the Abstract Expressionist movement. Included in this volume are artists such as Charlotte Park, Pat Passlof, Yvonne Thomas, and Michael West, who were centrally involved (figs. 1–4). While many others were genuinely attached to the movement, it should not come as a surprise that several female artists destroyed canvases when their lives later centered on family and household responsibilities. Vita Petersen, for example, was highly regarded in her day but left almost no record of her work of the 1950s. Scores of virtually unknown artists would be completely lost to history were it not for the stories and the photographs left to family members. For this exhibition, we looked at more than a hundred women artists and found that most were not consistent participants in the movement.[4]

Female artists exhibited paintings alongside their male colleagues, and some were partners or otherwise personally involved with the artists and/or critics of the movement. Many studied in the same classes as men,

OPPOSITE: FIG. 2. Pat Passlof,
Score for a Bird, 1958. Oil paint
on linen, 72 × 60 in. (182.88 ×
152.4 cm). The Milton Resnick
and Pat Passlof Foundation;
courtesy of Elizabeth Harris
Gallery, New York.

ABOVE: FIG. 3. Yvonne
Thomas, *Transmutation,*
1956. Oil paint on linen, 70 ×
66 in. (177.8 × 167.64 cm).
Collection of Art Enterprises,
Ltd., Chicago.

taught by Hans Hofmann, Hassel Smith, Clyfford Still, and Esteban Vicente, among others. They socialized and worked in studios near each other. In New York, they frequented the Cedar Street Tavern, attended meetings at The Club, and showed their work at Betty Parsons and in exhibitions such as the *Ninth Street Show* and the Stable Gallery *Annuals.* On the West Coast, they exhibited at such of-the-moment venues as the Ferus Gallery and the Six and King Ubu galleries.[5] From all accounts, women on the West Coast were on more equal footing with men than those on the East Coast.[6]

The paintings gathered here—for the first time ever—show personal responses to life experiences. Several themes recur among the canvases of the female painters, each according to individual encounters and in each artist's own way. These include

FIG. 4. Michael West, *Untitled,* 1948. Oil paint on canvas, 31 × 21 in. (78.74 × 53.34 cm). McCormick Gallery, Chicago.

responses to place—whether at home or traveling; to the body; to a time of day or night; to the seasons; to change; and to life events including death and loss. The paintings are almost always quite abstract but are about real events and real places, people, memories, and experiences. Many canvases include referential titles, whether immediately assigned or added after the painting was complete.

Literature, mythology, religion, poetry, music, and dance all elicited responses from these artists; personal biography and firsthand experience figure prominently. These include specific people, particular locales, and effects of time and season. Nature, as evidenced in a particular place or event, was something for these artists to respond to, in contrast to Jackson Pollock, who famously announced, "I am nature." Mythology and religion were touchstones for Abbott's *Oisin's Dream* (cat. 1), Frankenthaler's *Jacob's Ladder* (cat. 17), and Gechtoff's *The Beginning* (cat. 22), among others. While references to real things are abundant, these are not literal accounts. Despite openly cited references to real things, the true subject of these paintings was never the thing, but the painterly expressions brought on through direct or remembered experience.

City and countryside both evoked responses, as in Hartigan's series of "place" paintings, such as *Ireland* (1958, The Solomon R. Guggenheim Foundation Peggy Guggenheim Collection, Venice), and Abbott's *Virgin Islands* series (cat. 3). Mitchell painted *Hudson River Day Line* (cat. 40) and *East Ninth Street* (cat. 41), locations that were important touch points within the history of the New York School (some female painters had studios on Ninth Street, and several took part in the famed *Ninth Street Show* in 1951).

Whether impetus or afterthought, the experience of the seasons is reflected in the titles of such works as Krasner's opus *The Seasons* (cat. 34) and Fine's *Summer I* (cat. 13). Temporal effects are also invoked in Shirley Goldfarb's *Storm* (fig. 5), Fine's *Early Morning Garden* (cat. 12), and Schwabacher's *Dead Leaves,* also known as *Autumn Leaves* (cat. 48). Other titles refer to epic changes. The forces of nature and geology spurred DeFeo's *Mountain* series (cat. 5) and *Incision* (cat. 6); Krasner's *Charred Landscape* (cat. 36); and Frankenthaler's *Mountains and Sea* (fig. 6) and *Mountain Storm* (cat. 16). Smaller-scale changes are in Alma Thomas's *Red Abstraction* (fig. 7), inspired by the garden outside her window.

Personal biography informed paintings by Hartigan (*Portrait of W;* cat. 27), Schwabacher, Gechtoff, Godwin, and Elaine de Kooning. The deaths of Schwabacher's

GWEN F. CHANZIT

FIG. 5. Shirley Goldfarb, *Storm,* c. 1950. Oil paint on canvas, 36¼ × 55½ in. (92.08 × 140.97 cm). Loretta Howard Gallery, New York.

husband and of Gechtoff's mother, the relationship between Elaine de Kooning and her husband, Willem, and the friendship between dancer/choreographer Martha Graham and Judith Godwin all elicited responses. Going beyond life-drawing traditions, some Abstract Expressionists pushed expression of the body in works such as Godwin's *Woman* (cat. 23). While music and dance are arts traditionally associated with feminine interests, Godwin's expressive tribute to Graham is anything but traditional (cat. 24). In Godwin's words, "I can see her gestures in everything I do."[7]

References to home—both literally and psychologically—are abundant. Schwabacher's *Pennington I/ Pelham II* refers to her youthful domicile and the one she shared with her husband (cat. 49). While home has its place, travel and the experience of exotica also prompted responses. Elaine de Kooning's experience seeing bullfights in Juárez had a profound impact that lasted even after she returned to her New York studio (cat. 11).

Social events and political realities figured into paintings such as Gechtoff's *Children of Frejus,* sparked by a newspaper account of a dam in France that collapsed, killing hundreds, including many children (cat. 21). Michael West acknowledged the overarching fear of the bomb in *Nihilism* (see fig. 14). Not only world politics, but also art-world politics were at hand. Hartigan's *The King Is Dead* references the one to beat—Picasso—who must have loomed large in her consciousness (cat. 26).

Specific literary works are the subject of Schwabacher's *Antigone I* and Gechtoff's *Anna Karenina* (cats. 50 and 19, respectively). Both Abbott and Hartigan collaborated with poet Barbara Guest. Krasner's title, *What Beast Must I Adore?,* comes from the Symbolist poet Arthur Rimbaud (cat. 37).[8]

Process and experimentation with materials weren't exclusive to men. They are the hallmarks of works by some female painters, including DeFeo, Frankenthaler, and Mitchell. Other female painters, though, were focused on what we might call interior, emotional gesture. These more specific, personal references to experience are no less a part of Abstract Expressionism.

FIG. 6. Helen Frankenthaler,
Mountains and Sea, 1952.
Oil paint and charcoal on
canvas, 86⅝ in. × 9 ft., 9½ in.
(220.03 × 298.45 cm). Helen
Frankenthaler Foundation,
New York, on extended loan to
the National Gallery of Art,
Washington, D.C.

By 1962, Clement Greenberg had this to say about the movement, then more than a decade old: "If the label 'Abstract Expressionism' means anything, it means painterliness: loose, rapid handling, or the look of it; masses that blotted and fused instead of shapes that stayed distinct; large and conspicuous rhythms; broken color, uneven saturations or densities of paint, exhibited brush, knife, or finger marks."[9]

Not only are canvases by Abstract Expressionist women compatible with this definition, they express compelling points of view by individuals who were *individual* in every sense. This exhibition celebrates their contributions to the rich fabric of the movement. At a time when opportunities for women were often limited, these artists went beyond customary gender roles. Their authentic expressions belong front and center in the annals of Abstract Expressionism.

FIG. 7. Alma Thomas, *Red Abstraction*, 1960. Oil paint on canvas, 36¼ × 30 in. (92.1 × 76.20 cm). Smithsonian American Art Museum, Washington, D.C. Gift of the artist.

Notes

Epigraph: Elaine de Kooning quoted in Rose Slivka, "Essay," in *Elaine de Kooning: The Spirit of Abstract Expressionism: Selected Writings* (New York: George Braziller, 1994), 30.

1. Harold Rosenberg, "The American Action Painters," *ARTnews* 51 (December 1952): 22–23.

2. Ann Eden Gibson, *Abstract Expressionism: Other Politics* (New Haven: Yale University Press, 1997); Joan Marter, *Women and Abstract Expressionism, Painting and Sculpture, 1945–1959* (New York: Sidney Mishkin Gallery, Baruch College/CUNY, 1997); Norman L. Kleeblatt, ed., *Action/Abstraction* (New Haven and New York: Yale University Press in association with the Jewish Museum, 2008).

3. Hedda Sterne was known to use only her initial, "H.," and Corinne West went by Michael West. In the early 1950s, Grace Hartigan used the first name George, in tribute to novelists George Sand and George Eliot.

4. Many artists dabbled briefly in freely expressive painting before moving in separate directions, such as Joan Brown, who became well regarded for figuration; Miriam Schapiro and Joan Semmel; Audrey Flack, whose Abstract Expressionist canvases were the subject of an exhibition at Hollis Taggart Galleries in 2015; and Agnes Martin, who showed at Betty Parsons Gallery in the mid-1950s. From every part of the country—East to West and North to South—women artists came to study and take up Abstract Expressionism with Hans Hofmann in New York, Hassel Smith in San Francisco, and others; most never achieved recognition beyond their local communities.

5. Some sources refer to this as "6 Gallery." The gallery used both the numeral "6" and the word "Six" in announcements and posters. For consistency, "Six" is used throughout this publication.

6. Sonia Gechtoff, interview by Marshall N. Price, 2006, in *Sonia Gechtoff: The Ferus Years* (New York: Tim Nye, 2011), 11, and Susan Landauer essay in this volume.

7. David Ebony, "Abstract Portrayal: The Work of Judith Godwin," in *Judith Godwin: Early Abstractions* (San Antonio, TX: McNay Art Museum, 2008), 16–19.

8. Robert Hobbs, *Lee Krasner* (New York: Abbeville, 1993), 21–22.

9. Clement Greenberg, "After Abstract Expressionism," *Art International* 6 (October 25, 1962): 25.

MISSING IN ACTION

ABSTRACT EXPRESSIONIST WOMEN

JOAN MARTER

Although art critics and historians have been writing about Abstract Expressionism for more than sixty years, most of the women involved continue to be marginalized. Many writers have refused to acknowledge that these women artists of the 1940s and 1950s could be innovators, and certain curators and critics have simply ignored them while continuing to focus attention on male members of the group. In recent decades, a younger generation of scholars—many of them women—has attempted to integrate these women artists into the burgeoning literature on Abstract Expressionism. Works created by these women affirm their participation in what was then a radical new aesthetic, though they have been largely absent from art historical discourse until recently.

The year was 1950, and Abstract Expressionism was capturing attention as a major development in American painting. Jackson Pollock was beginning to sell his canvases and receiving accolades in the press. Willem de Kooning painted *Excavation* (1950, Art Institute of Chicago) and was gaining recognition. New ideas for abstract painting were percolating on Eighth Street, in other locations in Manhattan, and outside the city in Springs, in the town of East Hampton, New York. Male and female artists alike, many of them students of Hans Hofmann, were experimenting with bold gestures, individualized expression, and improvisational effects. All looked for opportunities to exhibit their latest works.

Some of the women were members of the American Abstract Artists group or active at Atelier 17, the printmaking workshop. A few, such as Lee Krasner, Perle Fine, and Joan Mitchell, had shown with commercial galleries, but for most of the women, group exhibitions were their best chance of gaining recognition and making sales.

In a most fortuitous development, a group of uptown galleries joined forces to sponsor a series of annual exhibitions of abstract art. The first—the *Ninth Street Exhibition of Paintings and Sculpture*—was held in May and June of 1951 at 60 East Ninth Street, in Greenwich Village. After that, from 1953 to 1957, the *New York Painting and Sculpture Exhibitions* took place annually uptown, at the Stable Gallery, located at 924 Seventh Avenue, at Fifty-Eighth Street. Housed in a converted horse stable, these shows were sponsored by galleries that represented a few of the artists.[1] Three women—Perle Fine, Joan Mitchell, and Elaine de Kooning—often sat on the twenty-five-member Committee of Artists that selected the painters and sculptors for the shows. Not coincidentally, these three (and also Grace Hartigan and Yvonne Thomas) were included in every annual exhibition; Helen Frankenthaler was selected for all but one of the shows.

Photographs taken by Aaron Siskind at the *Ninth Street Show* evidence the individuality of the artists, but also the shared approaches to gestural abstraction, regardless of gender (fig. 8). Joan Mitchell's painting

FIG. 8. Installation of *Ninth Street Show*, New York, 1951. Photograph by Aaron Siskind.

(fig. 9) was installed along with those of Jackson Pollock and others. The artists viewed themselves as colleagues: all were ambitious and energetic, the creators of a new direction in American modernism. The *Ninth Street Show* and the Stable Gallery *Annuals* were essential for introducing Abstract Expressionism to an interested art public, and crucial to the artists themselves. Clement Greenberg acknowledged their importance, writing on the poster of the *Second Annual Exhibition of Painting and Sculpture* at the Stable Gallery (fig. 10):

> This exhibition was conceived and organized by artists, the event rightly to be considered the precedent for this one was the famous "Ninth Street" show held in the spring of 1951. . . . Like this one, that exhibition was organized, and its participants named and invited, by artists themselves, and a range of the liveliest

tendencies within the mainstream of advanced painting and sculpture in New York was presented. I don't think the reverberations of that show have died away yet.

The present exhibition, like its predecessor, has the merit of giving a large place to the work of artists, some who do not show regularly with dealers, and who thus have the chance to measure themselves against their more established colleagues in a directer way than usual. At the same time the public has a chance to see what is going on in the studios, many blocks distant from 57th Street, where the newer generation of painters and sculptors incubate what may be—in some instances—the liveliest art of the near future.[2]

As Greenberg suggests, artists without dealers had limited opportunities to exhibit. In these annual shows,

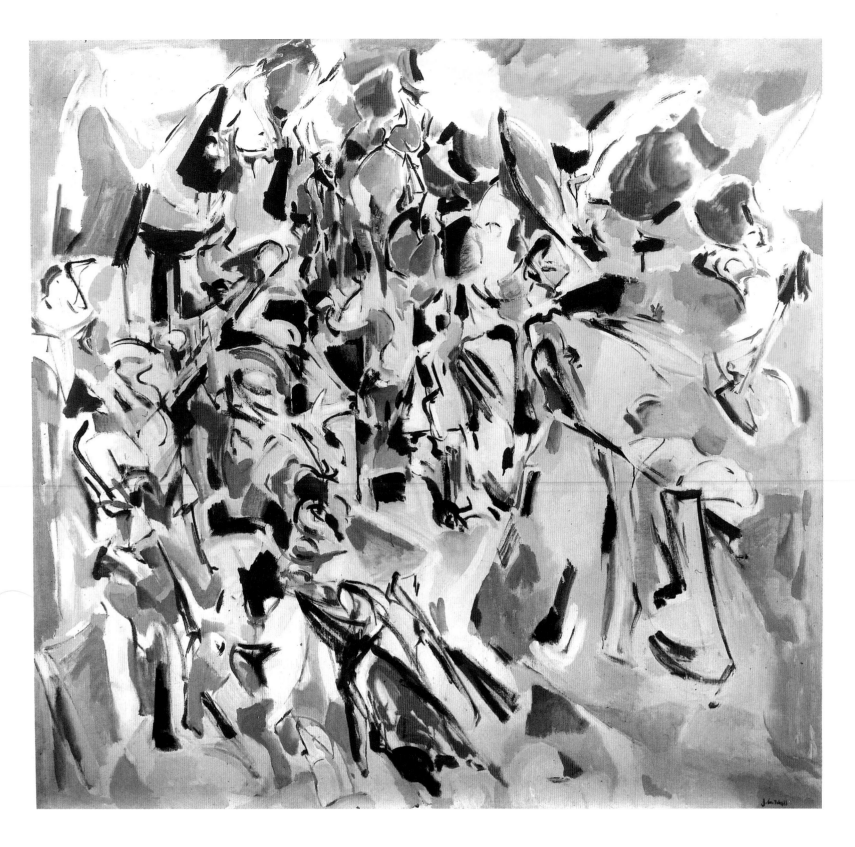

FIG. 9. Joan Mitchell, *Untitled*, 1950. Oil paint on canvas, 69 × 72 in. (175.26 × 182.88 cm). Private collection.

between 1951 and 1957, at least fifty women were selected to participate—some for several shows and some just once. As members of the Committee of Artists, Fine, de Kooning, and Mitchell became activists for themselves and for other women artists seeking recognition. Since only a few commercial galleries and a handful of co-op galleries downtown would show women's art in the 1950s, these shows gave dozens of women artists an opportunity to have their work on exhibit, as well as the hope of being discovered.[3]

The women must have had some awareness of the macho attitude of their male counterparts when they were treated poorly at the Cedar Bar, a popular meeting place for the artists, and marginalized at the Eighth Street Club.[4] Membership in The Club, a gathering place for artists and intellectuals, was initially restricted to males only. Women attended some meetings and even participated in events, including spirited debates on whether "Abstract Expressionism" was an appropriate designation for the art they were producing. For

example, on March 7, 1952, a group of younger painters including Hartigan, Mitchell, and Jane Freilicher joined a panel discussion on Abstract Expressionism—it was the fourth "symposium" held on the topic since the publication of Thomas Hess's influential *Abstract Painting* two months earlier.[5]

Despite all evidence of their presence, participation, and paintings, it would be decades before more than a handful of women could take their place in the annals of art history as part of Abstract Expressionism.[6] There were inklings, however, as Hartigan in 1951 remarked in her journal after a visit with Frankenthaler, Krasner, Pollock, and Barnett Newman: "Clem [Greenberg] got on his kick of 'women painters.' Same thing—too easily satisfied, 'finish' pictures, polish, 'candy.' . . . He says he wants to be the contemporary of the first great woman painter. What shit—he'd be the first to attack."[7] Three years later—after having gained a modicum of success through exhibitions and sales—Hartigan wrote an ultimatum to Greenberg: "In your discussion of me and my painting I think you have been flagrantly irresponsible. You must know that your remarks have been repeated to me, and that I helplessly fuming hear you think I am 'not even a painter.' . . . Whatever opinion you have of my work, you must respect my seriousness and energy. When an artist presents a show, he backs it up with his life. You are a coward because you back your words with more words."[8] Greenberg had been an early supporter of Hartigan, featuring her and Krasner in a new-talent show he co-organized with Meyer Schapiro at the Samuel Kootz Gallery in 1950. But after Hartigan introduced figures into her paintings in 1953, Greenberg withdrew his support for the artist.

A few women artists had joined co-op galleries on Tenth Street in Greenwich Village by the mid-1950s, but there remained a bias, particularly against some of the older women such as Krasner and Elaine de Kooning. Both had been working seriously and with some success along with the "first-generation" artists since the 1940s. However, their position as wives of famous artists associated with Abstract Expressionism's most important innovations impeded their own acceptance on their singular merits. As Krasner once remarked, "I daresay that a great deal of my so-called position or lack of position, whichever you want to call it, in the official art world is based on the association with Pollock. It is almost impossible to deal with me without relating it to Pollock."[9] In a 1949 article in *ARTnews* titled "Man and Wife," a critic noted that Krasner's paintings could be seen as an attempt to "tidy up" Pollock's uncontrolled facture.[10]

Younger artists such as Mitchell, Hartigan, and Frankenthaler, whose artistic careers were just beginning in the 1950s, had a somewhat easier time and were from the outset ranked in the "second generation" of Abstract Expressionism. Did any of the women painters of the New York School comprehend the extent of the prejudice against their art because of their gender?

By 1957, the Stable *Annuals* had lost their importance. Pollock had died the previous year, and Willem de Kooning was assuming a position of influence in the art world. Wide recognition was coming to the Abstract Expressionists, but not to the women. As articles on Abstract Expressionism, and then books, began to appear, the women realized that they had been all but erased from the history of Abstract Expressionism.

The policies of the Museum of Modern Art (MoMA) were indicative of the bias. When an international exhibition of works by seventeen Americans titled *The New American Painting* was organized by MoMA in 1958 and traveled to eight countries, only one woman was included: Grace Hartigan. (Previously shunned by Greenberg for her figuration, her works were now being recognized as related to figurative compositions by Willem de Kooning.)

Selective narratives of the women associated with Abstract Expressionism acknowledge them as sharing the aesthetic principles, creating paintings, drawings, and collages, and continuing to seek opportunities to exhibit. In the early 1950s, these women artists did not

FIG. 10. Poster of the *Second Annual Exhibition of Painting and Sculpture,* 1953. The Stable Gallery, New York. Private collection.

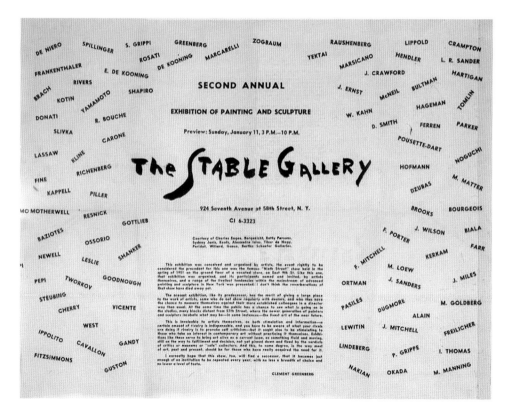

Because Miss Fine has very nearly eliminated allusions to natural appearance and has instead limited her means of expression to those elements indigenous to the spatial arts, the meaning of her pictures cannot even be approximated in words. Their emotional and ideological impact therefore vary considerably with the beholder and must in any case be as real and as intangible as are all experiences sub-(or super-)lingual.[12]

In the mid-1950s, Parsons eliminated Fine from the gallery's roster because of poor sales. Seeking a less competitive, more tranquil environment, she moved to the Springs section of East Hampton (her neighbors were Pollock, Krasner, and the de Koonings, but Fine worked in relative isolation). There, after 1954, she produced some of her best Abstract Expressionist compositions (cat. 13). She devised her own version of gestural abstraction, using house paint and working with collage in a large format. When working on the floor, rather than striding across the canvas (like Pollock), she used a plank to move along the surface of the canvas on her knees. Fine titled her paintings as though they were based on studies of nature, but the non-objective world was her inspiration, and as a follower of Mondrian's Neo-Plasticism, she emphasized an alternative to natural forms: the creation of pure abstractions. For these choices, she found difficulty being accepted among certain Abstract Expressionists, but continued to make paintings that she hoped would establish her as a member of the group.

When Fine was included in *Nature in Abstraction* at the Whitney Museum of American Art in 1958, John Baur, writing in the exhibition catalogue, seems to have understood her links to abstraction as a universalized approach to nature.[13] Almost two decades later, in a plaintive plea for recognition, Fine appealed to the staff of the Whitney Museum planning *Abstract Expressionism: The Formative Years* (held in 1978). When her first letter received no response, she wrote a second: "Last week I wrote you concerning the exhibition of Abstract Expressionism that you are planning. . . . I feel strongly that I should be included here. . . . I want to acquaint you with my activities as an abstract artist and an abstract expressionist."[14] Fine was not included in the exhibition.

realize that they would be written out of art history— that a so-called canon would arise that solidified Abstract Expressionism as male. Existentialism as a philosophical response to postwar life would be reserved for men only, and women could participate only as "Muse."[11]

As mentioned, at least fifty women participated in the *Annuals,* including nine in the *Ninth Street Show* of 1951. Perle Fine exhibited in all the shows; Anne Ryan and Michael West were included in one or two. It is instructive to consider, even briefly, how these three artists who experienced success in the early years of Abstract Expressionism in the end suffered egregious neglect.

Perle Fine (fig. 11) began to show her abstractions in the 1940s, had a solo exhibition in 1945 at the Willard Gallery, achieved some renown in 1947 for making a successful posthumous copy of Piet Mondrian's *Victory Boogie-Woogie,* and in 1949 began showing at the Betty Parsons Gallery (one of the sponsors of the *Ninth Street Show*). In the late 1940s, she set up her studio on Tenth Street (identified by Harold Rosenberg as central to the group), where she associated with the nascent male Abstract Expressionists who were her neighbors. In 1951, she became one of the first (of a very few) women invited to join The Club. A critic wrote:

> The language of Miss Fine's art is completely per-
> sonal. She has in her pictures established a private
> reality that is as totally unrelated to sensuous
> appearance as [to] a mathematical formula. . . .

Anne Ryan was incredibly prolific, producing four hundred collages and paintings in her brief career. She showed work at the Museum of Modern Art in 1951

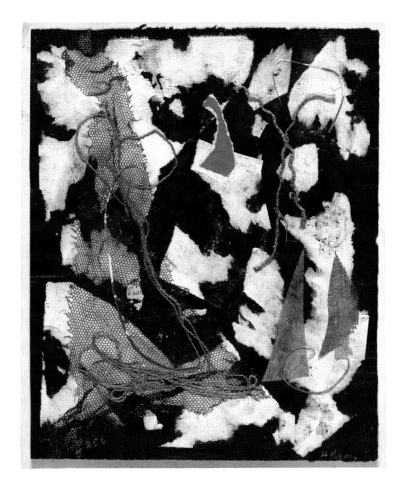

and was included in exhibitions at the Parsons Gallery until the time of her death in 1954.

Ryan moved to New York in the late 1930s. In the early 1940s, she set up a canteen in the ground floor of her Greenwich Village apartment building where artists and writers could congregate. After studying at Atelier 17, where she made etchings using experimental methods, she settled on collage as her medium of choice. Her mostly small works first acknowledged the Cubist *papiers collés*, and then the Dada collages of Kurt Schwitters. Ryan was interested in new materials, and by the late 1940s her collages became more expressionistic, combining colored papers, cloth in variegated colors and textures, and pieces of string in lively compositions. Her use of strings in circular arrangements (figs. 12–13) could have been her personal response to Pollock's improvisational methods.

What would have happened to this productive artist had she lived longer? It is ironic to think of how Pollock's reputation soared after his death, while Ryan was largely forgotten. Her collages are in the collections of the Metropolitan Museum of Art and the Museum

of Modern Art, but because of their small scale they are seldom exhibited.

Michael (Corinne) West was a student of Hofmann, although she worked in a Cubist style, then in the Neo-Plasticist style of Mondrian. A friend of Arshile Gorky (who approved her adoption of a male name), she moved in the circles of the avant-garde and knew Pollock and Richard Pousette-Dart, who both had a lasting influence on her. In 1945, she exhibited with Adolph Gottlieb, Mark Rothko, and others at the Pinacotheca Gallery, and in 1953 her work at the Stable Gallery *Annual* was installed in a prominent group with works by Willem de Kooning, Helen Frankenthaler, Franz Kline, and Robert Motherwell.

By the late 1940s, West was developing a personal response to the growing power of the Abstract Expressionists, and works such as *Nihilism* show her strategy for re-surfacing her derivative earlier compositions for more expressionistic, violent abstract canvases (fig. 14). She was among a few women artists who seemed to share the existentialist ennui of the atomic age and the Cold War. By the time she was included in the 1953

LEFT: FIG. 12. Anne Ryan, *Collage, 256,* May 6, 1949. Pasted colored and printed papers, cloth, and string on paper, 6³/₄ × 5¹/₂ in. (17.15 × 13.97 cm). The Museum of Modern Art, New York. Gift of Elizabeth McFadden.

RIGHT: FIG. 13. Anne Ryan, *Untitled,* c. 1950. Pasted colored paper and printed papers, cloth, and string on paper, 8 × 6³/₄ in. (20.32 × 17.145 cm). Collection of Thomas McCormick and Janis Kanter, Chicago.

Stable Gallery *Annual,* her response to nuclear proliferation was already manifested in titles such as *Nihilism* and *Dagger of Light,* reflecting her dismay about the prospects for global annihilation as a result of a nuclear holocaust (fig. 15). Her paintings show her anxiety: carefully layered surfaces are then obliterated by a seemingly random application of thin washes that wipe out portions of the composition.

Although West continued painting works that were bold and gestural through the 1980s, she died with no acknowledgment. Her estate was claimed by the city of New York and purchased by a collector. She has since received some belated recognition, including a small exhibition of her paintings at the Pollock-Krasner House in East Hampton.[15]

That women artists made a contribution to the aesthetics of Abstract Expressionism is a topic that should be of great significance but is overlooked. As evidenced by their serious work and commitment to professionalism, they shared with their male contemporaries an interest in individualism, an improvisational approach, allover compositions, and the intent to produce abstract paintings with universal valence.

It is the "interest in individualism" that elicits some of the controversy. Irving Sandler has dismissed some artists as being "too French,"[16] including Perle Fine, possibly because she adhered too closely to the Neo-Plasticism of Mondrian, and others such as Byron Browne, Louise Bourgeois, and African American artist Norman Lewis. Reflecting the nationalistic fervor supported by Greenberg and other critics, this was echoed in the chauvinism of artists such as Jackson Pollock, who had never been to Europe and compared his methods of working on the floor of his studio to the Navajo sand painters. Joan Mitchell, even after her move to France in the late 1950s, and her involvement with the Canadian abstractionist Jean-Paul Riopelle, remained closely linked to the bold gestures and improvisational methods she had employed to produce abstract paintings a decade earlier.

Figuration was another controversial topic. Grace Hartigan and Elaine de Kooning are discussed elsewhere in this publication as artists who revived their interest in figurative subjects, a change that was not surprising given the almost continuous figuration in the work of Willem de Kooning. Lee Krasner, too, after Pollock's death in 1956, moved into Pollock's studio in Springs and produced some of the most vivid, energetic paintings of her artistic career, many with figurative implications.

By the end of the 1950s, the situation for women artists had changed—drastically, and for the worse. Fewer opportunities to sell their work, lack of gallery representation, and their growing absence from group exhibitions caused great discouragement, not to mention disappointment and even anger. As A. Deirdre Robson noted: "Although the remarkably high prices fetched by Pollock's work in the late 1950s undoubtedly owed a good deal to his 'nonliving' status, the prices of the other Abstract Expressionist artists also rose substantially in these years, as their critical and commercial standing became more assured."[17]

The women could only look on as their careers and accomplishments were sidelined. "When the chance of finding acceptance by a large segment of the art collecting world was remote, there was little competition among artists, male or female," writes Kathleen Housley. "It was only when the door began to crack open that the gender of the artist began to play a prominent role. Suddenly, if one were to be considered influential, maleness mattered, and aggressive artistic characteristics that were perceived to be masculine became valorized."[18]

In 1957, the popular press finally acknowledged that women artists were among those with "serious careers." While extolling five contemporary women, including "none over 35," in a photo essay titled "Women Artists in Ascendance," *Life* magazine resolutely declared that only a "handful" of women artists over the centuries had achieved lasting stature. According to *Life,* only a few American women artists, such as Mary Cassatt, Georgia O'Keeffe, and Loren MacIver, had significant reputations, but beginning in the 1940s "paralleling their achievements in other professions, women in growing numbers began to distinguish themselves as artists."[19]

Among the five young painters appearing in the *Life* photos, the dark-eyed beauty Helen Frankenthaler faces the camera as she curls elegantly on a studio floor covered with canvases (fig. 16). Jane Wilson, who also "works as a New York fashion model," is pictured reclining on a curved sofa that echoes the contours of her torso. Joan Mitchell, holding up the edge of an enormous unstretched canvas, is identified as "one of the leading young exponents of the abstract expressionist school," who works in both New York and Paris and "has evolved a spontaneous, complex style to produce energetic images of 'remembered landscapes which involve my feelings'"(fig. 17).[20] None of these artists is actually shown painting, but rather posed appealingly for *Life*'s cameras. Despite including Frankenthaler, Mitchell, and Grace Hartigan in "Young Group Reflects Lively Virtues of U.S. Painting," the only mention of Abstract Expressionism is in passing connection with Mitchell.[21] There is no acknowledgment of other American artists such as Lee Krasner, Elaine de Kooning, or Perle Fine, the closest chronological contemporaries of the acknowledged first-generation Abstract Expressionists who were widely recognized by then.

In fact, few published articles acknowledged women as integral to the New York School. A few months after the *Life* article, Irving Sandler's perceptive "Mitchell Paints a Picture" appeared in *ARTnews.* Both artist and author were willing to identify the paintings being discussed with the New York School. In his serious, respectful assessment of Mitchell's art, accompanied by photos of the artist at work, Sandler claimed that Mitchell had assimilated some of the methods of Arshile Gorky, Willem de Kooning, and Franz Kline and that she experienced "a kindred involvement with space."[22] Comparing Mitchell to the "elders of Abstract Expressionism," Sandler wrote: "She not only appreciates the early struggle of the older painters, whose efforts expedited acceptance for those following them,

but finds a number of qualities in their work that have a profound meaning for her."[23] Many decades later, in his memoir, *A Sweeper-Up after Artists,* Sandler continues to position Mitchell as a disciple, as a follower rather than an innovator:

I lived through the 1950s. . . . I was a partisan of gesture painting, unreserved in my admiration of first generation artists such as de Kooning, Kline and Guston. I also had a high opinion of younger artists, notably, Helen Frankenthaler, Michael Goldberg, Grace Hartigan and Joan Mitchell, but I did not consider them the equals of their elders. . . . Of the younger gesture painters, I most admired Joan Mitchell. . . . In many ways, Joan typified her generation. She recognized that she was a follower, a member of the New York School, but she also believed that she could create a personal style—and she did. . . . In 1956, Joan's self-characterization as a second-generation

FIG. 15. Michael West, *Dagger of Light,* 1951. Oil paint, enamel, and sand on canvas, 55 × 35 in. (139.7 × 88.9 cm). Michael Borghi Fine Art, New Jersey.

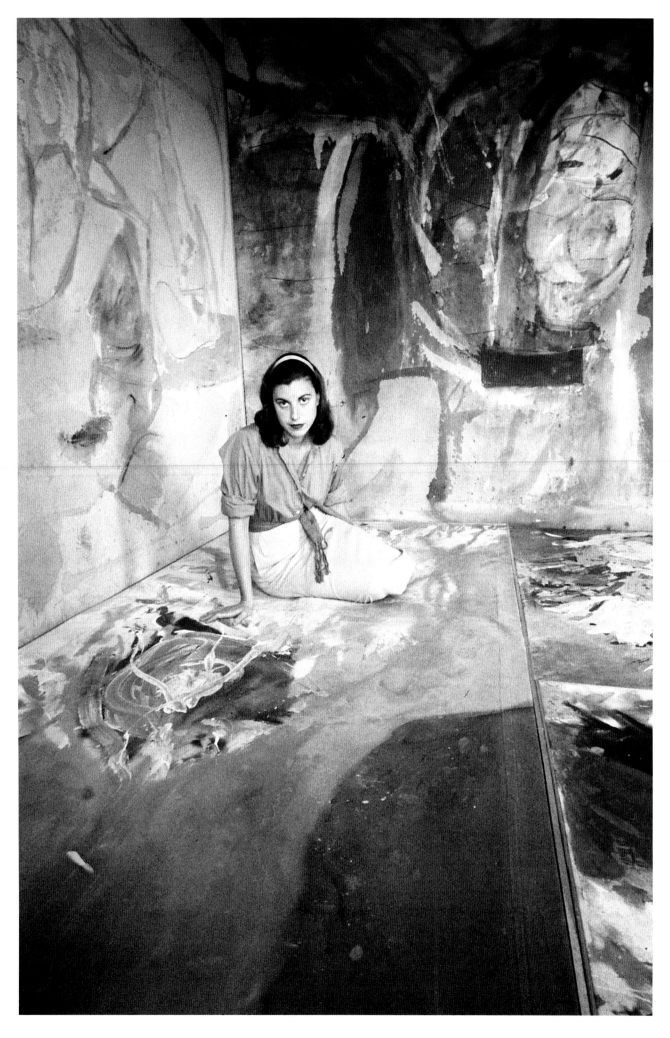

FIG. 16. Helen Frankenthaler in her New York studio, c. 1957. Photograph by Gordon Parks, *Life* magazine.

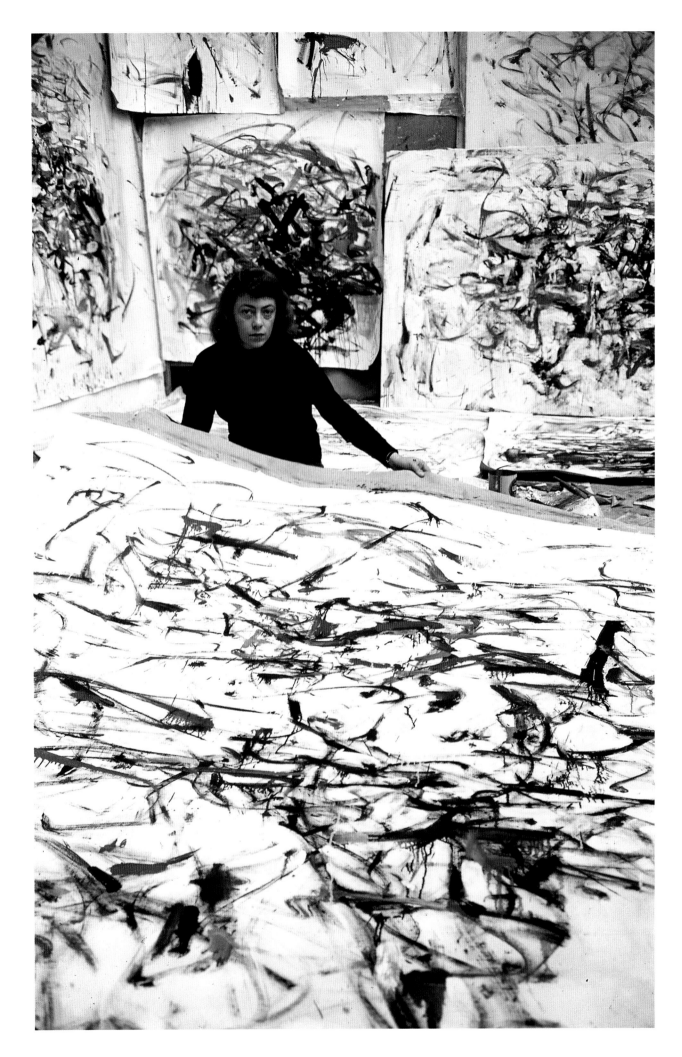

FIG. 17. Joan Mitchell in her studio, September 1956. Photograph by Loomis Dean, *Life* magazine.

abstract expressionist was acceptable in my circle. . . . However, this view soon troubled me. I acknowledged that Joan's painting was "felt" and in its lyrical references to nature, a fresh departure, but it did not compare in range and depth of feeling with that of de Kooning, Kline and Guston. What was it then, that made the difference? There was nothing wrong in working in a tradition if an artist extended it in an individual way, which Mitchell had, but the tradition was originated by Pollock, de Kooning, and others of their generation. Innovation counted.[24]

This topic of the first generation and second generation, and the notion that women made references to nature and provide, as Sandler called it, a "fresh departure" from de Kooning, warrants further consideration.

For a variety of reasons it seems that younger women such as Mitchell, Frankenthaler, and Hartigan, who were born in the 1920s and began exhibiting in the 1950s, were more easily championed by the "elders of Abstract Expressionism" and their critics. Because these women came to their artistic maturity at a time when the canonical Abstract Expressionists were already well established, they could more acceptably be considered as disciples or "second-generation" artists. In 1958, Alfred Barr included Hartigan's *Interior, "The Creeks"* as one of four works by her in *The New American Painting* exhibition, which traveled to eight European museums (cat. 29). She was the only woman among the seventeen artists included in the show, as previously mentioned.[25] After seeing the show in Berlin, Will Grohmann wrote: "[Willem] de Kooning also has influence; Grace Hartigan, the only woman painter of the group, belongs to his way of expression."[26]

Eventually, the younger women shared the fate of the first-generation women artists, as all were dropped from the annals of Abstract Expressionism until feminist scholars resurrected some of their careers. Abstract Expressionism was—and to a large extent, still is— primarily discussed as the art practice of a select number of white males, even though the abstraction and gesturalism explored by women artists of the New York School stem from similar intellectual and artistic roots. While recent scholarship has probed the sources, political ideologies, and individuated art practices of the best-known Abstract Expressionists, most authors continue to focus on the few who became accepted as the pioneers of this mid-century development. Other New York artists of the 1940s and early 1950s—most of the women and a number of men as well—are generally dismissed as derivative, as painters who reworked in

an empty and mannered fashion the heroically authentic forms of the pioneers.

Lee Krasner, Perle Fine, and Elaine de Kooning already were working in an Abstract Expressionist idiom in the 1940s. Krasner made her *Little Image* paintings in the late 1940s, and de Kooning's abstractions, her *Black Mountain* series, date to 1948. When Joan Mitchell introduced connections to nature with her large, gestural brushstrokes, or Helen Frankenthaler explored Color-Field modes of abstraction, these approaches were not the debasement of an established style, but a challenge to the modernist notion that "newness" and "legitimacy" are only the prerogatives of a select few.

What are the reasons, socially and culturally, for this marginalization? Even today, the typical roll call of Abstract Expressionists includes only white urban males, the occasional woman (usually Krasner), and virtually no African Americans such as Norman Lewis and Romare Bearden. If Abstract Expressionist painting is to be understood as negotiating visual metaphors for disorder, chaos, materiality, and other issues of the postwar era in the United States, it must be acknowledged that women artists also appropriated this language. Can women such as Krasner, Mitchell, and Hartigan be identified with "heroic" painting? Within the metaphorics of Abstract Expressionism, women do demarcate the "language of difference." Some of these issues have been addressed, mostly by feminist art historians, and these scholars have sought to expand the roster of artists associated with Abstract Expressionism. The canon of Abstract Expressionism can be reconstituted to include these women.

Notes

1. For complete information on the *Ninth Street Show* and the *New York Painting and Sculpture Annuals* at the Stable Gallery, see Marika Herskovic, ed., *New York School, Abstract Expressionists: Artists Choice by Artists* (Franklin Lakes, NJ: New York School, 2000), 8–39.

2. Statement by Clement Greenberg on the poster for the *Second Annual Exhibition of Painting and Sculpture,* Stable Gallery, 1953. See Herskovic, *New York School,* 20.

3. "In 1951 Barnett Newman masterminded a meeting with Parsons, to discuss the future of her gallery. With him were Pollock, Rothko, and Clyfford Still. They proposed that she throw out all the other artists she represented and deal only with them. . . . She refused." Lee Hall, *Betty Parsons, Artist, Dealer, Collector* (New York: Abrams, 1991), 101–2. Other commercial dealers such as Sam Kootz would not represent women, although they were included in some group shows at the gallery.

4. Ibram Lassaw, whose studio on Eighth Street was the location of "The Club," claimed that the original intention of the founding members was to exclude women. Ann Eden Gibson, *Abstract Expressionism: Other Politics* (New Haven: Yale University Press, 1997), xxv.

5. Thomas Hess, *Abstract Painting: Background and American Phase* (New York: Viking, 1951). See Irving Sandler, "The Club," in *Abstract Expressionism: A Critical Record,* ed. David Shapiro and Cecile Shapiro (Cambridge, UK: Cambridge University Press, 1990), 53.

6. Ann Eden Gibson notes that until the 1980s, only the work of what could be called the "essential eight"—Adolph Gottlieb, Willem de Kooning, Robert Motherwell, Barnett Newman, Jackson Pollock, Ad Reinhardt, Mark Rothko, and Clyfford Still—seemed central. Gibson, *Other Politics,* xx.

7. William T. La Moy and Joseph P. McCaffrey, eds., *The Journals of Grace Hartigan 1951–1955* (Syracuse, NY: Syracuse University Press, 2009), 18.

8. Ibid., 132–33.

9. Lee Krasner, interview, in Cindy Nemser, *Art Talk: Conversations with 15 Women Artists* (New York: HarperCollins, 1975), 90.

10. G. T. M. [Gretchen T. Munson], "Man and Wife," *ARTnews* 48 (October 1949): 45.

11. Michael Leja, *Reframing Abstract Expressionism: Subjectivity and Painting in the 1940s* (New Haven: Yale University Press, 1993), 256.

12. Jean Franklin, "Perle Fine," *The New Iconograph* (fall 1947): 22–25; reprinted in Ann Eden Gibson, *Issues in Abstract Expressionism: The Artist-Run Periodicals* (Ann Arbor: UMI Research Press, 1990), 110–13.

13. John Baur, *Nature in Abstraction: The Relation of Abstract Painting and Sculpture to Nature in Twentieth-Century American Art* (New York: Whitney Museum of American Art, 1958).

14. Letters from Perle Fine, September 22, 1976, and October 5, 1976, Springs, New York, in Artist File, Whitney Museum of American Art, New York.

15. Gibson, *Other Politics,* 80–83; Chris McNamara, ed., *Michael West: Painter-Poet* (East Hampton, NY: Pollock-Krasner House and Study Center, 1996).

16. Irving Sandler mentioned this phrase and applied it to certain artists such as Byron Browne and Norman Lewis in an interview by the author, February 21, 2013.

17. A. Deirdre Robson, *Prestige, Profit, and Pleasure: The Market for Modern Art in New York in the 1940s and 1950s* (New York: Garland, 1995), 249.

18. Kathleen L. Housley, "The Tranquil Power of Perle Fine's Art," *Woman's Art Journal* 24 (spring/summer 2003): 6.

19. "Women Artists in Ascendance," *Life,* May 13, 1957, 74–77. Artists presented in this article include Grace Hartigan, Helen Frankenthaler, Nell Blaine, Joan Mitchell, and Jane Wilson. Only young women were chosen for this article, despite the active careers of many women artists who were over forty at the time of its publication.

20. Ibid., 76.

21. Ibid.

22. Irving Sandler, "Mitchell Paints a Picture," *ARTnews* 56 (October 1957): 44–45.

23. Ibid.

24. Irving Sandler, *A Sweeper-Up after Artists* (New York: Thames and Hudson, 2003), 217–18.

25. See Alfred H. Barr, *The New American Painting* (New York: Museum of Modern Art, 1958). Hartigan's *The Persian Jacket* (fig. 31) had been purchased by the museum in 1953.

26. Will Grohmann, *Der Tagesspiegel* [Berlin], September 7, 1958.

"BIOGRAPHIES AND BODIES"

SELF AND OTHER IN PORTRAITS BY ELAINE AND BILL DE KOONING

ELLEN G. LANDAU

It is as difficult for [the Action painter] to explain what his art *is* as to explain what he himself *is;* but, since he paints with the question and not with the answer, explanation is not an issue.
—Elaine de Kooning, 1958

There they are, the de Koonings—New York's art-world king and queen—preserved exactly as we'd like to remember them by photographer Hans Namuth in 1953 (fig. 18).[1] Elaine, makeup on, nails polished, wearing gladiator sandals and pedal pushers, sits slightly askew on a paint-spattered chair, legs akimbo, smoking of course. Sporting a devilishly disheveled mop of cascading wavy hair, Bill, in a dark T-shirt and jeans, stands slightly forward and to Elaine's left, arms crossed tightly against his body. Only he makes (perhaps slightly dazed) eye contact with Namuth's camera lens; hers is a sideward, skeptical glance. Most notably, one of Bill's *Woman* paintings in progress separates (or joins?) the married abstractionists.

A few years earlier, Namuth had captured another, not dissimilar Abstract Expressionist studio scene; his subject then was Jackson Pollock, de Kooning's chief rival for pre-eminence in postwar American art. Pollock is shown with his wife, Lee Krasner, who is likewise relegated to "also-artist" status through strategies of visual presentation (fig. 19). Living in the country, Lee is dressed with far less style than Elaine; dangling her

slippers, she sits on a nearby stool, one leg crossed over the other, watching Jackson paint. Pollock, by contrast, appears to accelerate dramatically into the picture's foreground. Dripping brush in hand, he is fully absorbed in the creation of *One: Number 31, 1950* (1950, Museum of Modern Art, New York), a work as iconic today as de Kooning's *Woman* series. While they are not identical, significant parallels between these two artist-couple images imply their interpretation can be linked.[2]

Indeed, when Elaine de Kooning specifically asked Namuth to take her picture with one of her husband's current *Woman* paintings to prove she *wasn't* their model, as many were attempting to claim, she had no way of knowing that this version from his 1953 shoot (especially when viewed alongside Namuth's earlier portrait of Pollock and Krasner) would one day acquire the significance of a feminist trope.[3] Art historians and critics commonly recognize the gendered asymmetry these two seated-wife shots so obviously demonstrate. As Michael Leja describes, the men in both appear "more proprietary" and "closer to action," while "the women stand as essential accessories of bohemia,

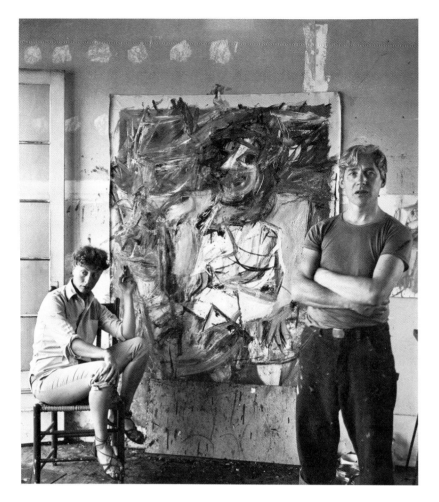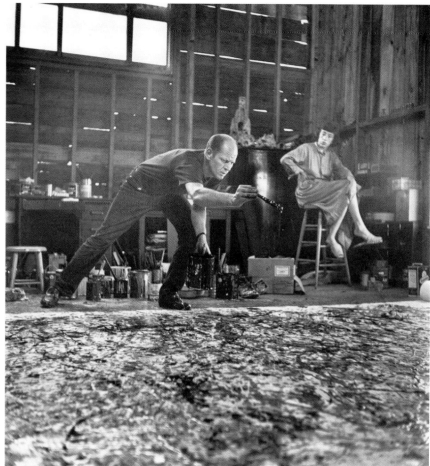

LEFT: FIG. 18. Elaine and Willem de Kooning, 1953. Photograph by Hans Namuth.

RIGHT: FIG. 19. Jackson Pollock and Lee Krasner, 1950. Photograph by Hans Namuth.

their casual dress and posture helping to fill out a cultural image (or fantasy) of the male artist. They also keep that image within certain limits by confirming the heterosexuality or 'masculinity' of their partners." It would have been unthinkable in those days, Leja explains, for the cliché to have become reversed, allowing the men to readily acquiesce to posing in a studio used primarily by their wives.[4] By implication, we might also assume that a similar unlikelihood would have precluded the male artists' agreement to be depicted by their "better half."

For the de Koonings, however, the latter was definitely not the case. No serious examination of their intertwined lives and careers could be complete without inclusion of their varied illustrations of self and formative usage of each other's visage and body. Many such examples are well known; others, as we shall see, remained a well-kept secret. With the exception of Mexican painters Diego Rivera and Frida Kahlo, it may be that no artist couple of the mid twentieth century chose to use each other as models as often as Bill and Elaine.[5] Elaine de Kooning's long-term reputation, moreover, was built on what might be described as her development of a blatantly oxymoronic skill set, fueled in part by this very experience. It was her cleverness at binding Abstract Expressionism's energy to the traditional genre of portraiture that led to her commission to paint John F. Kennedy, president of the United States.

How should we begin her story? Analysis of an earlier photo session featuring Elaine and Bill is a good place to start. The basic ingredients of the most frequently reproduced of the c. 1940–41 images are essentially identical to Namuth's later setup: the two artists (not yet married) are depicted together in Bill's studio, against the backdrop of his current paintings—and each posed separately as well, probably on the same day. Conspicuously, however, this time the photographer was a woman, Ellen Rosenberg Auerbach, recently arrived with her husband from Germany via Tel Aviv, London, and Philadelphia. In 1930, she, with her friend Grete Stern, had formed a commercial photography studio in Weimar Berlin.[6] Through the avant-garde bohemian crowd in which they circulated as quintessential "New Women," Ellen met set designer Walter Auerbach. She and Stern photographed creative denizens of their milieu, including dancer Claire Eckstein and Edwin Denby, Eckstein's collaborator. Denby, later known as a poet and dance critic, met Swiss photographer Rudy Burckhardt in 1934. A year after, the two men moved to New York, renting a fifth-floor loft on

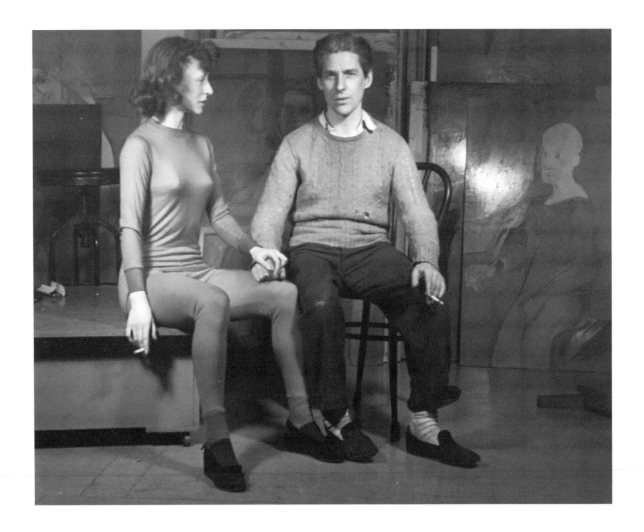

FIG. 20. Willem and Elaine de Kooning in his studio with a working version of *Seated Man (Clown),* c. 1940–41. Photograph by Ellen Auerbach.

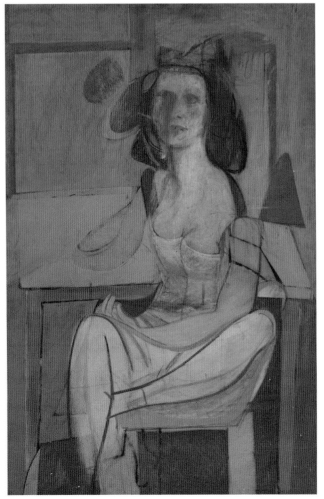

FIG. 21. Willem de Kooning, *Seated Woman,* c. 1940. Oil paint and charcoal on Masonite, 54 1/16 × 36 in. (137.32 × 91.44 cm). Philadelphia Museum of Art. The Albert M. Greenfield and Elizabeth M. Greenfield Collection, 1974.

West Twenty-First Street; in 1936, after his kitten turned up on their doorstep bedraggled in the rain, they befriended their artist neighbor, Willem de Kooning.[7]

Most probably at Denby's suggestion, in 1940 the Auerbachs moved to that same Chelsea block, a circumstance that no doubt led directly to Ellen's project to photograph Bill and Elaine. As Ellen Auerbach recalled, it was obvious when she met him that de Kooning was "TERRIBLY in love."[8] In her portrait, Bill now sits in a studio chair, holding hands with Elaine, who is perched on the edge of a model stand (fig. 20). Seen in profile, Elaine stares over her shoulder at Bill's handsome face. Although they are obviously posing (even appearing somewhat puppet-like), their slightly open mouths suggest interrupted conversation. Noteworthy from a documentary point of view, a working version of Bill's *Seated Man (Clown)* (private collection) finished in 1941—its facial features still resemble the painter's; no false nose yet—is visible propped to his left, and behind the couple we catch a glimpse of *Seated Woman,* de Kooning's first significant female figure painting (fig. 21). Not finished either, *Seated Woman* unmistakably reflects Elaine; in another Auerbach shot, she models for it, left leg bent, right arm touching her breast, and left fingers brushing her wistful face.[9]

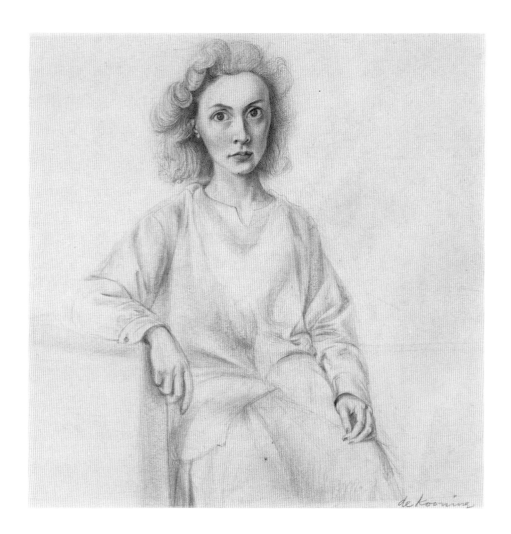

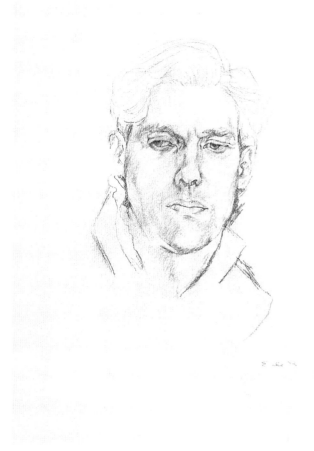

It is well known that, during the Depression, Bill de Kooning also used as subject matter friends such as Denby and Burckhardt or, employing a mirror, repurposed his own shirtless self to paint a series of sad male figures. He also drew directly from Auerbach's photographs, sometimes reshuffling body parts and often scraping out facial features, repainting them numerous times. As we'll see, Elaine would adopt this practice of facial erasure for her own purposes later on.[10] Compared to Bill's brash 1950s works, these late 1930s compositions can appear somewhat tentative; as Judith Zilczer has pointed out, many constitute "conflations or palimpsests of multiple earlier states."[11] Deeply influenced by Arshile Gorky, his closest friend, Bill would regularly complain to Denby that he was "beating his brains out about connecting a figure and a background." Not yet applying modernist principles, like Gorky at that time, he wanted to use form "the way the standard masterpieces had form—a miraculous force and weight of presence moving from all over the canvas at once."[12]

What did it mean for Elaine Marie Catherine Fried, a young artist just starting out, to see herself depicted with the "palpable physicality" of an Old Master drawing (fig. 22) and to be learning not directly from Cubist and Fauvist examples (as many of her peers, including

Krasner and Mercedes Matter, were being taught by Hans Hofmann), but rather from the weighty and anxiety-laden drawings and paintings of de Kooning and Gorky?[13] That she had to salvage from Bill's studio floor this very Ingresque pencil portrait of herself wearing his oversized shirt is a situation rife with both aesthetic and psychological implication.[14] Rather curiously, on the occasion of the couple's fortieth wedding anniversary, it was this image of Elaine, meticulously drawn well before the tension between abstraction and figuration overtook Bill's female subjects, that *Vogue* chose to feature in celebration. It was presented in the magazine alongside a contemporaneous depiction of Bill that Elaine had drawn with a similar "needle-like precision" (fig. 23).[15]

Why, despite her later fascination with sports, prehistoric cave imagery, and bullfighting in Mexico as seen in the *Juárez* series (cat. 11), has art history mainly viewed Elaine de Kooning as a portraitist—yet interpreted her husband differently, even when he was drawing or painting a similar subject? (Bill, Elaine once quipped, always thought that portraits were pictures *girls* made.[16]) As Sidney Tillim pointed out in 1965, just after the movement's demise in the face of the explosion that was Pop Art, the primary function of the figure

FIG. 22. Willem de Kooning, *Portrait of Elaine,* c. 1940–41. Pencil on paper, 12¼ × 11⅞ in. (31.12 × 30.16 cm). Private collection.

FIG. 23. Elaine de Kooning, *Portrait of Willem de Kooning,* c. 1939. Pencil on paper, 10½ × 6¹¹⁄₁₆ in. (26.67 × 16.99 cm). Location unknown.

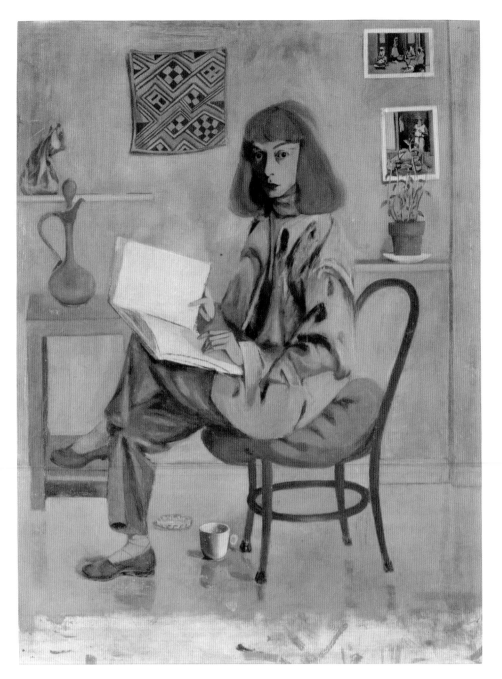

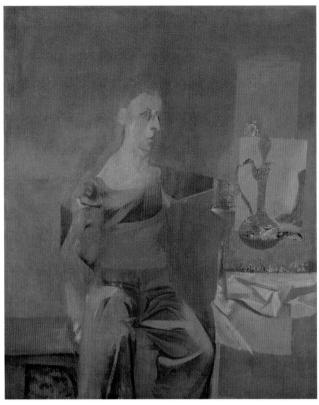

in Action Painting seemed to be the bearing of witness to its own destruction by "the tensions of style." As a result, any imagery resulting from Abstract Expressionism's apocalyptic acts could be considered only "a secondary presence" at best. Of course, Tillim notes, by imploding his portraits of women and thus contributing to the mythology of crisis, de Kooning was relieved of guilt by association. Bill, Elaine explained, was always involved in gesture, even in the 1930s.[17]

As such, Elaine's choice in 1946 to depict herself in a standard seated pose, wearing an artist's smock and surrounded by mundane household or studio items with the "lady artist's accessory" of a lap sketchbook, might appear bewildering for its date (fig. 24).[18] Pollock, for example, was already starting to drip, and Krasner had begun her abstract series of *Little Images* around

that time. Despite Elaine's impassive look, this self-portrait's *retardataire* (or maybe performative?) aspect takes on something of an emotional cast in view of her adoption of the "dreamy metaphysical light" and Pompeiian "hushed ochre" palette common to Bill's earlier single-figure compositions. Parallels are especially strong with *The Glazier,* where, despite the specific title, he had once again presented a gloomy-looking Everyman based in large part on himself (fig. 25). While *The Glazier* features the identical curvy, stoppered decanter positioned on a small table in Elaine's composition, the walls surrounding Bill's blankly staring figure are completely empty. No additional knickknacks, plants, or art reproductions are included to anchor his subject in comparable domesticity. Creation of this painting, moreover, was supposedly aided by the use of a surrogate manikin Bill created with his own discarded clothes: "I made a mixture out of glue and water," he recalled, "dipped the pants in and dried in front of the heater, and then of course I had to get out of them. I took them off—the pants looked so pathetic. I was so moved, I saw myself standing there. I felt so sorry for myself."[19]

Elaine, it turns out, had paved the way for her 1946 self-portrait's "self-conscious and gendered, ferocious but feminine" pose with her own form of role-playing, as evidenced by a number of sketches in different mediums apparently made in conjunction with it.[20] Two of these, delicate drawings executed in pen and ink,

cap, was probably made around the same time and prefigures a number of Elaine's subsequent oil paintings, including *Bill at St. Mark's,* completed around the time of their separation (cat. 9). Presenting Bill in analogous poses but usually more professionally attired, her images of him (fig. 27) count among a portrait group alternately known as gyroscope or faceless men, a series that includes the suited critics Thomas Hess and Harold Rosenberg as well.[21]

Much has been said about Elaine's prominent role from the late 1930s through the early 1950s as Willem de Kooning's model and muse; a lot like those of photographer Alfred Stieglitz's images of painter Georgia O'Keeffe, Bill's presentations of Elaine have often been read as emblems of his own (and our) understanding of *his* work. But, unlike Stieglitz's use of O'Keeffe's body or, closer to home, Herbert Matter's sensual photographic depictions of his wife, Elaine's close friend Mercedes, Bill does not appear to have been interested in asking Elaine to pose in the nude.

relate most closely to the conclusive image. In one, Elaine depicts herself in the act of copying her own likeness; her eyes appear to tilt toward an unseen mirror (fig. 26). In the other, several oil sketches for the final portrait (which are still extant), and the portrait itself, are already under way behind her. One of the smaller studies is propped on the floor, one is tacked to the wall, and the big painting is set up behind her on an easel. All are shown in mirror image.

It is unclear if another set of self-portraits, these done in pencil, immediately preceded (or, less likely, followed) the completed version in 1946 (Elaine claimed at one point to have spent two years using only herself as a model), and although her attire is different in each case, in two of the three related pencil sketches her intense, challenging stare is nearly identical to that in the final oil painting. In one, where she is dressed only in a blouse, underwear, and ballet slippers, Elaine is positioned in a similar direction to the final canvas, but she sits on a stool with her right leg bent toward the ceiling; in another, wearing mannish slacks, a scarf, and sweater, she's posing sideways and upright in the same chair as in the full-size version. Anticipating the assertively sexual pose later favored for seated depictions of her husband, as well as other men (many of whom she was also purportedly intimate with), here her legs are spread apart and her hands turned toward each other at crotch level. A comparable sketch, seemingly of Bill de Kooning in an outdoor jacket and Dutch sailor's

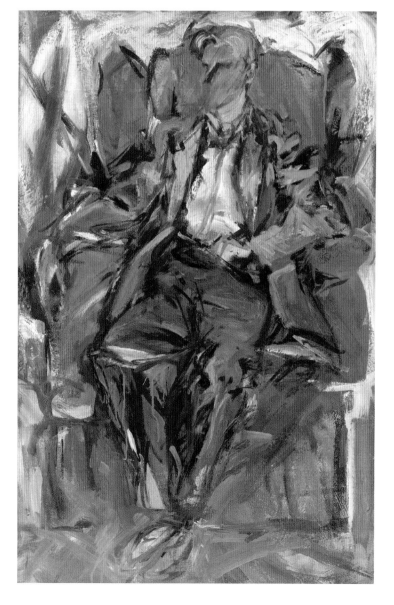

He did draw a former girlfriend, Juliet Browner, naked, presenting her in an elongated reclining position that echoes one of his favorite images at the Metropolitan Museum of Art, the *Odalisque in Grisaille* of c. 1824–34, a work at that time considered to be by Ingres. In contradistinction to his subsequently more aggressive approach toward representing women, Juliet's generalized shapes hinder sexual connotation.

It comes as something of a surprise therefore to discover that Elaine made (and then kept out of sight) a significant number of eroticized sketches of Bill, supine and totally undressed.[22] Many are quick pen and ink impressions probably executed on the same day—or night, since he is clearly asleep—but several are more sensitively rendered, finely detailed pencil portraits. In all cases she makes no attempt to mask any part of Bill's body (fig. 28). While similar in subject, these long-hidden drawings differ in tone from another such undertaking unusual for an early twentieth-century American woman artist: Alice Neel's humorously priapic 1933 painting of a naked Joe Gould (private collection) adorned with multiple penises. Elaine's portrayals of Bill in bed predate by decades works by Sylvia Sleigh in which a variety of men, including her own husband, Lawrence Alloway, are likewise portrayed without any clothes. Sleigh's rather deadpan nude figures, comical today because of their oversized hair, constitute an exercise in the potential (or not) to reverse the art

FIG. 28. Elaine de Kooning, *Bill Asleep,* 1950. Pencil on paper, 23³⁄₄ × 17⁵⁄₈ in. (60.33 × 44.76 cm). Private collection, New York.

FIG. 29. Sylvia Sleigh, *Paul Rosano Reclining,* 1974. Oil paint on canvas, 53³⁄₄ × 77³⁄₄ in. (136.53 × 197.49 cm). Friends of Sylvia Sleigh.

historical objectification of women (fig. 29). Her works, and Neel's naked odalisque of poet, curator, and critic John Perrault (1972, Whitney Museum of American Art, New York), have become textbook examples—quite literally. These have frequently been used since their creation in the 1970s to illustrate the first-generation feminist argument that women artists are never successful at appropriating the male gaze.[23] Elaine de Kooning's private depictions of Bill, whose face and body she thought "physically stunning," put the lie to that belief. "I don't think anyone can become an artist without having a sense of passion toward another artist," she once explained. "I had that passion about Bill, about Bill as an artist as well as Bill as a human being."[24]

While the softer body language in these reclining sketches of Bill differs from the forceful gesturalism of her faceless men—he looks, as Elaine said in another context, "limpid and angelic"—this choice of subject still went against the grain of her era's accepted femininity.[25] Colleagues and critics alike were confounded by Elaine de Kooning's real-life and artistic combination of glamour and toughness: how could someone who looked and painted like she did ever be accepted as "one of the boys," with all the rights and privileges pertaining thereto? Yet, similar to many of the male Abstract Expressionists, including her husband, Elaine considered herself free to pursue a widely varied carnal life. It is probably not at all remarkable that she, in describing the engagement of drawing, called upon erotic terminology, terming it "climactic action," nor that she declared her goal was to "paint men as sex objects."[26] But in no additional known case, however close her relationship to the sitter, did she present any other male subject quite so intimately. The majority of Elaine's portraits of men (whose facial features are typically blurred—no gazing back at *her* allowed) comprise long, spiky strokes painted with a fast brush in order to emphasize the active angular dynamic of the masculine physique. Fascinated, she said, by the way men dress, Elaine emphasized their sexual power in openly assertive postures culled from multiple viewpoints (cat. 8).[27] Her seated male portraits, as a result, "acquire liveliness in passivity."[28]

When she looked at and painted another person, Elaine de Kooning claimed, she always strove to put herself in *their* shoes.[29] Bill's most penetrating gaze, by contrast, had a consistently inward focus. Speaking about his work in general (not excluding his abstractions), "I am always in the picture somewhere," he once stoutly maintained. Specifically regarding his most

FIG. 30. Willem de Kooning, *Untitled (Two Figures)*, c. 1947. Oil paint, watercolor, charcoal, and graphite on paper, 22½ × 22 in. (57.15 × 55.88 cm). Fine Arts Museums of San Francisco. Museum purchase, Gift of Mrs. Paul L. Wattis, 1999.131.

infamous series, Willem de Kooning's numerous statements often comprise variations on the same theme. "Many of my paintings of women have been self-portraits," he asserted, conjecturing at one point, "Maybe I was painting the woman in me."[30] Despite Elaine's protestations, at least the first several paintings in her husband's 1950s *Woman* series, including the iteration captured by Namuth in progress, must have been informed at least in some part by his unsettled feelings about their by-now increasingly fractious relationship. "A sensibility as alive to the emotional resonance of the female form," Bill's biographers write, "could not help but let inchoate feelings about the marriage find expression in this painted woman whom he had so much trouble 'resolving.'"[31]

In 1947 or 1948, several years before *Woman I* (1950–52, Museum of Modern Art, New York), Bill completed two oil-on-paper works. These not only seem to set the scene for the *Woman* series; in an oddly prescient way they also anticipate the Namuth photo shoot, but in an exceedingly unpleasant fashion. Both drawings are similar in subject, but with the protagonists' positions reversed. *Untitled (Two Figures)* depicts a severely distorted woman at left who grins at her partner

malevolently; her suited companion at right stares squarely at the viewer with a somewhat worried look, presaging the artist's own 1953 bewildered gaze (fig. 30).[32] Not four years after Namuth demonstrated what we took at first to be the ideal 1950s artist couple, Elaine and Bill de Kooning would pretty much go their separate ways. They never divorced, however, even though he had a daughter with another woman. After many decades estranged, in the mid-1970s the two would more or less reconcile, with Elaine moving to East Hampton to help her husband overcome debilitating alcohol abuse. By 1987, his Alzheimer's disease had begun advancing to a more serious stage, but Elaine died first, succumbing to lung cancer two years later. Bill would never understand (or perhaps even know) she had finally gone for good.

While none depicted their lovers or husbands as did Elaine, there were other Abstract Expressionist women who created self-portraits, most notable among them Lee Krasner before she met and married Pollock, and Grace Hartigan in the 1950s. A gestural painting Hartigan made showing herself wearing a Persian jacket was the first canvas by a female painter of the second generation of Abstract Expressionists acquired by the Museum of Modern Art (fig. 31). Elaine de Kooning's story is certainly distinguished by what Ann Eden Gibson termed the "density" of her exposure to a canonical practitioner of the movement's ideology,[33] added to the nearly collaborative aspect of her own and Bill's mutual efforts with the figure, a subject both refused to dismiss from the avant-garde. Caught in the web of contradictions about art and being—reflected in her epigraph statement in this essay where, despite the strength of her own artistic ambition, she speaks of Action Painting using male pronouns only—the dilemmas Elaine faced as a woman and a painter were unavoidably centered on the deeply entwined roots she shared with a partner notorious (whether true or not) for his male-centric and misogynistic view of female sexuality.

Abstract Expressionism, of which Willem de Kooning was simultaneously a singular and a paradigmatic archetype, appears metonymic of an era in American cultural life described by Michael Leja as wholly committed to the subjectivity of modern man. "The specifically male individual," Leja has explained, "became the locus of the interaction of complex forces and drives, the site of the conflicts at the source of modern life's crises."[34] But, in her exceptionally personal way (certainly so in comparison to Hartigan or Helen Frankenthaler and Joan Mitchell, slightly younger, more successful female "Action" artists), Elaine at least started the ball

rolling in a different direction, intently doing all kinds of things—some on canvas—that were "simply not done" by *girls* in those days.

"A painting to me," Elaine de Kooning pronounced in 1959, "is primarily a verb, not a noun—an event first and only secondarily an image."[35] Perhaps as a result, compared to his representations of her, Elaine's depictions of Bill read more empathetically, although their originality is less emphatic. Celia Stahr cites an observation made in regard to Pablo Picasso as also apropos to Elaine. Portraiture, Stahr quotes Joanna Woodall as saying, "involves a perpetual oscillation between artist and sitter, observer and observed." The composite representation of identity produced thereby implicates equally "biographies and bodies."[36]

Seen from the vantage point of Elaine's admission to Tom Hess that she considered painting a portrait to be tantamount to stealing another person's secrets, the de Koonings' paired game of self and "other" obviously embraced many uneasy transactions where, as Harold Rosenberg described in a different regard, sitter and portraitist become "locked in a silent wrestle of imaginations."[37] For Elaine de Kooning, the contest's outcome was never in question: the privacy that her practice of portraiture most "rigorously" invaded was always her own.

Notes

Epigraph: Quoted in Elaine de Kooning, "Two Americans in Action: Franz Kline and Mark Rothko," *ARTnews Annual* 27 (1958). The entire essay is reprinted in Elaine de Kooning, *The Spirit of Abstract Expressionism: Selected Writings* (New York: George Braziller, 1994).

1. As art dealer Leo Castelli put it, "Elaine and Bill de Kooning—this remarkable couple, these two artists—weren't *at* the center of the art world; they *were* the center for many years. What would American art be without them? One cannot imagine!" A friend said: "Being around them was like being in a radioactive area, a highly charged atmosphere of sex, ambition, talent, intelligence and energy." Lee Hall, *Elaine and Bill: Portrait of a Marriage* (New York: Cooper Square, 2000), 3.

2. John Canaday termed Elaine Abstract Expressionism's "mascot, sybil and recording secretary," underestimating her talents as both painter and writer; Rose Slivka, essay, in de Kooning, *Spirit of Abstract Expressionism,* 19, quoting Canaday's "Two Ways to Do It," *New York Times,* April 28, 1963, II, 13.

3. Elaine explained to John Gruen that Bill's *Women* "were becoming more grotesque and ferocious, and I was beginning to get quite indignant at suggestions that they were inspired by me. Hans Namuth, the photographer, was taking pictures of artists that summer and I said, 'Take one of me in front of the painting to demonstrate, once and for all, that it has nothing to do with me.' Hans snapped me standing in front of the painting and I was fascinated to discover that I became part of the painting, as though I were the 'Woman's' daughter and she had her hand, protectively, on my shoulder"; John Gruen, *The Party's Over Now: Reminiscences of the Fifties—New York's Artists, Writers, Musicians, and Their Friends* (New York: Viking, 1972), 218. She here refers to another Namuth shot where she stands closer

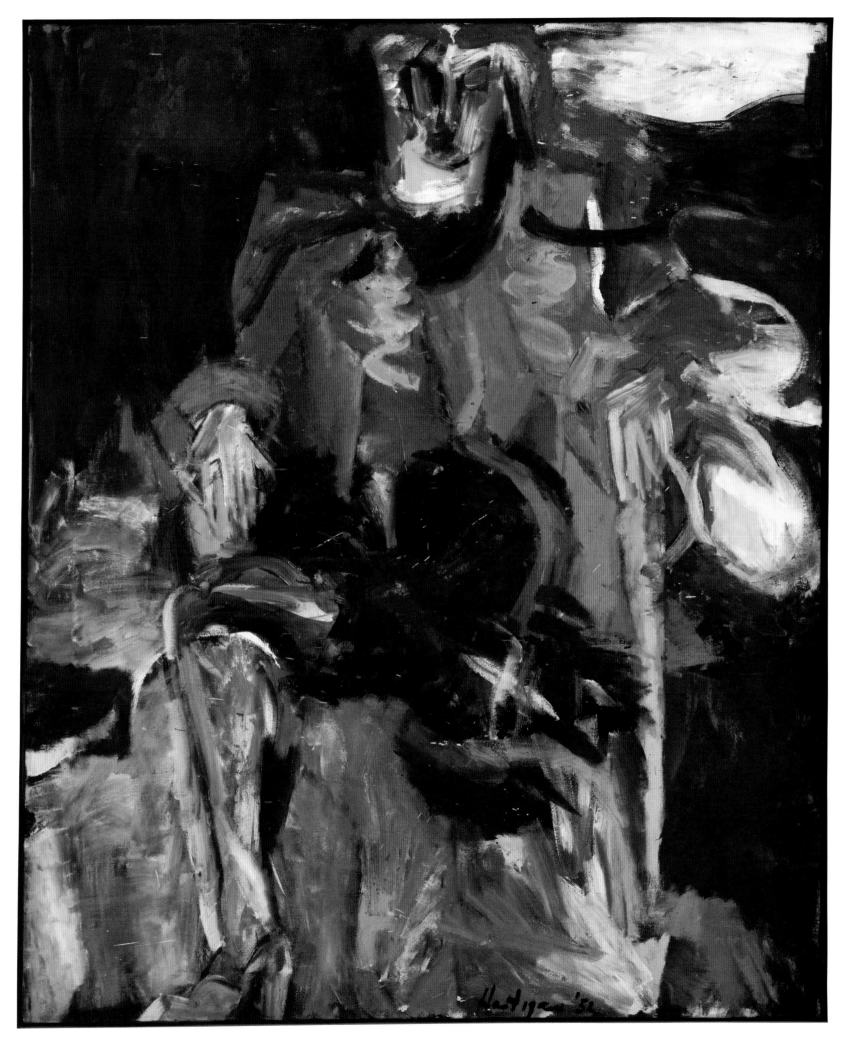

to *Woman II,* her arms folded, with Bill next to her, clasping his hands below the waist. These poses fit the masculinist argument somewhat less neatly. Bill's domineering mother, Cornelia, is also considered a critical psychological model for the 1950s *Woman* series.

4. Michael Leja, *Reframing Abstract Expressionism: Subjectivity and Painting in the 1940s* (New Haven: Yale University Press, 1993), 254–55. Leja compares Namuth's photograph of Bill and Elaine, with her seated, to a 1955 René Bouché painting that is similarly positioned. Bouché, Leja states, presents another case emphasizing the male's outward-directed attention and the female absorbed within, with the man commanding space, the woman contained. Their equivocal facial expressions in Namuth's seated photo perhaps don't quite match this description.

5. See Ellen G. Landau, "Performing the Self and the Other: Portraits and Self-Portraits by Diego Rivera and Frida Kahlo," *Crónicas: El Muralismo, Producto de la Revolución Mexicana en América* (March 2002–February 2003): 15–34.

6. "Ellen Auerbach Dies at 98; Avant-Garde Photographer," obituary, *New York Times,* August 1, 2004, http://www.nytimes.com/2004/08/01/arts/ellen-auerbach-dies-at-98-avant-garde-photographer.html (accessed September 24, 2014). Clara Sandler and Juan Mandelbaum, "Ellen Auerbach 1906–2004," *Jewish Women's Archive Encyclopedia,* http://jwa.org/encyclopedia/article/auerbach-ellen (accessed September 24, 2014).

7. Edwin Denby, "The Thirties: An Essay," in *Dance, Writings and Poetry,* ed. Robert Cornfield (New Haven: Yale University Press, 1998), 1–5.

8. Mark Stevens and Annalyn Swan, *De Kooning: An American Master* (New York: Alfred A. Knopf, 2004), 155; authors' emphasis retained.

9. For the "working version" of *Seated Man (Clown),* see Jennifer Field, "Paintings of Men," in *De Kooning: A Retrospective,* ed. John Elderfield et al. (New York: Museum of Modern Art, 2011), 92–96. On Elaine posing for *Seated Woman,* see Judith Zilczer, *A Way of Living: The Art of Willem de Kooning* (London: Phaidon, 2014), 34. Stevens and Swan, *American Master,* 155, date Auerbach's photographs to the late 1930s, which is not correct.

10. "I was always interested in portraiture," Elaine stated. "If you see someone three blocks away, you recognize them immediately. You do not see the face, but you recognize them . . . a glimpse, the proportions, the kind of rhythm. You don't need to see features, a kind of redundancy"; "My First Exhibit—To Now—Elaine de Kooning," *Art/World* 7 (October 1982): 12; from a conversation with Bruce Duff Hooton.

11. Zilczer, *Way of Living,* 50.

12. Denby, "Thirties," 3. De Kooning and Gorky's admiration for Ingres and the Le Nain brothers has been widely discussed, most recently by Zilczer and Field. Paul Cummings quotes Thomas B. Hess, who claimed that de Kooning drew studies of the male figure from Auerbach's photos; see Paul Cummings, "The Drawings of Willem de Kooning," in *Willem de Kooning—Drawings—Paintings—Sculpture* (Munich: Prestel-Verlag and the Whitney Museum of American Art, 1983), 13.

13. Elaine described, "I met Arshile Gorky and Bill de Kooning both when I was 17, fresh out of high school and going to art school, and they seemed to me to be doing something different from French art, from Picasso and Matisse and so on, and I was very enthralled by that difference. There seemed to me to be something that was absolutely new"; Elaine de Kooning, "My First Exhibit," 12.

14. Field, "Paintings of Men," 85. This drawing was saved through acquisition by the de Koonings' artist friends Daniel Brustlein and Janice Biala. For "palpable physicality," see Cummings, "Drawings," 15.

15. See "De Kooning Memories," *Vogue,* December 1983, 352, an account by Elaine of summer 1948 at Black Mountain College. For "needle-like precision," see Lawrence Campbell, "Elaine De Kooning: The Portraits," in *Elaine de Kooning,* by Jane Bledsoe et al. (Athens: University of Georgia Museum, 1992), 37.

16. Elaine quoted by Lee Hall in Maria Catalano Rand, *Elaine de Kooning Portraits* (Brooklyn: The Art Gallery, Brooklyn College, 1991), 21.

17. Sidney Tillim, "The Figure and the Figurative in Abstract Expressionism," *Artforum* 4 (September 1965): 45–47. Elaine quoted in Hall, *Portrait of a Marriage,* 58.

18. For more about Elaine's dislike of women's standard self-portrait poses, see Aliza Rachel Edelman, "The Modern Woman and Abstract Expressionism: Ethel Schwabacher, Elaine de Kooning, and Grace Hartigan in the 1950s" (Ph.D. diss., Rutgers, the State University of New Jersey, 2006), 153–54. The original source is Rosalyn Drexler, "Eight Artists Reply: Why Have There Been No Great Women Artists?" *ARTnews* 69 (January 1971): 40.

19. On the manikin, see Sally Yard, *Willem de Kooning: Works, Writings and Interviews* (Barcelona: Ediciones Polígrafa, 2007), 21; for its use in *The Glazier,* see Thomas B. Hess, *Willem de Kooning: Drawings* (Greenwich, CT: New York Graphic Society, 1972), 22.

20. The description is by Wendy Wicks Reaves, "Self-Portrait: Elaine de Kooning (1918–1989)," in *Face Value: Portraiture in the Age of Abstraction,* by Brandon Brame Fortune et al. (Washington, DC: National Portrait Gallery, Smithsonian Institution, 2014), 56. See also Brandon Brame Fortune, Ann Eden Gibson, and Simona Cupic, *Elaine de Kooning Portraits* (New York: DelMonico/Prestel for the National Portrait Gallery, 2015).

21. For more on the gyroscope men, see n27.

22. I am grateful to Mark Borghi for access to Elaine de Kooning's works, including unpublished ink and pencil drawings. I also thank James Levis, Clay Fried, and Michael Luyckx for their cooperation.

23. For a comparison of Elaine's gyroscope men and Neel's *John Perrault,* see Lisa Beth Stahl, "Gender Construction and Manifestation in the Art of Elaine de Kooning" (Ph.D. diss., Temple University, 2009), 68–69. Stahl had no knowledge of or access to Elaine's nude depictions of Bill.

24. Hall, *Portrait of a Marriage,* 5, 63.

25. For Elaine's comments on Bill's looks, see Stevens and Swan, *American Master,* 254, from a Dutch interview.

26. Ann Eden Gibson, *Abstract Expressionism: Other Politics* (New Haven: Yale University Press, 1997), 135, from an October 9, 1987, interview between the author and artist. For "climactic action," see Slivka, "Essay," 56.

27. "I was very interested in the male attire," Elaine told Bruce Duff Hooton, "the fact that men's clothes divide them in half. You know, the parting of the jacket, and the trousers, and so on. I was interested in the way men sat in about five different poses. There are men who fold themselves up, press their arms, cross their legs, and there are men who sit up only with their arms at their sides, and their legs akimbo. I just reduced it to these formal elements, and since they were the center of the space, I just had that image of the gyroscope in mind. I talked about it in 1960 to [existential psychologist] Rollo May, who later coined the term 'gyroscope men'"; Elaine de Kooning, "My First Exhibit," 1. According to Gibson, *Other Politics,* 134–35, Elaine used that designation because "the rigidity with which a spinning gyroscope maintains a position perpendicular to the earth's surface reminded her of men's stereotypical relationship to women."

28. Parker Tyler, *ARTnews* 55 (May 1956): 51. Perhaps the closest contemporary work to Elaine's visually expressed admiration of Bill's body would be Larry Rivers's 1954 oil portrait and related drawings of his lover, the poet-curator Frank O'Hara, attired in nothing but his boots.

29. Gerrit Henry, "The Artist and the Face: A Modern Sampling," *Art in America* 63 (January 1975): 36.

30. Upon completing *Woman I,* de Kooning told Amei Wallach that he'd discovered, "It looks like me. Not the woman in me, but me"; Amei Wallach, "My Dinners with De Kooning," *Newsday,* April 24, 1994, 9. See also David Sylvester, "The Birth of 'Woman I,'" *Burlington Magazine* 138 (April 1995): 220–32.

31. Stevens and Swan, *American Master,* 344.

32. Ibid., 241–42; John Elderfield, "Men and Women, and Women without Men," in Elderfield et al., *Retrospective,* 145–49.

33. Gibson, *Other Politics,* 196n48.

34. See Leja, *Reframing Abstract Expressionism,* chap. 4, 203–74.

35. Elaine de Kooning, "Statement," *It Is* (autumn 1959): 29–30.

36. Celia S. Stahr, "Elaine de Kooning, Portraiture, and the Politics of Sexuality," *Genders* 38 (2003): 9. For Joanna Woodall's summary of Marcia Pointon's arguments, see her introduction to *Portraiture: Facing the Subject* (Manchester, UK: Manchester University Press, 1997), 21. Beginning around 1967, Bill started drawing and painting wildly deformed figures—mostly women, but some men—with similarly splayed legs.

37. Valerie Peterson characterizes Elaine's gyroscope men as "the only self-portrait[s] by someone else on record"; Valerie Peterson, "U.S. Figure Painting: Continuity and Cliché," *ARTnews* 61 (summer 1962): 38, 51. On stealing another's secrets, see Thomas B. Hess, "There's an 'I' in Likeness," *New York Magazine,* November 24, 1975, 84–85. For Harold Rosenberg's comments (re: photographer Richard Avedon), see Harold Rosenberg, "Portraits: A Meditation on Likeness," in *The Case of the Baffled Radical* (Chicago: University of Chicago Press, 1985), 105.

THE ADVANTAGES OF OBSCURITY
WOMEN ABSTRACT EXPRESSIONISTS IN SAN FRANCISCO

SUSAN LANDAUER

There is a great irony that cleaves to any account of Abstract Expressionism in San Francisco, a paradox so simultaneously dire and delightful that it borders on black humor. That lover of dark comedy, the painter Hassel Smith, was probably the first to declare publicly that the essential feature of the San Francisco School was its utter lack of financial support.[1] Yet with neither commercially sustainable galleries nor patronage of consequence, Bay Area artists were free to express themselves however they pleased, to create art as noncommercial, experimental, audacious—and as deeply personal—as they could fathom.

This situation had enormous ramifications for women. Unlike their counterparts in the East, women artists in San Francisco never had to contend with what Alfonso Ossorio called the "doctrinaire powerhouses" that excluded them.[2] The chauvinism that women in New York encountered, not only from the critics, galleries, and institutions of the art establishment, but also from their male colleagues, has been well documented. Ann Eden Gibson, who has investigated the gender politics of the New York School most exhaustively, has argued that women artists attempting to join the movement were practically forced to shed their feminine identities: "For these women, to paint seriously was to become almost an aesthetic transvestite, to paint, or to sculpt, in drag. . . . In order to be recognized it was necessary to switch sexes, metaphorically, at least, by producing

works that had 'masculine' characteristics."[3] To be sure, toughness rather than taste was a mantra in San Francisco, particularly among the ex-GIs who disembarked in droves from the Pacific theater at the close of World War II. But discrimination by nearly all accounts was rare or muted. Jay DeFeo, an underground legend in her own time whose reputation eclipsed that of her husband, the painter Wally Hedrick, spoke for other women in her circle when she stated: "I really felt that I had the respect of all my male friends who were artists. It wasn't an issue [being a woman] maybe because there wasn't any competition for wall space, even any competition for jobs."[4] Perhaps because the women Abstract Expressionists faced relatively little resistance in San Francisco, few seem to have concerned themselves with gender-specific imagery or attributes.

San Francisco's distance from the entrenched art establishment of the East also afforded women parity with men in roles of institutional power, which gave them access to influential teaching positions and greater opportunities for museum exposure. Two women, Grace McCann Morley and Jermayne MacAgy, became the leading champions of international avant-garde art in San Francisco, promoting Abstract Expressionists of both genders. As director of the San Francisco Museum of Art (now Modern Art), Morley, a friend of Peggy Guggenheim, was perhaps more pioneering than Alfred Barr and his successors at the Museum of Modern Art

in New York in giving experimental artists from around the country their first solo museum shows.[5] MacAgy, as assistant director and then acting director of the California Palace of the Legion of Honor, held annual exhibitions there in the late 1940s that put San Franciscans in touch with the latest achievements of East Coast artists. She and her husband, Douglas MacAgy, director of the California School of Fine Arts (CSFA, now the San Francisco Art Institute), "energized the community, acting as the initiators, providing the catalyst for creativity."[6]

The artistic background shared by many early Abstract Expressionists was Surrealism, which made early inroads in San Francisco. Local interest, particularly in the abstract Surrealists who immigrated to the United States during the war, was nurtured by their high-profile presence in California. A number of the European exiles who would profoundly influence the New York School came to the Bay Area—Gordon Onslow-Ford, Stanley William Hayter, Wolfgang Paalen, and Roberto

Matta, to name a few.[7] Morley had brought the Museum of Modern Art's *Fantastic Art, Dada, and Surrealism* to San Francisco in 1937 as well as *Abstract and Surrealist Art in the United States,* which she organized with Sidney Janis in 1944. As early as 1940, San Francisco's artist-run *Montgomery Street Skylight* pronounced that the inner-directed ethos of the Surrealist movement had arrived.[8]

Even within this context, Ruth Armer and Claire Falkenstein stand out as early innovators, manifesting key principles of Abstract Expressionism well *avant la lettre.* The heritage of late Surrealism in the work of both is apparent in their employment of ambiguous biomorphic forms and spontaneous gestures; both artists worked intuitively, one stroke dictating the next, each artwork unfolding without premeditation. Both worked non-objectively very early and pursued what Robert Motherwell later termed "plastic" as opposed to "psychic" automatism, which would become a hallmark of Abstract Expressionism.[9]

FIG. 32. Ruth Armer, *Immaterial Forms,* 1940. Oil paint on canvas, 26⅛ × 38⅛ in. (66.36 × 96.84 cm). Smithsonian American Art Museum, Washington, D.C. Gift of Mr. Joseph Branston.

FIG. 33. Claire Falkenstein, *Colorspace #1,* 1941. Oil paint on canvas, 33½ × 29¾ in. (85.09 × 75.57 cm). Collection of Jack Rutberg Fine Arts, Los Angeles.

The first female artist in San Francisco to have an exhibition of non-objective paintings (1931), and with a career spanning half a century, Armer is almost forgotten now.[10] She was included in important national shows, such as the Metropolitan Museum of Art's *American Painting Today—1950,* and in the 1951 publication *Modern Artists in America,* edited by Motherwell and Ad Reinhardt.

In the late 1930s, Armer turned to what she described as feelings generated from within. *Immaterial Forms* is an early example of these richly pigmented, painterly abstractions, which concentrate on jagged, interlocking forms (fig. 32). As the artist explained, "What I paint are neither shapes nor symbols. . . . They are created out of the space itself. . . . The forms are not always fully crystallized and their position and movement in the picture depend on the path of the observer's approach to them. . . . It is this activity of seeing that keeps the organization alive and moving."[11] Armer's paintings of the late 1940s, with their flat, craggy patches, are

strikingly reminiscent of Clyfford Still, though her work evolved in a gradual, self-referential process.[12] While not closely associated with Still, these canvases equally pushed beyond the boundaries of their edges. A critic wrote: "She hints not only at infinities of distance but at infinities of dimension as well; she is one of those abstract painters who lets us sense what the speculations of astrophysicists are like."[13]

Such dematerializing of matter and transcending spatial limitations became leitmotifs for Claire Falkenstein's entire oeuvre. "Exploding volume" became her raison d'être, and the urge to "open things up" included fusing artistic categories, for while she is best known as a sculptor, Falkenstein also worked in a variety of media.[14] More than two decades before Jay DeFeo's celebrated conflation of sculpture and painting in *The Rose* (see fig. 44), Falkenstein was blurring the boundaries of artistic disciplines, utilizing an extraordinary range of materials and techniques. She began her genre-bending explorations in the late 1930s with

SUSAN LANDAUER

her "sculpto-paintings," as Russian avant-garde sculptor Alexander Archipenko called them, which were non-objective artworks created out of boldly textured, polychromed ribbons of clay. Falkenstein's groundbreaking experiments in industrial plastics followed a decade later—engraved and laminated relief sculptures, illuminated by fluorescent light and visible simultaneously from both sides to create ever-changing compositions. Among other career highlights are her "Topological Image Transducers" of the 1970s, consisting of rotating sheet metal sculptures that incorporated light projections of her paintings.[15]

Falkenstein was an undergraduate at UC Berkeley when she was invited to have a solo show at the East-West Gallery of Fine Arts in San Francisco in 1930. She presented expressive drawings, mostly of male nudes, dissolving into a kind of liquefied Cubist space, and was quickly embraced as a fresh voice among the region's leading proponents of abstraction. She took master classes at Mills College in Oakland—in 1933 with Archipenko and in 1940 with the Bauhaus-affiliated artists László Moholy-Nagy and György Kepes, who encouraged her experimental, multimedia bent.

Most influential, however, was Stanley William Hayter. Falkenstein made her first etchings in the summer of 1940 in his printmaking class at the CSFA and appears to have been highly receptive to what Hayter called his "researches in space."[16] For example, her *Colorspace #1* takes Hayter's taut, curvilinear line and weaves a looser, airier web, incorporating semitransparent, amorphous shapes (fig. 33).

Falkenstein's drawings and paintings throughout the 1940s served as a roadmap for the trajectory of her sculpture. She attempted in myriad ways to dematerialize wood and metal, and to infuse these materials with the open space and movement seen in her paintings such as *Barcelona #2* (see page 172) and ink drawings like the one she submitted to Jermayne MacAgy's *Large Scale Drawings by Modern Artists* (1950), with its monumental 23-foot span.[17]

As the director of the CSFA during 1945–50, Douglas MacAgy, who had been Morley's chief curator during the war, played an essential role in creating an environment where Abstract Expressionism could flourish. He allowed studios to remain open twenty-four hours a day and exempted "advanced" students from grades. Envisioning the CSFA as a "laboratory" or "proving ground" for experimentation, he insisted his faculty would not "impose a ready-made set of visual arrangements or prescribed meanings" and would pay respect "at all times to the ultimate integrity of the individual

artist."[18] Students found the atmosphere inspiring, and Mark Rothko, who taught there in the summers of 1947 and 1949, described the impact on his own work as "momentous."[19]

Clyfford Still's shatteringly innovative work contributed to the ferment, pushing artists to go further, to circumvent the commonplaces of Surrealism and Cubism. Still's anti-decorative stance, his "willingness to use something really raw and brutal,"[20] appealed especially to war-hardened veterans such as Frank Lobdell.[21] Still's solo exhibition at the California Palace of the Legion of Honor in 1947 also coincided with a national backlash against modernism that provided what Renato Poggioli called the "antagonistic moment" that often ignites a collective avant-garde.[22] With both the U.S. Congress and President Truman denouncing abstraction as un-American, modernists found themselves under assault. The local papers were full of attacks on Morley for exhibiting abstract painting, and the shrillest denunciations were met with some of the most unbridled experimentation in the arts.[23]

Madeleine Dimond, like other women who gave rise to the CSFA's distinctive contribution to Abstract Expressionism, had no qualms about embracing the anti-decorative aesthetic of the San Francisco School, generally equated with the machismo of the ex-GIs. She herself had served in the Women Accepted for Volunteer Emergency Service (WAVES) naval reserve, as had Ruth Wall, an outstanding Abstract Expressionist printmaker, who transported planes for the army before becoming a Women's Army Corps (WAC) officer.[24] Women were treated no differently from men, according to Deborah Remington, as long as they demonstrated commitment.[25]

Among the women Abstract Expressionists, Lilly Fenichel felt a special empathy for the veterans at the CSFA, since she too had been deeply shaken by the war. Born in Vienna to an illustrious Jewish family who were members of the Austrian intelligentsia, Fenichel was eleven when the Nazis annexed Austria. The family escaped to Great Britain and then to Los Angeles, where Fenichel attended the Chouinard Art Institute before moving to Monterey and joining Henry Miller's circle, including Zev, who gave her private painting lessons. Hassel Smith and Edward Corbett, both Marxists, were her most influential teachers at the CSFA

Fenichel's early abstractions, however, had more in common with the brooding palette and rugged paint handling of ex-GIs such as Lobdell and Walter Kuhlman. *Ochre Red and Blue,* for example, is marked by an earthy organicism as well as broad areas of shifting

color (fig. 34). Fenichel liked to emphasize that she was not an Abstract Expressionist, but merely a "non-objective" painter, eschewing labels as a capitulation to the art world's commercial packaging. Nonetheless, she conformed to the San Francisco School's "consensus by negation."[26] The CSFA artists were, in fact, clear about what they *rejected:* any recognizable reference to visual reality; the swirling, looping lines redolent of Surrealism; and the hard edges associated with Neo-Plasticism and various offshoots of Cubism. Among the San Francisco painters, geometry was almost universally equated with a sympathetic view of technology no longer tenable after the war, and by the late 1940s, the machine aesthetic had come to represent the forces of tyranny and oppression. Linear contours were considered too confining.[27] Still was especially adamant in this regard, declaring: "To be stopped by a frame's edge was intolerable; a Euclidean prison. It had to be annihilated, its authoritarian implications repudiated."[28]

One artist whose paintings did flirt with geometry during this time was Emiko Nakano. Nakano had experienced the disruptive forces of the war firsthand as one of at least 110,000 Americans of Japanese

heritage sent to internment camps after Japan's attack on Pearl Harbor. Her paintings, however, exude a joyous sensuality and delight in her manipulation of paint, with a colorful palette of unrestrained luminosity. It is tempting to interpret these works as expressing the euphoric freedom one might expect after release from prolonged bondage. Painted in a single key verging on monochrome, Nakano's *Untitled* (1950, private collection) is composed of irregular blocks and wedges in a loosened grid, anticipating Richard Diebenkorn's *Berkeley* abstractions of 1953–55. Though not, like Diebenkorn's, inspired by aerial views, Nakano's paintings often refer to landscapes, alluding to seasons or times of day. *June Painting #2,* for example, with its glimpses of spring greens and poppy-flower golds peeking through a soft expanse of multiple shades of gray, is reminiscent of a fog-enshrouded Bay Area summer day (fig. 35). This painting exemplifies Nakano's capacity for achieving rich textural effects, ranging from scumbled layers, which lend a glowing opalescence to fleeting passages of paint, to rapid-fire incisions, zigzagging and spiraling with the dexterity of an etching burin. *June Painting #2* hints at geometry, but hard edges are nowhere to be found.

FIG. 34. Lilly Fenichel, *Ochre Red and Blue,* 1950. Oil paint on canvas, 51½ × 68 in. (130.81 × 172.72 cm). Collection of Lilly Fenichel.

SUSAN LANDAUER

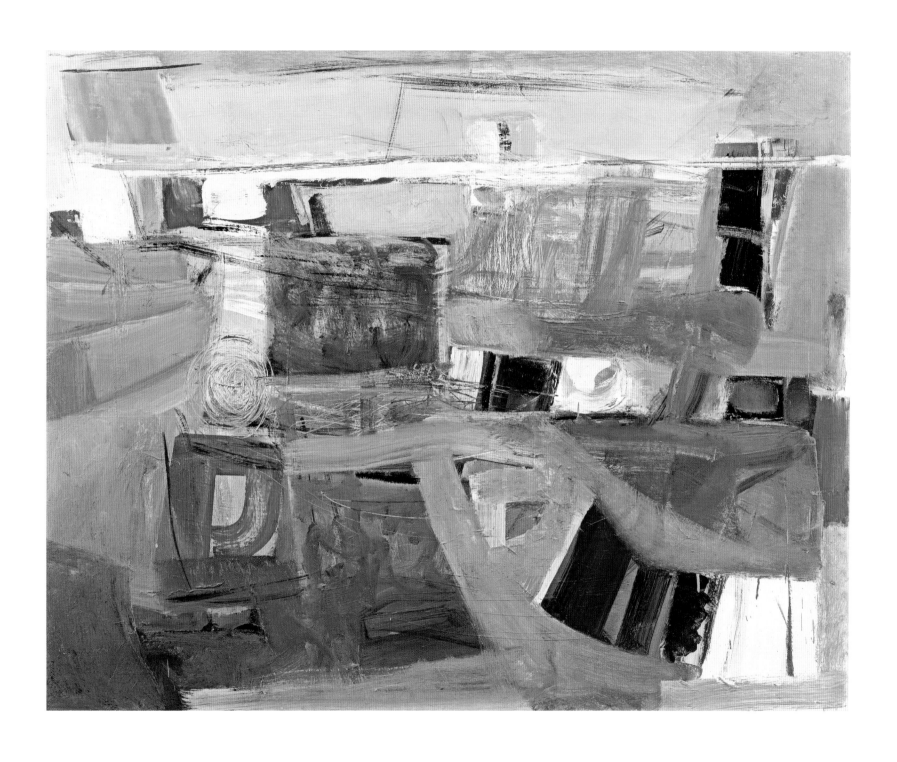

FIG. 35. Emiko Nakano, *June Painting #2*, 1957. Oil paint on canvas, 40 × 50 in. (101.60 × 127 cm). Private collection.

Zoe Longfield also developed an independent style while remaining within the CSFA's "open-form" idiom. Longfield's oil paintings of the late 1940s partake of an essentially watercolorist aesthetic, reliant upon the fluid effects of liquid paint methods. In *Untitled,* for example, exceedingly thin washes make use of the white priming of her canvases (fig. 36). Though familiar with the watercolor-like techniques of Rothko, Longfield took up the challenge of Edward Corbett's tonic call for blind-folded exploration.[29] The critic Alfred Frankenstein noted this when he singled her out as an exceptional participant of the as-yet-unnamed Abstract Expressionist movement: "Of all the numerous artists who have taken up the new credo of arbitrary (or spontaneous) expression in unrestrained colors and unrestrained shapes, Miss Longfield impresses me as one of the most successful."[30]

Longfield became one of the few women Still admitted into his inner circle—"Stillites," as Hans Hofmann called the artists from San Francisco who followed Still

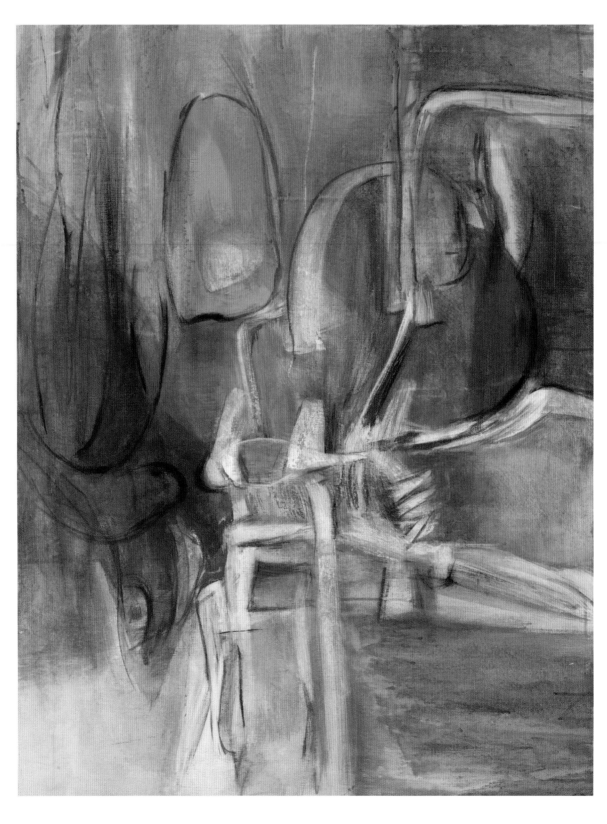

FIG. 36. Zoe Longfield, *Untitled,* 1948. Oil paint on canvas, 44 × 34 in. (111.76 × 86.36 cm). Collection of Susie Alldredge.

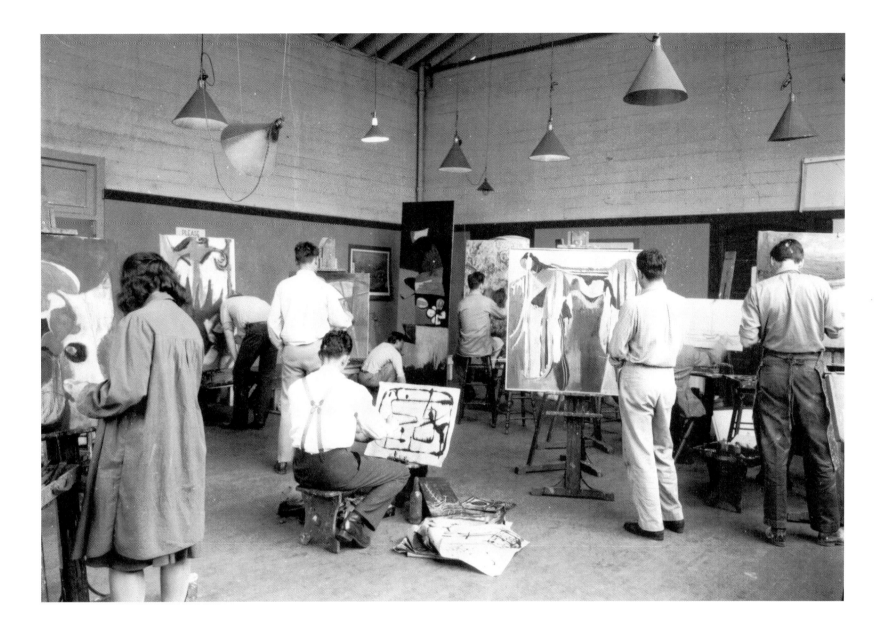

FIG. 37. Classroom at California School of Fine Arts (Zoe Longfield on far left; Frank Lobdell, second to right), 1948. Photograph by William Heick.

to New York in 1950[31]—though Still adamantly discouraged imitation (fig. 37). But of greater historic significance is the role Longfield played in establishing the artist-run Metart Galleries, the forerunner of a series of underground venues that would flourish in San Francisco during the 1950s. Opened in April 1949 in a former laundry at the gate of Chinatown by Longfield and eleven other Still students, Metart espoused their teacher's anti-commercial ethos and was meant to "enable artists not to have to beg or curry favors from the art establishment."[32] Each gallery member had the entire space for one month per year. Metart was short-lived, however, closing in the summer of 1950 with an exhibition of Still's paintings—his last solo show in San Francisco before moving to New York. This exhibition signaled a farewell to the "golden years" of the CSFA, for MacAgy's freewheeling tenure at the school also ended, to be replaced by the Bauhaus-oriented Ernest Mundt.

For women, however, the best years lay still ahead. With the shift of activity from the CSFA's machismo to a free-spirited underground community, they entered an era of unparalleled opportunity, in which women were not just participants, but became leaders of artistic activity. In this environment the King Ubu Gallery opened its doors with a show of sculptor Miriam Hoffman, and Los Angeles's Ferus Gallery gave its first solo exhibition to Sonia Gechtoff. Deborah Remington helped found the Six Gallery, the legendary San Francisco artist-run cooperative, and Jay DeFeo's *The Rose* became the chef-d'oeuvre among paintings of the Beat Generation.

Many women artists gravitated to Hassel Smith, an early and unwavering advocate of women's rights since the late 1930s. After he lost his CSFA teaching position in 1952, a formidable group of women that included Dimond, Fenichel, Gechtoff, Remington, and Adelie Landis (along with equally formidable men) joined Smith's informal, home-based "atelier." These artists also formed a loose confederation within San Francisco's underground, showing together at the King Ubu Gallery, as well as in a group show in New York at

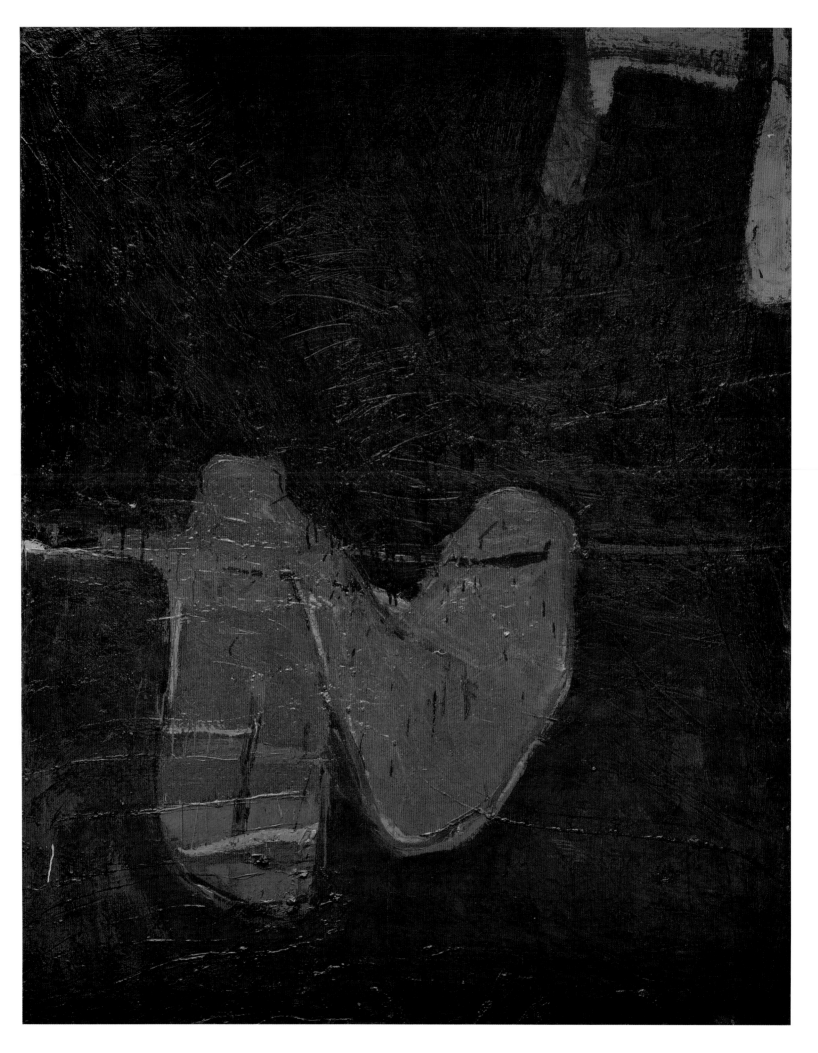

OPPOSITE: **FIG. 38.** Joan Brown, *Zoo*, 1958–59. Oil paint on canvas, 60 × 47³/₄ in. (152.40 × 121.29 cm). Private collection.

LEFT: FIG. 39. Madeleine Dimond, *Untitled*, c. 1950–52. Oil paint on canvas, 37 × 48¹/₂in. (93.98 × 123.19 cm). Collection of Mag Dimond.

the Kaufmann Art Gallery.[33] The humorous variant of Abstract Expressionism some of these artists developed had no significant counterpart in the New York School. It set a precedent for a whole line of whimsical art that would give rise to the wacky Funk ceramic sculpture of Davis School artists and the outlandish abstractions Joan Brown created in the late 1950s (fig. 38) before turning to the intensely autobiographical figurative paintings that occupied the rest of her career.[34]

Madeleine Dimond stands out as an early proponent of San Francisco's subversive brand of witty abstraction. One of her few surviving paintings from the 1950s, *Untitled* (fig. 39), is representative of Dimond's cartoonlike vocabulary (like many of her peers, she admired comic strips, particularly George Herriman's "Krazy Kat"). Her exuberant line takes on an antic life of its own as it rises from a rope-like tangle to lasso a red orb, perhaps a cunning spoof of Still's admonition against line as an enclosing agent.

Of more enduring significance are the irreverent paintings of Deborah Remington. Her rebellious nature was evident at a young age. At Pasadena City College, she befriended Wally Hedrick, Hayward King, John Allen Ryan, and David Simpson, forming a gang of artists

calling itself the Progressive Art Workers (PAW). In 1954, this group would reunite in San Francisco to found the Six Gallery (fig. 40), where on October 7, 1955, Allen Ginsberg read "Howl," marking the "semi-official" launch date of the Beat Generation.[35]

Remington entered the CSFA in 1947, and though her early abstractions show the influence of Elmer Bischoff, Corbett, Smith, and Still, she soon railed against a movement that she felt undermined its core value of freedom with an exclusionary ethos.[36] This was evident in the paintings she exhibited at the King Ubu Gallery in

FIG. 40. Deborah Remington with fellow co-founders of the Six Gallery. From left to right: Jack Spicer, Hayward King, John Allen Ryan, and Wally Hedrick (the sixth co-founder, David Simpson, is not pictured). c. 1954–55.

1953, with crazy-quilt patterns and whimsical spots in Day-Glo–like colors. As Remington explained, she was seeking to create humor by introducing elements that were at once "perverse" and "unexpected."[37] Her campy titles, such as *Fast Company* (1954), *Gopher Baroque* (1955), and *A Cool Kitty on a Hot Tin Roof* (c. 1955), impart a sense of Remington's fanciful strategies to undermine any preconception of high art.

In the mid-1950s, Remington embarked on an extensive trip throughout East Asia, visiting China and Nepal, living in Japan for more than two years, and studying calligraphy. The work she produced after returning shows the influence of this painstaking training in its enhanced sensitivity to stroke and gesture. Although sometimes lyrical, most of Remington's paintings pack a vigorous punch, as in *For H. M.,* with its powerful sense of centrifugal movement that one critic likened to a "tornado-like force," with swaths of electric cobalt swinging from side to side through a field of mostly raw sienna (fig. 41).[38]

Bernice Bing's reputation as an Abstract Expressionist has only just begun to be resurrected (fig. 42). Bing was born in San Francisco's Chinatown amidst ongoing "Yellow Peril" paranoia; her father died in jail and her mother died when she was five. Growing up in a series of Caucasian foster homes, Bing stayed occasionally with her grandmother, her most important family connection to her Chinese heritage. She won a scholarship in 1957 to the California College of Arts and Crafts (now California College of Arts) in Oakland, intending to study advertising, but after taking classes with Diebenkorn, Nathan Oliveira, and Saburo Hasegawa, Bing began to paint and transferred to the CSFA. With classmates Joan Brown, Manuel Neri, and William T. Wiley, Bing quickly fell in with the "Fillmore crowd," the circle around DeFeo and Hedrick that gathered in their studio-flats on Fillmore Street. Participating in the Batman Gallery's historic *Gangbang* show in 1960, she premiered along with many of the leading lights of the city's avant-garde.[39]

Bing was among the few artists in San Francisco to acknowledge the influence of the New York School. She admired the big-brush, slashing diagonals of Franz Kline and Willem de Kooning, as well as the more delicate morphologies of Arshile Gorky, with their "secret doodling" resulting occasionally in vaguely sexual connotations.[40] In *Two Plus,* aspects of these artists' techniques are assimilated into Bing's own aesthetic (fig. 43). This painting glories in juxtaposition, the bold, dry strokes and opaque slabs of color contrasting with intensely saturated, liquid meanderings of the brush. Here, Bing

sets up the makings of an architectonic structure, only to place it precariously next to a mysterious, crimson-edged orifice. She synthesized the disparate worlds of her own identity: the limitless void of Buddhism, the spontaneity of Asian calligraphy, and the brash paint handling of Abstract Expressionism.[41]

Sonia Gechtoff was older and more experienced than most of the Fillmore artists, having launched her career in Philadelphia in the 1940s, with a B.F.A. from the Philadelphia Museum School of Industrial Art, a solo show at the Dubin Gallery, and a teaching position—which she quit to move to San Francisco. Although initially inspired by Still's work, Gechtoff's paintings soon bore more resemblance to the quirky, jazz-inspired abstractions common to Smith's atelier.[42] Gechtoff and her artist husband, James Kelly, moved into "Painterland," as the Fillmore Street complex became known, taking a flat next to DeFeo and Hedrick. By 1955, she was painting in a highly original style, combining three to six colors on a palette knife and applying them, blended and unblended, in a single swipe to the canvas.[43] Works such as *The Beginning* (cat. 22) show a hedonistic affection for paint laid on in sweeping strokes, similar to DeFeo's slightly later paintings.

In 1957, the M. H. de Young Memorial Museum gave Gechtoff her first museum exhibition. The local newspapers were dithyrambic in their praise; critic Frankenstein declared her oils "a monumental achievement," noting her "distinctive style."[44] Nature and poetry were frequent sources of inspiration, as in *Mountains* (1955, Jan Shrem and Maria Manetti Shrem Museum of Art, University of California, Davis) and *Mystery of the Hunt* (1956, San Francisco Museum of Modern Art), also the title of a poem by Fillmore friend Michael McClure.

Gechtoff was one of the few San Francisco artists to gain national recognition. In the Solomon R. Guggenheim Museum's 1954 roundup of new talent, *Younger American Painters,* her work was shown next to that of Willem de Kooning, Franz Kline, Robert Motherwell, and Jackson Pollock. Walter Hopps brought her de Young exhibition to his new Ferus Gallery in Los Angeles.[45] And in 1958, Gechtoff and Grace Hartigan were the only women chosen to represent the United States at the Brussels World's Fair. Later that year, Gechtoff became a member of Poindexter Gallery's high-profile stable and moved back East, to Manhattan.[46]

Jay DeFeo admitted having a sense of relief when Gechtoff left San Francisco.[47] She recalled being disturbed by Gechtoff's knack for anticipating her ideas, producing work that she had conceived but not yet begun.[48] DeFeo had studied under the modernists at

FIG. 41. Deborah Remington, *For H. M.,* 1962. Oil paint on canvas, 72½ × 62¼ in. (184.15 × 158.12 cm). Collection of the Oakland Museum of California. Gift of Harry Hunt.

FIG. 42. Bernice Bing in her North Beach studio, San Francisco, late 1950s. Photograph by Charles Snyder.

FIG. 43. Bernice Bing, *Two Plus*, 1960. Oil paint on canvas, 30 × 30 in. (76.2 × 76.2 cm). Collection of Alexa Young.

the University of California, Berkeley. Infatuated with Renaissance art and architecture, after receiving an M.A. in 1951, she spent a couple years traveling throughout Europe, staying principally in Italy. Her *Florence* series (1952), ink and tempera paintings on torn and collaged paper, combined the improvisational energy of Abstract Expressionism with the delicacy of Asian calligraphy, often executed in the rich monochrome that became a hallmark of her immense oil paintings of the late 1950s. Their archetypal vocabulary of circles, triangles, and particularly crosses would recur in various media throughout her career, and although she insisted that her interest in these shapes was purely formal, they would take on what her close friend Michael McClure described as an "alchemical" quality in some of her best-known works, notably *The Rose,* with its intimations of a cruciform.[49]

A latecomer to Abstract Expressionism, DeFeo burst on the art scene in 1954, the year she married Wally Hedrick, moved to San Francisco, and had her first exhibition at The Place. She and Hedrick's two flats, at 2322–2330 Fillmore Street, became the hub of vanguard activity for the underground art community. DeFeo experimented with an eclectic array of styles, materials, and techniques, producing works as diverse as the torrential *Doctor Jazz* (1958, Nora Eccles Harrison Museum of Art, Logan, Utah) and the meticulously rendered and mesmerizing drawing *The Eyes* (1958, Whitney Museum of American Art, New York). In 1956, DeFeo began the first of several large-scale abstractions teeming with movement, consisting of flurries of dabs and strokes, each a brush- or knife-load of more than one color at a time. The technique was similar to Gechtoff's, but the surfaces of some paintings became densely piled encrustations with a topography of ridges and valleys deep enough to cast shadows. Thick impasto had been a characteristic of San Francisco Abstract Expressionism since Still's blistered-slab paintings, but DeFeo's generation took the technique to an unprecedented extreme.

The Rose, measuring eleven inches thick and weighing about a ton—now a centerpiece of the Whitney Museum's collection—is the most famous painting to have come out of the San Francisco movement (fig. 44). The enduring fascination stems not from its innovative technique or media-blurring facture, but rather from its commanding presence, enigmatic nature, and legendary history. The story of DeFeo's single-minded devotion to the painting for the better part of eight years is well documented. Removing the work required cutting a hole into a wall and lowering the piece on a forklift into

a truck, an event immortalized in Bruce Conner's film *The White Rose* (1965). What gives *The Rose* such power is not only its imposing size but its quality of light, an inner, radiant light that exerts an active force on the viewer. *The Rose,* like all great works of art, defies definition—as critic Michael Duncan put it, the painting offers "no closure but infinite quest," oscillating between "the concave and the convex, between emanation and inhalation, between transcendence and abnegation."[50]

DeFeo, the artist who worked for so many years without recognition on the farther shore of Abstract Expressionism, has now become a national icon. But in the context of San Francisco's underground, DeFeo is iconic in another sense, as representative of a host of

FIG. 44. Jay DeFeo, *The Rose,* 1958–66. Oil paint with wood and mica on canvas, 10 ft., 8 7/8 in. × 92 1/4 in. × 11 in. (327.3 × 234.32 × 27.94 cm). Whitney Museum of American Art, New York. Gift of The Jay DeFeo Trust and purchase, with funds from the Contemporary Painting and Sculpture Committee and the Judith Rothschild Foundation, 95.170.

women artists who were equally devoted to painting for the sheer sake of painting, without concern for posterity. DeFeo was not alone in choosing to preserve her artistic ideals over commercial success. Ruth Armer proved just as heedless of financial gain when she turned down the Poindexter Gallery's offer to join its stable in the 1950s.[51] The same can be said of Claire Falkenstein, who could have made a name for herself in New York after success in Paris, but remained in Southern California. Like DeFeo, Falkenstein also bridged genres, was adventurous in her experimental approach to making art, and developed a profoundly idiosyncratic and eclectic sensibility. Indeed, Madeleine Dimond and Deborah Remington were aesthetic risk takers who shared DeFeo's self-proclaimed "chancing the ridiculous" with their eccentric, often bizarre abstractions.[52] In overcoming obstacles and keeping her creative spark alive, Bernice Bing easily matched the stamina of DeFeo. It was a given for these California women that preserving their integrity as artists required some struggle. For these Abstract Expressionists, it was not so much a matter of gender as their opting for the advantages of obscurity in San Francisco over the heady possibilities for success in New York.

Notes

1. See Hassel Smith, "Sulla scuola di San Francisco," *Evento delle Arti* 2 (1958): 26.

2. Alfonso Ossorio quoted in Ann Eden Gibson, *Abstract Expressionism: Other Politics* (New Haven: Yale University Press, 1997), 90.

3. Ibid., 156. See also Whitney Chadwick, *Women, Art and Society* (London: Thames and Hudson, 1990), 320.

4. DeFeo quoted in Rebecca Solnit, "Heretical Constellations: Notes on California, 1946–61," in *Beat Culture and the New America, 1950–1965,* by Lisa Phillips et al. (New York and Paris: Whitney Museum of American Art, in association with Flammarion, 1996), 82.

5. For example, Morley gave solo shows to Ruth Armer in 1936, 1939, and 1950; to Claire Falkenstein in 1940, 1943, and 1948; and to future members of the New York School more than a decade before eastern institutions, including Gorky (1941), Still (1943), Pollock (1945), Tobey (1945), Rothko (1946), Motherwell (1946), and Hofmann (1946).

6. David Beasley, *Douglas MacAgy and the Foundations of Modern Art Curatorship* (Simcoe, Ont.: Davus, 1998), 19.

7. Morley gave solo shows to Yves Tanguy (1940), Hayter (1940, 1946), Onslow-Ford and Paalen (1948), and Matta (1950).

8. Martin Leuer, "Recipe Art Moderne," *Montgomery Street Skylight* 16 (December 6, 1940): n.p.

9. Irving Sandler, *The Triumph of American Painting: A History of Abstract Expressionism* (New York: Harper and Row, 1970), 41.

10. Armer had a one-woman show of her synesthetic abstractions in 1931 at the Stanford Art Gallery (now the Cantor Arts Center at Stanford University).

11. Armer quoted in Samuel Heavenrich and Grace Morley, *California Painting—40 Painters* (Long Beach, CA: Long Beach Municipal Art Center, 1955), n.p. See also "Ruth Armer, Painter," in *Art and Artist* (Berkeley: University of California Press, 1956), 1–8.

12. See Spencer Barefoot, "Around the San Francisco Art Galleries," *San Francisco Chronicle,* April 28, 1948.

13. Alfred Frankenstein, "An Impressive Showing at the Museum of Art," *San Francisco Chronicle,* n.d. (Ruth Armer Papers, roll 2200, Archives of American Art, Smithsonian Institution, Washington, DC).

14. Falkenstein quoted in Michael Duncan, "Claire Falkenstein: Exploding the Volume," in *Claire Falkenstein,* by Susan M. Anderson, Michael Duncan, and Maren Henderson (Los Angeles: Falkenstein Foundation, 2012), 30.

15. On Falkenstein's "sculpto-paintings," see Maren Henderson, *Claire Falkenstein: Looking Within—A Point of Departure, Collected Works, 1927–1997* (Fresno, CA: Fresno Art Museum, 1997), 8–9. On her Lucite, Plexiglas, and Bakelite pieces, see Claire Falkenstein, "Falkenstein," *Arts and Architecture* 64 (December 1947): 28–29.

16. Hayter quoted in Susan Landauer, *Paper Trails: San Francisco Abstract Expressionist Prints, Drawings, and Watercolors* (Santa Cruz, CA: Art Museum of Santa Cruz County, 1993), 28n37.

17. Ibid., 15.

18. Douglas MacAgy quoted in Susan Landauer, *The San Francisco School of Abstract Expressionism* (Berkeley: University of California Press, 1996), 36.

19. Rothko to Clay Spohn, May 1948, unfilmed Spohn Papers, Archives of American Art, Smithsonian Institution, Washington, DC, quoted in ibid., 91.

20. CSFA student Jack Jefferson quoted in ibid., 81.

21. See ibid., 142.

22. Renato Poggioli, *The Theory of the Avant-Garde,* trans. Gerald Fitzgerald (Cambridge, MA: Harvard University Press, 1968), 26.

23. For more on the impact of the Cold War, see Susan Landauer, "Countering Cultures: The California Context," in *Art of Engagement: Visual Politics in California and Beyond,* by Peter Selz (Berkeley: University of California Press, 2006), 2–7.

24. For more on Ruth Wall, see Claire Carlevaro, *Love of the Stone: Ruth A. Wall, Abstract Expressionist Prints, 1952* (San Francisco: Art Exchange Gallery, 2007).

25. See Deborah Remington, interview by Paul Cummings, May 29, 1973–July 19, 1973, transcript 16–17, the Oral History Collections of the Archives of American Art, Smithsonian Institution, Washington, DC.

26. Landauer, *San Francisco School,* 64–71.

27. Ibid. See also Douglas MacAgy, "Contemporary Painting" (lecture, Dominican College, San Rafael, CA, February 17, 1947), transcript in Archives of the Anne Bremer Memorial Library, San Francisco Art Institute.

28. Still quoted in Henry Hopkins, ed., *Clyfford Still* (San Francisco: San Francisco Museum of Modern Art, 1976), 123–24.

29. See Mary Fuller McChesney, *A Period of Exploration: San Francisco 1945–50* (Oakland, CA: Oakland Museum, 1973), 16.

30. Alfred Frankenstein, "Around the Galleries," *San Francisco Chronicle,* December 11, 1949. The terms "Abstract Expressionism" and "New York School" were not recognized in San Francisco in the late 1940s. Besides "open-form," "free-form," and "Non-objectivism," the movement was referred to by various critics as "First Sensation," "Amorphous Chromatism," "Spiritism," and, in less hospitable quarters, the "Drip and Drool School."

31. Landauer, *San Francisco School,* 127.

32. Zoe Longfield, interview by the author, July 1989. The gallery took its name from "metamorphosis." See also "Metart Gallery Experiment in Non-Commercial Exhibitions," *San Francisco Art Association Bulletin* 15 (September 1949): n.p.

33. *From San Francisco: A New Language in Painting* (1954) included Roy De Forest, Madeleine Dimond, Sonia Gechtoff, James Kelly, Hassel

Smith, and Julius Wasserstein. See the review, "San Francisco Group," signed "A. N.," *Art Digest* 29 (March 1, 1954): 18.

34. See Susan Landauer, *The Lighter Side of Bay Area Figuration* (Kansas City, MO: Kemper Museum of Contemporary Art, 2000).

35. For more on the Six Gallery, see *Lyrical Vision: The 6 Gallery, 1954–57* (Davis, CA: Natsoulas Novelozo Gallery, 1990), and Nancy M. Grace, "Inside and Around the 6 Gallery with Co-Founder Deborah Remington," The Beat Studies Association, http://www.beatstudies.org/pdfs/symposium_2008/6gallery.html (accessed July 14, 2014).

36. Deborah Remington, telephone interview by Carlos Villa, August 10, 2005, "Rehistoricizing the Time Around Abstract Expressionism in the Bay Area, 1950s–1960s," http://www.rehistoricizing.org /deborah-remington-2/html (accessed January 22, 2014).

37. Remington, interview by Cummings, transcript 47, Archives of American Art, Smithsonian Institution, Washington, DC.

38. Constance Perkins, "Deborah Remington Shows Art with Dynamic Vitality," *Los Angeles Times,* February 11, 1963.

39. The *Gangbang* exhibition took place December 4, 1960–January 1, 1961, and included Bruce Conner, Jay DeFeo, Wally Hedrick, George Herms, Michael McClure, Manuel Neri, Carlos Villa, and William T. Wiley.

40. "Secret doodling" is art dealer Julien Levy's term, quoted in Sandler, *Triumph of American Painting,* 52.

41. Bing later reflected: "I feel in many ways that art has been the means by which I was able to understand my two cultures." Quoted in Moira Roth, "Bernice Bing: A Narrative Chronology," Queer Culture Center, http://www.queerculturalcenter.org/Pages/Bingshow /BBChron.html (accessed January 24, 2014).

42. An example of this early work is *These Foolish Things* (1952, location unknown). This tempera was reproduced in *Sixteenth Annual Watercolor Exhibition* (San Francisco Art Association, in association with the San Francisco Museum of Art, 1952), n.p., and was the winner of the San Francisco Art Association Prize.

43. These began in 1955 with paintings such as *Mountain* (1955), in the collection of the Nelson Gallery, University of California, Davis, and her technique was fully developed "no later than March, 1956." Cynthia Weisfield (who is writing a biography on Gechtoff), e-mail message to author, June 4, 2014.

44. Alfred Frankenstein, "Sonia Gechtoff Exhibit Blazes with Vision," *San Francisco Chronicle,* January 23, 1957.

45. Kristine McKenna, *The Ferus Gallery: A Place to Begin* (Göttingen, Ger.: Steidel, 2009), 46.

46. Gechtoff's *Love at High Noon* (1958) (destroyed) was reproduced in the *Time* magazine article on the exhibition and the controversy about the number of West Coast artists included. See "Americans in Brussels: Soft Sell, Range, and Controversy," *Time,* June 16, 1958, 70–75.

47. Jay DeFeo, interview by Paul J. Karlstrom, June 3, 1975–January 23, 1976, transcript 27, the Oral History Collections of the Archives of American Art, Smithsonian Institution, Washington, DC.

48. Ibid. DeFeo recalled: "Often times our ideas would overlap to the point where I would go over and see her, and there would be this painting before my eyes that was still in a germinal state in my head. If you can understand what kind of an impact this had on me psychologically for one thing, it just kind of robbed me of my identity."

49. Michael McClure, voice mail message to author, July 2014.

50. Michael Duncan, "Chancing the Ridiculous: Jay DeFeo and the No Generation," in *Jay DeFeo: A Retrospective,* by Dana Miller (New York: Whitney Museum of American Art, 2012), 68.

51. Ruth Armer, interview by Paul J. Karlstrom, roll 3196, frame 197, Archives of American Art, Smithsonian Institution, Washington, DC.

52. DeFeo quoted in Duncan, "Chancing the Ridiculous," 61.

KRASNER, MITCHELL, AND FRANKENTHALER
NATURE AS METONYM

ROBERT HOBBS

Since critics and art historians have long thought that first-generation Abstract Expressionism, with the sole exception of Lee Krasner, was comprised of only men, there has been a concomitant tendency to regard this art as a singularly male prerogative. According to this gender-biased reading, only in the early 1950s, when the ideas of this art began to be disseminated, were women able to participate in this primarily heroic and macho-oriented art, and they did so by diminishing the work's intuitive power and its rigorous emphasis on individual autonomy. In this scenario, the second generation, which includes Joan Mitchell and Helen Frankenthaler among other females, never managed to plumb the depths of the unconscious that had served as the first generation's fountainhead, and so their art became more associated with an external rather than an internal nature. Like many myths, this one contains some truths, while falsifying others, and it glorifies works by members of the first generation, at the expense of art by later artists, because it does not recognize that these subsequent individuals were using improvisational techniques to achieve very different goals. In this essay, I will be looking at the work of three widely acknowledged women Abstract Expressionists—Lee Krasner, Joan Mitchell, and Helen Frankenthaler—in terms of the poetic tropes found in their works that diverge substantially from those utilized by male artists of the first generation. These differences, in my opinion, are predicated on the women's preference for metonyms instead of the metaphors found in work by male Abstract Expressionists. My basic understanding of metonyms is indebted to Hugh Bredin's excellent analysis.[1] Stated simply, metonymy is a noncomplex and nondependent relation between objects that is already known through established conventions, while metaphor is an invented relation dependent on an overarching concept.[2]

In recent years, feminist scholars in a number of fields have tried to characterize metonymy as a universal trope characteristic of women, while metaphor is viewed as belonging to the male domain. Consequently, French literary theorist and feminist Domna C. Stanton questions the appropriateness of metaphor for symbolizing motherhood. She finds metonymy more suitable for "generat[ing] indefinite explorations of other desirable known and unknown female functions," because it explores "concrete contextual inscriptions of differences within/among women."[3] Traditionally, metonymy has been regarded as marginally figurative: according to this rationale, it is useful for condensing and classing established contingent, tangential, and contextual relationships in terms of associations, making it especially relevant for realistic prose and representational art, more so than for poetry and abstraction. Beginning with the Greeks, philosophers have tended to personify metonymy indirectly as the lackluster stepsister of its

FIG. 45. Lee Krasner, *The Eye Is the First Circle,* 1960. Oil paint on canvas, 92¾ in. × 15 ft., 11⅞ in. (235.59 × 487.36 cm). Private collection.

assumed-to-be more mature, original, intelligent, and proactive poetic male counterpart, metaphor, due to the latter's capability to transpose terms from one semantic field to another, thereby enacting stirring and often innovative shifts in thought.[4] In 1982, the respected feminist, ethicist, and psychologist Carol Gilligan took the important step of making positive connections between traditional metonymical characteristics and females' orientation to the world. She postulates, "The psychology of women that has consistently been described as distinctive in its great orientation toward relationships and interdependence implies a more contextual mode of judgment [i.e., metonymy] and a different moral understanding." She believes an ethics with "insistent contextual relativism" might appear to be "inclusive and diffuse to the male perspective." Gilligan is convinced that "women's development points toward a different history of human attachment, stressing continuity and change in configuration, rather than replacement and separation."[5] Literary theorist Jill Matus reinforces this metonymical reading in terms of "a new language in psychology to deal with a different sense of [the female] self—one that emphasizes affiliations, maintenance of connections and relationships," thereby stressing "context, relativism and connection links."[6]

While these thoughtful engendered interpretations of metaphor and metonymy aim to establish universal differences throughout time, my investigation of paintings by Krasner, Mitchell, and Frankenthaler in terms of metonyms will consider the appearance of this trope in their work from a strictly historical point of view. It will not regard either metaphor or metonymy as the universally valid and sole prerogative of either one gender or the other throughout time. Instead, it will look at metonyms in the art of these three Abstract Expressionists in terms of the mid-twentieth century, when they were acculturated to certain expectations about women's traditional roles.

Krasner was able to take advantage of the Roosevelt administration's emergency tactics for helping unemployed artists during the Great Depression, resulting in the formation of the Works Progress Administration (WPA), when she joined its mural division. And she, together with Mitchell and Frankenthaler, faced changing attitudes toward women both during and after World War II. Throughout the war, women were first ushered into the workforce in great numbers, before having to cope with an entirely different set of postwar cultural norms, many propagated by the U.S. government, in its efforts to find jobs for returning soldiers, while redirecting former "Rosie the Riveters" to the home and to old-style family values.[7] Although both Mitchell and Frankenthaler were still in school during World War II, their life choices indicate their appreciation of the brief move away from stereotypical roles for women

heavens forever opening up, like asymmetrical, unpredictable spontaneous kaleidoscopes. It is magic, it is joy, it is gardens of surprise and miracle. It is energy, impulse. It is question and answer. It is transcendental reason. It is total in its spirit . . . it is a doorway to liberation. It is a spark from an invisible central fire. . . . Paintings must have form but not necessarily in any preconceived or set known way."[12] Although one will certainly find metonymical statements by some of these artists, the metaphorical ones take precedence. They do so because this trope enables these men to address the then all-important role of being generators and disseminators of form, and to realize in their work the type of inspiration they believed only male artists, as enlightened individuals, were capable of handling.

While the metonymical/metaphoric split has traditionally privileged the latter poetic trope with actively changing thought and the former with simple stenographic condensation, such widely assumed polarities between the two have been overstated and, in fact, falsify the evidence, giving metonym insufficient credit for being a selective and highly poetic trope. Metonymic relationships are not as self-evident as has been supposed: they are chosen from a number of possibilities that can be "contextual, contiguous, spatial," according to Matus, making this figure a far more creative and useful trope than formerly considered.[13] French psychoanalyst and psychiatrist Jacques Lacan has rightly understood metonymy's role in the contiguity and displacement that the unconscious mind enacts, thereby connecting it with desire or longing. Lacan explains: "And the enigmas that desire . . . poses for any sort of 'natural philosophy' are based on no other derangement of instinct than the fact that it is caught in the rails of metonymy, eternally extending toward the desire for something else."[14] Viewed in this way, metonymy serves as an excellent retrospective tool for looking at the role desire plays in Krasner's, Mitchell's, and Frankenthaler's works where nature's metonymic connections are not reified or known beforehand in terms of either a specific or generalized landscape. Instead they are established through intuited needs and yet held in abeyance as perpetual mysteries, with clues tauntingly revealed slowly over time in terms of painted fragments, shards reflective of lives undergoing continual transformation in terms of breakup, renewal, and reconnection.

Since Lee Krasner almost never titled her own works and instead depended on conversations with friends and their suggestions, she was surprised to realize instinctively one of her *Umber* paintings needed to be called

during the war and their rejection of the reimplementation of traditional attitudes toward women after the war.

As Abstract Expressionists, all three were among the few female members welcomed into the male-dominated group known as the Eighth Street Club (and simply called The Club), which was founded in late 1949. And yet. as artists, they were confronted with an entrenched male-dominated style predicated on assertive metaphors. In order to appreciate the far-ranging use of this imperative trope, one need only recall Jackson Pollock's famous assertion, "I am nature"; Barnett Newman's "The first man was an artist";[8] Rothko's "I think of my pictures as dramas; the shapes in the pictures are the performers";[9] Clyfford Still's "I never wanted color to be color. I never wanted texture to be texture, or images to become shapes. I wanted them to fuse together into a living spirit";[10] and Willem de Kooning's "Some painters, including myself, do not care what chair they are sitting on. . . . They do not want to 'sit in style.' Rather they have found that painting . . . to be painting at all [is], in fact—a style of living."[11] These artists metaphorize art, respectively, as nature, work by male artists, drama, living spirit, and life. One of the more ecstatic metaphors is by Richard Pousette-Dart, the least macho artist in the group. He allies his work with the following string of metaphors: "Art for me is the

The Eye Is the First Circle (fig. 45), which she later discovered was the first line of American Transcendentalist Ralph Waldo Emerson's "Circles" (1841), an essay she had read during her teens and thought she had completely forgotten. In this piece, experiences, whether good or tragic, encourage people to break free of conditioned attitudes in order to enter ever-increasing and wider spheres of understanding.[15] In "Circles," Emerson moves far from the fixed view expressed only five years before in "Nature," which he had conceived as a metaphor of the human mind. Instead, he embraces in "Circles" a metonymical view of the world by pointing out "there are no fixtures in nature," because "the universe is fluid and volatile. Permanence is but a world of degrees."[16] Given the number of eyes emerging from the cascading waves of loosely brushed and flung paint in *The Eye Is the First Circle,* suggesting a range of viewpoints, we might conjecture that the theme of eyes puns the shifting pronoun "I," which refers back to whomever is using it, undermines the type of unitary self often clearly expressed in metaphors, and posits, instead, the work of art and the self as multifaceted consciousnesses that look back at viewers, appraising and interrogating them. It is significant that Krasner remembers only seeing the eyes after the painting was done and was initially unaware that her own painting was in fact appraising her.[17]

Perhaps the clearest example of a metonym in Krasner's work is the *Earth Green* series painted soon after Pollock's death. Beginning with *Listen,* which her friend and collector, B. H. Friedman, helped name, Krasner elaborates on her signature so that it expands to become the armature for the entire painting (fig. 46).[18] This emphasis on her connection to her own name occurs in a number of other contemporaneous works, including *Sun Woman I* (fig. 47), *Sun Woman II* (1957– c. 1973, Pollock-Krasner Foundation), and *The Seasons* (cat. 34). Far more than the simple act of affixing her name to a work of art, the umber-colored signature and its extension into the painting come at a time when Krasner was forging a separate identity from Pollock and a period when many Abstract Expressionists had already settled on self-defining schemas known as their "signature images," including Pollock's drips, Rothko's veils, Newman's zips, Still's rugged patchwork of stalactitic and stalagmitic forms, Motherwell's ripped and torn edges, Gottlieb's primordial *Bursts,* and Willem de Kooning's women. Whether Krasner chose to be a maverick or accepted this default role as her path, her prominent signature and its underlying and unifying role in *Listen* can be considered a parody of one-image art. But its significance does not end here.

Starting in the lower right of *Listen,* Krasner's sprawling name appears either to have initiated or concluded the initial phase of outlining the composition with an umber *imprimatura.* Whether undertaken at the beginning or reinforced at the end of this process, the integral use of the artist's name connects the overall work with her identity and helps to explain the intense emotional reaction she felt while making it. "I can remember," she later told her friend, the poet and noted translator Richard Howard, "that when I was painting *Listen* which is so highly keyed in color—I've seen it many times since and it looks like such a happy painting—I can remember that while I was painting it I almost didn't see it, because tears were literally pouring down."[19] As Krasner later said, "No one was more surprised than I was when the breasts appeared."[20] Instead of invoking

FIG. 47. Lee Krasner, *Sun Woman I,* 1957. Oil paint on canvas, 97$\frac{1}{4}$ × 70$\frac{1}{4}$ in. (247.02 × 178.44 cm). Private collection.

a holistic sense of self in this painting, Krasner presents fragmented images of herself in terms of the signature and the breast-like forms occupying the position traditionally accorded to flowers in a vase, which is comprised partly of flourishes stemming from her signature or culminating in it. The artist's nature is metonymically connected to the breasts and to the leaf-like forms in the painting, which resemble the same scraggly indoor plant appearing in some of Krasner's Picasso-style still-life paintings of the early 1940s and also in a couple of often-reproduced photographs of her made during the time (fig. 48). Since Krasner is metonymically connected to this painting, one might expect that she would, of course, be profoundly moved by amputated breasts and hothouse plant leaves as well as by the lack of connection with an integral or self-sustaining nature that this work underscores.

In light of Krasner's reaction, French deconstructionist Jacques Derrida's conjectures about signatures in works of art as examples of self-sacrifice are particularly relevant: "The law producing and prohibiting the signature (in the first modality) of the proper name, is that by not letting the signature fall outside the text any more, as an undersigned subscription, and by inserting it into the body of the text, you monumentalize, institute and erect it into a thing or a strong object. But in doing so, you also lose the identity, the title of ownership over the text; you let it become a moment or a part of the text, as a thing or common name."[21] Krasner's sadness in

creating *Listen* indicates an awareness of the necessary loss involved in consigning part of one's identity/nature to a work of art. Once the work is finished, the umbilical cord is cut. Even when a painting is constructed as a surrogate identity, comprised of telling fragments, as *Listen* evidently is, the new ensuing creation assumes an existence separate from that of the artist, and so relations to the self's partial identity in the work are severed, creating yet other metonymical longings needing to be connected.

Looking at aspects of the world as separate from the self and yet connected to it, through the metonym of spontaneously applied paint, is a thematic that took a special turn in the early 1950s, several years before Krasner's *Listen,* when French Impressionism, formerly considered old-fashioned, was rethought as a basis for mid-twentieth-century modern art. In 1953, when New York's Museum of Modern Art (MoMA) exhibited a recently acquired Claude Monet painting of water lilies, critics and artists alike began to discern connections between these early twentieth-century works and advanced post–World War II art. Almost overnight, Monet was hailed as the equal of Paul Cézanne, who until then had been accorded the undisputed role of modern art's father. Three years later, in 1956, this new attitude toward Impressionism continued to resonate. That year, critic Hilton Kramer pronounced, "The process of reconstructing Monet into an avant-garde master of heroic dimensions [seems] now [to be] in full swing."[22]

Impressionism, then, was rehabilitated as one of modern art's progenitors in the 1950s with remarkable ease and rapidity. Looking back on this time, critic and art historian Irving Sandler pointed out in the 1970s, "The Impressionist component in the gesture painting of the second generation [of the New York School] . . . more than anything else distinguishes it from that of the first."[23] In her article "Subject: What, How or Who?" published in April 1955 in *ARTnews,* artist and critic Elaine de Kooning could count twice as many Abstract Impressionists as Abstract Expressionists. She took note of Abstract Impressionism's tendency to create allover compositions through a "quiet, uniform pattern of strokes . . . spread over the canvas without climax or emphasis."[24] In her opinion, the American Impressionists banish traditional subject matter that interested their nineteenth-century artistic forebears and instead attempt to manifest personally intuited "spiritual states" through resolutely optical means.[25]

At this time, paint itself became metonymically equated with nature, a connection important for

appreciating both Mitchell's and Frankenthaler's work as involved with abstracted fragments referring to landscapes, by conceptualizing them as comprised of nature while representing aspects of nature abstractly. The critic and figurative painter Fairfield Porter opines, "The Impressionists taught us to look at nature very carefully; the Americans teach us to look very carefully at the painting. Paint is as real as nature and the means for a painting can contain its ends."[26]

Particularly attuned to subtle connections between seeing and feeling in both Impressionism and its mid-twentieth-century abstract offshoot, Hilton Kramer frames this connection in his analysis of "sensation" as a special distillate found in Monet's art: "It was nothing less than the fluidity of sensation itself which came ultimately to occupy the center of Monet's interest—sensation perceived as a continuous inter-weaving of the particles of experience, unfettered in its headlong course by any single moment of perception and the memory of perception impinging upon and submitting to the sweet flux of all sensation as it unfolds itself to the senses."[27]

Creating material fragments cohering feeling and seeing in painted passages is a goal to which Mitchell often alludes when commenting on her work, even though she does not use the word "sensation." A few of her statements, however, are enough to underscore her continued insistence on connecting herself to her art through painterly segments, which are, in effect, sensations. In 1957, Mitchell stated that she painted "remembered landscapes which involve my feelings," and added the following year these are "remembered landscapes that I carry with me."[28] For the process-oriented *ARTnews* series focusing on cutting-edge artists painting a picture, Mitchell started working on *Bridge* and then switched to *George Went Swimming at Barnes Hole, but It Got Too Cold,* in which her dog, George, and the East Hampton beach provided the artist with the incentive to work (fig. 49).[29] Later, Mitchell recalled: "I've got to think of something and get into a situation where I feel something, and where I love something, and it was George. George swimming at Barnes Hole. We used to go swimming together. I think of something that makes me feel good. I paint out of love. Love or feeling is getting out of yourself and focusing instead on someone or something else."[30] On another occasion, she spoke of her long fascination with Vincent van Gogh's sunflowers, a strong attachment reaching back to childhood; she articulated her goal as "want[ing] to make something like the feeling of a dying sunflower," thus addressing the desire to

empathize with an aspect of the world, an approach endemic to metonymy.[31]

The special emphasis placed on metonymy in Mitchell's work can be more clearly articulated by considering her long-term great admiration for William Wordsworth's Romantic poetry and feelings of kinship with it, beginning at Smith College when she took two literature courses taught by Helen Randall. In my opinion, the aspects of Wordsworth's poetry most important to Mitchell are this poet's special under-standing of Aristotelianism, which relies on his being impressed by a force incarnated in distinct objects and fragments, so that agency is lodged in them rather than in the poet himself. In his poetry Wordsworth embraced several basic Aristotelian beliefs, including first this view of external subjectivities, with their essences comprising nature, which are eminently accessible for understanding, and second a concomi-tant faith in the impact these spiritualized forms can have on both one's receptive intellect and sense.[32] This pair of Aristotelian attitudes is evident in one of this poet's most important works, "Tintern Abbey," where "with an eye made quiet by the power / Of Harmony, and the deep power of joy, / We see into the life of things."[33] And, as we have seen from our cursory sum-mary of Mitchell's statements about her work, this Wordsworthian connection with nature as agent and with the artist as its recipient was crucially important for her and for her work.

Sometimes called an Abstract Impressionist, but more rarely than Mitchell, Helen Frankenthaler was also intrigued with distilling feelings in her work, a goal reaching back to childhood, when she would play the game of attempting to convey emotions or feelings abstractly.[34] Later, as a mature artist, Frankenthaler remained fascinated with the concept of manifesting sensations in her Color Field paintings. At one point she couched this desire in terms of the words "clumsy or puzzled." She acknowledged, "[They] are not exactly mastery, but they often lead to the same risk or another word I use: *magic.*"[35] On another occasion she described her way of painting as being "involved in making her pictures 'hold' an explosive gesture; something that is moving in and out of landscapelike depths but lies flat in local areas—intact but not confined."[36]

This in and out movement provides an important clue to the ongoing operative of "sensation" in Franken-thaler's painting, referring again to Hilton Kramer's insight into Monet's art. It also is a basis for the lyricism found in all her work, constituting a primary reason for referring to her painting as "lyrical abstraction," which

has usually been reserved for a later development of her Color Field work. However, in Frankenthaler's case, lyrical abstraction can be used to describe her entire oeuvre after the breakthrough painting *Mountains and Sea* (see fig. 6). While lyricism is traditionally connected etymologically with the lyre and its associations with music as well as with singing and time-based intangibles, in the visual arts it takes the form of soft light, hazy atmospheres, liquidity, seeming artlessness, lack of pretension, graceful arabesques, subtle modulations, the pastoral tradition, gentle melancholy, and evocations of nostalgia.[37]

Lyricism, as philosopher Scott Alexander Howard has pointed out, can also be analyzed in terms of a specific ongoing tension. In "Lyrical Emotions and Sentimentality," Howard identifies the components comprising lyrical emotions as well as their distinct manner of interacting.[38] Using haiku as a guide, he finds lyrical feelings arising from situations involving temporal contrasts between evanescent moments projected in high relief against timeless or long-term universals, resulting in piercing, yet briefly poignant realizations of beauty's fugitiveness, the brevity of life, and the transitoriness of things. This affective emotion is predicated on contrasts between the momentousness of a single instant projected against the screen of eternity, making specific fragments of time appear particularly moving and descriptions of metonymical associations connecting specific moments essential. Frankenthaler's improvisations of poured, sponged, and drawn paint seen in terms of her many allusions to enduring landscapes and art's universality is sufficient for generating lyricism's affecting emotions. In addition, the contiguity of paint utilized as nature and naturalized as artistic media—coupled with evocations of a blank eternal silence, arising from the white spaces of the unprimed canvas she often left untouched—forms a sufficient conjunction of related, yet opposing perspectives between the transient and the eternal for viewers to experience lyric sensations in her work.

This essay has set out to historicize the woman-metonymy dyad in terms of the historically based and engendered views affecting the ways Krasner, Mitchell, and Frankenthaler have each figured aspects of themselves when connecting with external nature. "Nature," however, is such a troublesome term that the renowned Welsh New Left theorist Raymond Williams regarded it as one of the most complex words in the English language.[39] Similar to environmentalist Bill McKibben in *The End of Nature,* I am convinced nature's power is to be found in "its separation from human society,"

where it remains undefined and uncircumscribed.[40] Instead of being in league with human destiny or conformable to it, nature is better understood as an ongoing conundrum, existing as both part of and apart from human beings. The alternative view of nature as no longer significant in the highly industrialized world of the mid-twentieth-century United States, which believed itself to have moved beyond it, is perhaps overly severe, because it condemns people to life alone in the cosmos, existing in a world of their own construction. One of the major strengths of the metonymical strategies evidenced by Krasner's, Mitchell's, and Frankenthaler's art is the mystery of fragmented references to themselves and nature in their art, causing both to remain unassailably diffuse and continually recalcitrant. Alliances with nature in particular works are only temporarily fashioned and uneasily won. Sustaining a connection with nature is not easy: usually it must be begun afresh in the next painting, as one's own human nature, a perpetual enigma, and its bonds with its external counterpart must yet again be plumbed, rediscovered, and then mined in the course of making art. Rather than regarding works by these three Abstract Expressionists as essentialized and reified pictures of nature, we can more productively regard them as contingent views of each of these women's own nature, which is partially and indistinctly witnessed through its connections with the physical world as it is being poetically invoked through the process of painting. Because paint in the mid-century United States was itself thought to be related to nature, each of these three women were in effect using nature (their paint) to forge composite personal and external conditional attachments between themselves and the world.

Looking at these three female Abstract Expressionists developing metonymical relations with their artistic selves enables us to reconsider the type of male-dominated Abstract Expressionism that has been hailed as "American Type Painting"[41] and "the Triumph of American Painting."[42] Instead of allying work by Krasner, Mitchell, and Frankenthaler with the hegemony of the United States during the postwar period, my consideration of paintings by these women strongly points to coexistence rather than dominance; continuity with earlier artists attuned to relationships with nature—Charles Burchfield, Arthur Dove, Georgia O'Keeffe, and Wassily Kandinsky, among others, come to mind—rather than breaking off connections with the past; and contextual affiliations with the world around them rather than one-image works reifying individuality in terms of developing and sustaining a particular brand.

Notes

The author gratefully acknowledges the help of Samina Iqbal, Thalhimer Research Assistant in Virginia Commonwealth University's Department of Art History, in finding relevant statements by Mitchell and Frankenthaler.

1. Hugh Bredin, "Metonymy," *Poetics Today* 5, no. 1 (1984): 45–58.

2. Ibid., 53–58.

3. Domna C. Stanton, "Difference on Trial: A Critique of the Maternal Metaphor in Cixous, Irigaray and Kristeva," in *The Poetics of Gender,* ed. Nancy K. Miller (New York: Columbia University Press, 1986), 175.

4. Both this phrase and the concept of transferring items from one semantic field to another are indebted to the thoughtful analysis of metaphors by feminist philosopher Eva Feder Kittay; see Eva Feder Kittay, "The Identification of Metaphor," *Synthese* 58, no. 2 (February 1984): 153–202. The phrase I cite can be found on p. 174. A fuller development of Kittay's approach is found in Eva Feder Kittay, *Metaphor: Its Cognitive Force and Linguistic Structure* (Oxford: Clarendon, 1987).

5. Carol Gilligan, *In a Different Voice* (Cambridge, MA: Harvard University Press, 1982), 22 and 48, cited in Jill Matus, "Proxy and Proximity: Metonymic Signing," *University of Toronto Quarterly* 58, no. 2 (winter 1998/99): 318–19.

6. Matus, "Proxy and Proximity," 319.

7. I am also relying on continental philosopher and gender theorist Judith Butler's groundbreaking studies *Gender Trouble: Feminism and the Subversion of Identity* (New York: Routledge, 1990) and *Bodies That Matter: On the Discursive Limits of "Sex"* (New York: Routledge, 1993), in which she explored traditional views of intrinsic sexual differences and found them to be mostly acculturated, part of a largely unexamined and little-understood ideology. In *Gender Trouble,* Butler employed the term "performative" to indicate the coercive social, historical, and political norms serving to present gender as a grand masquerade naturalized as part of daily life. Her use of "performative" comes from J. L. Austin's posthumously published book *How to Do Things with Words* (Cambridge, MA: Harvard University Press, 1962), in which he refers to such societal acts as saying "I do" in a wedding ceremony as performatives because they are determined by social and linguistic conventions, not personal intention. Relying on this definition, Butler theorizes gender itself as a performative, a way of enacting the imposition of societal norms through which one's gender is constituted in advance, making it cultural rather than natural, and a compulsory act, not a personal choice; see Butler, *Bodies That Matter,* 125.

8. Barnett Newman, "The First Man Was an Artist," *The Tiger's Eye* 1, no. 1 (October 1947): 57–60.

9. Mark Rothko, "The Romantics Were Prompted," *Possibilities* 1 (winter 1947–48): 84.

10. Clyfford Still statement quoted by Katherine Kuh, without source, in John O'Neill, *Clyfford Still* (New York: Metropolitan Museum of Art, 1979), 11.

11. Willem de Kooning, "What Abstract Art Means to Me" (lecture, "What Is Abstract Art?" symposium, Museum of Modern Art, New York, February 5, 1951).

12. Richard Pousette-Dart (lecture, School of the Museum of Fine Arts, Boston, 1951), 2. A typescript of this talk is on deposit in the library of the Museum of Modern Art, New York.

13. Matus, "Proxy and Proximity," 307.

14. Jacques Lacan, "Agency of the Letter in the Unconscious," in *Écrits: A Selection,* trans. Alan Sheridan (New York: W. W. Norton, 1977), 166–67.

15. Ralph Waldo Emerson, "Circles," in *Essays: First Series* (1841), text online at Ralph Waldo Emerson Texts, http://www.emersoncentral.com/circles.htm. Emerson's beginning is:

> The eye is the first circle; the horizon which it forms is the second; and throughout nature this primary figure is repeated without end. It is the highest emblem in the cipher of the world. St. Augustine described the nature of God as a circle whose centre was everywhere, and its circumference nowhere.

It has indeed been a privilege and pleasure over the years to be able to undertake and complete two sustained meditations on Lee Krasner's work. The first is Robert Hobbs, *Lee Krasner* (New York: Abbeville, 1993), which is vol. 15 in Abbeville's *Modern Masters* series. The second, also titled *Lee Krasner,* served as the catalogue for the first full-scale retrospective of her work, which opened at LACMA in 1999 before traveling to the Des Moines Art Center and Akron Art Museum (2000), then concluding its tour in 2001 at the Brooklyn Museum; see Robert Hobbs, *Lee Krasner* (New York: Independent Curators International, in association with Harry N. Abrams, 1999). My discussion of Krasner's art in this essay, not surprisingly, builds on my prior work.

16. Emerson, "Circles."

17. Lee Krasner, conversation with author, summer 1977, Springs, New York.

18. B. H. Friedman, telephone conversation with author, January 22, 1999.

19. Richard Howard, "A Conversation with Lee Krasner," *Lee Krasner Paintings 1959–1962* (New York: Pace Gallery, 1979), n.p.

20. Krasner cited in Ellen Landau, "Lee Krasner's Past Continuous," *ARTnews* 83 (February 1984): 76.

21. Jacques Derrida, *Signéponge/Signsponge,* trans. Richard Rand (New York: Columbia University Press, 1984), 56.

22. Hilton Kramer, "Month in Review," *Arts* 31, no. 2 (November 1956): 52–54.

23. Irving Sandler, *The New York School: The Painters and Sculptors of the Fifties* (New York: Harper and Row, 1978), 55.

24. Elaine de Kooning, "Subject: What, How or Who?" *ARTnews* 54, no. 2 (April 1955): 26.

25. Ibid.

26. Fairfield Porter, "American Non-Objective Painting," *The Nation,* October 3, 1959, reprinted in Rackstraw Downes, ed., *Fairfield Porter: Art in Its Own Terms: Selected Criticism 1935–1973* (New York: Taplinger, 1979), 56.

27. Kramer, "Month in Review," 54. While the word "sensation" is of crucial importance to French phenomenologist Maurice Merleau-Ponty in his landmark book *The Phenomenology of Perception,* published in France in 1945, his treatment of it as a "unit of experience" would have been rarely known in New York in the 1950s. It became current in the 1960s, when many of this thinker's writings were published in English. My research on critic Harold Rosenberg has revealed a close friendship with Merleau-Ponty and the importance of his phenomenological views for Rosenberg's "The American Action Painters," published in the December 1952 issue of *ARTnews.* See Robert Hobbs, "Merleau-Ponty's Phenomenology and Installation Art," in *Installations, Mattress Factory, 1990–1999,* ed. Claudia Giannini (Pittsburgh: University of Pittsburgh Press, 2001), 18–23.

28. "Women Artists in Ascendance," *Life,* May 13, 1957, 76; and Joan Mitchell, letter to John I. H. Baur, quoted in *Nature in Abstraction: The Relation of Abstract Painting and Sculpture to Nature in Twentieth-Century American Art* (New York: Whitney Museum of American Art, 1958), 75.

29. Irving Sandler, "Mitchell Paints a Picture," *ARTnews* 56 (October 1957): 70.

30. Judith E. Bernstock, *Joan Mitchell* (New York: Hudson Hills, in association with Herbert F. Johnson Museum of Art, Cornell University, 1988), 43.

31. Yves Michaud, "Joan Mitchell: Abstract Expressionism and Feeling," in *Joan Mitchell,* ed. Nils Ohlsen (Heidelberg: Kehrer Verlag, 2009).

32. Essaka Joshua, "Wordsworth amongst the Aristotelians," *Journal of the History of Ideas* 67, no. 3 (July 2006): 511–12.

33. William Wordsworth, *Poems,* vol. 2, ed. John O. Hayden (London: Penguin, 1977), "Tintern Abbey," 48–50, cited in Joshua, "Wordsworth amongst the Aristotelians," 513.

34. John Elderfield, *Frankenthaler* (New York: Abrams, 1989), 121.

35. Cindy Nemser, "Interview with Helen Frankenthaler," *Arts* 46 (November 1971): 38.

36. "Helen Frankenthaler" in "New Talent," *Art in America* 45 (March 1957): 29.

37. Robert Reiff, "Lyricism as Applied to the Visual Arts," *Journal of Aesthetic Education* 8, no. 2 (April 1974): 73–78. Reiff's mellifluous prose and abundant descriptions of lyricism in the visual arts, making his essay a prose poem, is very helpful in circumscribing the type of visual work that can be called "lyric."

38. Scott Alexander Howard, "Lyrical Emotions and Sentimentality," *The Philosophical Quarterly* 62, no. 248 (July 2012): 546–68.

39. Raymond Williams, *Keywords: A Vocabulary of Culture and Society* (New York: Oxford University Press, 1983), 219.

40. Bill McKibben, *The End of Nature* (New York: Random House, 1989), 64.

41. Clement Greenberg, "'American Type' Painting," *Partisan Review* 22 (spring 1955): 179–96; reprinted in Clement Greenberg, *Art and Culture* (Boston: Beacon, 1961), 208–29.

42. Irving Sandler, *The Triumph of American Painting: A History of Abstract Expressionism* (New York: Harper and Row, 1976).

AN INTERVIEW WITH IRVING SANDLER

FEBRUARY 21, 2013, NEW YORK

JOAN MARTER

Before the interview began, Sandler mentioned that if he were choosing artists (now) for his first book, *The Triumph of American Painting: A History of Abstract Expressionism,* he would add five artists—one of them Lee Krasner.

IS: There was an uptown group: Robert Motherwell, Barnett Newman, Mark Rothko, Jackson Pollock when he came into town, and David Smith. And a downtown group. The uptown group lived in apartments and socialized over dinners. The downtown group lived in lofts and associated at the Cedar Street Tavern and The Club. The uptown group were Betty Parsons people. The downtown group were Charles Egan people, Stable Gallery people, and Tibor de Nagy Gallery people.

The important thing to remember is that Helen Frankenthaler, Grace Hartigan, and Joan Mitchell were the really strong painters. They were the strongest painters at the time. There were other painters that were terrific—Alfred Leslie, for example, Michael Goldberg—but these three just stood out. Grace and Joan were in my world more than Helen. I once called Helen's painting "feminine," and she said, "Is it more 'feminine' than Morris Louis?" And I never used the word "feminine" again. This was pre-feminism.

JM: What about The Club? Didn't some of the women participate at The Club?

IS: Yes, women were on panels. Grace not so much. Helen not at all. Joan and Grace were part of a very interesting group of poets: Frank O'Hara, James Schuyler, John Ashbery when he was in the United States, and Elaine de Kooning, who was a member of this coterie.

JM: Did you like Elaine de Kooning's work?

IS: That's a beautiful one over there [points to his wall].

JM: She did these works at Black Mountain that are very tight. Then she did these big bulls . . . more Abstract Expressionist.

IS: And Action Paintings of athletes. She would go to the training camps and actually watch them train. She was beautiful, and would pick them up, walk into the Cedar Street Bar with, say [Brooks] Robinson of the Orioles. The place went wild. My favorite story is one night she brought a boxing world champion. Ezzard Charles . . . nine feet tall. Beautiful man. Herman Cherry, who stood about five feet tall, begins to tell Charles about Action Painting. "You know, Mr. Charles, it's like

boxing. You make a move and the canvas moves back," and he begins sparring around Charles. Shadowboxing. And Ezzard Charles listens very carefully to Cherry and he says, "I understand what you're saying, but the canvas don't hit back, do it?" It was a real scene.

JM: How about the galleries?

IS: The major galleries would have been the Stable Gallery, Tibor de Nagy, Poindexter, Peridot, and then, of course, Betty Parsons. Tenth Street in the '50s was much more open for women. The Tanager Gallery was the leading gallery. Two of the founders were Sally Hazelet Drummond and Lois Dodd. Later on, Perle Fine showed there. The March Gallery, where Mark di Suvero showed, also exhibited Pat Passlof. You really began to get a mix of women and men on Tenth Street.

JM: Why was the first group of artists so macho?

IS: I really hate to say this, but there didn't seem to be women of the stature of, say, Mark Rothko, Bill de Kooning, Jackson Pollock. They just weren't there.

JM: Well, they were there. We know that Lee Krasner had been successful as a WPA artist in the 1930s.

IS: Lee made small paintings; then she showed at Parsons. But she wasn't showing regularly until after Pollock died. On the other hand, in the 1930s, there were women in the American Abstract Artists group.

JM: There were a number of very interesting women there.

IS: One of the best artists was Gertrude Greene.

JM: They called her Peter Greene.

IS: It's interesting that Grace Hartigan tried to pass herself off as "George." Which she said was in honor of George Sand.

JM: Do you think that the male artists had something to do with the lack of recognition for women? It's been mentioned that the Surrealists who came here were very straight and very sexist in their attitudes toward women. Did they encourage the Americans to be more macho?

IS: No.

JM: You don't think that the men tried to emulate the Surrealists? They were such a big presence in this country. Salvador Dalí, for example.

IS: Not in my group.

JM: What about David Hare?

IS: He was part of my group and the Surrealists, but he wasn't that central to the Americans. I certainly don't think that the Americans picked up macho attitudes from the Surrealists. They didn't have to; it was just in the air—particularly among the artists.

JM: That was one of the issues: the men had to separate themselves from the idea that art was something effeminate. They had to stress their masculinity in order to counter that impression.

IS: I think that's very true. So you had heavy drinking, and the general swagger. Then you finally get women who won't put up with that crap but are as tough as the men . . . besides, the women were such strong painters. I once asked Grace Hartigan if a male artist ever told her she painted as well as a man.

She said, "Not twice."

JM: This is where I have the confusion about the first and second generation. Because if you look at when Joan Mitchell starts working, it's 1950. She's pretty young, but she is still making enormous paintings.

IS: But the paintings were influenced by Bill de Kooning and Philip Guston. Joan Mitchell considered herself a second-generation artist. She emerges on the back of the older generation. And they quickly use the ideas of the older artists. But you can "smudge" that line because the artists themselves did. I moderated a panel with Al Held. It was about what it was like to be a second-generation artist. I said to Alfred Leslie, "What do you think about being a second-generation artist?" He said, "Stupidest question I ever heard!" Finally, Al Held said, "Come off it, Alfred, you are a second-generation artist." But it can be considered a put-down.

JM: Especially since all of the women get clumped into the second generation. They certainly see it as a put-down!

IS: Joan Mitchell didn't. In my article on Joan, I asked her that very explicitly. There was a first generation and a second generation of Abstract Expressionism. In *The Triumph of American Painting,* I had a final chapter with four artists: Philip Guston, Franz Kline, Jimmy Brooks, and Bradley Walker Tomlin, who were later in coming to the attention of critics.

JM: You said at the beginning if you were writing the *Triumph* book now, you would have added one woman, Lee Krasner—nobody else, but then you would have added four more men. But it would have only been Lee, not Elaine de Kooning, Perle Fine, or any of the others?

IS: I didn't think they were of the same stature as the men.

JM: But then when you wrote the second book on the 1950s, you had a number of women in that book.

IS: That was a survey of the younger artists. Women like Joan, Helen, and Grace were the leading artists of the early 1950s.

JM: In 1958–59, when there was an international traveling show that went all over Europe, one woman was included: Grace Hartigan.

IS: They also left Hans Hofmann out. By the late 1950s, Alfred Barr at the Museum of Modern Art had already signed off on Abstract Expressionism. He was looking at Rauschenberg and Johns, in a way that we weren't yet.

JM: One could argue, regarding the first generation, there were many male artists, too, who received little recognition. You mentioned Michael Goldberg; he's a very good painter.

IS: A terrific painter, as I pointed out.

JM: What about the people on the West Coast? There were some women out there: Deborah Remington, Sonia Gechtoff, and others who studied with Clyfford Still.

IS: Remington and Gechtoff are very interesting artists. But they had their own group.

JM: Isn't it fair to say that after Still leaves the area, that these artists on the West Coast are part of a broader view of Abstract Expressionism?

IS: Absolutely. But they are sort of separate from us in New York. In the 1950s, Sally Hazelet and Lois Dodd, they were very active on Tenth Street.

JM: What about Jane Wilson? In that article in *Life,* Jane Wilson is in there with Joan Mitchell and the others.

IS: There were other women: Jane Freilicher, Yvonne Thomas, Mary Abbott, for example.

[Sandler speaks while looking through the Tenth Street Days *catalogue.]*

It's really much more male than I remembered . . . Lenore Jaffe. There were about two hundred to two hundred fifty people in the New York School that knew one another.

JM: Grace was doing abstract painting, but by the mid-1950s she returned to figurative abstraction. How do you situate that within Abstract Expressionism? Looking at de Kooning and the *Women?*

IS: Exactly, and there were Pollock's figurative paintings of the early 1950s. For most or many of the New York artists, the division between figuration and abstraction was not really terribly interesting. And as Elaine de Kooning once said, there are probably more artists working figuratively than there are artists working abstractly, including Elaine herself. . . . There were leading younger artists—Wolf Kahn, Philip Pearlstein, Alex Katz. In other words, you could stress expressiveness in painting, like Richard Diebenkorn, or you could stress the subject, like Jane Freilicher or Fairfield Porter. These were the two main tendencies in figurative art of the 1950s.

JM: If you were to organize a show about Abstract Expressionism, would you cut it off at 1959?

IS: I would cut it off at 1958. By then the movement is pretty much established. That's the year when the big exhibition, *The New American Painting,* a major survey of Abstract Expressionism, was sent to Europe.

CATALOGUE OF THE EXHIBITION

CAT. 1. **Mary Abbott** (American, b. 1921), *Oisin's Dream,*
1952. Oil paint and oil stick on canvas, 68 × 84 in. (172.72 ×
213.36 cm). Collection of Susan and David Kalt, Glencoe, Ill.

M. Abbott

CAT. 2. **Mary Abbott**, *Imrie,* 1953. Oil paint and crayon on
canvas, 71 × 74 in. (180.34 × 187.96 cm). Collection of
Art Enterprises, Ltd., Chicago.

CAT. 3. **Mary Abbott**, *All Green*, c. 1954. Oil paint on linen,
49 × 44 in. (124.46 × 117.76 cm). Denver Art Museum:
Gift of Janis and Tom McCormick, 2013.250.

CAT. 4. **Jay DeFeo** (American, 1929–1989), *Torso*, 1952. Oil paint with string on canvas, 90 × 38½ in. (228.6 × 97.79 cm). The Jay DeFeo Trust, Estate no. E1295.

CAT. 5. **Jay DeFeo**, *Untitled (Everest)*, from the *Mountain* series, 1955. Oil paint on canvas, 96 × 74 in. (243.84 × 187.96 cm). Collection of the Oakland Museum of California. Gift of Jay DeFeo.

CAT. 6. **Jay DeFeo**, *Incision,* 1958–61. Oil paint and string on canvas mounted on board, 9 ft., 10 in. × 55⅝ in. × 9⅜ in. (299.72 × 141.29 × 23.81 cm). San Francisco Museum of Modern Art, Purchase with the aid of funds from the Society for the Encouragement of Contemporary Art.

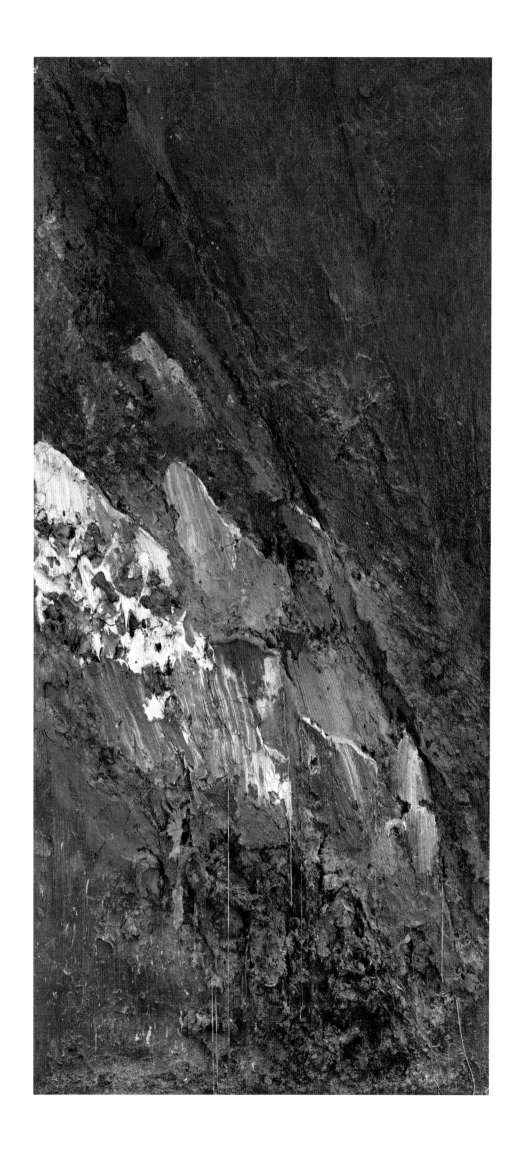

CAT. 7. **Elaine de Kooning** (American, 1918–1989), *Abstraction,*
1947. Oil paint on canvas, 11 × 14 in. (27.94 × 35.56 cm).
Collection of Craig A. Ponzio.

CAT. 8. **Elaine de Kooning**, *Bill,* 1952. Oil paint on canvas,
47 × 31³⁄₈ in. (119.38 × 79.69 cm). Collection of Jennifer and
David Stockman.

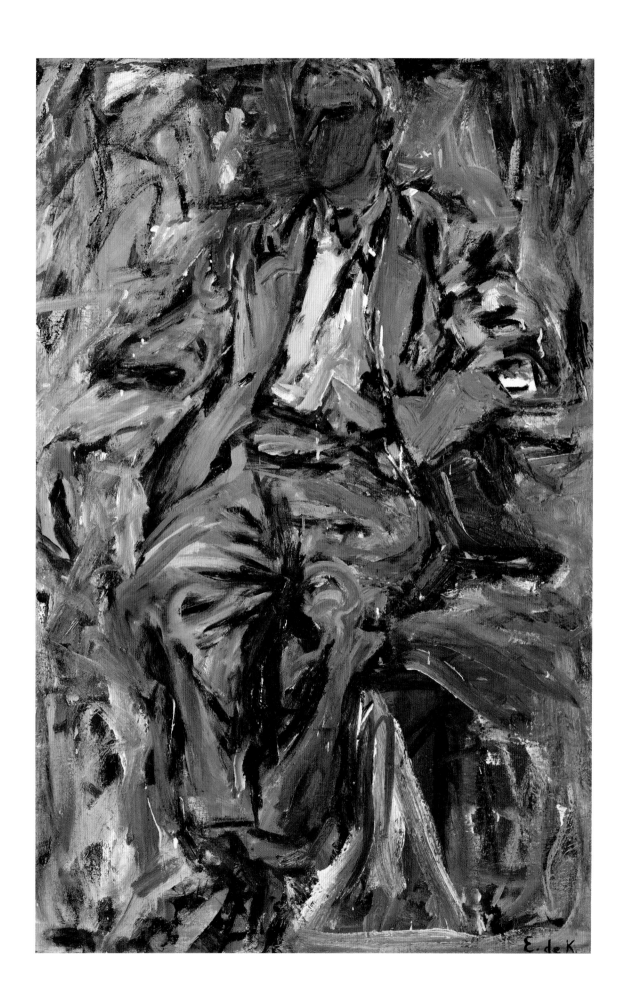

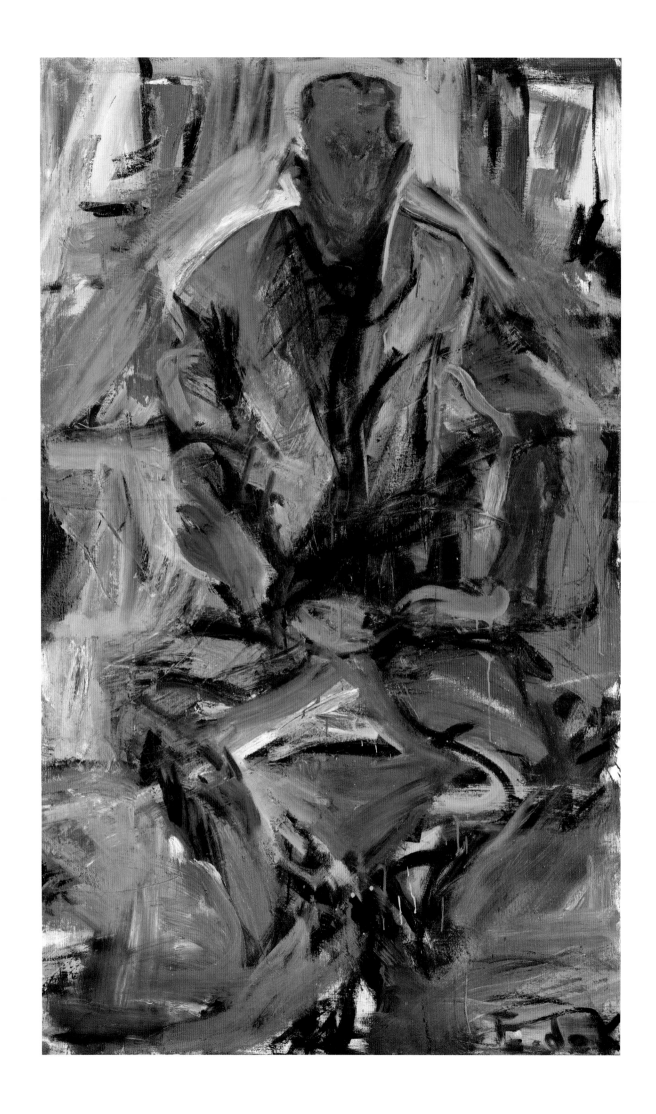

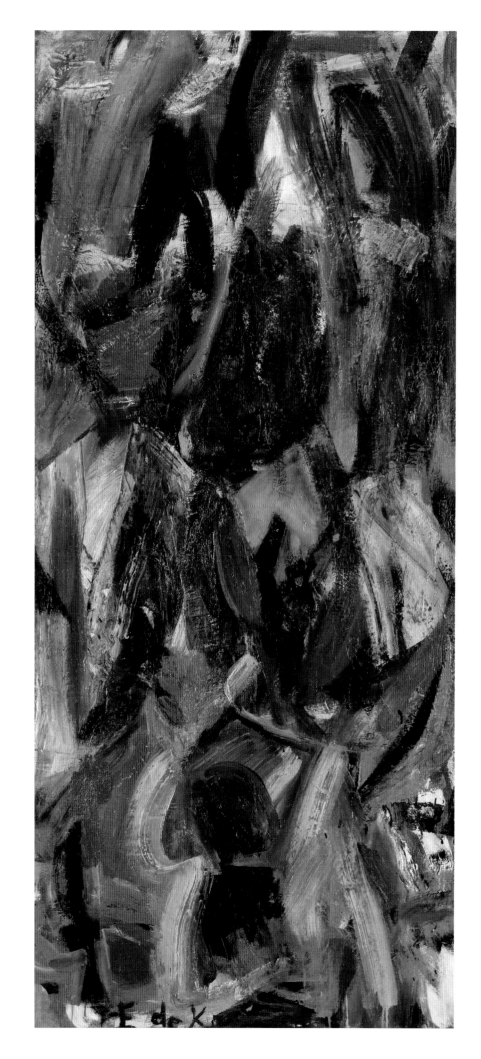

OPPOSITE: CAT. 9. **Elaine de Kooning**, *Bill at St. Mark's,* 1956. Oil paint on canvas, 72 × 44 in. (182.88 × 111.76 cm). Collection of Craig A. Ponzio.

RIGHT: CAT. 10. **Elaine de Kooning**, *Falling Man,* 1957. Oil paint on canvas, 68 × 30 in. (172.72 × 76.20 cm). Private collection.

OVERLEAF: CAT. 11. **Elaine de Kooning**, *Bullfight,* 1959. Oil paint on canvas, 77⅝ in. × 10 ft., 10½ in. (197.17 × 331.47 cm). Denver Art Museum: Vance H. Kirkland Acquisition Fund, 2012.300.

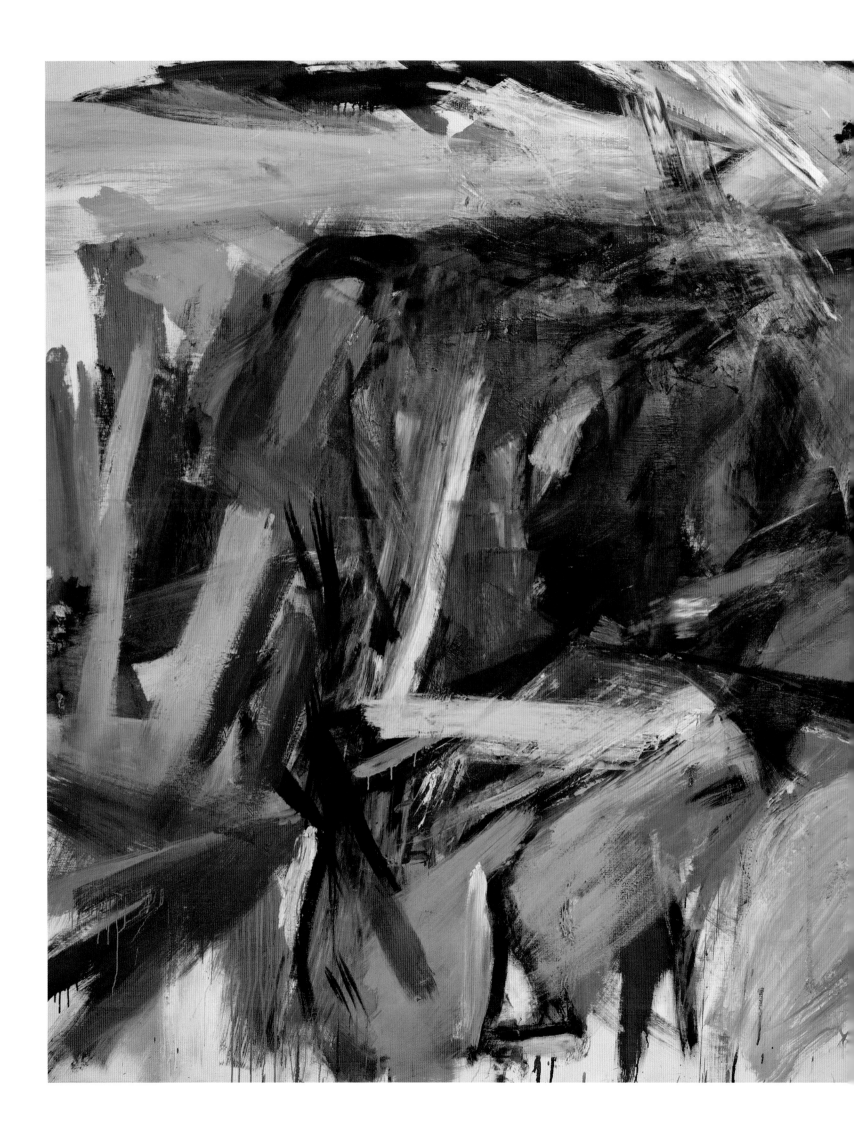

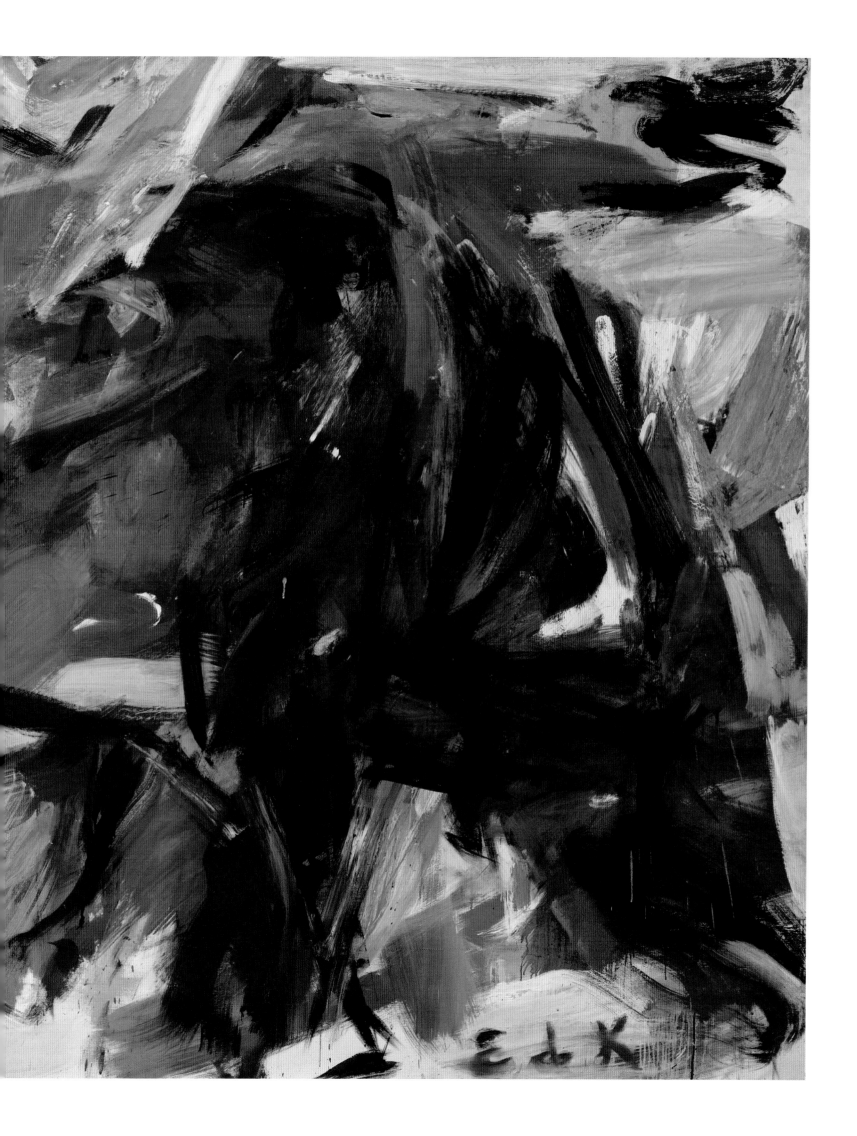

CAT. 12. **Perle Fine** (American, 1905–1988), *Early Morning Garden,* 1957. Oil paint and collage on canvas, 44 × 36 in. (111.76 × 91.44 cm). Collection of Art Enterprises, Ltd., Chicago.

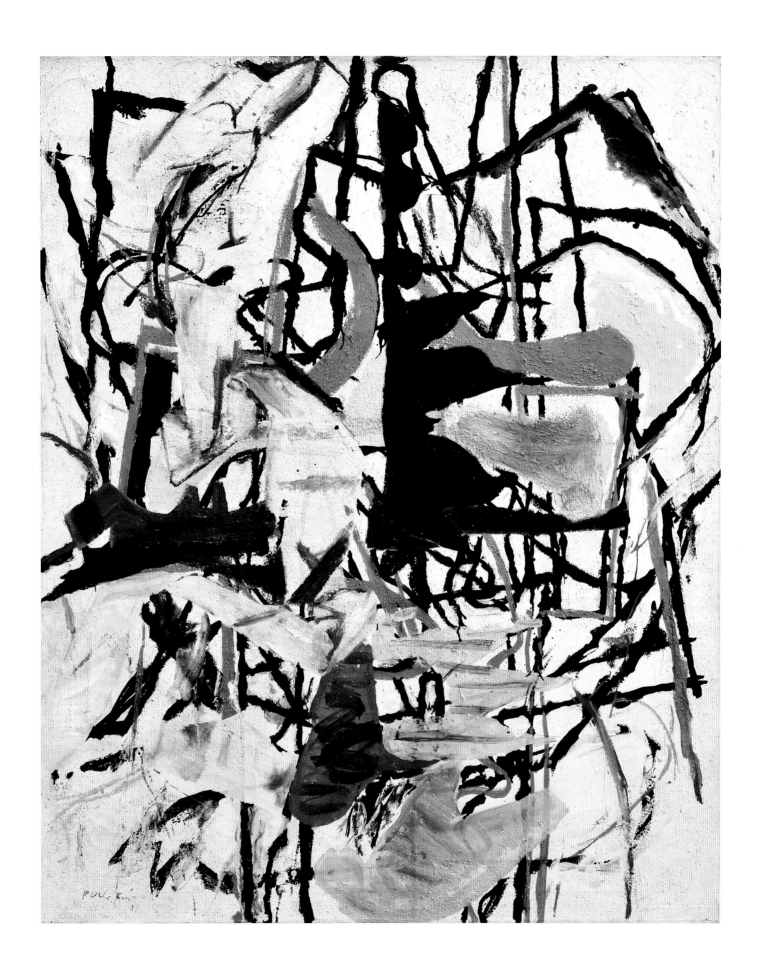

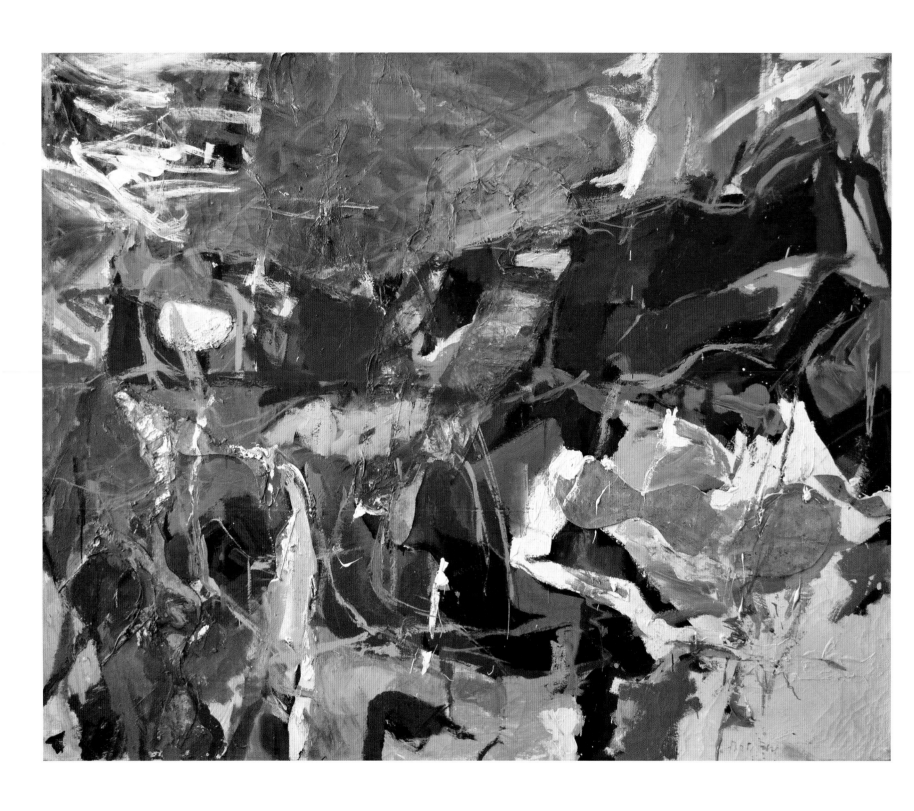

CAT. 13. **Perle Fine**, *Summer I,* 1958–59. Oil paint and collage
on canvas, 57 × 70 in. (144.78 × 177.8 cm). Collection of
Craig A. Ponzio.

CAT. 14. **Perle Fine**, *Image d'Hiver,* 1959. Oil paint and mixed media on canvas, 34 × 36 in. (86.36 × 91.44 cm). Collection of Thomas McCormick and Janis Kanter, Chicago.

CAT. 15. **Helen Frankenthaler** (American, 1928–2011), *Untitled,* 1951. Oil paint and enamel on canvas, 56⅜ × 84½ in. (143.19 × 214.63 cm). Crystal Bridges Museum of American Art, Bentonville, Ark.

CAT. 16. **Helen Frankenthaler**, *Mountain Storm,* 1955. Oil paint
on canvas, 72 × 48 in. (182.88 × 121.92 cm). Anonymous.

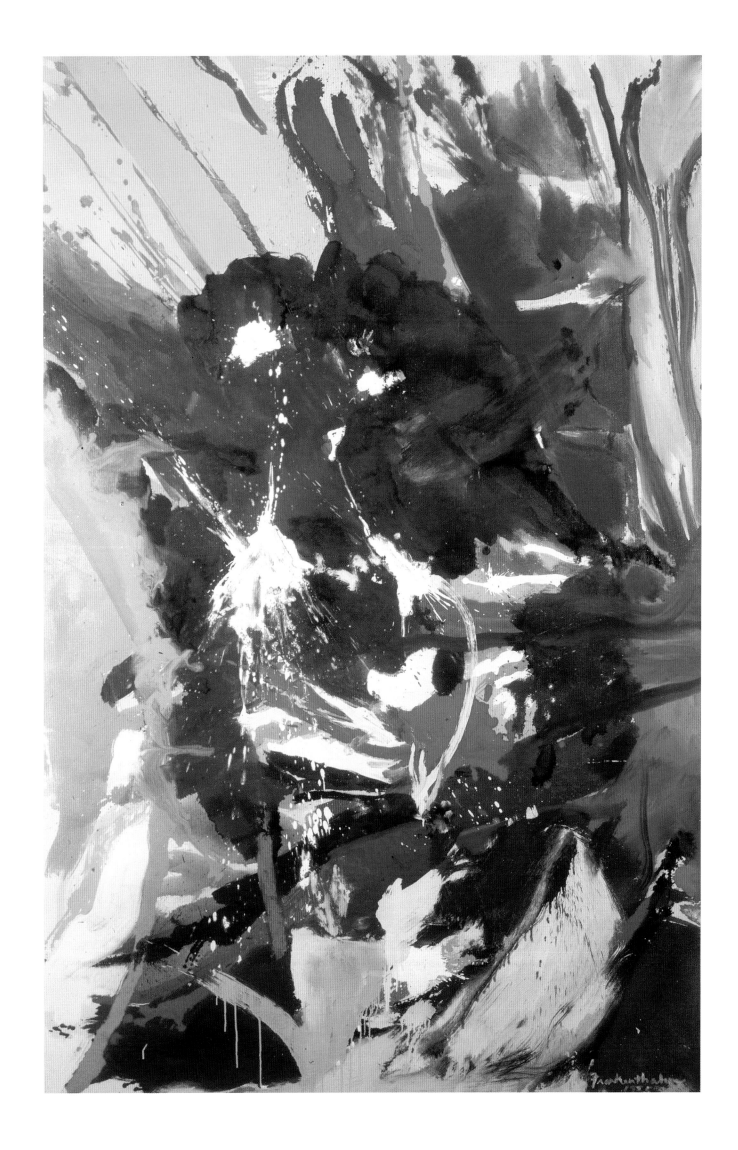

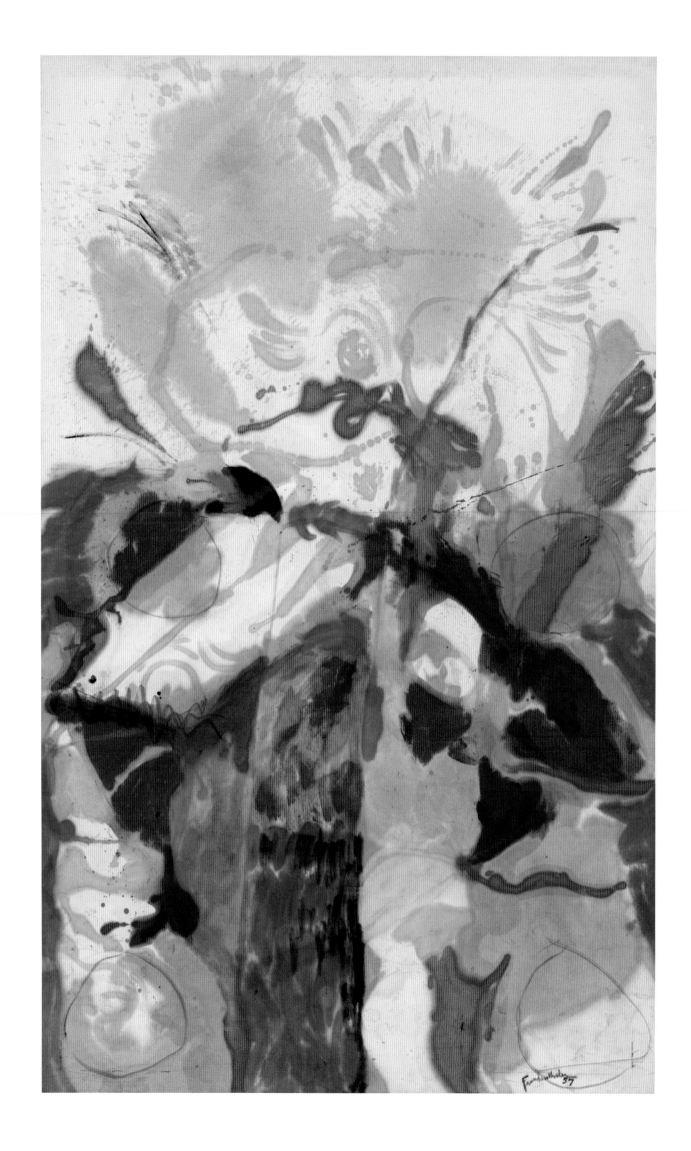

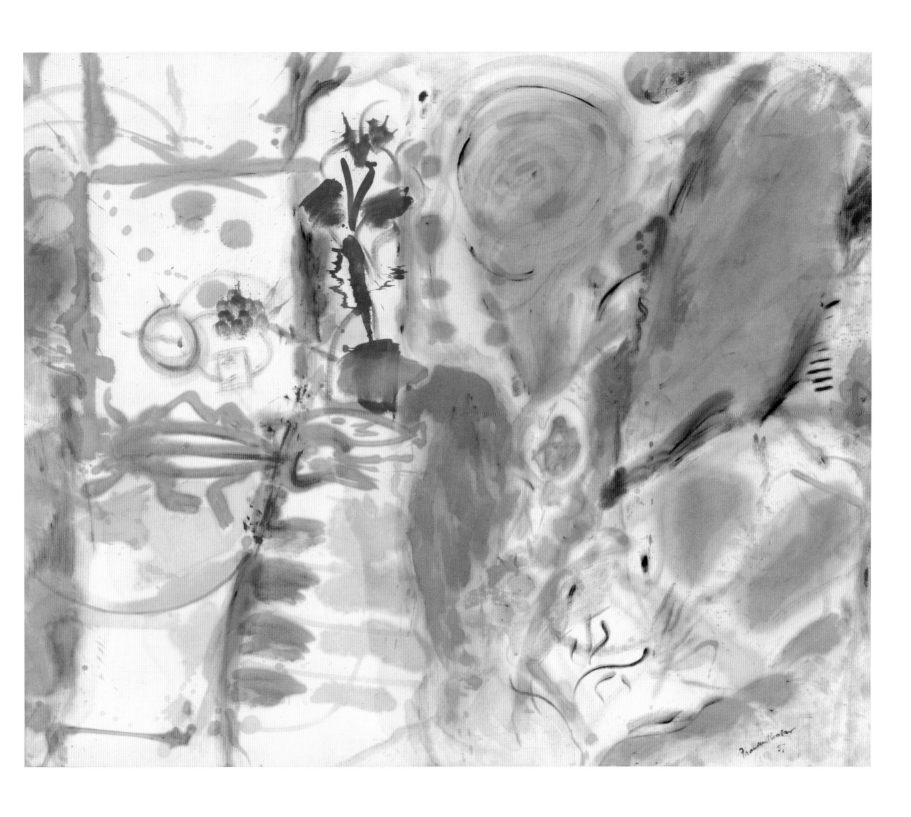

OPPOSITE: CAT. 17. **Helen Frankenthaler**, *Jacob's Ladder,* 1957. Oil paint on canvas, 9 ft., 5³⁄₈ in. × 69⁷⁄₈ in. (287.97 × 177.48 cm). The Museum of Modern Art, New York. Gift of Hyman N. Glickstein, 1960.

CAT. 18. **Helen Frankenthaler**, *Western Dream,* 1957. Oil paint on unsized, unprimed canvas, 70 × 86 in. (177.8 × 218.44 cm). Helen Frankenthaler Foundation, New York.

CAT. 19. **Sonia Gechtoff** (American, b. 1926), *Anna Karenina*, 1955. Oil paint on canvas, 61 × 41 in. (154.94 × 104.14 cm). Private collection.

CAT. 20. **Sonia Gechtoff**, *Untitled #2*, 1955. Oil paint on canvas,
53¼ × 49¼ in. (135.26 × 125.1 cm). Private collection.

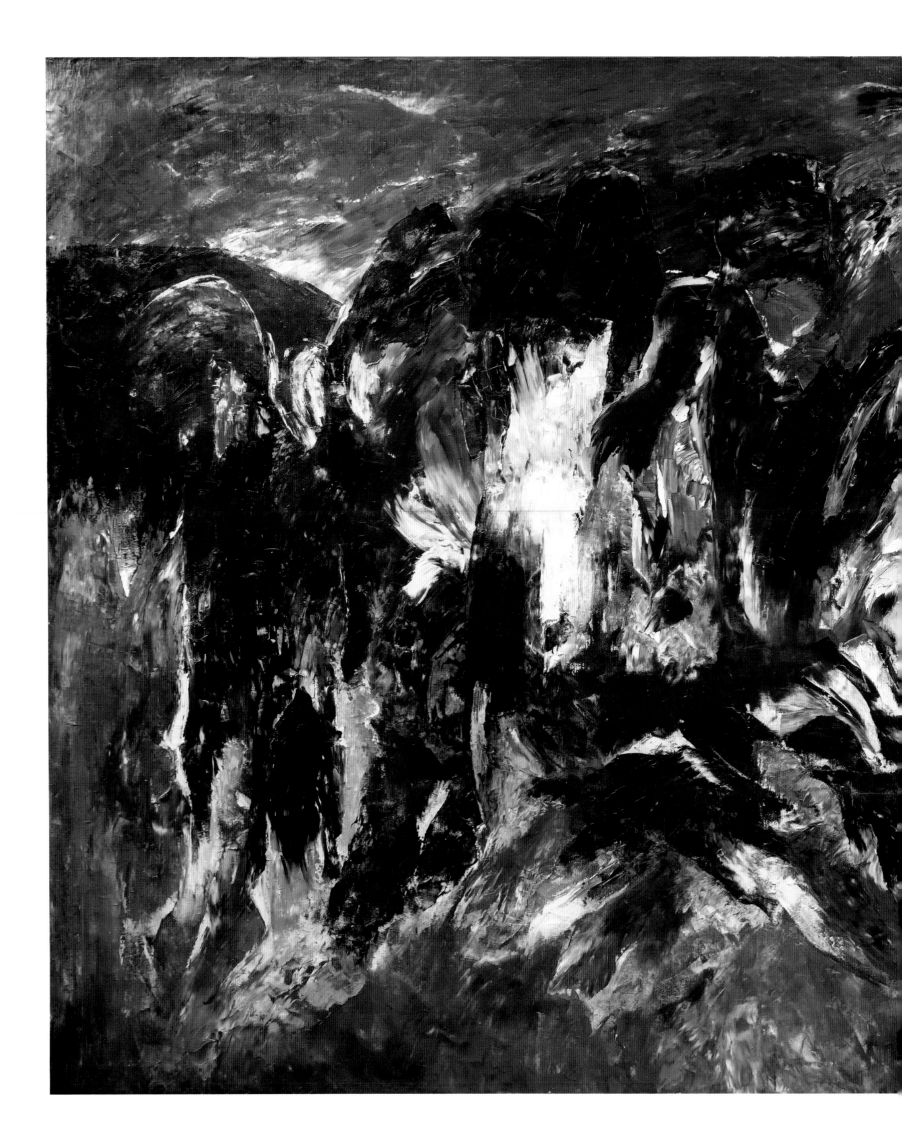

CAT. 21. **Sonia Gechtoff**, *Children of Frejus*, 1959. Oil paint on canvas, 76¾ × 102 in. (194.95 × 259.08 cm). Private collection.

CAT. 22. **Sonia Gechtoff**, *The Beginning,* 1960. Oil paint on
canvas, 69 × 83 in. (175.26 × 210.82 cm). Denver Art Museum:
Vance H. Kirkland Acquisition Fund, 2015.62.

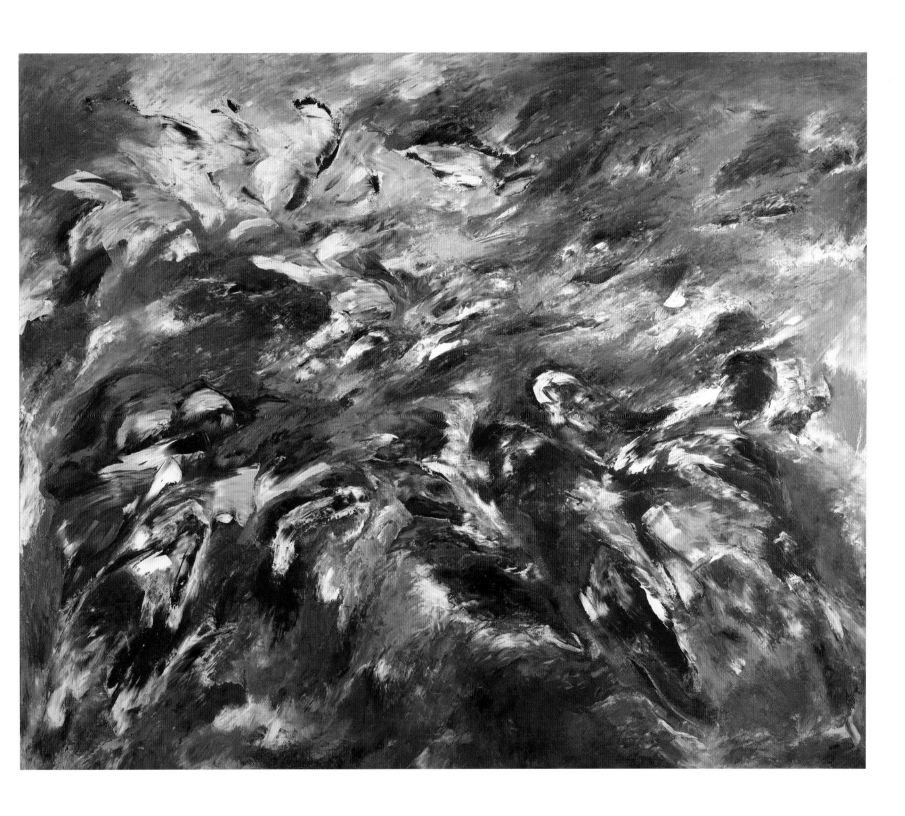

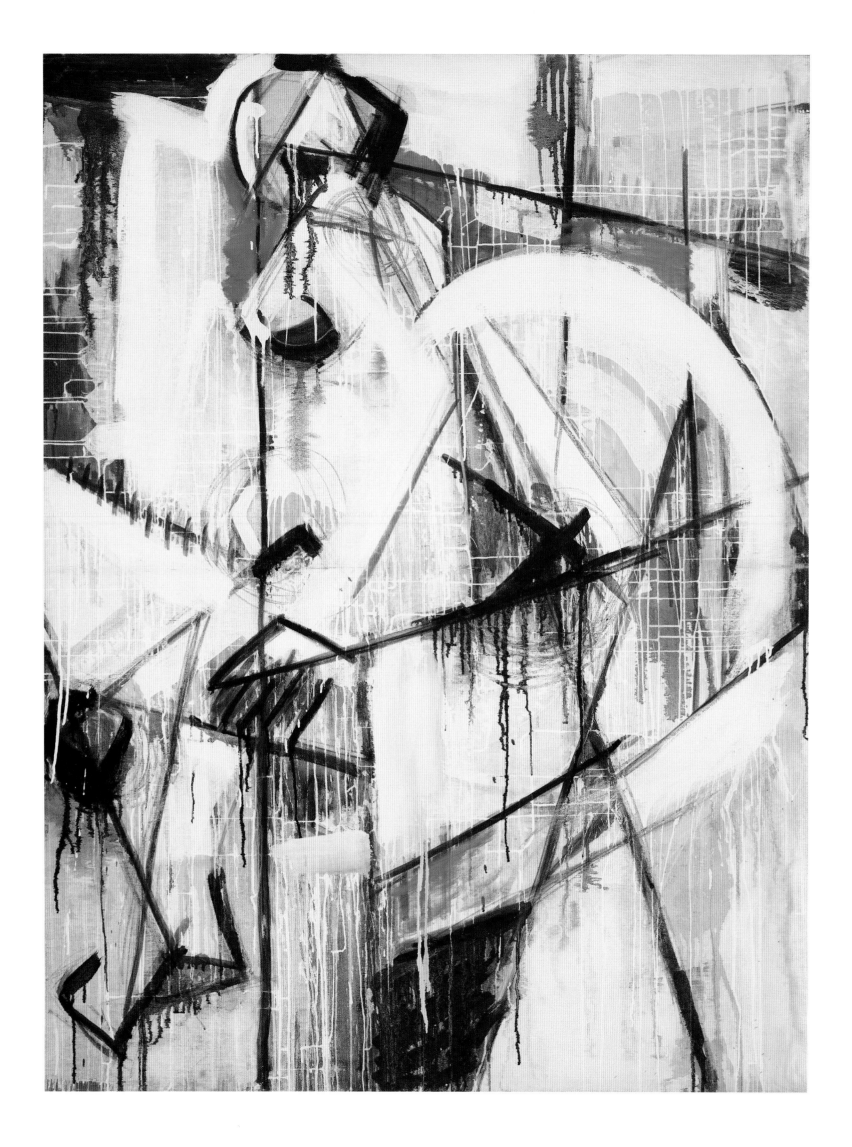

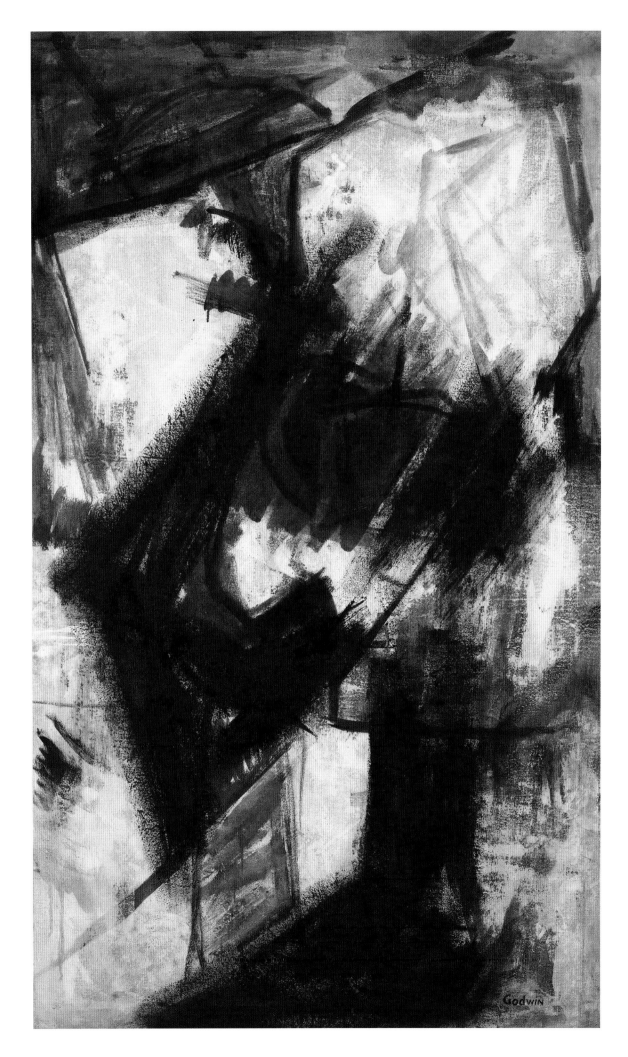

OPPOSITE: CAT. 23. **Judith Godwin** (American, b. 1930), *Woman,* 1954. Oil paint on canvas, 68 × 52 in. (172.72 × 132.08 cm). Judith Godwin, New York.

CAT. 24. **Judith Godwin**, *Martha Graham—Lamentation,* 1956. Oil paint on canvas, 60 × 35¾ in. (152.4 × 90.81 cm). Judith Godwin, New York.

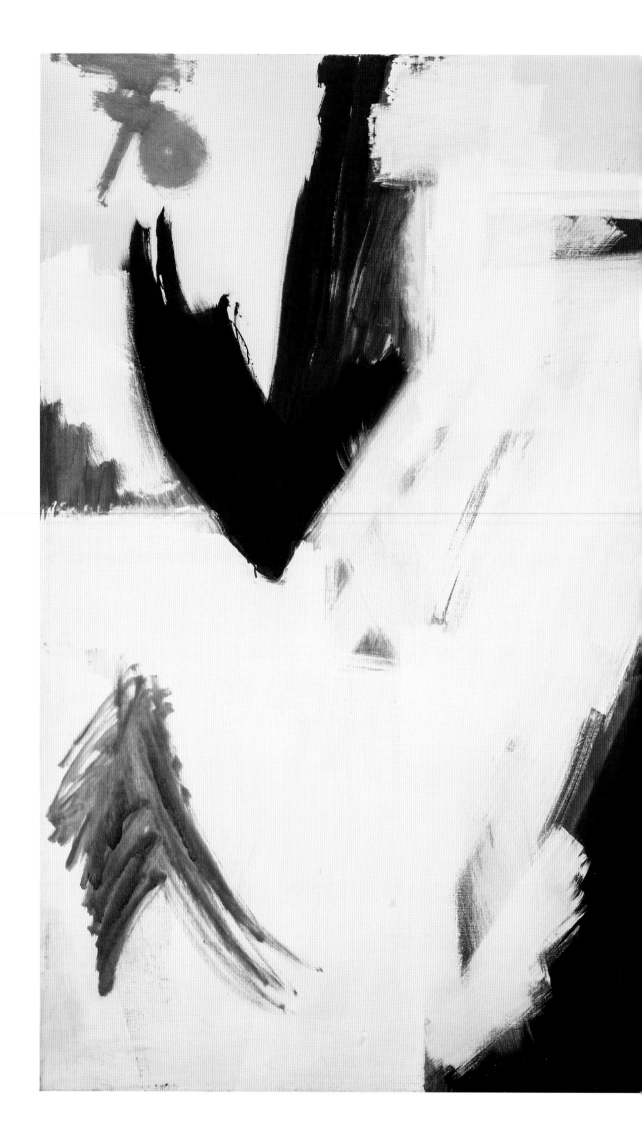

CAT. 25. **Judith Godwin**, *Epic*, 1959.
Oil paint on canvas (diptych), 82 in. ×
8 ft., 4 in. (208.28 × 254 cm). National
Museum of Women in the Arts,
Washington, D.C., Gift of Caroline
Rose Hunt.

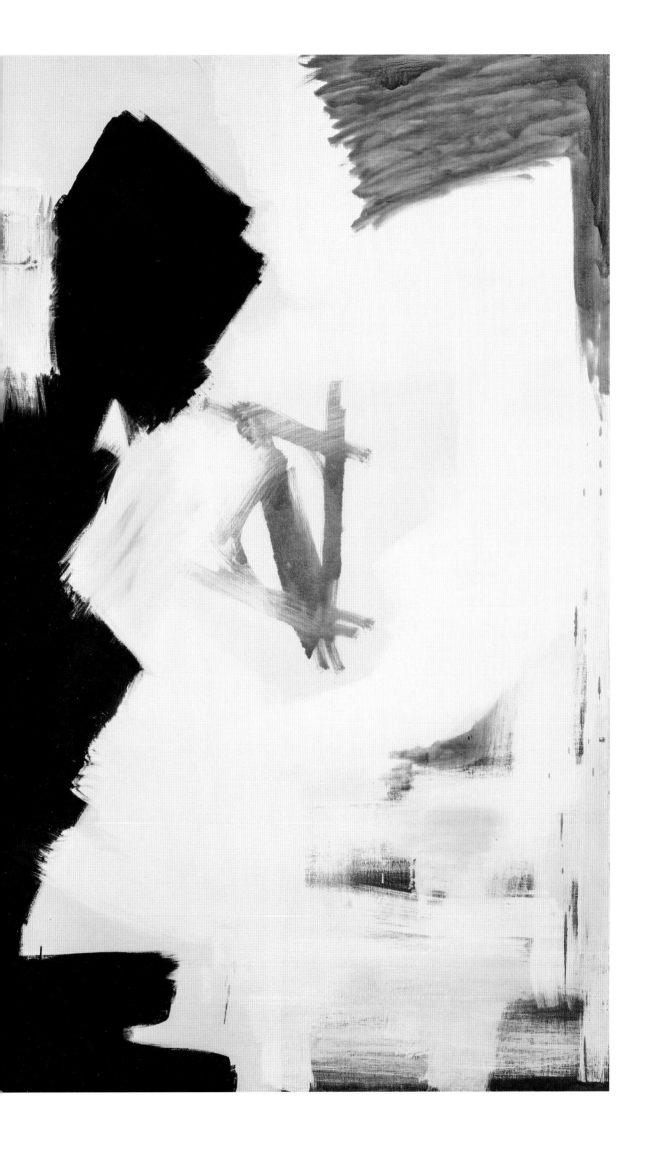

CAT. 26. **Grace Hartigan** (American, 1922–2008), *The King Is Dead,* 1950. Oil paint on canvas, 65 × 96½ in. (165.10 × 245.11 cm). Permanent Collection, Snite Museum of Art, University of Notre Dame. Purchased with funds provided by Mr. Al Nathe, 1995.023.

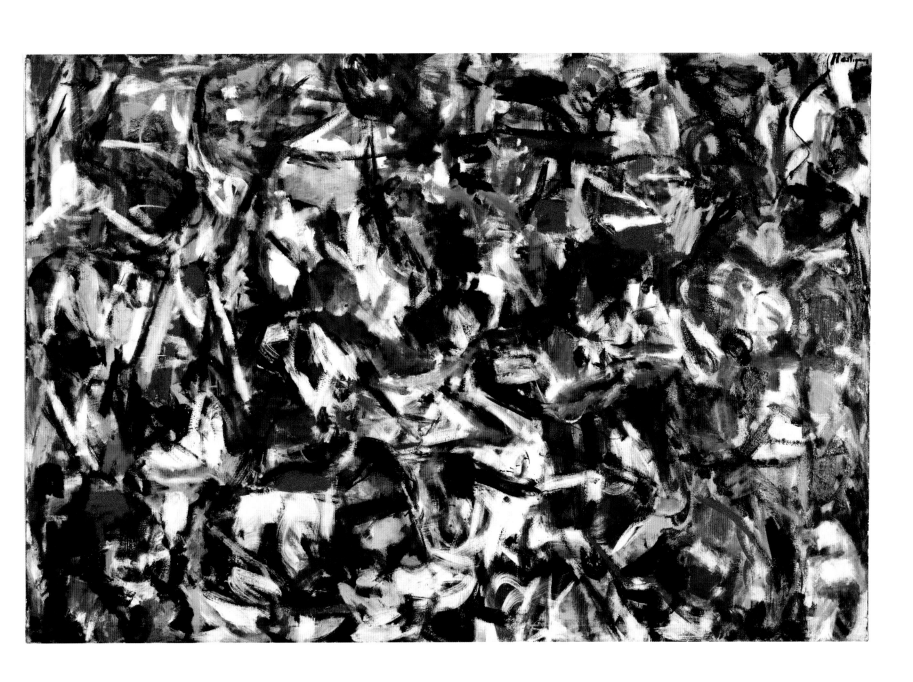

CAT. 27. **Grace Hartigan**, *Portrait of W,* 1951–52. Oil paint on canvas, 85 × 58 in. (215.90 × 147.32 cm). Collection of Craig A. Ponzio.

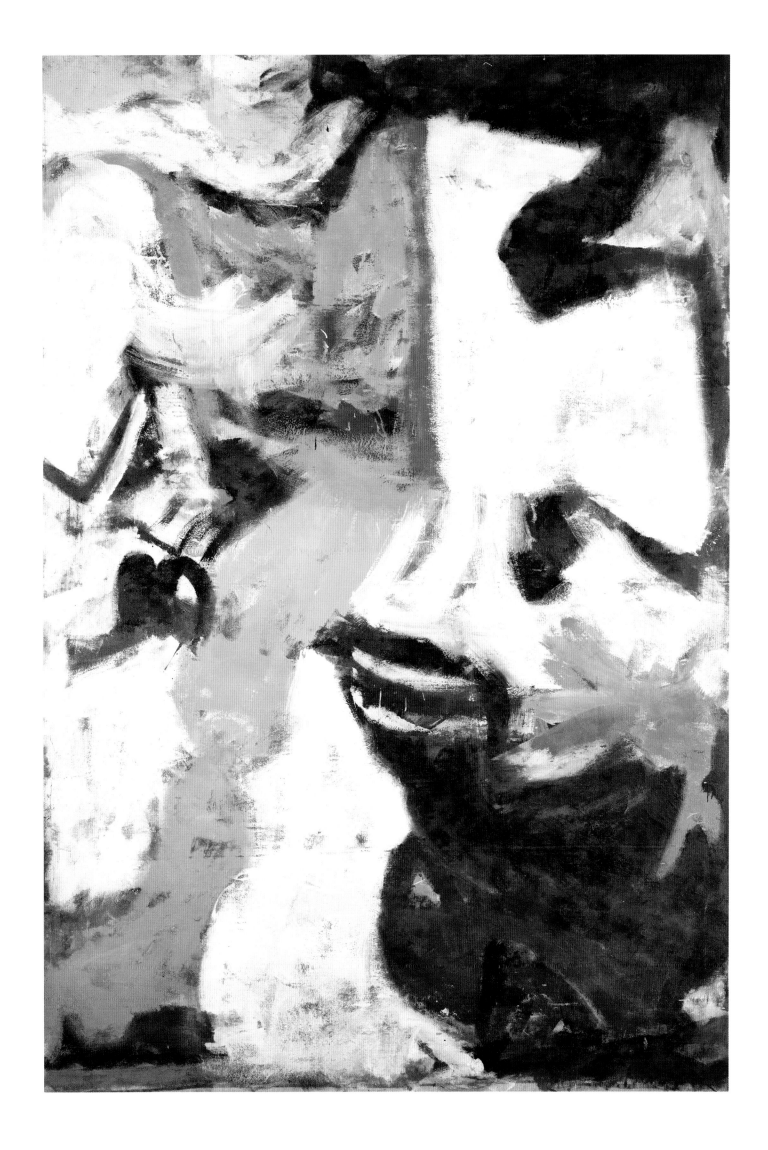

CAT. 28. **Grace Hartigan**, *The Massacre*, 1952. Oil paint on canvas, 80 in. × 10 ft., 7³⁄₄ in. (203.2 × 324.49 cm). Collection of the Kemper Museum of Contemporary Art, Kansas City, Mo. Bebe and Crosby Kemper Collection. Gift of the Enid and Crosby Kemper Foundation, 1995.38.

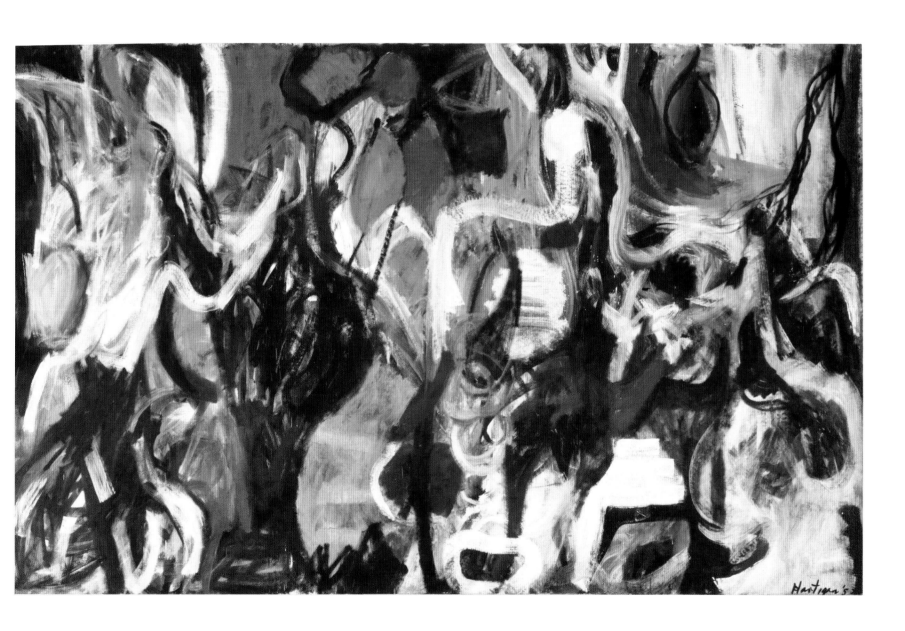

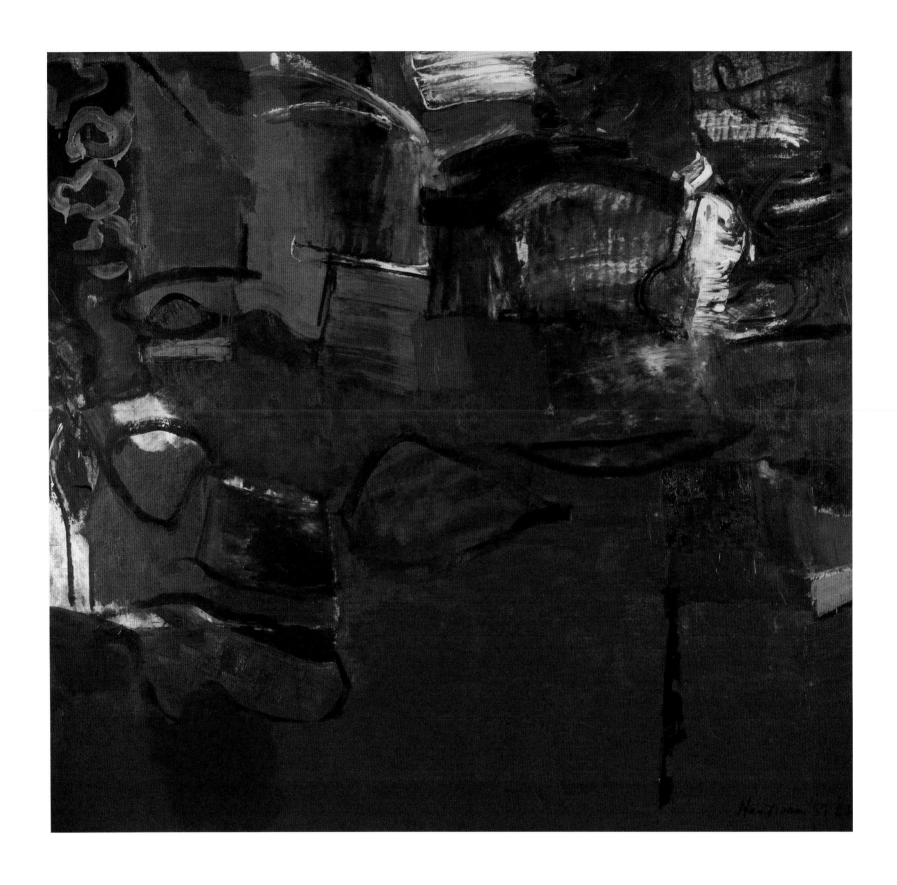

CAT. 29. **Grace Hartigan**, *Interior, "The Creeks,"* 1957. Oil paint
on canvas, 90⁷⁄₁₆ × 96¹⁄₄ in. (229.71 × 244.48 cm). The
Baltimore Museum of Art. Gift of Philip Johnson, New Canaan,
Conn., BMA 1983.45. DENVER ONLY.

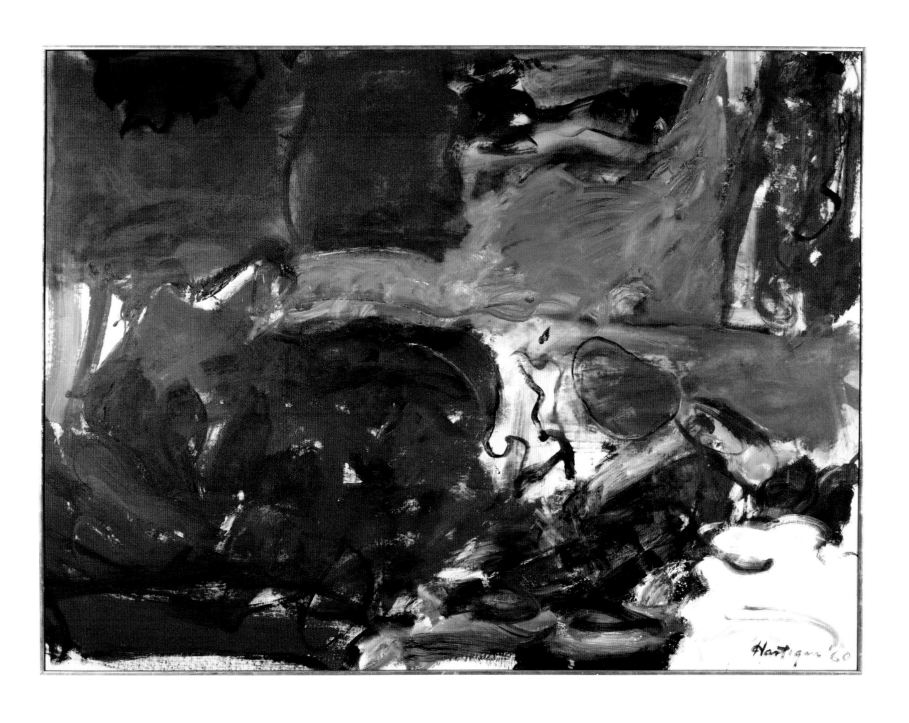

CAT. 30. **Grace Hartigan**, *New York City Rhapsody,* 1960. Oil
paint on canvas, 67¾ × 91⁵⁄₁₆ in. (172.09 × 231.93 cm). Mildred
Lane Kemper Art Museum, Washington University, St. Louis,
Mo. University purchase, Bixby Fund, 1960, WU 3883.

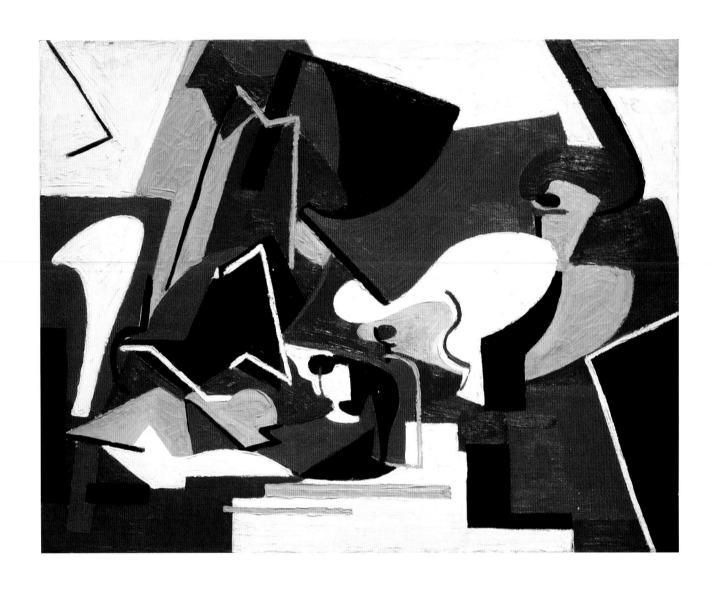

CAT. 31. **Lee Krasner** (American, 1908–1984), *Untitled,* 1942.
Oil paint on linen, 21 × 27 in. (53.34 × 68.58 cm). Collection of the
University Art Museum, California State University, Long Beach.
Gift of the Gordon F. Hampton Foundation, through Wesley G.
Hampton, Roger K. Hampton, and Katharine H. Shenk.

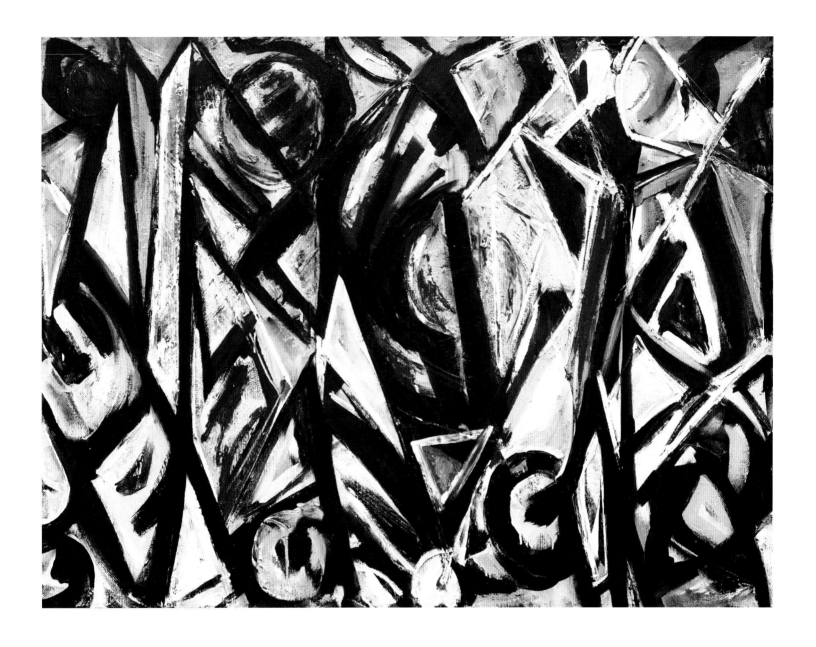

CAT. 32. **Lee Krasner**, *Gothic Frieze,* 1950. Oil paint on Masonite, 36 × 48 in. (91.44 × 121.92 cm). Collection of the University Art Museum, California State University, Long Beach. Gift of the Gordon F. Hampton Foundation, through Wesley G. Hampton, Roger K. Hampton, and Katharine H. Shenk.

CAT. 33. **Lee Krasner**, *Stretched Yellow,* 1955. Oil paint with collaged paper on canvas, 82½ × 57¾ in. (209.55 × 146.69 cm). Collection of the University Art Museum, California State University, Long Beach. Gift of the Gordon F. Hampton Foundation, through Wesley G. Hampton, Roger K. Hampton, and Katharine H. Shenk.

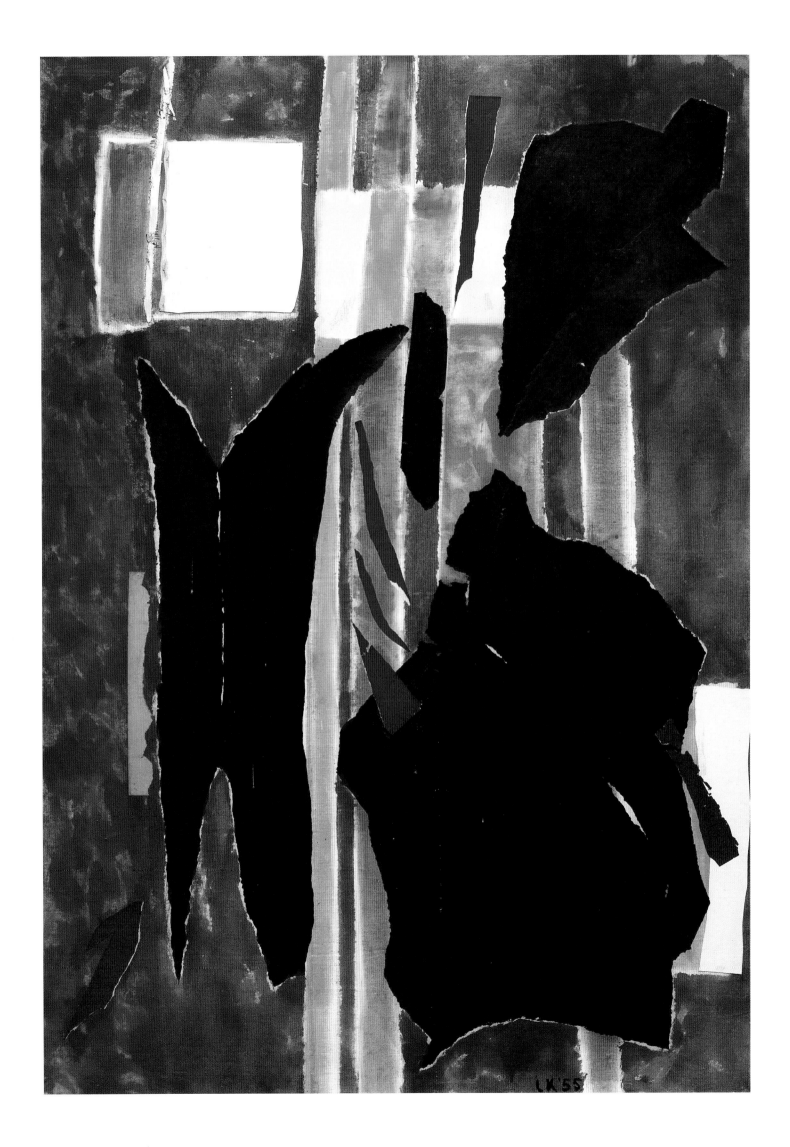

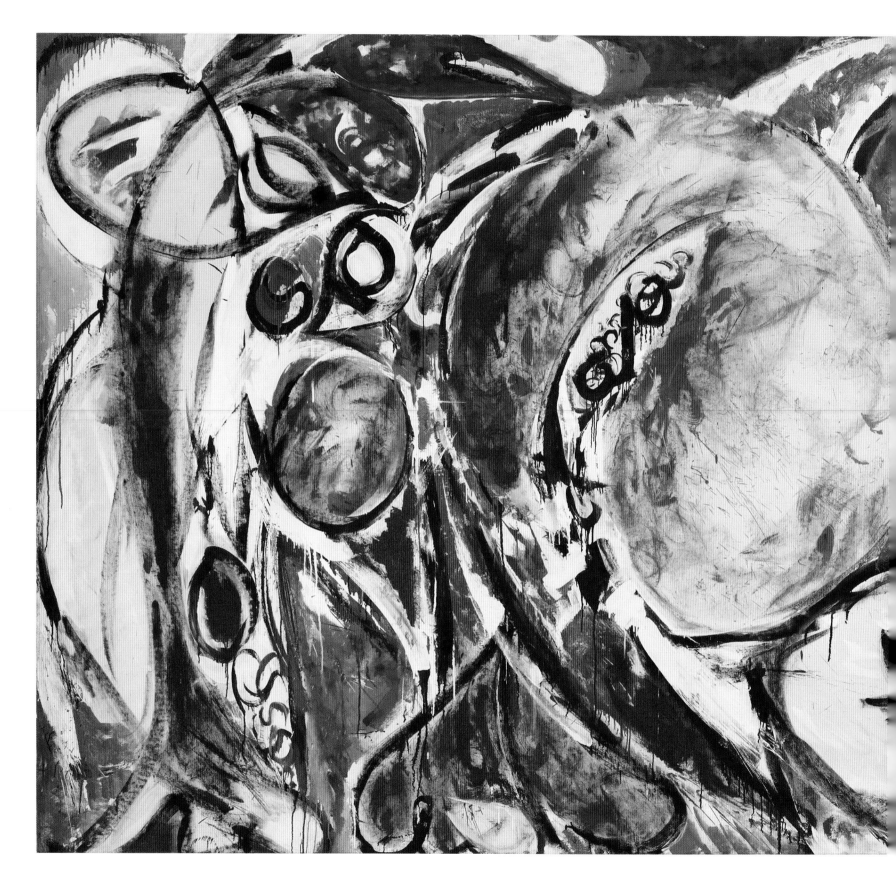

CAT. 34. **Lee Krasner**, *The Seasons,* 1957. Oil and house paint on
canvas, 92¾ in. × 16 ft., ⅞ in. (235.59 × 517.8 cm). Whitney Museum
of American Art, New York. Purchase, with funds from Frances and
Sydney Lewis by exchange, the Mrs. Percy Uris Purchase Fund
and the Painting and Sculpture Committee, 87.7. DENVER ONLY.

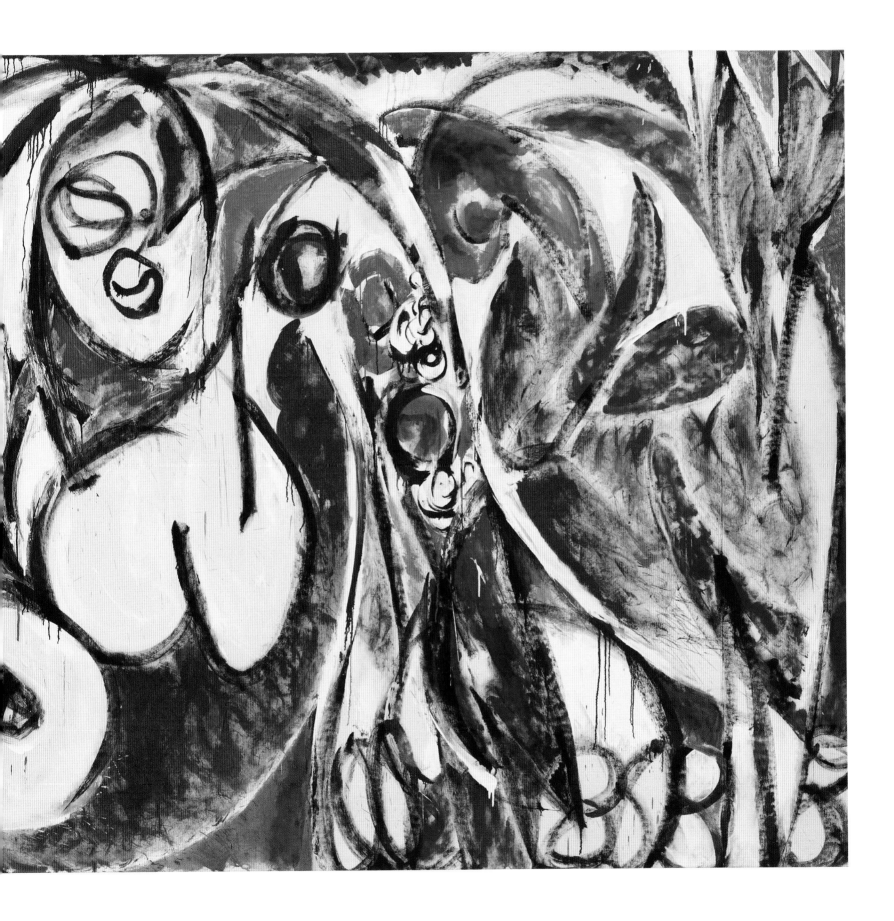

CAT. 35. **Lee Krasner**, *Cornucopia,* 1958. Oil paint on cotton duck, 90½ × 70 in. (229.87 × 177.8 cm). Collection of the University Art Museum, California State University, Long Beach. Gift of the Gordon F. Hampton Foundation, through Wesley G. Hampton, Roger K. Hampton, and Katharine H. Shenk.

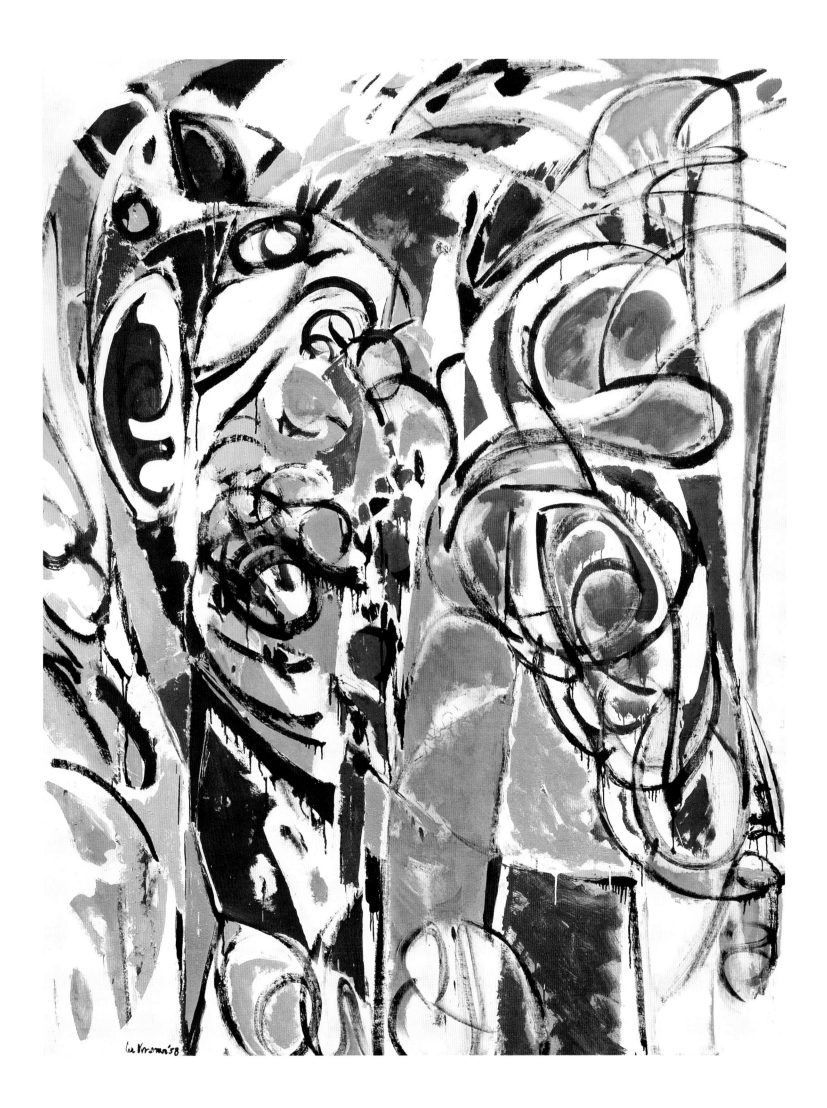

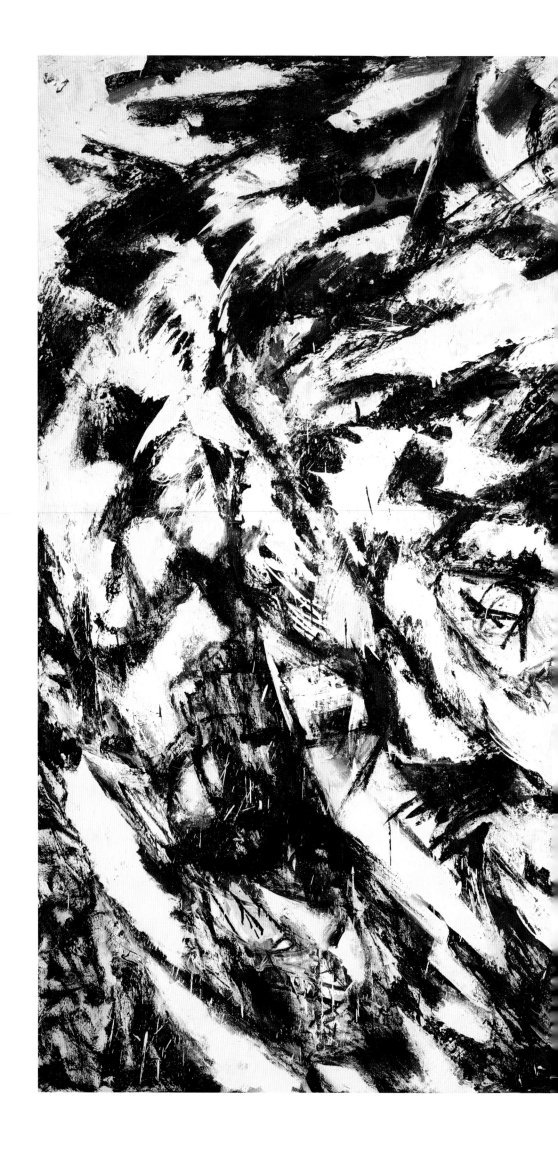

CAT. 36. **Lee Krasner**, *Charred Landscape*, 1960. Oil paint on canvas, 70 × 98 in. (177.8 × 248.92 cm). Collection of Craig A. Ponzio.

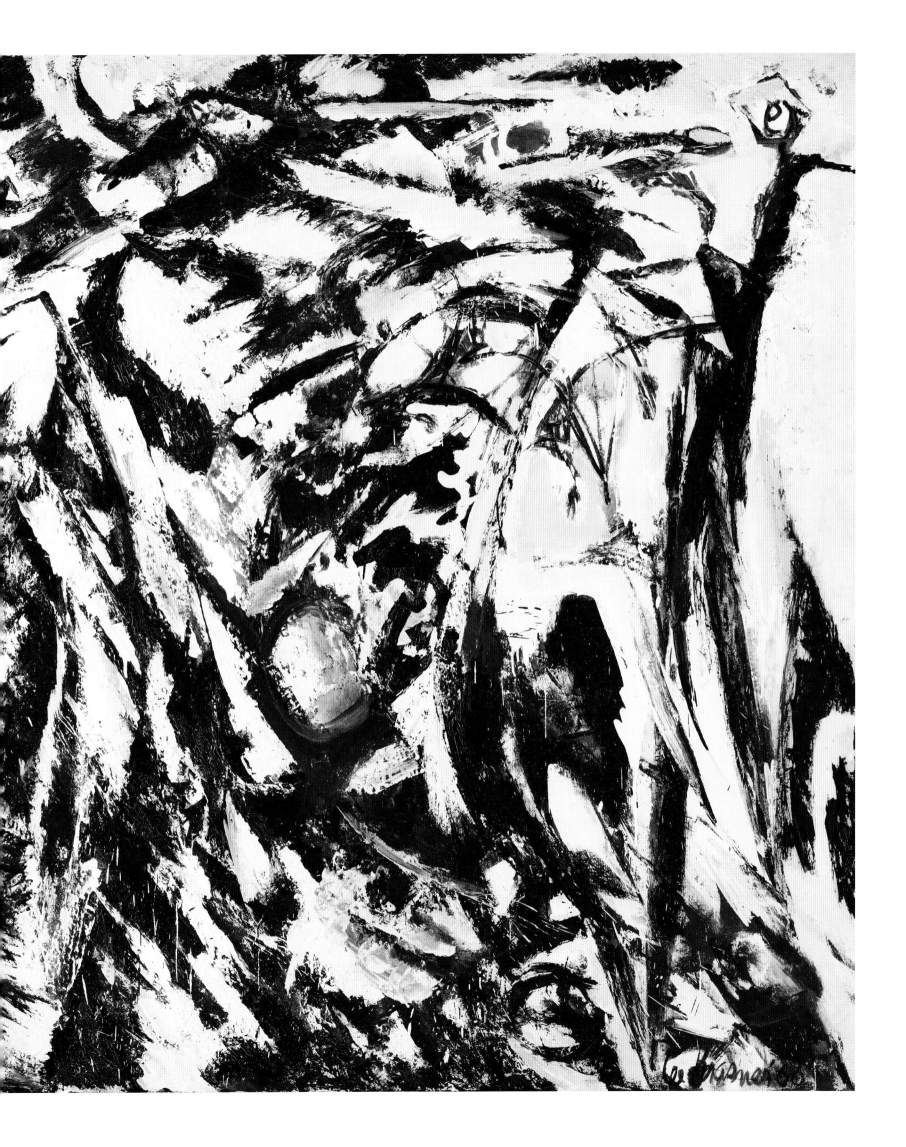

CAT. 37. **Lee Krasner**, *What Beast Must I Adore?* 1961. Oil paint
on canvas, 75 × 57⅛ in. (190.5 × 145.1 cm). Collection of the
University Art Museum, California State University, Long Beach.
Gift of the Gordon F. Hampton Foundation, through Wesley G.
Hampton, Roger K. Hampton, and Katharine H. Shenk.

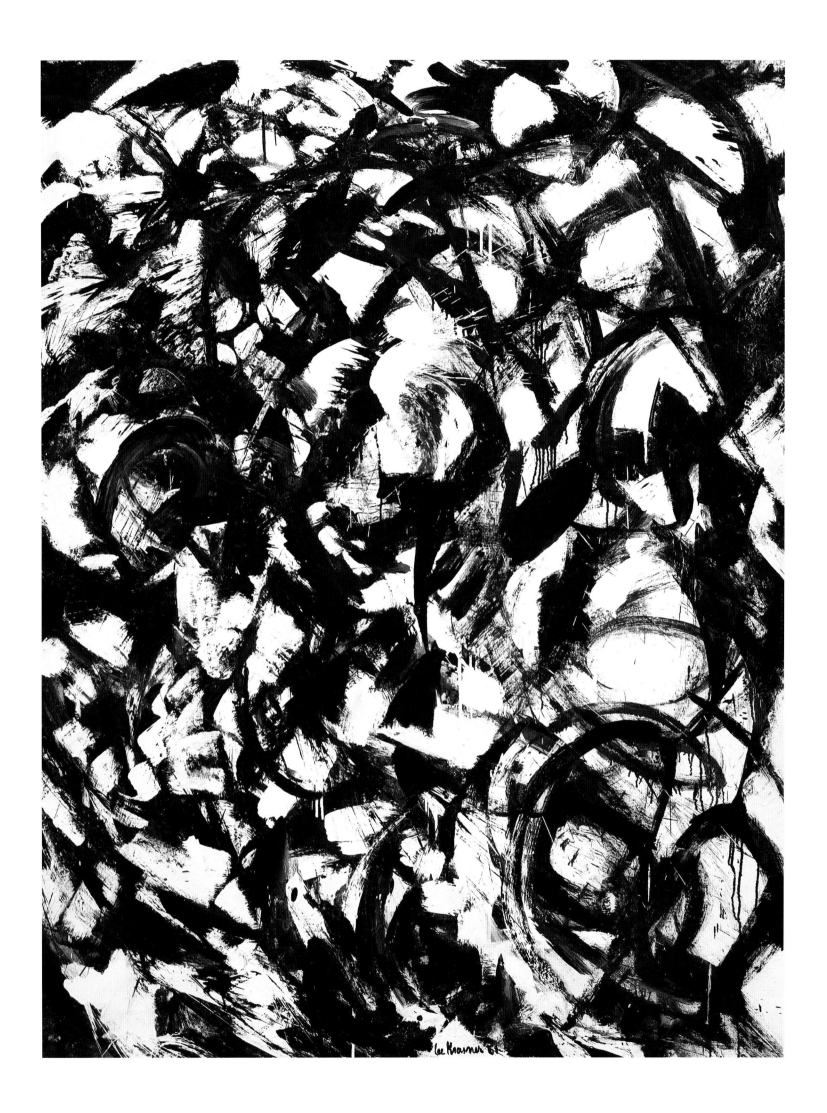

CAT. 38. **Joan Mitchell** (American, 1925–1992), *Untitled,*
1952–53. Oil paint on canvas, 64 × 60 in. (162.56 × 152.4 cm).
Collection of the Joan Mitchell Foundation, New York.

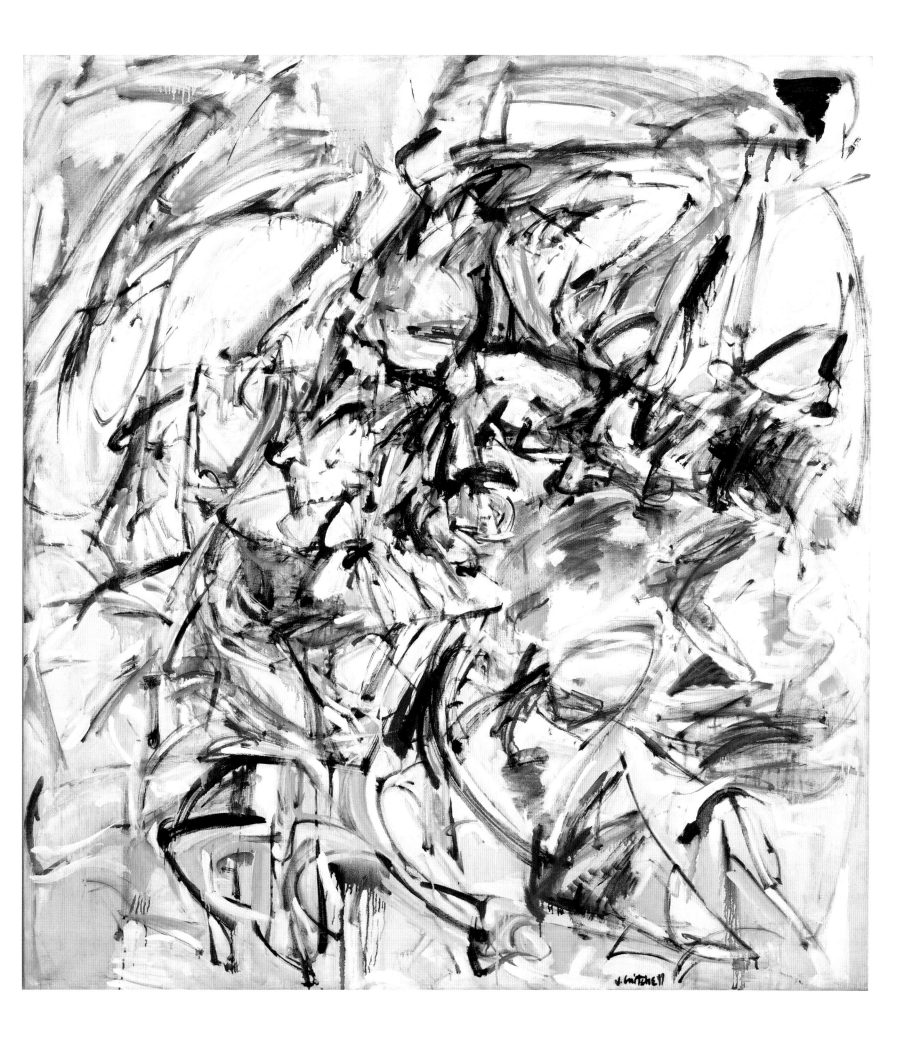

CAT. 39. **Joan Mitchell**, *Number 12*, 1953–54. Oil paint on canvas, 79⅝ × 73⅝ in. (202.25 × 187.01 cm). Collection of the Joan Mitchell Foundation, New York.

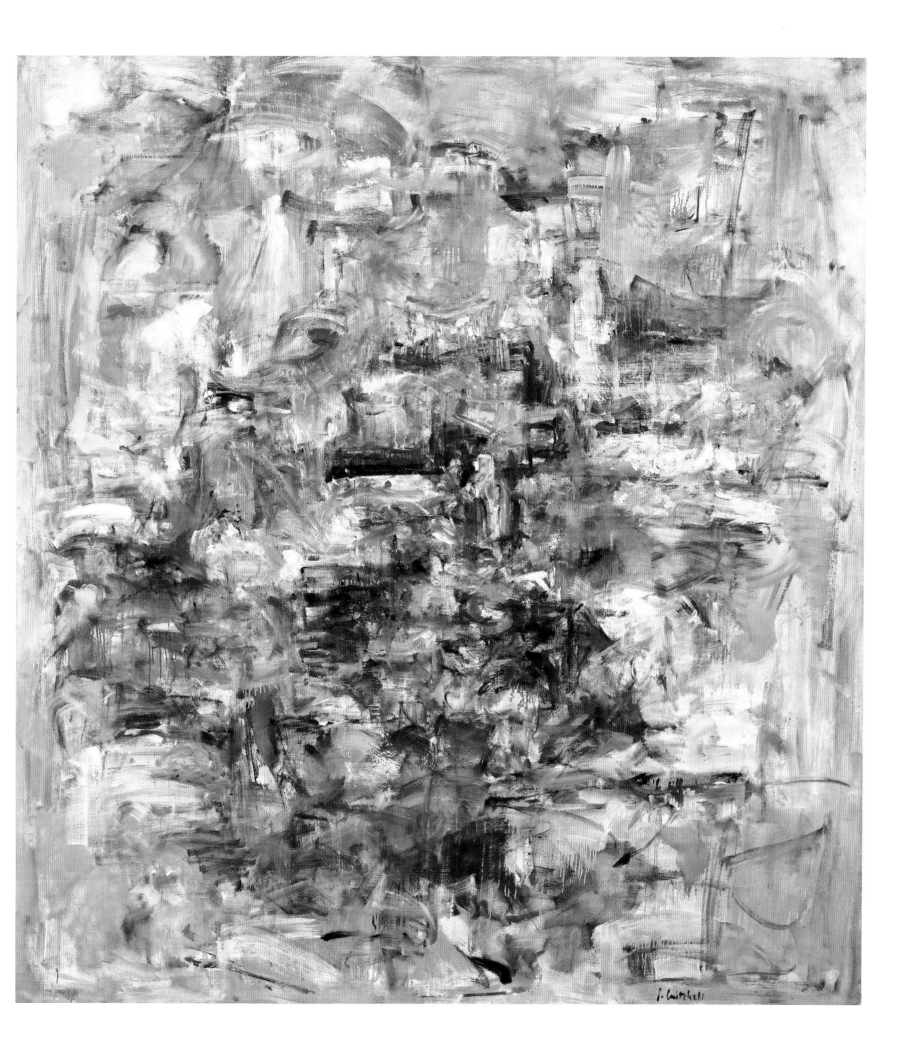

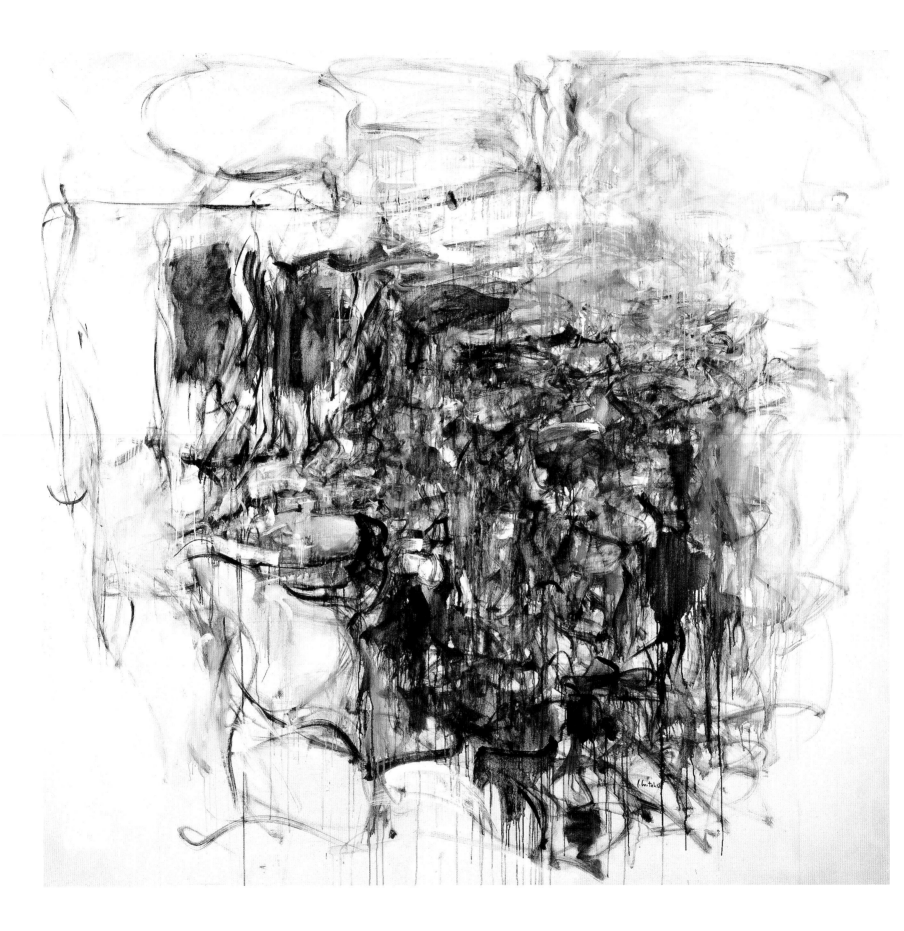

CAT. 40. **Joan Mitchell**, *Hudson River Day Line,* 1955. Oil paint on canvas, 79 × 83 in. (200.66 × 210.82 cm). Collection of the McNay Art Museum, San Antonio, Tex. Museum purchase with funds from the Tobin Foundation.

OPPOSITE: CAT. 41. **Joan Mitchell**, *East Ninth Street,* 1956. Oil paint on canvas, 80 × 64 in. (203.2 × 162.56 cm). Collection of the Los Angeles County Museum of Art. Gift of William Heller, Inc., M.62.62. DENVER ONLY.

CAT. 42. **Joan Mitchell**, *Evenings on Seventy-Third Street*, 1956–57. Oil paint on canvas, 75 × 84 in. (190.5 × 213.36 cm). Private collection. Courtesy of McClain Gallery. DENVER ONLY.

OPPOSITE: CAT. 43. **Joan Mitchell**, *Cercando un Ago*, 1957. Oil paint on canvas, 94¼ × 87⅝ in. (239.4 × 222.57 cm). Collection of the Joan Mitchell Foundation, New York.

CAT. 44. **Deborah Remington** (American, 1930–2010), *Eleusian,*
1951. Oil paint on canvas, 45¼ × 71⅝ in. (114.94 × 181.93 cm).
Courtesy of the Deborah Remington Charitable Trust for the
Visual Arts.

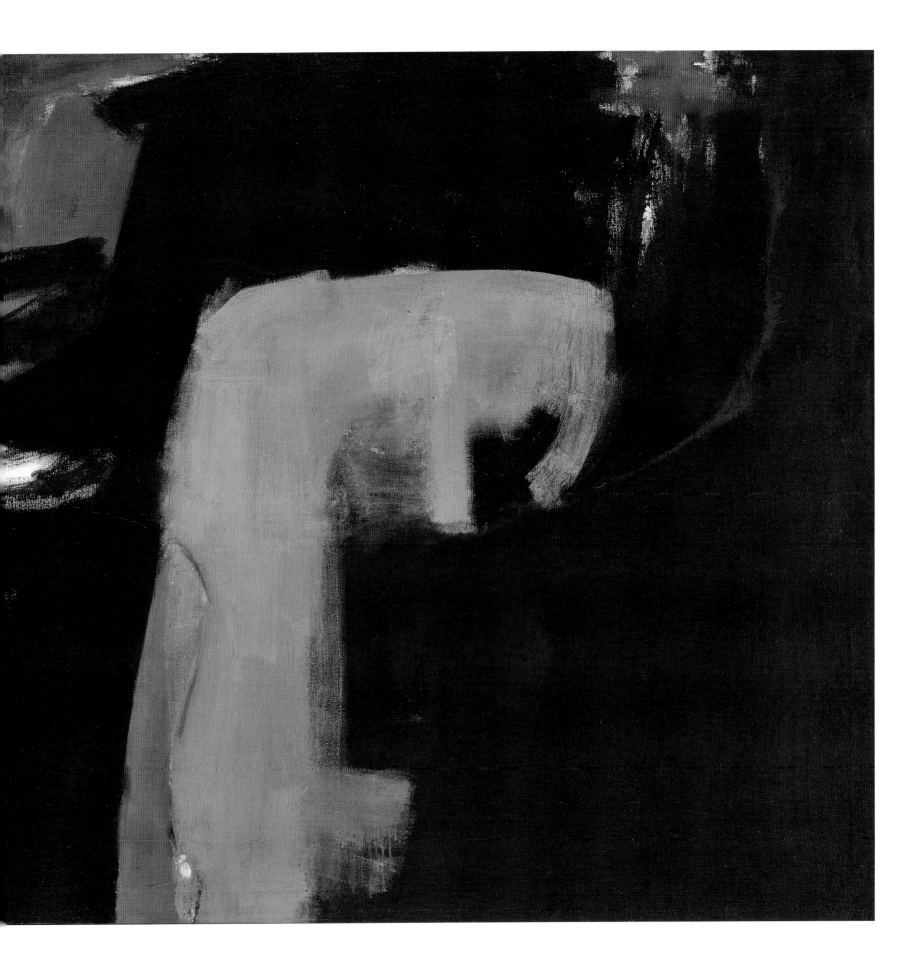

CAT. 45. **Deborah Remington**, *Apropos* or *Untitled,* 1953. Oil paint on canvas, 39 × 51 in. (99.06 × 129.54 cm). Denver Art Museum: Vance H. Kirkland Acquisition Fund, 2015.225.

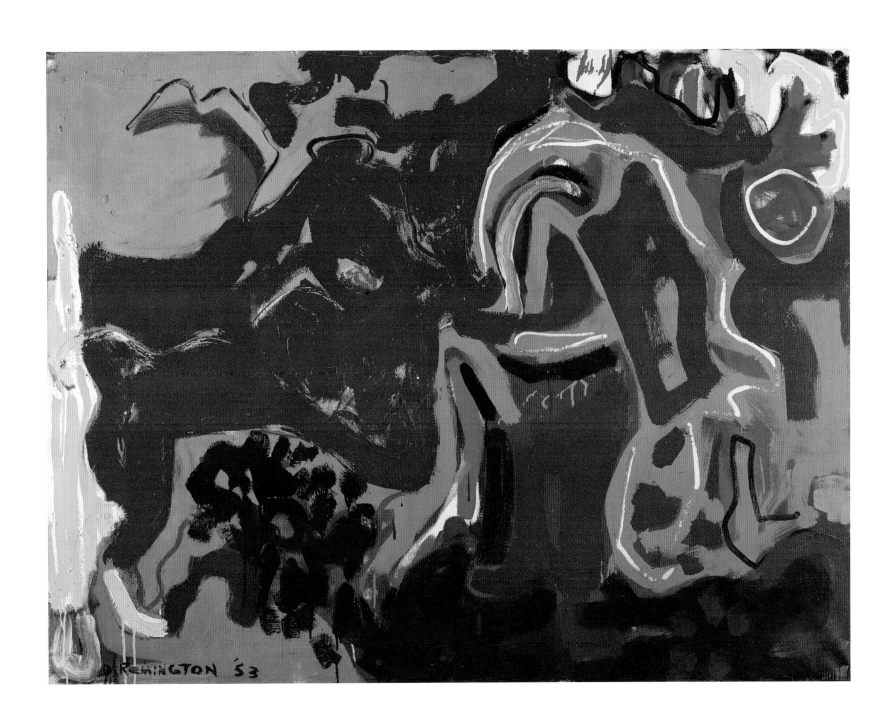

CAT. 46. **Deborah Remington**, *Phunky* or *Dacia,* 1956. Oil paint on canvas, 40¼ × 46¼ in. (102.24 × 117.48 cm). Private collection.

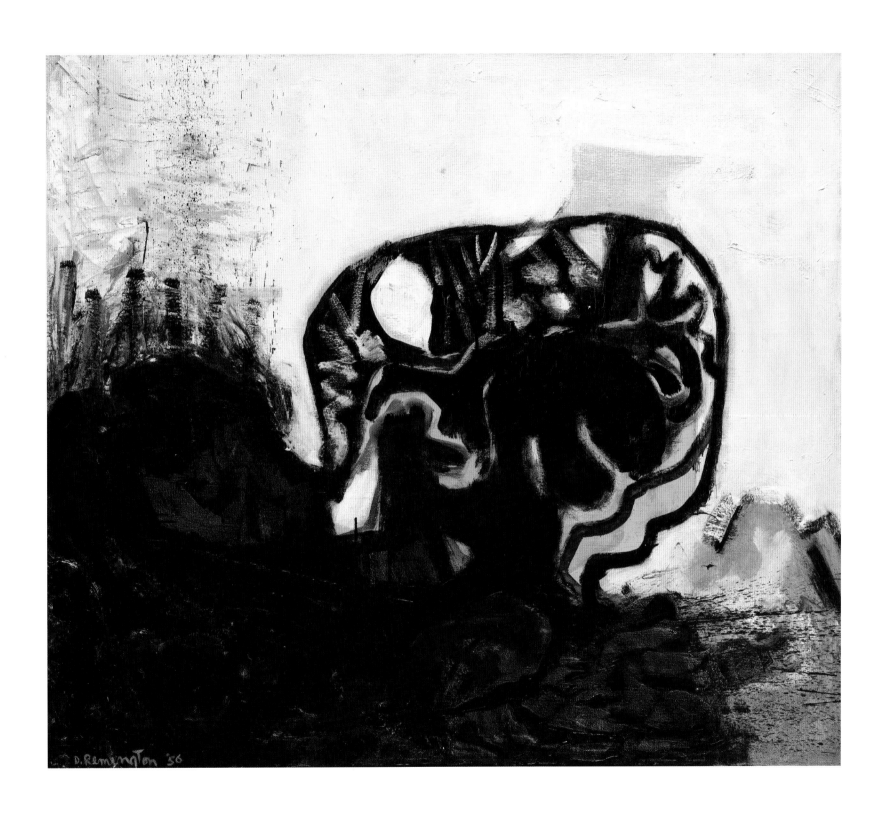

D. Remington '56

CAT. 47. **Deborah Remington**, *Exodus,* 1960. Oil paint on canvas,
71 × 62 in. (180.34 × 157.48 cm). Private collection.

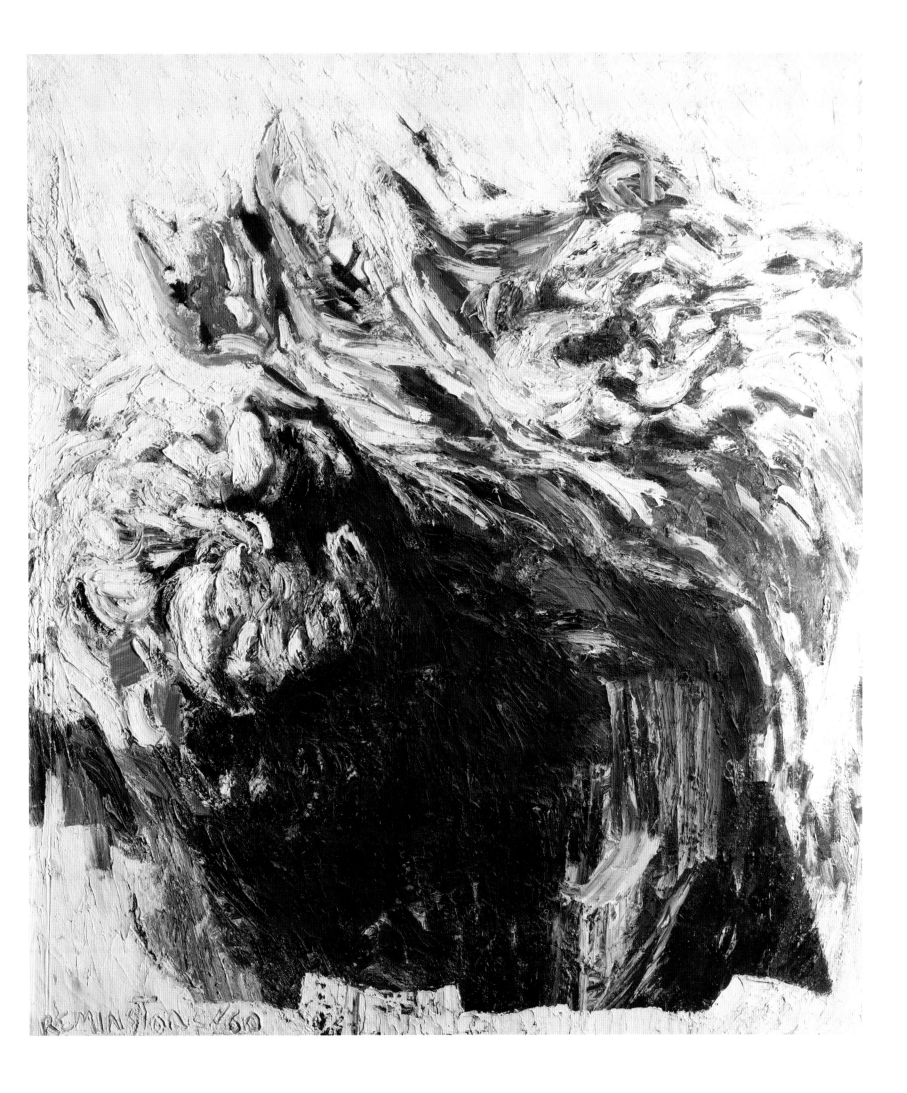

CAT. 48. **Ethel Schwabacher** (American, 1903–1984),
Dead Leaves or *Autumn Leaves*, 1956. Oil paint on canvas,
60½ × 50½ in. (153.67 × 128.27 cm). Private collection.

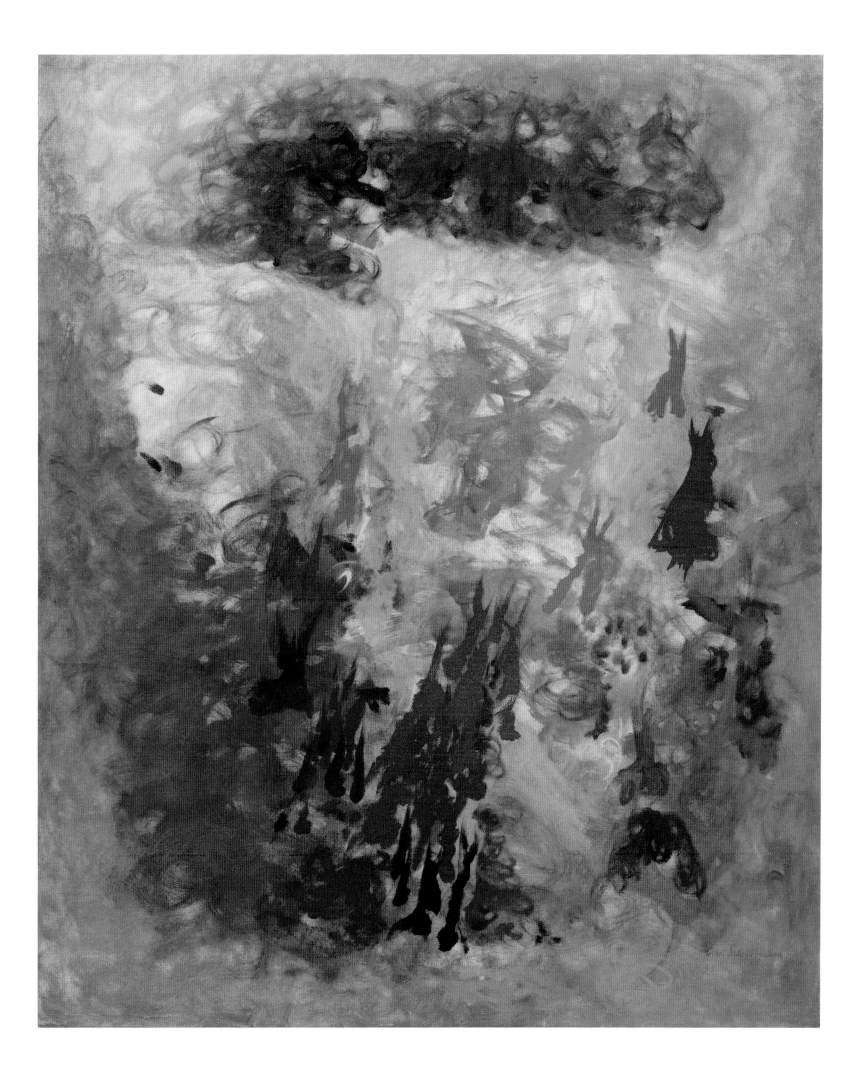

CAT. 49. **Ethel Schwabacher**, *Pennington I/Pelham II,* 1957. Oil paint on canvas, 60 × 50 in. (152.4 × 127 cm). Denver Art Museum: Gift of Christopher C. Schwabacher and Brenda S. Webster, 2014.160.

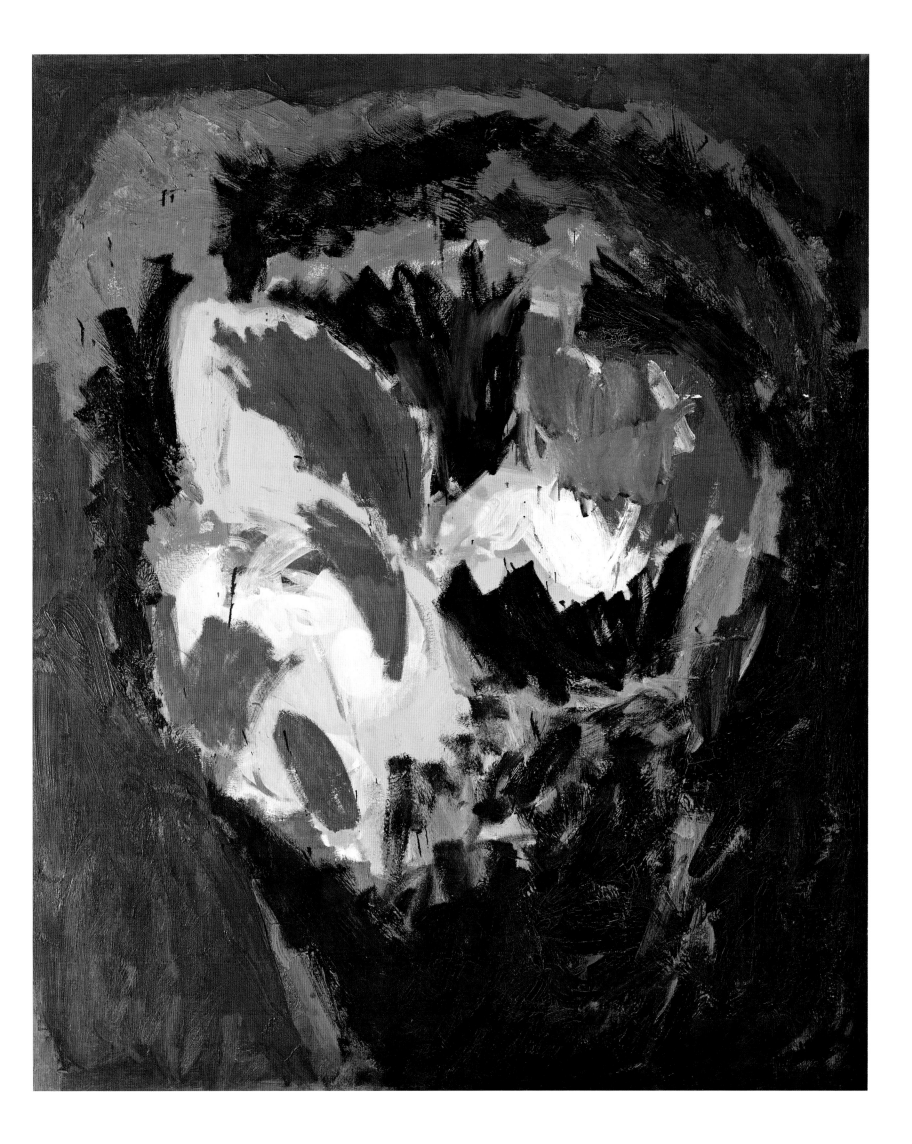

CAT. 50. **Ethel Schwabacher**, *Antigone I*, 1958. Oil paint on canvas, 50⅝ × 82¼ in. (128.59 × 208.92 cm). Collection of Christopher C. Schwabacher and Brenda S. Webster.

CAT. 51. **Ethel Schwabacher**, *Origins I,* 1958. Oil paint on canvas, 60 × 71¾ in. (152.4 × 182.25 cm). Collection of Christopher C. Schwabacher and Brenda S. Webster.

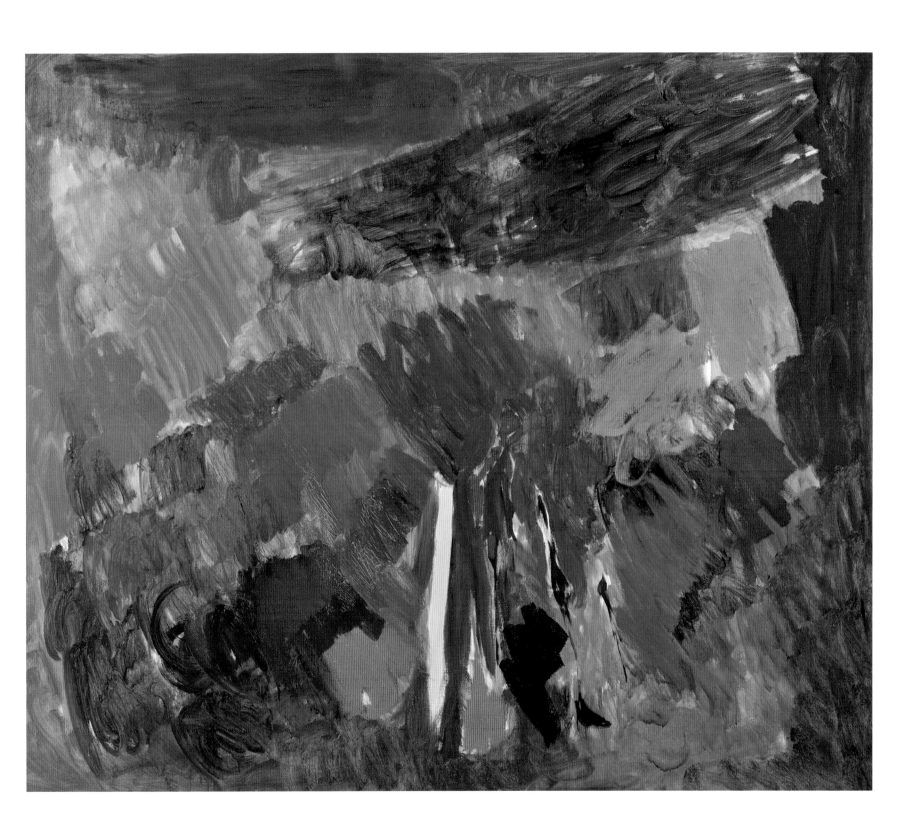

LENDERS TO THE EXHIBITION

Anonymous

Art Enterprises, Ltd., Chicago

Baltimore Museum of Art

University Art Museum, California State University, Long Beach

Crystal Bridges Museum of American Art, Bentonville, Ark.

The Jay DeFeo Trust, Berkeley

Denver Art Museum

Helen Frankenthaler Foundation, New York

Judith Godwin

Susan and David Kalt, Glencoe, Ill.

Kemper Museum of Contemporary Art, Kansas City, Mo.

Los Angeles County Museum of Art

Thomas McCormick and Janis Kanter, Chicago

McNay Art Museum, San Antonio, Tex.

Mildred Lane Kemper Art Museum, Washington University, St. Louis, Mo.

Joan Mitchell Foundation, New York

Museum of Modern Art, New York

National Museum of Women in the Arts, Washington, D.C.

Oakland Museum of California

Craig A. Ponzio

Private collection (four)

Deborah Remington Charitable Trust for the Visual Arts, New York

San Francisco Museum of Modern Art

Christopher C. Schwabacher and Brenda S. Webster

Snite Museum of Art, University of Notre Dame, South Bend, Ind.

Jennifer and David Stockman

Whitney Museum of American Art, New York

1933

Black Mountain College opens in Asheville, North Carolina. The college's democratic, communal environment eventually attracts artists such as Robert Motherwell, Willem de Kooning, and Franz Kline as instructors.

1934

The Hans Hofmann School of Fine Arts opens at 137 East Fifty-Seventh Street in New York. Lee Krasner and Mercedes Matter study with Hofmann at the school's various locations during the 1930s, as does Perle Fine. Joan Mitchell takes one class in 1947 but leaves, citing distaste for the way Hofmann erases students' marks to make their work look more like his style.

1935

Hans Hofmann opens a summer school in Provincetown, Massachusetts. Mercedes Matter attends in 1935, Perle Fine and Lil Picard in the late 1930s, Helen Frankenthaler and Yvonne Thomas in 1950, Judith Godwin in 1953, and Ida Kohlmeyer in 1956. Thomas says she finds "the courage of color" in Hofmann's class.[1]

Lee Krasner, Gertrude Greene, and Mercedes Matter are among the artists hired to work in the Works Progress Administration (WPA) Federal Art Project mural division.

There was no discrimination against women that I was aware of in the WPA. There were a lot of us working then.[2]

—Lee Krasner, 1977

Perle Fine (facing the camera) in Hans Hofmann's class, Provincetown, Mass., 1938. Photograph by Maurice Berezov.

1936

In order to be taken more seriously as an artist, Corinne Michelle West begins going by the name "Mikael." She changes the spelling to "Michael" in 1941.

Mercedes Matter and Lee Krasner are arrested on December 1 in New York during a protest over the abrupt firing of five hundred WPA models and artists. They become fast friends in jail.

1937

Hans Hofmann tells Lee Krasner that one of her studies "is so good you would not know that it was done by a woman."[3]

Krasner works on an unfinished mural by Willem de Kooning, who was dismissed from the WPA. Although it was never completed and installed, Krasner credits this experience as having an influence on the oversized canvases she painted later.

That whole experience taught me *scale*—none of the nonsense they call scale today. . . . Long before I met Pollock, too, I had been working that large.[4]

—**Lee Krasner on her WPA murals, 1979**

1943

Alma Thomas becomes vice president of the Barnett-Aden Gallery in Washington, D.C., the first gallery in D.C. to show work by artists of all races.

Exhibition by 31 Women runs January 5–31 at Peggy Guggenheim's Art of This Century Gallery and includes Buffie Johnson, Sonja Sekula, and Hedda Sterne. Art of This Century becomes *the* place to see Abstract Expressionism.

Elaine Fried marries Willem de Kooning on December 9 at New York City Hall.

1945

The Cedar Tavern moves to 24 University Place in Greenwich Village, near the studios and apartments of the early Abstract Expressionists. It becomes their favorite bar for many years.

Charlotte Park moves to New York, as does Grace Hartigan, who soon meets Adolph Gottlieb and Mark Rothko.

Perle Fine's first solo exhibition takes place at the Willard Gallery on East Fifty-Seventh Street in February.

Grace Hartigan at the Cedar Tavern, Greenwich Village, New York, 1959. Photograph by John Cohen.

The Women runs June 12–July 7 at Art of This Century Gallery, owned and run by wealthy collector Peggy Guggenheim. Artists in this show are Perle Fine, Sonja Sekula, Janet Sobel, and Hedda Sterne. Although Lee Krasner's name was listed initially, she was not included.

Joan Mitchell travels to Guanajuato, Mexico, in the summer. She spends her time sketching, painting, and attending bullfights. Mitchell returns to Mexico the following summer with a letter of introduction from the director of the Art Institute of Chicago, which helps her meet Mexican muralist José Clemente Orozco.

In October, Lee Krasner marries Jackson Pollock in New York. Soon after, the couple moves to Springs, in East Hampton, New York.

At the Dalton School in New York, Helen Frankenthaler studies painting with Mexican painter Rufino Tamayo during the fall.

From left to right: Alex Matter (son of Mercedes and Herbert Matter), Mercedes Matter, Lee Krasner, and Jackson Pollock in Springs, N.Y., 1948. Photograph by Herbert Matter.

1946

Mary Abbott returns to New York after living at military posts around the country with her husband, Lewis Teague. The couple separates soon after their return, and Abbott moves into a cold-water flat at 88 Tenth Street.

Charlotte Park begins private study with Australian artist Wallace Harrison, who in 1949 will also teach Helen Frankenthaler.

Betty Parsons opens her gallery at 15 East Fifty-Seventh Street in September with financial help from Hedda Sterne, Saul Steinberg, Hans Hofmann, and others. Her space becomes a favorite among artists who desire large, bright, open spaces for their mural-size abstract canvases.

1947

Charlotte Park and her husband, James Brooks, rent a studio at 46 East Eighth Street, where Lee Krasner and Jackson Pollock used to live. Mercedes Matter and her husband, photographer and designer Herbert Matter, begin to spend their summers in Springs, New York, in a rented cottage near Lee Krasner and Jackson Pollock. The two couples enjoy a close friendship centered on their art.

Hedda Sterne travels to Mexico in early fall. In November, *Hedda Sterne: Paintings* opens at the Betty Parsons Gallery.

Deborah Remington enrolls in the California School of Fine Arts at age seventeen.

1948

Pat Passlof attends Black Mountain College's Summer Institute and studies with Josef Albers, Buckminster Fuller, M. C. Richards, Merce Cunningham, and Willem de Kooning. Elaine de Kooning also spends the summer there and paints seventeen abstractions that remain unseen until 1985.

In the fall, Yvonne Thomas and Mary Abbott meet at the short-lived Subjects of the Artist School, an experimental school established by Robert Motherwell, David Hare, Clyfford Still, Barnett Newman, Mark Rothko, and William Baziotes in Motherwell's studio on 35 East Eighth Street.

> In 1948, after a long restless period, I joined the "Subjects of the Artist," a then new and unusual Art School . . . I became alive, felt wonderfully at home in that ambiance. This period represented a true liberation for me. . . . I was on my way as a painter.[5]
>
> —Yvonne Thomas, 2002

Elaine de Kooning becomes an editorial associate for *ARTnews*.

Pat Passlof continues private study with Willem de Kooning. He remains her instructor until 1950.

Around this time, Gertrude Greene creates her last sculpture; thereafter she focuses solely on abstract painting.

1949

During her brief marriage to artist Harry Jackson, Grace Hartigan spends the spring in San Miguel de Allende, Mexico, painting full time. The largest painting she completes in Mexico is included in *New Talent 1950* at the Kootz Gallery.

Alma Thomas is included in the *Eighth Annual Exhibition of Paintings, Sculptures and Prints by Negro Artists* at Atlanta University in April.

Shirley Goldfarb moves to New York and enrolls in classes at the Art Students League.

Madeleine Dimond enrolls in the California School of Fine Arts and expands on the training she received from George Grosz at the Art Students League.

> Women, man [*sic*], whatever—that really wasn't dealt with when I was at school. Nobody made distinctions like that because the women's movement hadn't come along yet . . . you were just painters or sculptures [*sic*] or whatever you were.[6]
>
> —Deborah Remington, 2010

> I felt like I was in some magic place, you know. I started painting abstractly right off, in Ed Corbett's class. I thought if everybody else could do it, why couldn't I? And I just started in.[7]
>
> —Madeleine Dimond, 1973

The Eighth Street Club is founded late in the fall. Like the Cedar Tavern, The Club becomes a meeting place for Abstract Expressionist artists. Mercedes Matter and Perle Fine are the earliest female members. Fine joins at the invitation of Willem de Kooning. Mary Abbott, Elaine de Kooning, Grace Hartigan, Helen Frankenthaler, Joan Mitchell, and Pat Passlof also join.

Mary Abbott spends the winter in St. Thomas, where she begins, in her words, "to venture into a purer form of abstraction, in which color, composition and gesture become the subject matter."[8]

1950

After being rejected by several New York galleries, Joan Mitchell is told by New York dealer Julius Carlebach, "Gee, Joan, if only you were French and male and dead."[9]

Judith Godwin meets modern dancer and choreographer Martha Graham. The two develop a lifelong friendship. Godwin's art becomes influenced by Graham's movements. She later tells critic David Ebony, "I can see her gestures in everything I do."[10]

Elaine de Kooning publishes "Hans Hofmann Paints a Picture" in the February edition of *ARTnews,* one in a series of important articles on artists she wrote for the magazine, none featuring women.

In April, Buffie Johnson has her first solo exhibition at Betty Parsons Gallery. Critic Dorothy Seckler writes that her works "show a sparkle and absence of formula that bespeaks an engaging and exuberant personality."[11] Later that year, Johnson and her husband, writer Gerald Sykes, buy a home in East Hampton, New York, near Krasner, Pollock, and the de Koonings.

The three-day "Artist Sessions at Studio 35" symposium is held in Robert Motherwell's studio April 21–23. Hedda Sterne and Janice Biala are the only women attending. The sessions tackle questions such as when a work is finished, whether titles are necessary, and how to create a group identity.

New Talent 1950, on view April 25–May 15 at the Kootz Gallery at 600 Madison Avenue, includes Grace Hartigan and Elaine de Kooning among its twenty-three up-and-coming artists. Samuel Kootz is one of only a few New York art dealers to promote the Abstract Expressionists. Clement Greenberg and Meyer Schapiro select the artists for *New Talent.*

That was the first show. I was only twenty-eight then, that was pretty good, to be in the Kootz Gallery with that company.[12]

—Grace Hartigan, 1979

Joan Mitchell travels to Haiti, Cuba, and Mexico's Yucatán peninsula in the summer with her husband at the time, publisher Barney Rosset. When she returns to New York, she becomes actively involved in the downtown art scene, hanging out at the Cedar Bar and attending meetings at The Club. She becomes an official member of The Club the following year.

I got involved in the Artists Club. They allowed very few women in, and I was included for $35 a year. And I got very involved in the Cedar Bar and the whole thing.[13]

—Joan Mitchell, 1986

1951

Grieving over her husband's unexpected death, Ethel Schwabacher immerses herself in her work and paints her *Women* series at nearly the same time that Willem de Kooning paints his famous *Woman* series. She would later condemn de Kooning's depictions, writing in her journal, "De Kooning's women, for instance, with their sharp teeth that seem eager to bite, seem to me to express sadism of women and against women which I find very unpleasant and disturbing."[14]

On January 15, *Life* magazine publishes the now-famous "Irascibles" group photo, with Hedda Sterne as the only woman pictured. In May 1950, these artists were among those who had written an open letter to the president of the Metropolitan Museum of Art protesting the absence of "advanced art," particularly Abstract Expressionism, in the museum's exhibition *American Painting Today—1950.*

Grace Hartigan's first solo show, *Paintings by George Hartigan,* runs January 16–February 2 at Tibor de Nagy Gallery, New York. She has solo exhibitions at the gallery every year through 1957 and again in 1959. By assuming the pseudonym "George," Hartigan aligns herself with French novelist Amantine-Lucile-Aurore Dupin and English novelist Mary Ann Evans, who went by George Sand and George Eliot, respectively.

The *Ninth Street Show,* organized by artists with the financial assistance of dealer Leo Castelli, is on view May 21–June 10 in an empty storefront at 60 East Ninth Street. Among those exhibiting are Elaine de Kooning, Perle Fine, Helen Frankenthaler, Grace Hartigan, Lee Krasner, Joan Mitchell, Anne Ryan, and Sonja Sekula.

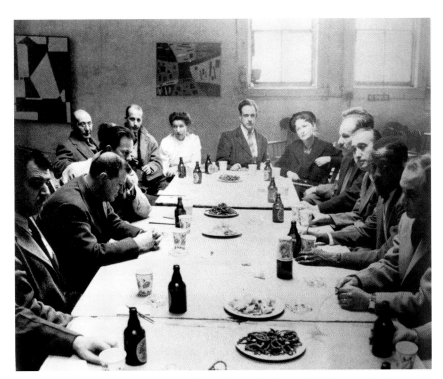

Above: Janice Biala (background, left) and Hedda Sterne (background, right) alongside other artists in one of the "Artist Sessions at Studio 35," New York, 1950.

Right: The group of American abstract artists labeled "The Irascibles," New York, November 24, 1950. From left to right, front row: Theodoros Stamos, Jimmy Ernst, Barnett Newman, James Brooks, and Mark Rothko; middle row: Richard Pousette-Dart, William Baziotes, Jackson Pollock, Clyfford Still, Robert Motherwell, and Bradley Walker Tomlin; back row: Willem de Kooning, Adolph Gottlieb, Ad Reinhardt, and Hedda Sterne. Photograph by Nina Leen.

Grace Hartigan (left) and Helen Frankenthaler (right), c. 1952. Photograph by Walter Silver.

From left: Sonia Gechtoff, Jay DeFeo, and Jim Kelly on New Year's Eve, 1957. Photograph by Wally Hedrick.

Sonia Gechtoff moves from Philadelphia to San Francisco.

> I thought two things: One, it sounds like a good place to go for painting. Two, it's as far from Philadelphia as I can get without leaving the United States . . . and it didn't sound as frightening as New York, and I knew it was cheaper too because even then New York was more expensive.[15]
>
> —Sonia Gechtoff, 2006

In November, Lee Krasner's debut solo exhibition, *Paintings 1951: Lee Krasner,* opens at Betty Parsons Gallery. Artist Robert Goodnough writes that she "has changed surprisingly from earlier, extremely intricate paintings and has turned to large, free abstractions which depend entirely on open areas of square, rectangular shapes and strips of color, these playing over the surface completely free of association."[16] This exhibition was held simultaneously with a show of Anne Ryan's works. Unfortunately, although Krasner's husband, Jackson Pollock, praised her canvases, Parsons was disappointed in the work and the show was a dismal failure.

Gertrude Greene's first solo exhibition at Grace Borgenicht Gallery is on view December 17, 1951–January 12, 1952. She receives a favorable review by Betty Holliday in *ARTnews:* "wife of painter Balcomb Greene, has been seen in a good many group shows, but now makes her first solo appearance with abstractions whose jagged forms and layers of pigment seem to be breaking open to let the white of the canvas show through."[17]

1952

Inspired by the landscape of Nova Scotia, Helen Frankenthaler paints *Mountains and Sea* on October 26, 1952 (see fig. 6). The method she uses of staining the canvas stands in direct contrast to the thick gestural strokes of most Abstract Expressionists.

In December, Harold Rosenberg publishes "The American Action Painters" in *ARTnews* and coins the term "action painting."

1953

Disappointed with her work, Lee Krasner tears up her drawings. This destruction inspires her to begin collaging with the pieces. Later she cuts her canvases with scissors and collages the strips; these collaged canvases, reusing the works from her failed show at Parsons as backdrop, are exhibited at the Stable Gallery in 1955. This later show is a success for Krasner.

Judith Godwin moves to New York at the urging of Martha Graham and enrolls in the Art Students League.

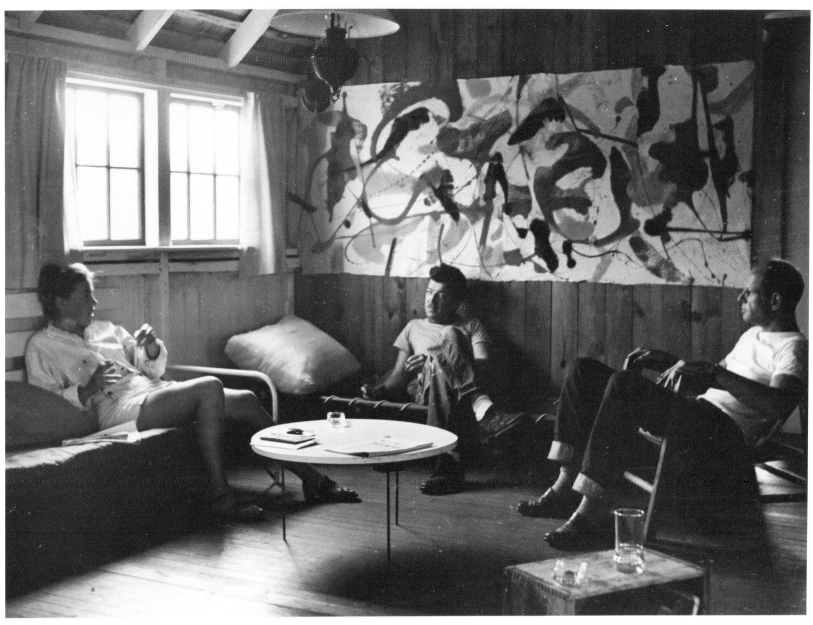

From left: Charlotte Park, James Brooks, and Jackson Pollock, Montauk, N.Y., 1953. Photograph by Hans Namuth.

In January, the *Second Annual Exhibition of Painting and Sculpture* opens at the Stable Gallery. Paintings by Janice Biala, Elaine de Kooning, Perle Fine, Grace Hartigan, Helen Frankenthaler, Mercedes Matter, Joan Mitchell, Yvonne Thomas, Michael West, and Jane Wilson are shown.

Sonia Gechtoff marries artist James Kelly in June. The couple moves to 2330 Fillmore Street in San Francisco, next door to Jay DeFeo, who later reflects on the location's "many memories of friends and paintings . . . a commitment to work . . . and a sharing of ideas with others."[18] Joan Brown moves into this apartment when Gechtoff relocates to New York in 1958.

In July, a group show including Madeleine Dimond, Lilly Fenichel, and Sonia Gechtoff opens at King Ubu Gallery in San Francisco at 3119 Fillmore Street. In October, Deborah Remington has a solo show and two-person show with Jorge Goya.

Soon after, the gallery's founders, poet Robert Duncan and painters Harry Jacobus and Jess, close the gallery, honoring their agreement to stay open for only a year.

1954

Buffie Johnson meets psychoanalyst Carl Jung in Switzerland while researching goddess imagery and the Great Mother on a Bollingen Foundation grant. She eventually publishes this research in *Lady of the Beasts: Ancient Images of the Goddess and Her Sacred Animals* (1988).

Shirley Goldfarb moves to Paris.

The *Third Annual Exhibition of Painting and Sculpture* at the Stable Gallery is held January 27–February 20 and includes work by Mary Abbott, Janice Biala, Elaine de Kooning, Perle Fine, Helen Frankenthaler, Gertrude Greene, Grace Hartigan, Joan Mitchell, Charlotte Park, Vita Petersen, Hedda Sterne, Yvonne Thomas, and Jane Wilson, alongside other Abstract Expressionists.

Grace Hartigan's fourth solo exhibition, *George [Grace] Hartigan,* opens in February at Tibor de Nagy Gallery.

It was a nice crowd, all seemed to admire etc., but I feel let down and fatigued. . . . What I really want above all this time is to sell, so that I can be relieved of financial worry for a few months.[19]
—Grace Hartigan, journal entry about 1954 solo exhibition

A hurricane in August knocks down Charlotte Park's rented studio space in Montauk, New York, and destroys all of her paintings.

Deborah Remington, *23° North by 82° West,* 1954. Tempera on paper, 11⅝ × 13½ in. (29.53 x 34.29 cm). Denver Art Museum: Gift of the Deborah Remington Charitable Trust for the Visual Arts, 2015.64.

In September, the Six Gallery opens in San Francisco in the space that previously housed King Ubu Gallery. Deborah Remington is one of the founders. Jay DeFeo and Sonia Gechtoff are original members and often show here. Allen Ginsberg reads his poem *Howl* at the gallery on October 7, 1955.

1955

Charlotte Park begins teaching art to children at the Museum of Modern Art (MoMA).

The *Fourth Annual Exhibition of Painting and Sculpture,* shown April 26–May 21 at the Stable Gallery, includes work by Mary Abbott, Janice Biala, Elaine de Kooning, Perle Fine, Helen Frankenthaler, Gertrude Greene, Grace Hartigan, Lee Krasner, Mercedes Matter, Joan Mitchell, Charlotte Park, Ethel Schwabacher, Hedda Sterne, Yvonne Thomas, and Jane Wilson.

Joan Mitchell moves to France and meets Canadian painter Jean-Paul Riopelle. In 1959, she settles permanently in France.

Joan Mitchell, Mary Abbott, and Hedda Sterne spend time together in Paris during the summer. Mitchell becomes close with Sterne and her husband, Saul Steinberg.

After receiving her B.A. from the California School of Fine Arts, Deborah Remington spends two years traveling around Japan, Southeast Asia, and India before returning to the United States to pursue painting full time.

1956

Mary Abbott's work is included in MoMA's *Recent Drawings U.S.A.* exhibition, which opens in April and travels to the Colorado Springs Fine Arts Center, among other places.

The *Fifth Annual Exhibition of Painting and Sculpture,* shown May 22–June 16 at the Stable Gallery, includes Ruth Abrams, Janice Biala, Elaine de Kooning, Perle Fine, Helen Frankenthaler, Grace Hartigan, Lee Krasner, Joan Mitchell, Charlotte Park, and Yvonne Thomas.

Hedda Sterne and Saul Steinberg travel across the United States to Alaska on a summer road trip.

In October, Yvonne Thomas has her first solo exhibition in New York at Tanager Gallery, an artist-run cooperative gallery on Tenth Street.

1957

Helen Frankenthaler has a solo exhibition at Tibor de Nagy February 10–March 2. Grace Hartigan and Joan Mitchell attend.

Sonia Gechtoff has the first one-person exhibition at the Ferus Gallery in Los Angeles, shown April 12–May 9.

Gertrude Greene, *Gray and Orange,* c. 1950–56. Oil paint on canvas, 40 × 34 in. (101.6 × 86.36 cm). Estate of Gertrude Greene and Balcomb Greene.

Hedda Sterne, *Alaska I,* 1958. Oil paint on canvas, 71 in. × 9 ft., 2 in. (180.34 × 279.4 cm). Albright-Knox Art Gallery, Buffalo, N.Y., Gift of Seymour H. Knox Jr. 1958.

From left: Joan Mitchell, Helen Frankenthaler, and Grace Hartigan at the opening of an exhibition of Frankenthaler's paintings, New York, 1957 (detail). Photograph by Burt Glinn.

The *Sixth Annual Exhibition of Painting and Sculpture,* held May 7–June 1 at the Stable Gallery, includes Mary Abbott, Ruth Abrams, Elaine de Kooning, Perle Fine, Grace Hartigan, Lee Krasner, Joan Mitchell, Charlotte Park, Pat Passlof, and Yvonne Thomas.

Life magazine publishes "Women Artists in Ascendance" on May 13. The article profiles Helen Frankenthaler, Grace Hartigan, Jane Wilson, Joan Mitchell, and Nell Blaine. None of the women is pictured in the act of painting, in marked difference to the heroic poses of male Action Painters common at the time (see figs. 16–17 and page 180). Despite this, the article is revolutionary in highlighting women as successful artists.

It was a real shock to see them with their huge paintings, standing there confidently in paint-splattered jeans when their contemporaries were all wearing tweedy classics in the suburbs, terrorized by the "feminine mystique." In 1957, avant-garde women artists were a pathetic minority, subjected to every kind of social and critical ridicule.[20]

—Art historian Barbara Rose, 1974

It's too bad that the women's liberation didn't occur thirty years earlier in my life. It would have been of enormous assistance at the time.[21]

—Lee Krasner, 1973

In October, *ARTnews* publishes Irving Sandler's "Mitchell Paints a Picture." In it, Joan Mitchell expounds upon her process while painting *Bridge,* a work she later discards and gives to Sandler, and *George Went Swimming at Barnes Hole, but It Got Too Cold* (see fig. 49).

I paint from a distance. I decide what I am going to do from a distance. The freedom in my work is quite controlled. I don't close my eyes and hope for the best.[22]

—Joan Mitchell, 1957

Michael West's solo show of thirty-one works at Uptown Gallery is on view November 1–15. Critic Clark Mills states that West's work "communicates to the viewer an immediate sense of the presence of vast and perhaps uncontrollable forces in motion around us."[23]

Charlotte Park has her first solo exhibition, at Tanager Gallery November 1–21.

1958

Nature in Abstraction, organized by the Whitney Museum of American Art and traveling to six other American museums, features work by Abstract Expressionists including Perle Fine, Helen Frankenthaler, Joan Mitchell, and Ethel Schwabacher, including Schwabacher's *Dead Leaves* (cat. 48).

In March, the Whitney Museum of American Art purchases Joan Mitchell's 1956 painting *Hemlock.*

MoMA's *The New American Painting* exhibition begins its yearlong international tour. Grace Hartigan is the only woman included among the seventeen painters.

In late November, Alma Thomas's work is included in *Contemporary American Paintings,* sponsored by the College Arts Traveling Service in Washington, D.C.

1959

Mary Abbott is introduced to the poet Barbara Guest; the two begin a collaborative working relationship. Guest recites a phrase as it comes to her and Abbott responds in paint; Guest then replies to Abbott's painterly gesture with words, and so on.

Artists in group discussion in the East Tenth Street studio of Milton Resnick, 1956. Among those pictured are (from left to right): George Spaventa (foreground), Angelo Ippolito (second, left), Milton Resnick (background, center), Ludwig Sanders (third, right), and Elaine de Kooning (second, right). Photograph by James Burke.

Pat Passlof exhibits at the March Gallery, New York, in April. Critic Dore Ashton writes that "most of her compositions emerge from a thick matrix of dimmed color—usually ochers or pinks, dusted into dull grays. They are loosely brushed canvases and are usually composed around a dominating void."[24]

Elaine de Kooning teaches at the University of New Mexico as a visiting lecturer. The time spent there has a dramatic effect on her art. In her own words: "There *were* the skies and the twilights and they were inescapable and tremendous. Then there was the spectacle of the bullfights in Juárez, just across the Mexican border."[25] Upon her return to New York, she completes a series of large, vibrant canvases (see cat. 11).

Curator Dorothy Miller includes Jay DeFeo in MoMA's *Sixteen Americans,* December 16, 1959–February 17, 1960, after seeing her work in San Francisco.

1960

Helen Frankenthaler has her first retrospective exhibition of nineteen paintings at the Jewish Museum, New York, in January.

In April, Yvonne Thomas has a solo exhibition at Esther Stuttman Gallery at 136 East Seventy-Sixth Street. Hubert Crehan's review reveals the prejudices faced by women artists: "Despite the size of her abstract work and the vigor with which she executes her paintings, Mrs. Thomas does not disguise who she is, for it is expressly in the personal color harmonies . . . that one discerns the feminine embellishment."[26]

60 American Painters, 1960: Abstract Expressionist Painting of the Fifties opens April 30 at the Walker Art Center in Minneapolis and features Elaine de Kooning, Helen Frankenthaler, Sonia Gechtoff, Grace Hartigan, Joan Mitchell, and Ethel Schwabacher.

Elaine de Kooning, c. 1960s. Photograph by Rudy Burckhardt.

Notes

1. Cited in *Abstract Expressionism: Second to None: Six Artists of the New York School* (Chicago: McCormick Gallery, 2011), 12.

2. Lee Krasner, interview by Eleanor Munro, in *Originals: American Women Artists* (New York: Da Capo, 1979), 108.

3. Lee Krasner, interview by Cindy Nemser, in *Art Talk: Conversations with 12 Women Artists* (New York: Charles Scribner's Sons, 1975), 85.

4. Krasner, interview by Munro, in *Originals,* 108.

5. *Yvonne Thomas: New York Paintings from the 1950s* (Chicago: McCormick Gallery, 2002).

6. Deborah Remington, interview by Carlos Villa, "Rehistoricizing the Time Around Abstract Expressionism in the San Francisco Bay Area, 1950s and 1960s," http://rehistoricizing.org/deborah-remington-2/ (accessed September 15, 2013).

7. Madeleine Dimond, interview by Mary Fuller McChesney, in *A Period of Exploration: San Francisco 1945–1960* (Oakland: Oakland Museum of California, 1973), 13.

8. Mary Abbott, interview by Thomas McCormick, *Mary Abbott: Island Works* (Chicago: McCormick Gallery, 2013), 14.

9. Cited in Patricia Albers, *Joan Mitchell: Lady Painter* (New York: Alfred A. Knopf, 2011), 144.

10. David Ebony, "Abstract Portrayals: The Work of Judith Godwin," in *Judith Godwin: Early Abstraction,* ed. Rose M. Glennon (San Antonio, TX: McNay Art Museum, 2008), 16.

11. Dorothy Seckler, *ARTnews* 49, no. 2 (April 1950): 47.

12. Grace Hartigan, interview by Julie Haifley, May 10, 1979, Archives of American Art, Smithsonian Institution, Washington, DC.

13. Joan Mitchell, interview by Linda Nochlin, April 16, 1986, Archives of American Art, Smithsonian Institution, Washington, DC.

14. Ethel Schwabacher, *Hungry for Light: The Journal of Ethel Schwabacher,* ed. Brenda S. Webster and Judith Emlyn Johnson (Bloomington: Indiana University Press, 1993), 125.

15. Jay DeFeo, "Biography of Jay DeFeo," 1975, Jay DeFeo artist file, Oakland Museum of California, Archives of California Art.

16. Robert Goodnough, *ARTnews* 50, no. 7 (November 1951): 53.

17. Betty Holliday, *ARTnews* 50, no. 8 (December 1951): 50.

18. Gechtoff, interview by Price, *Ferus Years,* 4.

19. William T. La Moy and Joseph P. McCaffrey, *The Journals of Grace Hartigan, 1951–1955* (Syracuse, NY: Syracuse University Press, 2009), 119.

20. Barbara Rose, "First-Rate Art by the Second Sex," *New York,* April 8, 1974, 80.

21. Lee Krasner quoted in Cindy Nemser, "Lee Krasner's Paintings 1946–49," *Artforum* 12 (December 1973): 65.

22. Joan Mitchell, interview by Irving Sandler, "Mitchell Paints a Picture," *ARTnews* 56, no. 6 (October 1957): 45.

23. Clark Mills, *Michael West Paintings* (New York: Voyages, in association with Uptown Gallery, 1957).

24. Dore Ashton, "Art: Looking Downtown," *New York Times,* April 16, 1959, 30.

25. Lawrence Campbell, "Elaine de Kooning Paints a Picture," *ARTnews* 59, no. 6 (December 1960): 39.

26. Hubert Crehan, *ARTnews* 59, no. 1 (March 1960): 14.

ALIZA EDELMAN

MARY ABBOTT
(b. 1921, New York)

Mary Lee Abbott was born into a prominent American family (John Adams was one of her ancestors). She lived variously in New York, Washington, D.C., and Southampton, New York. At a young age, she enrolled in Saturday classes at the Art Students League, later taking advanced courses under George Grosz, Anne Goldthwaite, and Morris Kantor, and pursuing summer study with Eugene Weiss at the Corcoran School of Art, Washington, D.C.

In 1946, she rented a studio at 88 Tenth Street in Manhattan, and in 1948 the sculptor and painter David Hare introduced her to the experimental Subjects of the Artist School. Abbott was one of a handful of women to attend, receiving instruction from Barnett Newman and Mark Rothko, and this pivotal experience clarified her turn toward complete abstraction. She was invited by Philip Pavia to join The Club as one of the few women members, and she frequented the Cedar Street Tavern to discuss art, philosophy, and ideas. Willem de Kooning, who delivered a talk at Subjects of the Artist and whom

she met around 1948–49, was a key figure in her personal life and artistic development. Their relationship engendered a lifelong aesthetic dialogue, evident in her early abstractions from the 1950s that show gestural vitality, graphic linearity, and broad brushwork. Abbott's *Bill's Painting* (c. 1951, private collection) is dedicated to de Kooning.

Many of her subjects from the late 1940s and early 1950s display the topography and light from her annual winter trips to Haiti and the Virgin Islands. In 1950, she moved to Southampton but maintained a studio in Manhattan. A collaboration between Abbott and Barbara Guest, a first-generation New York School poet, inspired a series of "poetry paintings." These works combined words and images and were displayed in the exhibition *Poetry and Painting* alongside work by Frank O'Hara, Kenneth Koch, and Larry Rivers. In 1974, Abbott began teaching at the University of Minnesota, returning to New York in 1980.

SELECTED GROUP EXHIBITIONS
Tanager Gallery, New York (1950–55)
Kootz Gallery, New York (1952)
Stable Gallery *Annuals,* New York (1954, 1955, 1957)
Poets Choose Painters, Tibor de Nagy Gallery, New York (1955)

Poetry and Painting, Kornblee Gallery, New York (1959)
Rose Fried Gallery, New York (1965, 1969, 1970)
Twelve New York Painters, David Findlay Jr. Fine Art, New York (2006)

SELECTED SOLO EXHIBITIONS
Kornblee Gallery, New York (1964–66)
Southampton College, Long Island University, NY (2005)
Mary Abbott, Abstract Expressionist Paintings: 1945–1985, McCormick Gallery, Chicago (2007)
Island Works: Paintings from the 1950s, McCormick Gallery, Chicago (2013)

SELECTED READINGS
Sara Lundquist, "Reverence and Resistance: Barbara Guest, Ekphrasis and the Female Gaze," *Contemporary Literature* 38, no. 2 (summer 1997): 260–86.
Sara Lundquist, "Another Poet among Painters: Barbara Guest with Grace Hartigan and Mary Abbott," in *The Scene of My Selves: New Work on New York School Poets,* ed. Terence Diggory and Stephen Paul Miller (Orono, ME: National Poetry Foundation, 2001), 253.
Phyllis Braff, "Mary Abbott's Art: Insights into a Career as an Abstract Expressionist," in *Mary Abbott: Abstract Expressionist Paintings: 1945–1985* (Chicago: McCormick Gallery, 2007), 13–17.

Mary Abbott in her studio, c. 1949–50.

RUTH ABRAMS
(b. 1912, Brooklyn, NY; d. 1986, New York [?])

Ruth Davidson Abrams studied painting in the 1930s at the Art Students League with Alexander Brook and shared studio space with Raphael Soyer. In the 1940s, she had further instruction in painting with Yasuo Kuniyoshi and studied sculpture with William Zorach and Alexander Archipenko. She was friends with artists John Graham and Wallace Harrison and worked with Charlotte Park and Helen Frankenthaler. In 1931, she married Charles Abrams, a successful urban planner and lawyer. They had two children in the early 1940s, and she struggled to maintain the multiple roles and identities expected of her social lifestyle, marriage, and motherhood. In 1943, she was included in a group exhibition at ACA Galleries that featured artists Irene Rice Pereira, Giorgio Cavallon, and Hans Hofmann. She traveled to Paris, where she met Milton Resnick and Philip Pavia. Dissatisfied with the restrictions placed upon women artists in the downtown scene, and disappointed not to be included as a charter member in the Artists Club, she used her resources to host salons at her Greenwich Village home.

She worked in series, including the *Great Mother, Travel,* and *Conversation* paintings, as well as her well-known *Microcosms* (each two to three inches square) from the 1950s through the 1970s. Her paintings underscored the significant tensions in Abstract Expressionist approaches between corporeality and structural planarity. Her artwork was further immersed in this period's collective expression of psychological analysis, Jungian archetypes, creation myths, and spirituality, at times referring to Jewish mysticism.

Her *Microcosms* were shown in *An Exhibition of Small Paintings* at D'Arcy Galleries, New York (1962), and she exhibited internationally at the Museum of Fine Arts, Caracas, Venezuela (1963), and Delson-Richter Gallery, Jerusalem, Israel (1976). In the 1970s, she participated in group shows at Landmark Gallery, 80 Washington Square East Galleries, and Marymount Manhattan College, all in New York, and at the Corcoran Gallery of Art, Washington, D.C.

SELECTED GROUP EXHIBITIONS
Stable Gallery *Annual,* New York (1956)
Tanager Gallery, New York (1956, 1959)

SELECTED SOLO EXHIBITIONS
Roko Gallery, New York (1956, 1959)
Camino Gallery, New York (1957)
Ruth Abrams: Paintings, 1940–1985, Grey Art Gallery
 and Study Center, New York University (1986)
Microcosms: Ruth Abrams, Abstract Expressionist,
 Yeshiva University Museum, New York (2012–13)

SELECTED READINGS
Thomas Livesay, "Essay," in *Ruth Abrams: Paintings,*
 1940–1985 (New York: Grey Art Gallery and Study Center,
 New York University, 1986).
Reba Wulkan, "Ruth Abrams: 1912–1986: A Microcosm within
 a Macrocosm" (master's thesis, Purchase College, State
 University of New York, 2002).

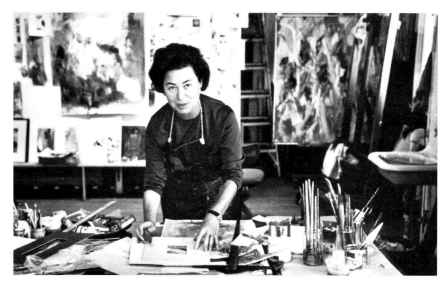
Ruth Abrams in her studio, c. 1970s.

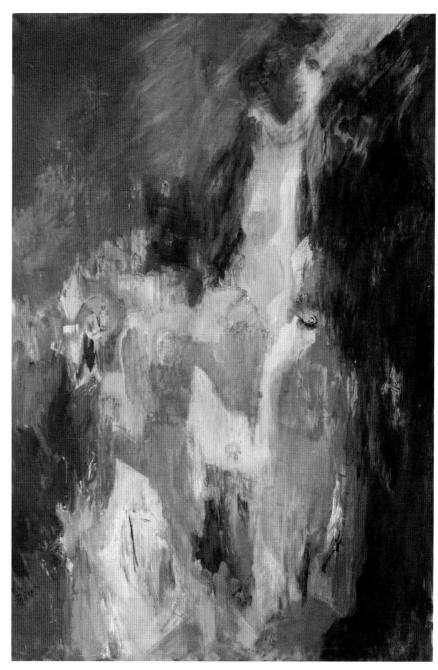
Ruth Abrams, *Memory of My Mother,* c. 1959. Oil paint on canvas, 63 × 43 in. (160.02 × 109.22 cm). Collection of Yeshiva University Museum, New York. Gift of the Estate of Ruth Abrams.

RUTH ARMER
(b. 1896, San Francisco; d. 1977, San Francisco)

Ruth Armer attended the California School of Fine Arts, San Francisco (now San Francisco Art Institute) (1914–15; 1918–19), where she later was a faculty member (1933–40). She also studied at New York's Art Students League under Robert Henri, George Bellows, and John Sloan. Returning to the West Coast, she was known in the Bay Area as a pioneer of non-objective painting. Her abstractions included an early series of synesthetic paintings that associated the emotional and aural characteristics elicited from sound into color and line. These abstractions were exhibited as early as 1931 at the Stanford Art Gallery (now Cantor Arts Center at Stanford University). The San Francisco Museum of Art (now San Francisco Museum of Modern Art) granted Armer solo exhibitions in 1936, 1939, and 1950, and Robert Motherwell and Ad Reinhardt included her in the 1951 edition of *Modern Artists in America.* She was also included in the Metropolitan Museum of Art's *American Painting Today* exhibition in 1950.

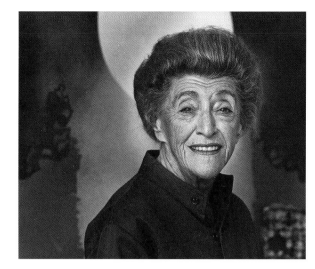

Ruth Armer, c. 1975. Photograph by Mimi Jacobs.

SELECTED SOLO EXHIBITIONS

Vickery, Atkins and Torrey Gallery, San Francisco (1922)
Oakland Art Gallery, Oakland, CA (1932)
Brownell-Lamberton Gallery, New York (1934)
San Francisco Museum of Art (1936, 1939, 1950)
Rotunda Gallery of the City of Paris, San Francisco (1948)
Raymond and Raymond Gallery, San Francisco (1952)
Eric Locke Gallery, San Francisco (1958)
Bolles Gallery, San Francisco (1963)
Gump's Gallery, San Francisco (1967)

SELECTED READINGS

Ruth Armer Papers, 1911–1976, Archives of American Art, Smithsonian Institution, Washington, DC.
Ernest Mundt, "Ruth Armer, Painter—Notes of an Interview by Ernest Mundt," in *Art and Artist* (Berkeley: University of California Press, 1956), 1–8.
Ruth Armer, oral history interview by Paul J. Karlstrom, August 14, 1974, Archives of American Art, Smithsonian Institution, Washington, DC.
Thomas Albright, "From the Earthy to the Psychedelic, via Ruth Armer," *San Francisco Chronicle,* June 9, 1979.
Ruth Armer, 1896–1977 (San Francisco: San Francisco Art Institute, 1979).
Patricia Trenton, ed., *Independent Spirits: Women Painters of the American West, 1890–1945* (Berkeley: University of California Press, 1995).

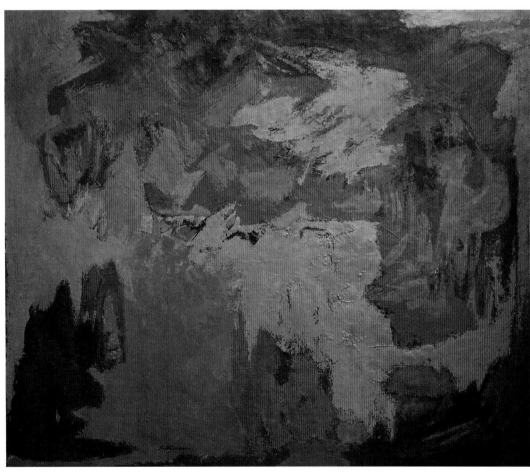

Ruth Armer, *Untitled,* c. 1952–53. Oil paint on canvas, 36 × 42 in. (91.44 × 106.68 cm). Private collection.

JANICE BIALA

(b. 1903, Bialystok, Poland; d. 2000, Paris)

Born in Poland, Schenehaia (Janice) Tworkovsky immigrated to New York with her family in 1913. She adopted the last name Tworkov, as did her brother (New York School artist Jack Tworkov). She took classes at the National Academy of Design with Charles Hawthorne and at the Art Students League (1924–25). She established herself as an artist with Edwin Dickinson (with whom she worked in Province-town, Massachusetts) and William Zorach. It was Zorach who suggested she change her last name to "Biala" to distinguish herself from her brother, who had already established himself as an artist.

In 1930, she moved to Paris, where she began a pivotal relationship with English novelist and editor Ford Madox Ford and cultivated a wide circle of artist and writer friends, including Ezra Pound, Gertrude Stein, and Constantin Brancusi. In 1935, the New York gallery Georgette Passedoit mounted her first solo exhibition, followed by frequent individual and group shows in Paris, including her first solo show at Galerie Zak (1938) and shows at Bignou Gallery (1941, 1943, 1945) and Galerie Jeanne Bucher (1948–49, 1951, 1956–58, 1960). After Ford's death in 1939 and the outbreak of World War II, she fled to New York in 1940, married French-born cartoonist and artist Daniel "Alain" Brustlein in 1942, and was affiliated with the downtown scene, associating with Elaine and Willem de Kooning, Harold Rosenberg, and Hedda Sterne. She attended the three-day symposium at Studio 35 in 1950 on the subject of modern abstraction, moderated by Robert Motherwell and Robert Good-nough and led by Alfred H. Barr, Jr., that later became known as the "Artist Sessions at Studio 35." Her paintings and collages represent a synthesis of the aesthetics of the School of Paris and the gestural lyricism of the New York School in the 1950s. She and Brustlein settled permanently in France in 1965.

SELECTED GROUP EXHIBITIONS
Annual Exhibition of Contemporary American Painting,
 Whitney Museum of American Art, New York (1946, 1955,
 1956, 1959, 1961)

SELECTED SOLO EXHIBITIONS
Stable Gallery, New York (1953, 1955, 1957, 1959, 1963)
Retrospective, *Biala: Vision and Memory,* Godwin-Ternbach
 Museum, Queens College, CUNY, NY (2013)

SELECTED READINGS
Guy Weelen, *J. Biala* (Paris: Presses Littéraires de France, 1952).
Eleanor Munro, "Biala Paints a Picture," *ARTnews* 55 (April
 1956): 32.
Diane Kelder, *Biala: Vision and Memory* (Flushing, NY:
 Godwin-Ternbach Museum, Queens College, CUNY, 2013).

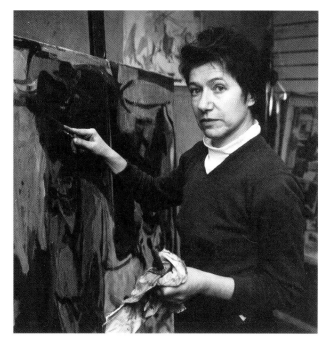

Janice Biala in her studio, 1956. Photograph by Rudy Burckhardt.

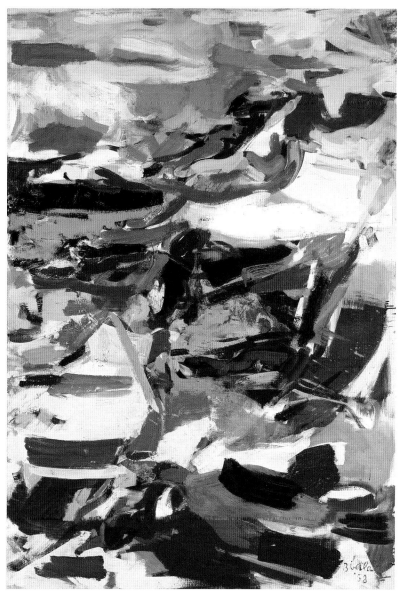

Janice Biala, *Beach,* 1958. Oil paint on canvas, 41½ × 32 in. (105.41 × 81.28 cm). Collection of Art Enterprises, Ltd., Chicago.

BERNICE BING

(b. 1936, San Francisco; d. 1998, Philo, CA)

Born to Chinese parents, Bernice Bing was raised in various Caucasian foster homes and an orphanage after her mother died in 1941. In 1957, she briefly attended the California College of Arts and Crafts, Oakland, where she studied painting with Nathan Oliveira, Richard Diebenkorn, and the Japanese-born painter Saburo Hasegawa, who introduced her to Zen Buddhism, Chinese philosophy, and traditional calligraphy. In 1958, she transferred to the California School of Fine Arts, where she studied with Elmer Bischoff and Frank Lobdell and received both B.F.A. and M.F.A. degrees. Her circle of Bay Area painters included Joan Brown, Wally Hedrick, Jay DeFeo, Bruce Conner, and Fred Martin.

Bing cited an early exposure to existential philosophy as a path to her pursuit of abstraction, combined with a broad array of musical, literary, film, and artistic influences, including the work of Willem de Kooning, Franz Kline, and Robert Motherwell. She acknowledged the prominence of D. T. Suzuki, Zen's Western authority, yet later in her life devoted her practice to Nichiren Buddhism.

Bing traveled throughout her life. She moved to the Napa Valley for a three-year period beginning in 1963, and during 1984–85, she traveled to Korea, Japan, and China, where she studied traditional Chinese ink painting and calligraphy.

Among her early shows in San Francisco were an exhibition with Wally Hedrick at The Cellar (1959); *Gangbang* at Batman Gallery (1960); and a show at New Mission Gallery with Manuel Neri (1960). In 1961, Batman Gallery mounted a solo exhibition featuring large-scale works, including *Las Meninas* (1960), based on Velázquez's painting of the same name.

SELECTED READINGS

Bernice Bing Papers, California Asian American Artists Biographical Survey, Department of Special Collections and University Archives, Stanford University, California Artist Files.

James Monte, "Three San Francisco Artists: Bernice Bing," *Artforum* 11 (July 1963): 31–33.

Bernice Bing, *Completing the Circle: Six Artists* (Santa Clara and San Francisco: Triton Museum of Art, in association with Southern Exposure Gallery, 1990).

Moira Roth and Diane Tani, eds., *Bernice Bing* (Berkeley, CA: Visibility, 1991).

Lydia Matthews, *Quantum Bingo* (San Francisco: SOMArts Gallery, 1999).

Jennifer Banta, "The Painting in the Rafters: Refiguring Abstract Expressionist Bernice Bing," *Sightlines* (2009): 14–20.

The Worlds of Bernice Bing, directed by Madeleine Lim (San Francisco: Asian American Women Artists Association, 2013), DVD.

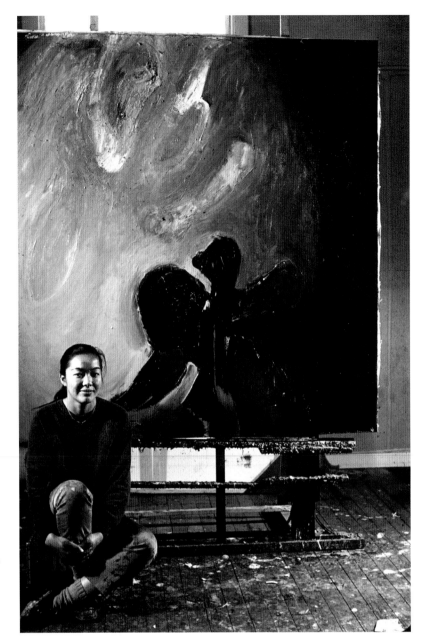

Bernice Bing in her North Beach studio, San Francisco, 1960.

Bernice Bing, *Two Plus,* 1960. Oil paint on canvas, 30 × 30 in. (76.2 × 76.2 cm). Collection of Alexa Young.

JOAN BROWN

(b. 1938, San Francisco; d. 1990, Puttaparthi, India)

In 1956, Joan Brown enrolled at the California School of Fine Arts, where she earned her B.F.A. and M.F.A. degrees. Instructors Elmer Bischoff, Nathan Oliveira, and Frank Lobdell were early influences, as was the art of Willem de Kooning. Typically associated with the Bay Area figurative school, Brown worked variously in figuration, abstraction, and assemblage. Her wide-ranging painterly subjects were both autobiographical and quotidian, including animals, still lifes, figures, and portraits.

In 1958, she moved with her then-husband, painter William H. Brown, into Sonia Gechtoff's former studio and flat next to Jay DeFeo and Wally Hedrick. In addition to her first two-person exhibition at the Six Gallery, San Francisco (1957), and a solo show at The Cellar, San Francisco (1958), Brown received early critical recognition with exhibitions at Staempfli Gallery, New York (1960, 1961, 1964), and the David Stuart Galleries, Los Angeles (1961, 1962, 1964). She was included in *Young America 1960,* curated by Lloyd Goodrich and John I. H. Baur at the Whitney Museum of American Art, and that same year she was featured in *Look* magazine with Georgia O'Keeffe, Louise Nevelson, and Claire Falkenstein. In 1962, she married artist Manuel Neri, with whom she had a son, a frequent portrait subject. Among many teaching appointments, she taught at the San Francisco Art Institute (1961–68) and the University of California, Berkeley (1974–90).

RECENT SOLO EXHIBITIONS

The Art of Joan Brown, Oakland Museum and the University Art Museum, University of California, Berkeley (1998–99)

Joan Brown: This Kind of Bird Flies Backward: Paintings by Joan Brown, San Jose Museum of Art, CA (2011)

SELECTED READINGS

Brenda Richardson, *Joan Brown* (Berkeley: University Art Museum, University of California, 1974).

Joan Brown, "In Conversation with Jan Butterfield," *Visual Dialog* [Los Altos, CA] (December 1, 1975, and January–February 1976): 15.

Christopher Brown and David Simpson, *On Painting: The Work of Elmer Bischoff and Joan Brown* (Berkeley: University Art Museum and Pacific Film Archive, University of California at Berkeley, 1992).

Karen Tsujimoto and Jacquelynn Baas, *The Art of Joan Brown* (Berkeley: University of California Press, 1998).

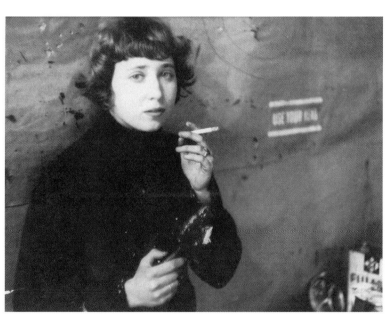

Joan Brown in her studio, 1950s.

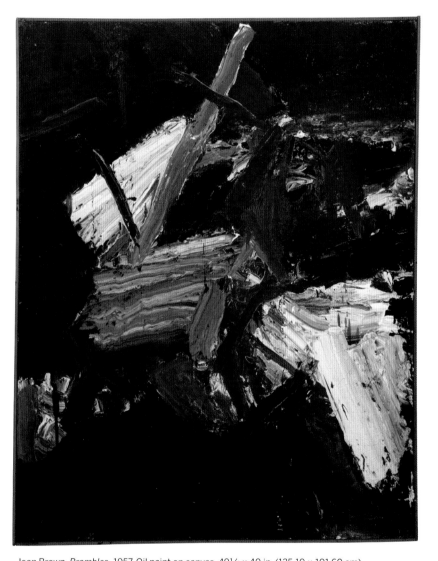

Joan Brown, *Brambles,* 1957. Oil paint on canvas, 49¼ × 40 in. (125.10 × 101.60 cm). Collection of the Oakland Museum of California. Gift of Robert J. Steinhart in memory of Barbara B. Steinhart.

JAY DeFEO

(b. 1929, Hanover, NH; d. 1989, Oakland, CA)

Mary Joan DeFeo moved with her parents to the Bay
Area in 1932. While in junior high school, she adopted
the nickname "Jay." DeFeo attended the University
of California, Berkeley, graduating with a B.A. and
M.A. in studio art (1950, 1951, respectively). She was
awarded a fellowship, which she used to travel in
Europe and North Africa, with an extended stay in
Florence. On a brief stopover in New York in January
1953, she saw and was fascinated by Philip Guston's
work. After returning to the Bay Area the next month,
she made paintings, collages, and sculpture. In 1954,
she married artist Wally Hedrick and moved to
Fillmore Street in San Francisco, where neighbors at
various times included Joan Brown, Sonia Gechtoff,
Dave Getz, and Michael McClure. DeFeo worked
frequently at the Six Gallery. In 1959, curator Dorothy
Miller included five of DeFeo's works in *Sixteen
Americans* (1959–60) at the Museum of Modern
Art, which featured only one other female artist:
Louise Nevelson.

DeFeo's artworks were associated with Abstract
Expressionism as well as with Surrealism and
spirituality. From the mid-1950s through the 1960s,
her large-scale paintings and drawings mounted on
canvas often have dense, gestural surfaces built
up from multiple layers of mixed media. For eight years,
from 1958 to 1966, DeFeo became preoccupied with
one painting, *The Rose* (see fig. 44). This monumental
work, which stands almost eleven feet high and weighs
approximately two thousand pounds, was acquired
by the Whitney Museum of American Art and has
been featured in several exhibitions there.

After completing *The Rose,* DeFeo stopped working
until the end of the decade. In the 1970s, she returned
to painting, drawing, and collage, experimenting with
new materials and taking up photography. From the
late 1960s through the 1980s, DeFeo taught art in the
Bay Area, becoming a professor of fine arts at Mills
College, in Oakland, California, in 1980. She died in
1989 at age sixty, before the renewed national and
international interest in her work.

SELECTED GROUP EXHIBITIONS

Action I, Santa Monica Pier, CA, organized by Walter
 Hopps (1955)
California School, Yes or No? Oakland Art Museum, CA (1956)
Objects on the New Landscape Demanding of the Eye,
 inaugural show, Ferus Gallery, Los Angeles (1957)

SELECTED SOLO EXHIBITIONS

The Place, San Francisco (1954)
Dilexi Gallery, San Francisco (1959)
Ferus Gallery, Los Angeles (1960)
Jay DeFeo: A Retrospective, Whitney Museum of American
 Art, New York (2012), and traveled

SELECTED READINGS

San Francisco Art Institute, *Jay DeFeo: Selected Works,
 Past and Present* (San Francisco: San Francisco Art
 Institute, 1984).
Sidra Stich, *Jay DeFeo: Works on Paper* (Berkeley: University
 Art Museum, University of California, 1989).

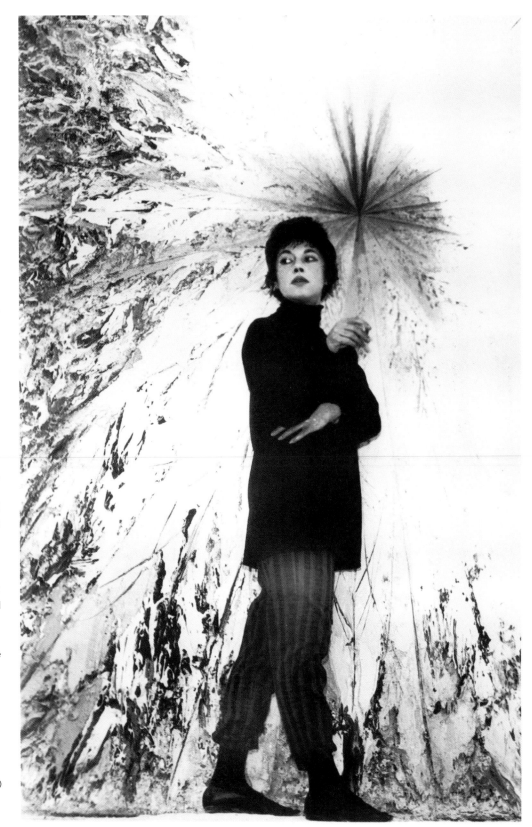

Jay DeFeo and *The Rose,* 1961. Photograph by Marty Sacco.

Jane Green and Leah Levy, eds., *Jay DeFeo and "The Rose"*
 (Berkeley and New York: University of California Press,
 in association with the Whitney Museum of American
 Art, 2003).
Dana Miller, *Jay DeFeo: A Retrospective* (New York and New
 Haven: Whitney Museum of American Art, in association
 with Yale University Press, 2012).

ELAINE DE KOONING
(b. 1918, Brooklyn, NY; d. 1989, Southampton, NY)

In 1936, Elaine Fried enrolled at Hunter College but soon left to study art at the Leonardo da Vinci Art School, where she was introduced to Willem de Kooning and Milton Resnick. Elaine became Willem's student and occasional model; they married in 1943 and began summering in East Hampton, New York, in 1951, eventually setting up studios (they unofficially separated in the mid-1950s but reconciled in 1975). In 1948, she was appointed an editorial associate for *ARTnews* (under Thomas Hess's helm) and began publishing art criticism.

In the summer of 1948, Willem de Kooning joined the staff at Black Mountain College, Asheville, North Carolina, where Elaine attended dance classes with Merce Cunningham, color theory lectures with Josef Albers, and physics lectures by Buckminster Fuller. She created enamel paintings on wrapping paper, later referred to as her *Black Mountain* series. Prior to that, in the early 1940s, she had worked on self-portraits and interiors with figures; her decision to pursue portraiture was a means to insert herself into the contemporary debate on abstraction versus representational painting. In her portraits, she used postwar gesturalism to address the male body, and many of her male sitters were authorities on postwar painting, including critics Harold Rosenberg, Thomas Hess, and Frank O'Hara and dealers John Bernard Myers and Leo Castelli. In 1947, she began a series referred to later as the *Faceless Men* (1947–56), some of which were shown at the Stable Gallery in her first solo exhibition (1954). Additional series focused on bullfights (1958–63), landscapes, Bacchus themes (1976–83), and cave paintings.

SELECTED GROUP EXHIBITIONS
Artists: Man and Wife, Sidney Janis Gallery, New York (1949)
New Talent 1950, selected by Clement Greenberg and
 Meyer Schapiro, Kootz Gallery, New York (1950)
Ninth Street Show, New York (1951)
Stable Gallery *Annuals,* New York (1953–57)
The New York School: Second Generation, Jewish Museum,
 New York (1957)
Young American Painters, Museum of Modern Art, New
 York (1957)
*60 American Painters, 1960: Abstract Expressionist Painting
 of the Fifties,* Walker Art Center, Minneapolis (1960)

SELECTED SOLO EXHIBITIONS
Stable Gallery, New York (1954, 1956)
Tibor de Nagy Gallery, New York (1957)
Retrospective, Lyman Allyn Art Museum, New London,
 CT (1959)
Graham Gallery, New York (1961, 1963, 1965)
Pennsylvania Academy of the Fine Arts, Philadelphia (1964)
Montclair Art Museum, NJ (1973)
Guild Hall, East Hampton, NY (1989)
Elaine de Kooning, Georgia Museum of Art, Athens (1992)
Elaine de Kooning: Portraits, National Portrait Gallery,
 Smithsonian Institution, Washington, DC (2015)

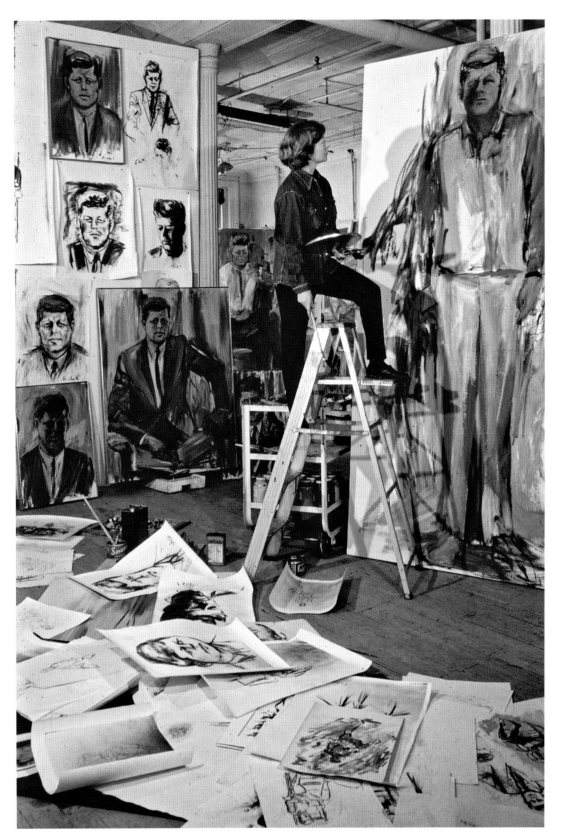

Elaine de Kooning working on a portrait of John F. Kennedy in her New York studio, 1964. Photograph by Alfred Eisenstaedt.

SELECTED READINGS
Elaine de Kooning, "Dymaxion Artist," *ARTnews* (September
 1952): 14–17, 40–42.
Jane K. Bledsoe, ed., *Elaine de Kooning* (Athens: Georgia
 Museum of Art, University of Georgia, 1992).
Marjorie Luyckx, preface, and Rose Slivka, essay, in *Elaine
 de Kooning: The Spirit of Abstract Expressionism,
 Selected Writings* (New York: George Braziller, 1994).

Celia S. Stahr, "Elaine de Kooning, Portraiture, and the
 Politics of Sexuality," in *Genders* 38 (2003): 1–21.
Brandon Brame Fortune, *Elaine de Kooning: Portraits*
 (Munich: Prestel, 2015).

MADELEINE DIMOND [MARTIN]
(b. 1922, New York; d. San Francisco, 1991)

Madeleine Dimond enrolled at the Art Students League (1941–42), where she took classes with George Grosz. During World War II, she served in the Women Accepted for Volunteer Emergency Service (WAVES) with the U.S. Navy. From 1948 to 1951, she attended the California School of Fine Arts on the GI Bill, studying under Edward Corbett and Hassel Smith, both important mentors. Along with Smith, Ernest Briggs, Joan Brown, and Sonia Gechtoff, she maintained a studio on Mission Street in San Francisco. Dimond was shown in formative exhibitions on Fillmore Street organized by artist-run galleries and cooperatives, including King Ubu Gallery (1953), along with Lilly Fenichel and Gechtoff; at the Six Gallery (1954, 1955) with Deborah Remington; and in Walter Hopps's *Action I* (1955), with Jay DeFeo and Gechtoff. She participated in the East and West Gallery's inaugural exhibition, *Nine Painters* (1955), with Gechtoff. Selected early group shows include: *Seventy-Second Annual Painting and Sculpture Exhibition of the San Francisco Art Association,* San Francisco Museum of Art (1953); and *From San Francisco: A New Language in Painting,* Kaufmann Art Gallery, YM-YWHA, New York (1954), which included Gechtoff, Adelie Landis, and Smith. After a period in Florence and Rome (1956–59), Dimond moved to New York in 1960 and, with her third husband, Peter Martin, founded the New Yorker Bookshop (1965–82). In 1984, Dimond returned to San Francisco, and following Martin's death in 1988, she co-founded, with Charles Strong, the Peter and Madeleine Martin Foundation for the Creative Arts in 1990.

SELECTED READINGS

Mary Fuller McChesney, *A Period of Exploration: San Francisco, 1945–1950* (Oakland, CA: Oakland Museum, 1973).

Susan Landauer, *The San Francisco School of Abstract Expressionism* (Los Angeles: University of California Press, 1996).

"Madeleine (Violett) Martin," in *The Beat Generation Galleries and Beyond,* by Seymour Howard et al. (Davis, CA: John Natsoulas, 1996), 114.

Madeleine Dimond, *Untitled,* 1950. Oil paint and mixed media on canvas, 36 × 30 in. (91.44 × 76.2 cm). Collection of Mag Dimond.

Madeleine Dimond in Hassel Smith's studio, San Francisco, c. 1953–54.

AMARANTH EHRENHALT

(b. 1928, Newark, NJ)

Raised in Philadelphia, Amaranth Ehrenhalt attended the Pennsylvania Academy of the Fine Arts on a scholarship and also studied at the Barnes Foundation in Merion, Pennsylvania. She earned an undergraduate degree from the University of Pennsylvania in 1951. While living in New York in the early to mid-1950s, she met many Abstract Expressionist artists. She made a first trip to Paris in the early 1950s; she then lived in France and Italy for more than thirty years, joining the coterie of American expatriate artists including Joan Mitchell, Sam Francis, and Shirley Jaffe. Sonia Delaunay recognized her artistic gifts and helped her purchase art supplies.

Ehrenhalt is proficient in multiple media, including mosaic, tapestry, ceramics, murals, and sculpture. Her paintings in the Abstract Expressionist style emphasize an organic linearity and vibrant color sense: a radiation of energy in constant motion. A featured artist throughout France, she completed a public commission of a ceramic mural in Bagneux in 1991. She returned to the United States in 2008.

SELECTED GROUP EXHIBITIONS

Salon des Réalités Nouvelles, Museum of the Grand Palais, Paris (1990–93)

SELECTED SOLO EXHIBITIONS

Galerie Zunini, Paris (1962)

Galerie Murs Blancs, Ostende, Belgium (1966–67, 1969)

Bagneux Cultural Center, Bagneux, France (1975)

Amaranth Ehrenhalt: Au Rythme des Saisons [As the Seasons Evolve], Maison des Arts de Bagneux, France (2007)

Amaranth Ehrenhalt: A Hidden Treasure, Anita Shapolsky Gallery, New York (first U.S. solo show, 2011–12)

SELECTED READINGS

Béatrice Comte, "Weaving Time," in Amaranth Ehrenhalt: Au Rythme des Saisons [As the Seasons Evolve] (Bagneux, Fr.: Maison des Arts de Bagneux, 2007).

Amaranth Ehrenhalt: A Hidden Treasure (New York: Anita Shapolsky Gallery, AS Art Foundation, 2011).

Amaranth Ehrenhalt in New York, 1952. Photograph by Val Telberg.

Amaranth Ehrenhalt, Umatilla, 1959. Oil paint on canvas, 59 × 87 in. (149.86 × 220.98 cm). Anita Shapolsky Gallery, New York.

CLAIRE FALKENSTEIN
(b. 1908, Coos Bay, OR; d. 1997, Venice, CA)

Claire Falkenstein was raised on a farm near Coos Bay, Oregon. In 1930, she graduated from the University of California, Berkeley, with a major in art. That same year she had her first solo show of drawings at the East-West Gallery, San Francisco. In 1933, she received a grant to study at Mills College, in Oakland, California, and was introduced to sculptor Alexander Archipenko and Bauhaus-associated artists László Moholy-Nagy and György Kepes. During the 1940s, she had various teaching appointments at Mills College (1946–47) and the California School of Fine Arts (1947–49) in San Francisco, where she met Clyfford Still.

Known primarily as a sculptor and jewelry designer, Falkenstein also worked extensively in painting, printmaking, and film. By 1944, she had her first solo show at the Bonestell Gallery, New York, and in 1948 she had a solo exhibition at the San Francisco Museum of Art. Her early artworks in stone, wood, and ceramics developed over the following decade in scale and technique, becoming highly technical structural systems incorporating Cor-Ten steel, glass, and sheet aluminum. After her first European show in 1948 in the *Salon des Réalités Nouvelles* in Paris, she moved there in 1950 and established a small studio (she also had studios in Venice and Rome), where she began experimenting with cheap stovepipe wire. In Europe, she developed her mature structures using wires, welded rods, and metal tubes, which expressed an expanding and interconnected spatial vocabulary of lattices and screens. Affiliated with the expatriate community, many of whom were Bay Area and Pacific Northwest artists, she was considered part of the "École du Pacifique," a term suggested by French writer-critic Michel Tapié, who became a close friend; Tapié also associated her work with his existential group, Art Autre, and she became a member of Galerie Stadler, for which he served as artistic advisor. She had a major one-person exhibition at the Galleria Montenapoleone, Milan, in 1954. In the early 1960s, she moved to Venice, California.

Among her public art commissions, she executed the gates for the Peggy Guggenheim Collection in Venice and the windows for St. Basil Catholic Church on Wilshire Boulevard, Los Angeles.

SELECTED READINGS

Michel Tapié, "L'école du Pacifique," *Cimaise* 1 (June 1954): 6–9.

Claire Falkenstein, *Claire Falkenstein, in San Francisco, Paris, Los Angeles, and Now Palm Springs Desert Museum* (Palm Springs, CA: Palm Springs Desert Museum, 1980).

Claire Falkenstein, oral history interview, 1995, Archives of American Art, Smithsonian Institution, Washington, DC.

Maren Henderson, *Claire Falkenstein: Looking Within—A Point of Departure: Collected Works, 1927 to 1997* (Fresno, CA: Fresno Art Museum, 1997).

Susan M. Anderson, Michael Duncan, and Maren Henderson, *Claire Falkenstein* (Los Angeles: Falkenstein Foundation, 2012).

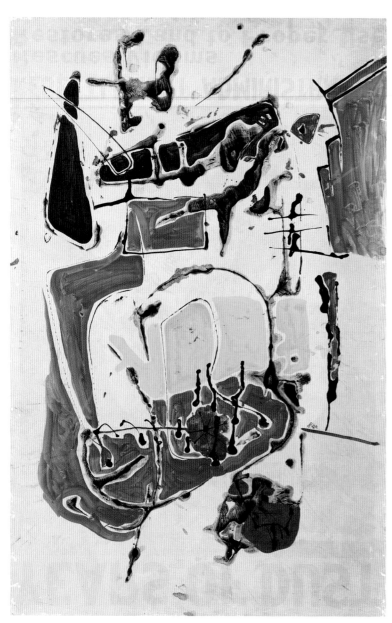

Claire Falkenstein, *Barcelona #2*, 1949. Gouache on paper mounted to canvas, 38½ × 25 in. (97.79 × 63.5 cm). The Falkenstein Foundation.

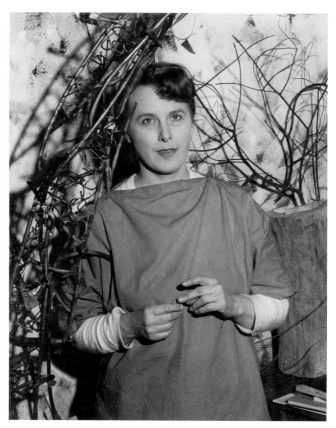

Claire Falkenstein, c. 1958. Photograph by Paul C. Greene, San Francisco.

LILLY FENICHEL

(b. 1927, Vienna)

Lilly Fenichel and her family fled the Nazis in 1939 with the onset of World War II, relocating to Great Britain and then the Los Angeles area in 1940. She enrolled at the Chouinard Art Institute in Los Angeles (1946–47) and Los Angeles City College (1947–48). From 1950 to 1952, she attended the California School of Fine Arts, where she studied under instructors Hassel Smith, Edward Corbett, David Park, and Elmer Bischoff. Her paintings from this period, with strong graphic elements and geometric structure, reflect the gestural expressionism associated with a younger generation of the Bay Area School. In 1952, she moved to New York, where she shared a studio with Harlan Jackson and taught art classes for children at the Museum of Modern Art.

Returning to Hollywood (1960–67), she worked variously on the West and East coasts as an art director and costume designer.

In 1951, she visited Edward Corbett in Taos, New Mexico, for the first time, and in 1959 she worked there with Clay Spohn. Along with her friend Beatrice Mandelman, she became a member of the Taos artists' community, or Taos Moderns. She set up her studio permanently in Taos between 1980 and 1984. She has also lived in Corrales and Albuquerque, New Mexico, making three-dimensional wood and fiberglass pieces as well as paintings made by pouring oil-based glazes on polypropylene. She showed in Taos at the Lutz-Bergerson Gallery (1980), Taylor Gallery (1981), and New Gallery (1983). She also showed at the Carlson Gallery, San Francisco (1990), and most recently at David Richard Gallery, Santa Fe (beginning in 2012).

SELECTED GROUP EXHIBITIONS

Two Painters, Philip Roeber and Lilly Fenichel, Lucien Labaudt Gallery, San Francisco (1951)

King Ubu Gallery, San Francisco (1953)

SELECTED SOLO EXHIBITION

Santa Barbara Museum of Art, CA (1968)

SELECTED READINGS

Lilly Fenichel (Santa Barbara, CA: Santa Barbara Museum of Art, 1968).

Susan Landauer, "An Interview with Lilly Fenichel," in *Lilly Fenichel, The Early Paintings* (San Francisco: Carlson Gallery, 1990), 9–17.

Lilly Fenichel: Just You Just Me (Albuquerque: Harwood Museum of Art of the University of New Mexico, 2004).

Lilly Fenichel at the Giacomo Patri School of Art, San Francisco, c. 1940s.

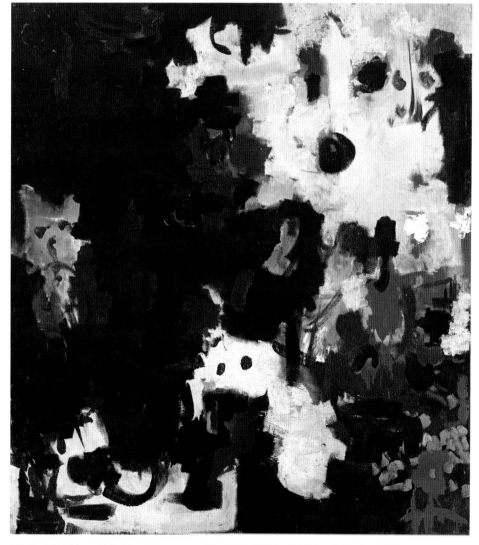

Lilly Fenichel, *Circus,* 1951. Oil paint on canvas, 48 × 43 in. (121.92 × 109.22 cm). Crocker Art Museum, Sacramento, Calif. Promised gift of George Y. and LaVona J. Blaire.

PERLE FINE
(b. 1905, Boston; d. 1988, Southampton, NY)

The daughter of Russian émigrés, Perle Fine moved in 1929 to New York, where she met Maurice Berezov (a fellow student and budding photographer and art director) at the Grand Central School of Art. They married in 1930. Fine enrolled at the Art Students League, studying drawing with Kimon Nicolaides. From the mid- to late 1930s, she attended classes occasionally at Hans Hofmann's school in Greenwich Village. She and Berezov began spending their summers in Provincetown, Massachusetts, and she attended Hofmann's summer art school there as well. In 1943, through Hilla Rebay, Fine received a grant from the Guggenheim Foundation. In 1944, she enrolled in printmaking classes at Atelier 17 with Stanley William Hayter and officially joined the American Abstract Artists group. On the invitation of Willem de Kooning, she became a frequent participant in discussions at The Club as one of its few female members.

Even as Fine worked through various styles in the mid- to late 1940s, non-objectivity was a central pursuit in her art, fueled by her desire to achieve a pure expression of color and linear relationships. Her artwork explored the flexible language of geometric abstraction and Neo-Plasticism advanced by Piet Mondrian, whom she met in New York. In 1947, she was commissioned by collector Emily Hall Tremaine to make two interpretations of Mondrian's *Victory Boogie-Woogie,* a painting left unfinished at his death in 1944. In 1954, she moved full-time to Springs, in East Hampton, New York. This change of environment influenced the scale and brushwork of her art, which at times incorporated wide swatches of black as well as collage elements. In her later career, she produced bas-relief paintings and allover grids. A renowned teacher, Fine was associate professor of fine art at Hofstra University, in Hempstead, New York, from 1962 to 1973.

SELECTED GROUP EXHIBITIONS
Art of This Century Gallery, New York (1943–44)
Abstract and Surrealist American Art, Art Institute of
 Chicago (1947–48)
Salon des Réalités Nouvelles, Paris (1950)
Ninth Street Show, New York (1951)

Nine Women Painters, Bennington College, VT (1953),
 alongside Helen Frankenthaler, Joan Mitchell,
 Sonia Sekula, and Hedda Sterne, among others
Stable Gallery *Annuals,* New York (1953–57)
*Nature in Abstraction: The Relation of Abstract Painting and
 Sculpture to Nature in Twentieth-Century American Art,*
 Whitney Museum of American Art, New York (1958)
The Art of Assemblage, Museum of Modern Art, New
 York (1961)

SELECTED SOLO EXHIBITIONS
Willard Gallery, New York (1945)
Nierendorf Gallery, New York (1946, 1947)
M. H. de Young Memorial Museum, San Francisco (1947)
Betty Parsons Gallery, New York (1949, 1951, 1952–53)
Graham Gallery, New York (1961, 1963, 1964, 1967)
Retrospective, Guild Hall, East Hampton, NY (1978)
Retrospective, *Tranquil Power: The Art of Perle Fine,* Hofstra
 University Museum, Hempstead, NY (2009), and traveled

SELECTED READINGS
David Deichter, *Perle Fine: Major Works, 1954–1978 (A
 Selection of Drawings, Paintings, and Collages)* (East
 Hampton, NY: Guild Hall of East Hampton, 1978).
Kathleen L. Housley, "The Tranquil Power of Perle Fine's Art,"
 Woman's Art Journal 24, no. 1 (spring/summer 2003): 3–10.
Kathleen L. Housley, *Tranquil Power: The Art and Life of Perle
 Fine* (New York: Midmarch Arts, 2005).

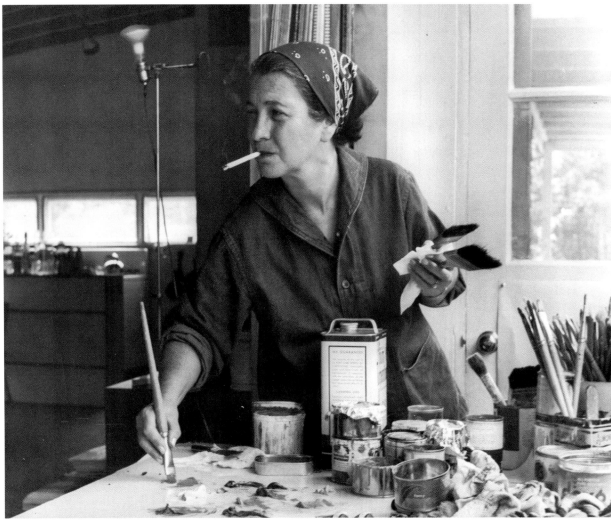

Perle Fine working in her Springs, N.Y., studio, 1959. Photograph by Maurice Berezov.

HELEN FRANKENTHALER
(b. 1928, New York; d. 2011, Darien, CT)

Helen Frankenthaler attended the Dalton School in New York, where she studied with Mexican artist Rufino Tamayo. At Bennington College, Vermont, she absorbed the vocabulary of Cubism from her art professor, Paul Feeley. During college, Frankenthaler traveled to Europe, shared various studios in New York, and studied with Wallace Harrison. In 1950, she took summer classes in Provincetown, Massachusetts, with Hans Hofmann and was selected by Adolph Gottlieb for the exhibition *Fifteen Unknowns* at the Kootz Gallery, New York. She met critic Clement Greenberg when she organized a Bennington alumni exhibition at Jacques Seligmann, New York, and he introduced her to key artists of the New York School. Frankenthaler and Greenberg became romantically involved, and he refrained from publicly critiquing her work until the 1960s. In 1958, she married Robert Motherwell, with whom she spent extensive periods in France; they divorced in 1971.

Willem de Kooning, Jackson Pollock, and Mark Rothko were formative influences. Pollock's dynamic process of applying paint, coupled with what Frankenthaler called his "spread" across the canvas, inspired her own revolutionary technique of stain painting. In 1952, upon her return from a trip to Nova Scotia, Frankenthaler created her breakthrough painting, *Mountains and Sea*, on unstretched and unsized cotton duck, by directly pouring a mixture of thinned paints, including house paint and enamel, from coffee cans (see fig. 6). Her staining technique was readily adapted by Morris Louis and Kenneth Noland and later known as Post-Painterly Abstraction or Color Field painting.

SELECTED GROUP EXHIBITIONS
Ninth Street Show, New York (1951)
Stable Gallery *Annuals,* New York (1953–56)
The New York School: Second Generation, Jewish Museum, New York (1957)
Young America 1957: Thirty American Painters and Sculptors under Thirty-Five, Whitney Museum of American Art, New York (1957)
Nature in Abstraction: The Relation of Abstract Painting and Sculpture to Nature in Twentieth-Century American Art, Whitney Museum of American Art, New York (1958)
Documenta II, Kassel, Germany (1959)
Paris Biennale (1959)
São Paulo Bienal, Brazil (1959)

SELECTED SOLO EXHIBITIONS
Tibor de Nagy Gallery, New York (1951, 1953–54, 1956–57)
Retrospective, Whitney Museum of American Art, New York (1969)
Sterling and Francine Clark Art Institute, Williamstown, MA (1980)
Solomon R. Guggenheim Museum, New York (1985)
Museum of Modern Art, New York (1989)

SELECTED READINGS
E. A. Carmean, Jr., *Helen Frankenthaler: A Paintings Retrospective* (New York: Harry N. Abrams, in association with the Museum of Modern Art, 1989).

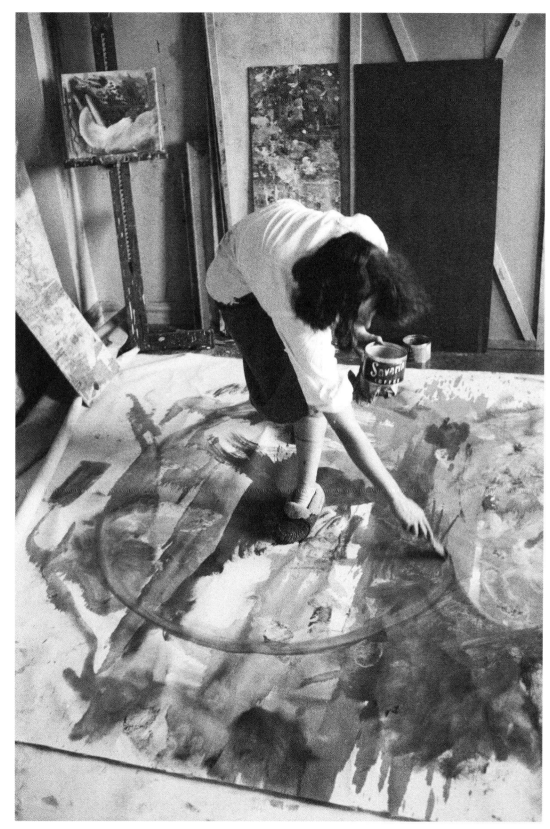

Helen Frankenthaler working in her New York studio, 1957. Photograph by Burt Glinn.

Jeanne Siegel, *Painting after Pollock: Structures of Influence* (Amsterdam: G and B Arts, 1999).
Lisa Saltzman, "On Gender and the Body in Helen Frankenthaler's Painting," in *Reclaiming Female Agency,* ed. Norma Broude and Mary D. Garrard (Berkeley: University of California Press, 2005), 373–84.
Sybil Gohari, "Gendered Reception: There and Back Again: An Analysis of the Critical Reception of Helen Frankenthaler," *Woman's Art Journal* 35 (spring/summer 2014): 33–39.

SONIA GECHTOFF
(b. 1926, Philadelphia)

Sonia Gechtoff learned art from her father, a moderately successful landscape and still-life painter. She received a scholarship to attend the Philadelphia Museum School of Industrial Art (B.F.A., painting, 1950), and in 1951 she moved to San Francisco, where she studied lithography with James Budd Dixon at the California School of Fine Arts (CSFA) and later taught there (1957–58) at the invitation of Elmer Bischoff. At CSFA she met painter James Kelly, and they married in 1953. They moved to the Fillmore Street studio building, home to many artists over the years. A few years later, Sonia's mother, Ethel Gechtoff, opened the East and West Gallery on Fillmore Street, across from the Six Gallery.

Although she arrived in California as a Social Realist painter, her oil paintings in the early 1950s developed large-scale painterly gestures. Many were inspired by nature as well as poetry. She grandly manipulated the palette knife and also created large graphite drawings. In the early 1950s, she saw a revelatory exhibition that included Clyfford Still.

Through his students, particularly Frank Lobdell and Ernest Briggs, she learned his philosophies and approach to abstraction.

In 1958, Gechtoff moved with Kelly to New York. There she found, in her opinion, a discouraging and unsupportive atmosphere for an Abstract Expressionist due to the ascent of Pop Art. While Gechtoff spent less than a decade in San Francisco, she credited her early success to an open environment for women, compared to misogynistic attitudes in New York.

Gechtoff showed in the 1950s at King Ubu Gallery (1953) and Six Gallery (1955, 1956), both in San Francisco. She was included in the United States Pavilion at the Brussels World's Fair (1958) and the São Paulo Bienal, Brazil (1961). In her later career, she was represented by Gruenbaum Gallery (1979–87), Kraushaar Galleries (1990, 1992, 1995), and Nyehaus Gallery (2011–12), all in New York.

SELECTED GROUP EXHIBITIONS
Younger American Painters, Solomon R. Guggenheim Museum, New York (1954)
Action 1, Santa Monica Pier, CA (1955)
California School. Yes or No? Oakland Art Museum. CA (1956)
Objects on the New Landscape Demanding of the Eye, Ferus Gallery, Los Angeles (1957)
60 American Painters, 1960, Walker Art Center, Minneapolis (1960)
Young America, 1960, Whitney Museum of American Art, New York (1960)

SELECTED SOLO EXHIBITIONS
M. H. de Young Memorial Museum, San Francisco (1957)
Poindexter Gallery, New York (1959, 1960)

SELECTED READINGS
Alfred Frankenstein, "Sonia Gechtoff Exhibit Blazes with Vision," *San Francisco Chronicle,* January 23, 1957.
Alexander Fried, "Smell the Paint: Sonia Gechtoff Puts Furious Energy into Her Oils," *San Francisco Examiner,* February 3, 1957.
James Mellow, "Concerning the Landscapes of Sonia Gechtoff," in *Sonia Gechtoff: New Works* (New York: Gruenbaum Gallery, 1980).
John Loughery, *Sonia Gechtoff: Four Decades, 1956–1995: Works on Paper* (Saratoga Springs, NY: Schick Art Gallery, Skidmore College, 1995).
Marshall N. Price, *Sonia Gechtoff: The Ferus Years* (New York: Tim Nye, 2011).

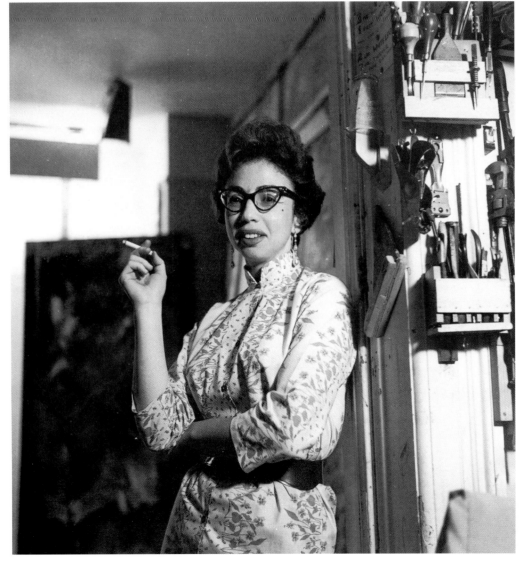

Sonia Gechtoff in her San Francisco studio, c. 1957–58. Photograph by Harry Redl.

JUDITH GODWIN

(b. 1930, Suffolk, VA)

Judith Godwin attended Mary Baldwin College in
Staunton, Virginia (1948–50), studied art with
Elizabeth Nottingham Day and Horace Day, and in 1951
transferred to Richmond Professional Institute (now
Virginia Commonwealth University) and completed
her degree in 1952. Encouraged by professors
Theresa Pollak and former Hans Hofmann student
Jewett Campbell, Godwin moved to New York in 1953.
She was also inspired to move to New York by modern
choreographer Martha Graham. Once there, Godwin
attended dance classes and performances, establish-
ing a lifelong friendship with Graham. In spring 1953,
she studied briefly with Will Barnet and Vaclav
Vytlacil at the Art Students League. She then enrolled
in classes with Hofmann, first at his summer school
in Provincetown, Massachusetts, and in the fall of
1954 at his school in New York. She was also friendly
with Franz Kline.

Godwin's artistic development in the mid-1950s
shows the direct influence of Hofmann's color
principles and an emerging structural organization
between figural and planar elements. Equally
important are the painterly relationships between
sweeping and extended corporeal gestures, arcs, and
angles inspired by modern dance. Her association
with Japanese painter Kenzo Okada encouraged her
growing interest in Zen Buddhism and the teachings
of D. T. Suzuki.

At James Brooks's invitation, Godwin exhibited
at Eleanor Ward's Stable Gallery (1958) and in the
inaugural exhibition that same year at Betty Parsons
Gallery's Section Eleven, an annex for younger artists,
along with David Budd, Agnes Martin, and Sidney
Wolfson. Godwin later showed in New York at Ingber
Gallery and Marisa del Re Gallery. In her later works,
she introduced collage elements that brought pattern
and texture to her broad gestures.

SELECTED GROUP EXHIBITION

Betty Parsons and the Women, Anita Shapolsky Gallery,
 New York (2005)

SELECTED SOLO EXHIBITIONS

Betty Parsons Gallery, New York (1959, 1960)
Judith Godwin: Style and Grace, Art Museum of Western
 Virginia, Roanoke (1997)
Judith Godwin: Color and Movement, Mary H. Dana Women
 Artists Series, Rutgers University, New Brunswick,
 NJ (2001)
Judith Godwin: Early Abstractions, McNay Art Museum,
 San Antonio, TX (2008)

SELECTED READINGS

Robert Hobbs, "Judith Godwin: Aesthetic Mediations
 Between East and West," *Woman's Art Journal* 14, no. 1
 (spring/summer 1993): 3–9
Ann Gibson and Mark Scala, *Judith Godwin: Style and Grace*
 (Roanoke: Art Museum of Western Virginia, 1997).
Joan Marter, "Judith Godwin: Color and Movement," in *Judith
 Godwin: Color and Movement* (New Brunswick, NJ:
 Rutgers, Mabel Smith Douglass Library, 2001).
Lowery Stokes Sims, "Judith Godwin's Objectified Gesture,"
 in *Judith Godwin: Early Abstractions* (San Antonio, TX:
 McNay Art Museum, 2008), 10–14.

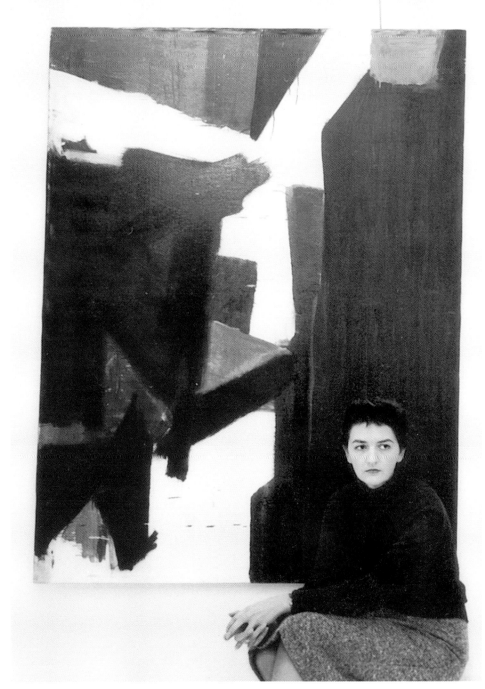

Judith Godwin at Betty Parsons Gallery, New York, with *Moon,* 1959.

SHIRLEY GOLDFARB
(b. 1925, Altoona, PA; d. 1980, Paris)

Shirley Goldfarb came to New York in 1949 and enrolled briefly at the American Academy of Dramatic Arts and the Juilliard School. She won a scholarship to study at the Art Students League in New York, where she also worked as a model. In 1952–53, she took classes during the summer with Nahum Tschacbasov in Woodstock, New York, and also attended the Skowhegan School of Painting and Sculpture in Maine. In 1954, she settled in Paris with her husband, Gregory Masurovsky, and became a familiar fixture on the bohemian expatriate scene. Artist friends included Michel Butor, Max Ernst, Sam Francis, Alberto Giacometti, David Hockney, Joan Mitchell, Jean-Paul Riopelle, and Man Ray. In Paris, Goldfarb evolved a dynamic approach to painting that coupled the gestural assertiveness of New York Abstract Expressionism as exemplified by Jackson Pollock (whom she had met at the Cedar Street Tavern) with its European counterparts, Tachisme and Art Informel. In her later career, color and gesture were restrained through the direct use of a palette knife, and her paintings, while light-filled and large scale, became more tightly constructed and meditative.

Goldfarb was a prolific journal writer and recorder of daily routines and habits in the cafés and studios, and a collection of her writings was published as *Carnets: Montparnasse, 1971–1980* (Paris: Quai Voltaire, 1994). She was also involved in theater, film, and television.

SELECTED GROUP EXHIBITIONS
Salon des Réalités Nouvelles, Paris (1955, 1956, 1961)
American Abstract Sculptors and Painters in Paris, Galerie Arnaud, Paris (1956)
Salon Comparaisons, Paris (1956, 1957, 1961)
Salon de Mai, Paris (1958, 1966, 1968, 1969)
Some Americans in Paris, Centre Georges Pompidou, Paris (1977)

SELECTED SOLO EXHIBITIONS
Studio Paul Facchetti, Paris (1956, 1965)
Minneapolis Institute of Arts (1967)
Shirley Goldfarb—Retrospective, Galerie Eric Franck, Geneva (1983)
Galerie Zabriskie, Paris (1991, 1994)
Retrospective, National Museum of Women in the Arts, Washington, DC (1997)
Retrospective, Loretta Howard Gallery, New York (2013)

SELECTED READINGS
Shirley Goldfarb: Neuf Grandes Peintures (Pontoise, Fr.: Musée de Pontoise, 1980).
Shirley Goldfarb and Michel Butor, *Shirley Goldfarb* (Paris: Paris Art Center, 1981).

Shirley Goldfarb, c. 1949.

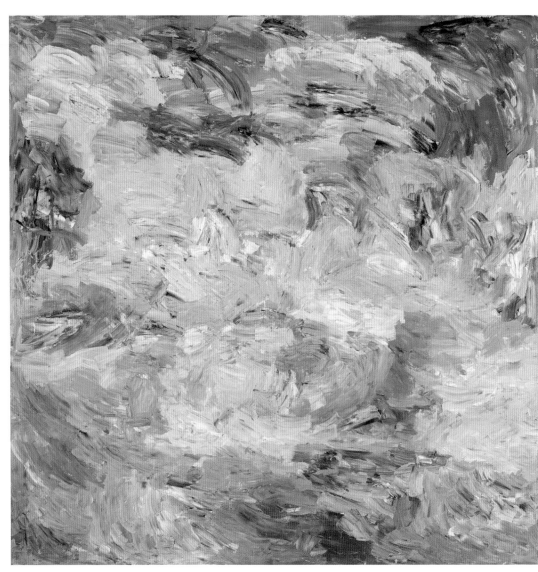

Shirley Goldfarb, *Where Angels Got Lost and Then Left,* 1957. Oil paint on canvas, 77 × 77 in. (195.58 × 195.58 cm). The Estate of Shirley Goldfarb.

GERTRUDE GREENE
(b. 1904, Brooklyn, NY; d. 1956, New York)

By 1924, Gertrude Glass was taking evening classes in sculpture at the Leonardo da Vinci Art School in New York (1924–26). In 1926, she married writer and artist John Wesley (Balcomb) Greene, and five years later they traveled to Paris and set up a studio in Montparnasse, an experience that exposed them to European and Russian strains of Constructivism, Neo-Plasticism, and Surrealism. Back in New York in 1933, Greene began making sketches and small constructions in wood and metal and became a charter member of the American Abstract Artists (AAA) group. Greene's association with the group was prompted to a certain extent by the absence of American artists in Alfred H. Barr, Jr.'s *Cubism and Abstract Art* exhibition at the Museum of Modern Art. Greene was the AAA's first salaried employee and organizer of its inaugural show at the Squibb Galleries in 1937. She was also a charter member of the leftist American Artists Union and the Federation of Modern Painters and Sculptors. She was known in art circles as "Peter," after a childhood nickname, "Petra."

Greene bridged European Neo-Plasticism and geometric abstraction, and combined these developments with the gestural impact and dynamism of Abstract Expressionism. Beginning in 1936, she was one of the first American artists to create non-objective painted relief constructions by layering flattened biomorphic and geometric wooden shapes. Until 1946, her constructions, influenced by Mondrian and El Lissitzky, progressed as interlocking configurations on spatially active yet stable planes. Around 1948, Greene deliberately transitioned to painting, carefully negotiating a balanced geometric surface with a painterly approach reliant on the palette knife as a primary tool. She maintained her Manhattan studio, but beginning in 1947, the Greenes increasingly resided in Montauk, New York.

In 1937, Greene exhibited in the inaugural show of the Museum of Non-Objective Painting (now the Solomon R. Guggenheim Museum), curated by Hilla Rebay, and in the same year her sculpture *Composition* was purchased for the Museum of Living Art, at New York University. She was featured in *Masters of Abstract Art* at Helena Rubinstein's New Art Center (1942), in the annual painting exhibition at the Whitney Museum of American Art (1950), and in *Abstract Painting and Sculpture in America* at the Museum of Modern Art (1951). Greene's first solo shows were at Grace Borgenicht Gallery (1951) and Bertha Schaefer Gallery (1955, 1957–58), both in New York.

SELECTED READINGS

Jacqueline Moss, "The Constructions of Gertrude Greene, the 1930s and 1940s" (master's thesis, Queens College, City University of New York, 1980).

Linda Hyman, *Gertrude Greene: Constructions, Collages, Paintings* (New York: ACA Galleries, 1981).

Gertrude Greene, c. 1930s.

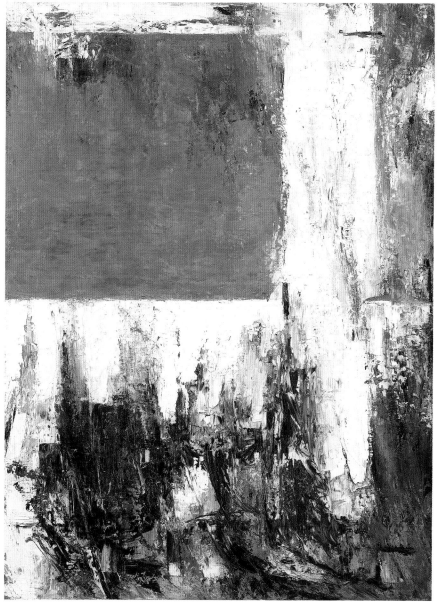

Gertrude Greene, *Composition II*, c. 1950–56. Oil paint on canvas, 40 × 30 in. (101.6 × 76.2 cm). Estate of Gertrude and Balcomb Greene.

GRACE HARTIGAN

(b. 1922, Newark, NJ; d. 2008, Timonium, MD)

Raised in New Jersey, Grace Hartigan moved to California after she married in 1941 and then began drawing classes in Los Angeles. During World War II, Hartigan worked in Newark, New Jersey, as a drafts-person in an airplane factory and briefly studied painting with Isaac Lane Muse in New York. She met Mark Rothko and Adolph Gottlieb, and upon viewing Jackson Pollock's 1948 exhibition at Betty Parsons Gallery, she began a series of gestural abstractions (1948–52). Through Pollock, she met Willem de Kooning, a formative influence and friend.

Hartigan married and divorced several times and for a period of time exhibited under the name "George Hartigan." Her colorful canvases often challenged the non-objective tenets of Abstract Expressionism by including references to contemporary life: gritty market vendors, urban storefronts, still lifes, clothing, costumes, and masks. In her *Matador* series from the early 1950s, she played with sexual identity. She collaborated with poet Frank O'Hara on a series called *Oranges,* in which she incorporated words from his poems. Another series on bridal imagery, a subject examined throughout her oeuvre, addressed broader social dimensions of American woman-hood, marriage, and consumerism. In 1956, she was the only woman included in *Twelve Americans,* at the Museum of Modern Art.

Four years later, she left the New York art world behind and moved to Baltimore with her last husband, Dr. Winston Price. She taught art at the Hoffberger School of Painting at the Maryland Institute College of Art, continued to paint, and showed her later work at the C. Grimaldis Gallery in Baltimore.

SELECTED GROUP EXHIBITIONS

New Talent 1950, Kootz Gallery, New York (1950)
Ninth Street Show, New York (1951)
Stable Gallery *Annuals,* New York (1953, 1954)
Twelve Americans, Museum of Modern Art, New York (1956)
The New York School: Second Generation, Jewish Museum, New York (1957)
São Paulo Bienal, Brazil (1957)
The New American Painting, Museum of Modern Art, New York (1958)
American Abstract Expressionists and Imagists, Solomon R. Guggenheim Museum, New York (1961)

SELECTED SOLO EXHIBITIONS

Tibor de Nagy Gallery, New York (1951–57, 1959)
Martha Jackson Gallery, New York (1962, 1964, 1967, 1970)
Gertrude Kasle Gallery, Detroit (1968, 1974, 1976)

SELECTED READINGS

J. F. [James Fitzsimmons], "Grace (George) Hartigan," *Arts Digest* 25 (February 1, 1951): 18–19.
Cindy Nemser, "Grace Hartigan," in *Art Talk: Conversations with Twelve Women Artists* (New York: Scribner's, 1975), 149–78.
Robert Saltonstall Mattison, *Grace Hartigan: A Painter's World* (New York: Hudson Hills, 1990).
Terence Diggory, "Questions of Identity in *Oranges* by Frank O'Hara and Grace Hartigan," *Art Journal* 52 (winter 1993): 41–50.
Grace Hartigan, *The Journals of Grace Hartigan 1951–1955,* ed. William T. La Moy and Joseph P. McCaffrey (Syracuse, NY: Syracuse University Press, 2009).
Aliza Edelman, "Grace Hartigan's *Grand Street Brides:* The Modern Bride as Mannequin," *Woman's Art Journal* 34 (fall/winter 2013): 3–10.
Cathy Curtis, *Restless Ambition: Grace Hartigan, Painter* (New York: Oxford, 2015).

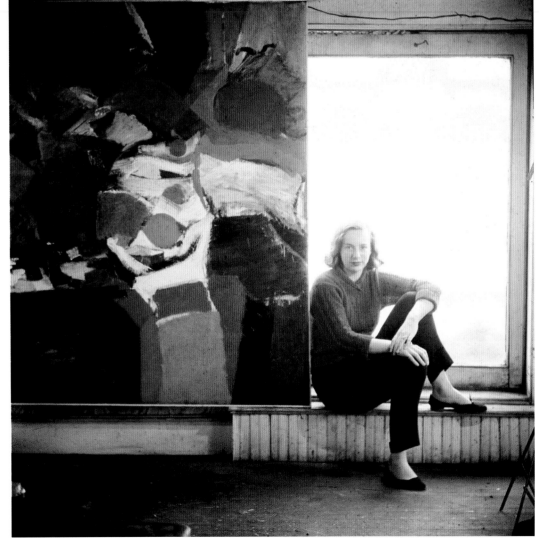

Grace Hartigan posed beside one of her works in her Lower East Side studio, New York, 1957. Photograph by Gordon Parks, *Life* magazine.

BUFFIE JOHNSON
(b. 1912, New York; d. 2006, New York)

After summer classes at the Art Students League (1927–28), Buffie Johnson graduated from UCLA (B.F.A., 1936). Her first solo show at Jake Zeitlin Gallery, Los Angeles, in 1937, was followed by travel to Paris, where she befriended Sonia Delaunay and received studio visits from Francis Picabia. Johnson had a solo show at Galerie André J. Rotgé in Paris in 1939. She also studied at the Académie Julian and Stanley William Hayter's Atelier 17. Returning to New York, she showed at Wakefield Gallery and Bookshop, then led by Betty Parsons. In 1943, she was included in Peggy Guggenheim's *Exhibition by 31 Women* at Art of This Century Gallery in New York, along with Sonja Sekula and Hedda Sterne, a significant experience that contributed to her awareness of the position of women in the male artistic environment. In the late 1940s, she traveled again to Europe, where she considered the environment more inclusive toward women artists.

Johnson's turn toward abstraction coincided with her friendship with architect and sculptor Tony Smith and her first show at Betty Parsons Gallery in 1950.

That year, she married art critic Gerald Sykes and set up a studio in East Hampton, New York. In 1954, her longstanding interest in the history of goddess imagery and the Great Mother, reflected in her paintings, led to a Bollingen Foundation grant for collecting images on the subjects. Egyptologist Natacha Rambova and archaeologist Marija Gimbutas were also important influences. In 1959, she created an epic abstract mural for the Astor Theatre, New York; in the 1960s and 1970s, she returned variously to representation, portraiture, and plant and flower imagery. In 1988, she published *Lady of the Beasts: Ancient Images of the Goddess and Her Sacred Animals,* a compilation of prehistoric representations of the goddess as sacred animals, including her own drawings and textual interpretations summarizing the vast "Mistress of all Creation." In her later years, she showed frequently at the Anita Shapolsky Gallery, New York. In 2007, she was a recipient of a Lifetime Achievement Award from the Women's Caucus for Art of the College Art Association Committee on Women in the Arts.

SELECTED GROUP EXHIBITIONS
Guild Hall, East Hampton, NY (1950, 1951, 1953, 1956, 1960, 1964)

Signa Gallery, East Hampton, NY, with Perle Fine and Grace Hartigan (1957)

Contemporary American Art Biennial, Whitney Museum of American Art, New York (1973)

Women Choose Women, New York Cultural Center (1973)

SELECTED SOLO EXHIBITIONS
Howard Putzel's 67 Gallery, New York (1945)
Ringling Museum of Art, Sarasota, FL (1948, 1949)
Betty Parsons Gallery, New York (1950)
Galerie Bing, Paris (1951, 1956, 1960)
Retrospective, Landmark Gallery, New York (1981)
Buffie Johnson: Paintings, curated by Alanna Heiss, PS 1, Long Island City, NY (1993)

SELECTED READINGS
Horace Gregory, "The Transcendentalism of Buffie Johnson," *Art International* 9 (November 20, 1965): 13.

Alexandra de Lallier, "Buffie Johnson: Icons and Altarpieces to the Goddess," *Woman's Art Journal* 3 (spring/summer 1982): 29–34.

Buffie Johnson, *Lady of the Beasts: Ancient Images of the Goddess and Her Sacred Animals* (San Francisco: Harper and Row, 1988).

Buffie Johnson: Transcendentalist (New York: Anita Shapolsky Gallery and A. S. Art Foundation, 2002).

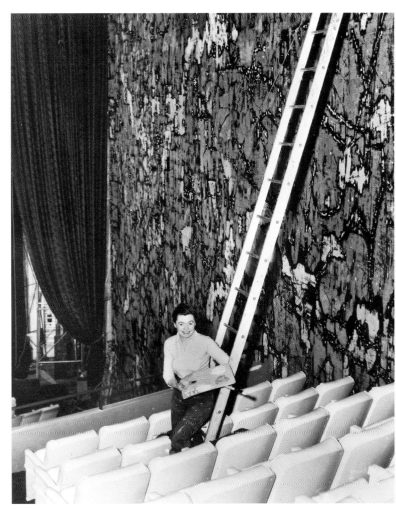

Buffie Johnson putting the finishing touches on her Astor Theatre mural, New York, 1959.

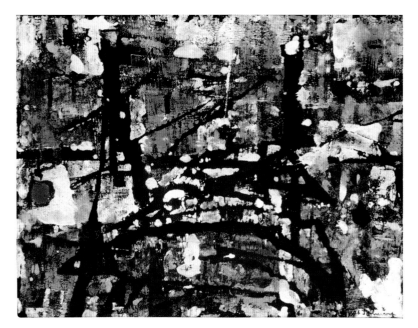

Buffie Johnson, *The Bridge,* 1949–51. Oil paint on canvas, 18³/₄ × 24³/₄ in. (47.63 × 62.87 cm). The William A. Clementi Family Collection.

IDA KOHLMEYER

(b. 1912, New Orleans; d. 1997, Metairie, LA)

Born Ida Rittenberg to Polish immigrant parents and raised in New Orleans, Kohlmeyer graduated with a literature degree from Newcomb College, Tulane University (B.A., 1933), married Hugh Kohlmeyer in 1934, and when she was in her thirties enrolled in art classes at the John McCrady Art School (1947). In 1956, she completed a graduate degree in painting from Newcomb School of Art. Department Chair George Rickey invited David Smith, Theodoros Stamos, Clyfford Still, and Jack Tworkov as visiting artists, and upon Still's recommendation Kohlmeyer spent the summer of 1956 in Provincetown, Massachusetts, studying with Hans Hofmann. Her painting shifted to abstraction. In 1957, she cultivated a friendship with Mark Rothko, who was a visiting artist at Newcomb. In New York, James Johnson Sweeney introduced her to gallerist Ruth White, with whom she had her debut exhibition in 1959 and subsequent exhibitions in 1961 and 1965.

Kohlmeyer had dozens of exhibitions in the United States. A selected list of shows includes solo shows at the New Orleans Museum of Art (1957, 1966, 1967, 1974); group exhibitions at the Corcoran Gallery of Art Biennial, Washington, D.C. (1963, 1965, 1967); and retrospectives at the High Museum, Atlanta (1972), the Turman Gallery, Indiana State University (1972), Mint Museum, Charlotte, North Carolina (opened 1983 and traveled), and the Morris Museum of Art, Augusta, Georgia (1996).

Ida Kohlmeyer, c. 1990s. Photograph by Donn Young.

SELECTED READINGS

Carol Donnell-Kotrozo, "Pictographic Grids that Feel," *Arts Magazine* 54, no. 8 (April 1980): 188–89.

Nancy Grossman and Ida Kohlmeyer, "Artist to Artist," *Art Papers* 5, no. 3 (May/June 1981): 2.

Ida Kohlmeyer: Thirty Years (Charlotte, NC: Mint Museum, 1983).

David W. Kiehl, *Ida Kohlmeyer: Recent Works* (Augusta, GA: Morris Museum of Art, 1996).

Michael Plante, *Ida Kohlmeyer: Systems of Color* (New York: Hudson Hills, in association with Newcomb Art Gallery, Tulane University, 2004).

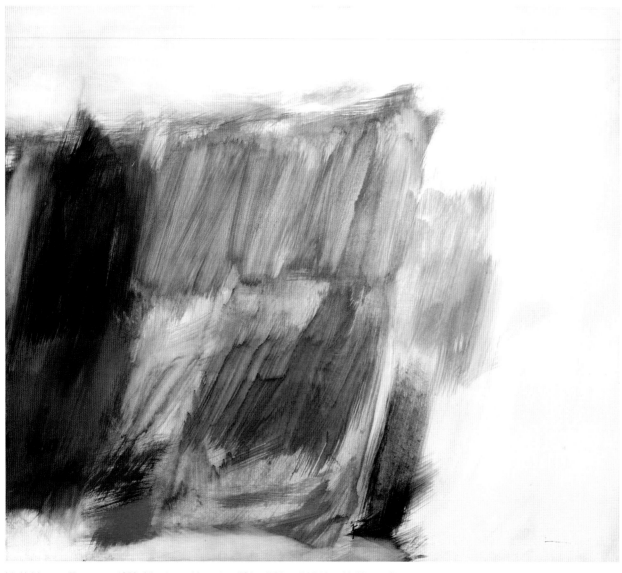

Ida Kohlmeyer, *Transverse,* 1959. Oil paint on Masonite, 41½ × 47½ in. (105.41 × 120.65 cm). Oklahoma City Museum of Art, Purchase Award, First Annual Southwest American Painting Exhibition.

LEE KRASNER
(b. 1908, Brooklyn, NY; d. 1984, New York)

Lee Krasner (born Lena Krassner) enrolled at the Women's Art School of Cooper Union in 1926 and briefly studied drawing at the Art Students League before receiving instruction at the National Academy of Design (1928–32). In the mid-1930s, Krasner worked with the Public Works of Art Project and in the mural division of the Federal Art Project/Works Progress Administration, which led to an unrealized public mural for radio station WNYC. In 1937, under the direction of Hans Hofmann at his school, she further integrated the principles of European abstraction and Cubism into her painting. She became a member of the American Abstract Artists group in 1939. Along with Jackson Pollock, she participated in *American and French Paintings* (1942) at McMillen Gallery, New York. Krasner also showed in *Abstract and Surrealist Art in America* at Sidney Janis Gallery, New York (1944), and *A Problem for Critics* at Howard Putzel's 67 Gallery, New York (1945). Krasner and Pollock married in 1945 and settled in Springs, in East Hampton, New York. Her first solo exhibition was held at Betty Parsons Gallery (1951) but was, in fact, a two-person show with Anne Ryan.

With Pollock's emerging success, Krasner struggled before she began the *Little Image* series in 1946. These paintings featured hieroglyphic configurations that referenced the processes of writing and calligraphy. In 1949, Krasner and Pollock exhibited together again at Sidney Janis's *Artists: Man and Wife*. Working in series, she continued in 1953–55 to make large collages, shown at the Stable Gallery (1955), incorporating organic forms and allusions to figures and executed by tearing and reusing old canvases and drawings, even Pollock's. After Pollock's death in 1956, she began her large *Earth Green* series in explosive, high-toned palettes suggestive of sexual, anthropomorphic components. In the early 1960s, the *Umber* paintings were larger and monochromatic, and culminated in a series of collage paintings from the mid- to late 1970s.

The Whitechapel Gallery, London, organized Krasner's first retrospective in 1965–66. She was the only woman shown in *Abstract Expressionism: The Formative Years* at the Whitney Museum of American Art in 1978. Before her death, she received a traveling retrospective organized by the Museum of Modern Art, New York (1983).

SELECTED READINGS

G. T. M. [Gretchen T. Munson], "Man and Wife," *ARTnews* (October 1949): 45.

Ellen G. Landau, "Lee Krasner's Early Career, Part One: 'Pushing in Different Directions,'" *Arts Magazine* 56 (October 1981): 110–22.

Ellen G. Landau, "Lee Krasner's Early Career, Part Two: The 1940s," *Arts Magazine* 56 (November 1981): 80–89.

Barbara Rose, *Lee Krasner: A Retrospective* (Houston and New York: Museum of Fine Arts and Museum of Modern Art, 1983).

Sandor Kuthy and Ellen G. Landau, *Lee Krasner, Jackson Pollock: Künstlerpaare, Künstlerfreunde; Dialogue d'artistes, Résonances* (Bern, Switz.: Trio-Verlag, 1989).

Robert Hobbs, *Lee Krasner* (New York: Abbeville, 1993).

Ellen G. Landau and Jeffrey D. Grove, *Lee Krasner: A Catalogue Raisonné* (New York: Harry N. Abrams, 1995).

Gail Levin, *Lee Krasner: A Biography* (New York: William Morrow, 2011).

Lee Krasner in her studio in East Hampton, N.Y., 1962.

ZOE LONGFIELD
(b. 1924; d. 2013)

Zoe Longfield received an undergraduate degree from the University of California, Berkeley (B.A., 1944), where she studied painting with Margaret Peterson and watercolor and gouache under John Haley and Erle Loran, both associated with the Berkeley School. She continued her education at the California School of Fine Arts from 1947 to 1949, a period during which Clyfford Still exerted considerable influence as an instructor and Mark Rothko taught during the summers of 1947 and 1949. Longfield joined Still's inner circle of students and was one of a few female artists granted admittance to his "graduate course," the West Coast's counterpart to New York's Subjects of the Artist School.

In April 1949, Longfield was part of the group of Still's students (along with Jeremy Anderson, Ernest Briggs, W. Cohantz, Hubert Crehan, Edward Dugmore, Jorge Goya, William Huberich, Jack Jefferson, Kiyo Koizumi, Frann Spencer, and Horst Trave) to open Metart Galleries in San Francisco's Chinatown. Metart was established as a cooperative and alternative venue, with members paying a small monthly fee to exhibit individually.

Zoe Longfield, c. 1948.

SELECTED READINGS

Press release for Metart Galleries, April 1949, Stable Gallery Papers, Archives of American Art, Smithsonian Institution, Washington, DC.

"Metart Gallery Experiment in Non-Commercial Exhibitions," *San Francisco Art Association Bulletin* 15 (September 1949): n.p.

"New Metart Is Opened in San Francisco," *Berkeley Daily Gazette,* September 22, 1949.

R. H. Hagan, "Around the Galleries," *San Francisco Chronicle,* December 11, 1949.

"Zoe Longfield," in *San Francisco and the Second Wave: The Blair Collection of Bay Area Abstract Expressionism,* by Scott Shields et al. (Sacramento, CA: Crocker Art Museum, 2004), 128–29.

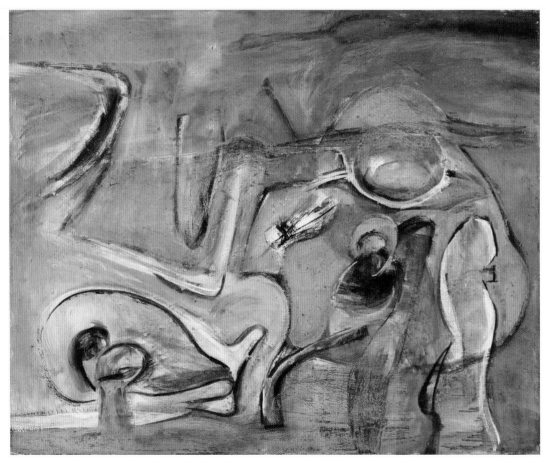

Zoe Longfield, *Untitled (Gray and Yellow Painting),* 1949. Oil paint on canvas, 26 × 32 in. (66.04 × 81.28 cm). Collection of Susie Alldredge.

MERCEDES CARLES MATTER

(b. 1913, New York; d. 2001, New York)

Mercedes Jeanne Carles was the daughter of American modernist Arthur B. Carles and Mercedes de Cordoba, a fashion illustrator and model for Edward Steichen. She was raised in New York, Philadelphia, and Europe. In summer 1932, she studied with Alexander Archipenko, and that fall joined Hans Hofmann's classes at the Art Students League, which resulted in an enduring friendship. Along with Hofmann, she spent the summer of 1933 in the artist community of Gloucester, Massachusetts.

By 1936, working in the mural division of the Federal Art Project of the Works Progress Administration, she was an assistant and translator for the group assigned to Fernand Léger on an unrealized project for the French Line pier on the Hudson River. Through Léger, she met Swiss-born graphic designer and photographer Herbert Matter (they married in 1941). In 1936, Mercedes Matter was a founding member of the American Abstract Artists group, exhibiting with them regularly until 1942. Both she and her husband were good friends with Jackson Pollock and Lee Krasner.

The couple was a strong presence at the Cedar Street Tavern and The Club, where Mercedes was one of the first female members and organized programs, including "Conversation with Lionel Abel" (1952). Matter's landscapes and colorful still lifes referenced the overarching spatial principles advanced in Hofmann's push-pull dynamics and surface-depth relationships. A prolific writer, Matter was an instructor and visiting critic at many universities. In 1953, she began teaching at the Philadelphia Museum School of Industrial Art (now University of the Arts, Philadelphia). In 1964, the New York Studio School of Drawing, Painting, and Sculpture was founded under her direction, where Matter organized courses around the teaching principles of Hans Hofmann. She taught well into her eighties.

SELECTED GROUP EXHIBITIONS

Abstract and Surrealist Art in America, Sidney Janis Gallery, New York (1944)
Stable Gallery, New York (1948–54)
Peridot Gallery, New York (1950–53)
Tanager Gallery, New York (1959)
Graham Gallery, New York (1964)

SELECTED SOLO EXHIBITIONS

Tanager Gallery, New York (1956)
Weintraub Gallery, New York (1963)
Brandeis University, Waltham, MA (1973)
Miami University, Oxford, OH (1975)
New York Studio School (1978)
Retrospective, *Mercedes Matter,* organized by Ellen G. Landau, Mishkin Gallery, Baruch College, NY, and traveled (2009–11)

SELECTED READINGS

Mercedes Matter, "Drawing," *It Is: A Magazine for Abstract Art* (winter/spring 1959).
Louis Finkelstein, "The Paintings and Drawings of Mercedes Matter," *Modern Painters* (autumn 1991).
Ellen G. Landau, "Action/Re-Action: The Artistic Friendship of Herbert Matter and Jackson Pollock" and "Appendix II: Chronology of the Relationship of the Matters and Pollocks," in *Pollock Matters* (Chestnut Hill, MA: McMullen Museum of Art, Boston College, distributed by University of Chicago Press, 2007).
Joan Marter, "Negotiating Abstraction: Lee Krasner, Mercedes Carles Matter and the Hofmann Years," *Woman's Art Journal* 28, no. 2 (fall/winter 2007): 35–40.
Ellen G. Landau et al., *Mercedes Matter* (New York: MB Art, 2009).

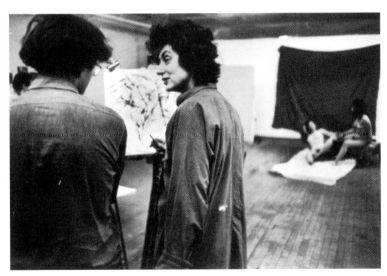

Mercedes Matter teaching, 1965.

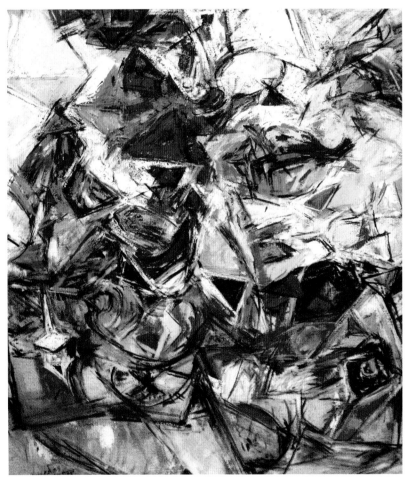

Mercedes Matter, *Tabletop Still Life,* 1952. Oil paint and charcoal on canvas, 36 × 30 in. (91.44 × 76.2 cm). Private collection.

JOAN MITCHELL
(b. 1925, Chicago; d. 1992, Paris)

Joan Mitchell was introduced to the visual arts, literature, and poetry by her mother, Marion Strobel Mitchell, co-editor of *Poetry* magazine. Mitchell attended weekend classes at the Art Institute of Chicago. At the Francis W. Parker School, she met her future husband, Barney Rosset; they married in 1949 and divorced in 1952, although they remained close friends. She graduated from the School of the Art Institute of Chicago (B.F.A. 1947; M.F.A. 1950). After a brief stay in New York, she departed for Paris in the spring of 1948. She spent the following year painting in Paris and in Le Lavandou, in Provence.

Back in New York in late 1949, Mitchell became a commanding presence in the downtown art scene and was invited to participate in the *Ninth Street Show* (1951). Her imposing character suited the younger generation of women artists, who positioned themselves with the senior Abstract Expressionists while forming close associations with a group of poets, such as Frank O'Hara and John Ashbery, and painters, such as Grace Hartigan. Upon her return to Paris in the summer of 1955, she began a complicated long-term relationship with painter Jean-Paul Riopelle. After 1959, she maintained her studio in Paris, first at rue Frémicourt and from 1968 in Vétheuil, a small village outside the city. During the late 1950s, Mitchell's critical success was further established when the Whitney Museum of American Art purchased *Hemlock* (1956), and the Museum of Modern Art acquired *Ladybug* (1957). Mitchell was the first recipient of the Distinguished Artist Award for Lifetime Achievement from the College Art Association (1988).

SELECTED GROUP EXHIBITIONS
Stable Gallery *Annuals,* New York (1953–57)
The New York School: Second Generation, Jewish Museum, New York (1957)
Nature in Abstraction: The Relation of Abstract Painting and Sculpture to Nature in Twentieth-Century American Art, Whitney Museum of American Art, New York (1958)
American Abstract Expressionists and Imagists, Solomon R. Guggenheim Museum, New York (1961)

SELECTED SOLO EXHIBITIONS
New Gallery, New York (1952)
Stable Gallery, New York (1952–58, 1961, 1965)
Joan Mitchell: Paintings, 1951–61, Southern Illinois University, Carbondale (1961)
My Five Years in the Country, Everson Museum of Art, Syracuse, NY (1972)
Whitney Museum of American Art, New York (1974)
The Paintings of Joan Mitchell: Thirty-Six Years of Natural Expressionism, Johnson Museum of Art, Cornell University, Ithaca, NY (1988–89), and traveled
The Paintings of Joan Mitchell, Whitney Museum of American Art, New York (2002–4)

SELECTED READINGS
Irving Sandler, "Mitchell Paints a Picture," *ARTnews* 56 (October 1957): 44–45.

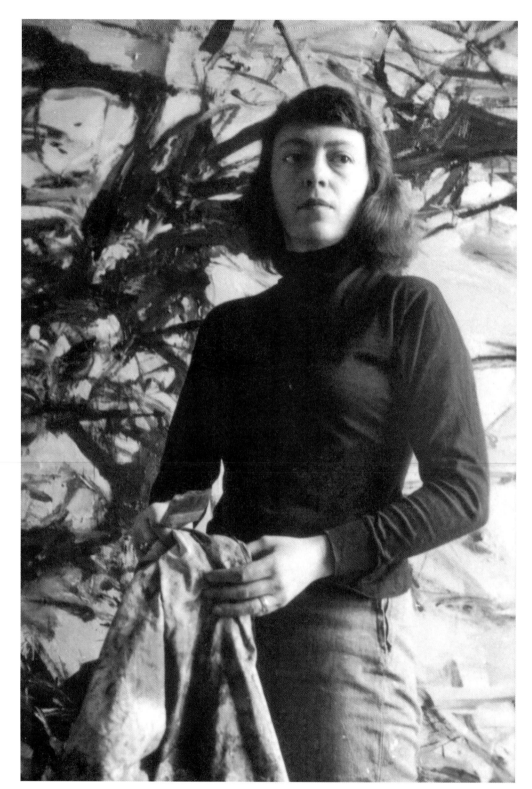

Joan Mitchell, 1957. Photograph by Rudy Burckhardt.

Judith E. Bernstock, *Joan Mitchell* (New York: Hudson Hills, 1988).
Michel Waldberg, *Joan Mitchell* (Paris: Éditions de la différence, 1992).
Joan Mitchell: Les Dernières Années, 1983–1992 (Paris: Galerie Nationale du Jeu de Paume, 1994).
Jane Livingston, ed., *The Paintings of Joan Mitchell* (Berkeley: University of California Press, 2002).
Patricia Albers, *Joan Mitchell: Lady Painter* (New York: Alfred A. Knopf, 2011).

EMIKO NAKANO
(b. 1925, Sacramento, CA; d. 1990, Richmond, CA)

During World War II, Emiko Nakano and her family were interned at Merced Assembly Center, in California, and Granada War Relocation Center (Camp Amache), in Colorado, as were many other Japanese-Americans. After the war ended, she moved to Richmond, California, and studied at the California School of Fine Arts under Elmer Bischoff, Edward Corbett, Richard Diebenkorn, James Budd Dixon, Hassel Smith, and Clyfford Still (1947–51). In the summer of 1949, she studied with Bauhaus émigré László Moholy-Nagy at the University of California, Berkeley. In 1952, she took classes at Mills College in Oakland, California.

Nakano supported herself primarily as a fashion illustrator as she pursued painting and printmaking.

She was recognized for her accomplishments in various media, including oils, watercolors, and printmaking, and her artwork was represented at West Coast annuals and elsewhere during the 1950s.

SELECTED GROUP EXHIBITIONS
Annual Oil and Sculpture Exhibition, San Francisco Art Association, San Francisco Museum of Art (1951–56, 1958–60)
Annual Drawing and Print Exhibition, San Francisco Art Association, San Francisco Museum of Art (1951–59, awarded prize 1953)
American Drawings, Watercolors, and Prints, Metropolitan Museum of Art, New York (1952)
San Francisco Women Artists annual exhibitions, San Francisco Museum of Art (1952, awarded prizes 1953, 1956)
Bay Region Painting and Sculpture, San Francisco Museum of Art (awarded prize 1955)

Emiko Nakano and Clayton Pinkerton, Richmond Art Center, CA (1955)
São Paulo Bienal, Brazil (1955)
Painting and Sculpture Now, San Francisco Museum of Art (1957)
Second Pacific Coast Biennial Exhibition of Paintings and Watercolors, Santa Barbara Museum of Art, CA (1957)
Fresh Paint—1958: A Selective Survey of Recent Western Painting, Stanford Art Gallery, Stanford University (1958)

SELECTED SOLO EXHIBITION
Crossing the Bridge: Emiko Nakano—Abstract Landscapes, Monterey Museum of Art, CA (2014–15)

SELECTED READINGS
Lawrence Ferling [Ferlinghetti], "San Francisco: Bay Area Roundup," *Arts Digest* (August 1, 1954): 16.
Michael D. Brown, *Views from Asian California 1920–1965, An Illustrated History* (San Francisco: Michael D. Brown, 1992).

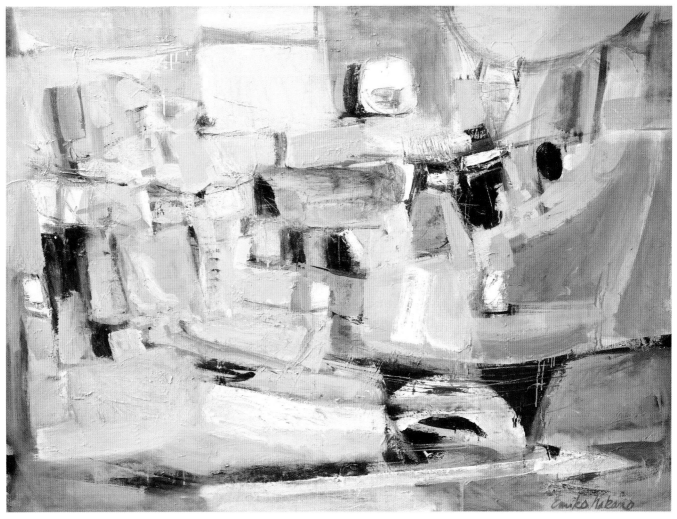

Emiko Nakano, *Composition in Yellow,* 1957. Oil paint on canvas, 34 × 46 in. (86.36 × 116.84 cm). Collection of David Keaton.

CHARLOTTE PARK

(b. 1918, Concord, MA; d. 2010, East Hampton, NY)

In 1939, Charlotte Park received an undergraduate degree in fine art from the Yale University School of Art. While working for the Office of Strategic Services in Washington, D.C., during World War II, she met James Brooks; they moved to New York in 1945 and married in 1947. In New York they rented a space formerly occupied by Jackson Pollock and Lee Krasner at 46 East Eighth Street. Park studied art privately with Wallace Harrison, who also instructed Brooks and Helen Frankenthaler.

Park and Brooks were frequent visitors to the Pollock/Krasner home in Springs, East Hampton, New York, and subsequently set up studios in Montauk, New York, in 1949 (much of their artwork was destroyed in a hurricane in 1954). Eventually they settled in East Hampton around 1957, while maintaining a small apartment in Manhattan. Park's formative series from the early 1950s uses shallow Cubist space and loose grids in limited color and black and white. These small paintings gradually developed into bold articulations of structure reliant on nature's vertical and horizontal planes, rhythmic lines, and vibrant fiery colors. In the late 1950s, she introduced collage, as had Lee Krasner, reusing previous works in her reconstructions. A series from the 1970s, based on the spatial theories of Piet Mondrian's Neo-Plasticism, reconsiders the relationships between expressionism and immaterial boundaries.

In later years, she received critical attention in exhibitions at the Parrish Art Museum, Southampton, New York (2002); in *Women of the '50s,* Anita Shapolsky Gallery, New York (1995); and in *Charlotte Park: The 1950s* at the Pollock-Krasner House and Study Center, East Hampton (2013).

SELECTED GROUP EXHIBITIONS
Invitational Show, Peridot Gallery, New York (1952)
Painting Annual, Whitney Museum of American Art, New York (1953)
Fifteen Artists of the Region, Guild Hall, East Hampton, NY, along with Franz Kline, Joan Mitchell, and Larry Rivers (1954)
Stable Gallery *Annuals,* New York (1954–57)

SELECTED SOLO EXHIBITIONS
Tanager Gallery, New York (1957)
Louise Himelfarb Gallery, Southampton, NY, jointly with James Brooks (1981)

SELECTED READINGS
D. A. [Dore Ashton], "Art: Gallery Pot-Pourri—Recent Abstractions by Charlotte Park Among Work on Exhibition Here," *New York Times,* November 8, 1957, 32.
Helen A. Harrison, "Art: Married Artists' Own Style," *New York Times,* August 23, 1981.

Charlotte Park in her Montauk, N.Y., studio, c. 1954. Photograph by Maurice Berezov.

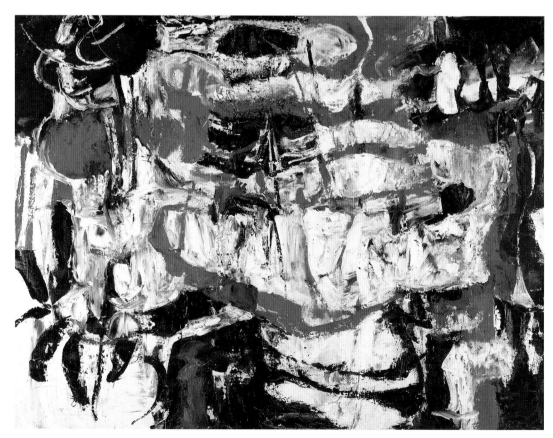

Charlotte Park, *Zachary,* 1955. Oil paint on canvas, 36 × 47 in. (91.44 × 119.38 cm). Private collection.

BETTY PARSONS
(b. 1900, New York; d. 1982, Southold, NY)

Raised in New York, Newport, and Palm Beach, Betty Bierne Pierson married Schuyler Livingston Parsons at age twenty, but they divorced three years later. For the next ten years, she lived in Paris and studied painting and sculpture at the Académie de La Grande Chaumière and in the studios of Émile-Antoine Bourdelle and Ossip Zadkine. In Montparnasse, she worked alongside Alberto Giacometti and associated with artists Alexander Calder and Romaine Brooks and poet Ezra Pound. In 1933, she had her first exhibition of watercolors and sculpture at the Galerie Quatre Chemins.

Returning to New York, she continued to exhibit watercolor landscapes, seascapes, and still lifes, but turned to abstractions in oil and acrylic in the late 1940s. Her paintings, many of which reference natural elements, feature biomorphic forms and lozenges levitating on muted color fields. She was also a sculptor; her later constructions combine painted wood made from materials collected near her studio in Southold, New York. After a solo show of watercolors in 1936 at Midtown Galleries, New York, she was offered her first gallery position. In the early 1940s, she managed the gallery in the Wakefield Gallery and Bookshop, where she exhibited the work of Hedda Sterne, Adolph Gottlieb, Alfonso Ossorio, and Theodoros Stamos, and then she managed Mortimer Brandt's modern section, showing Ad Reinhardt and Hans Hofmann.

As owner of the Betty Parsons Gallery from 1946 to 1982, she was renowned for her independent spirit and superior curatorial eye. From her earliest days, she cultivated an unparalleled roster of female and male artists. When Peggy Guggenheim's Art of This Century closed in 1947, Parsons secured Jackson Pollock, Mark Rothko, Clyfford Still, and eventually Barnett Newman (a significant friend who curated her inaugural show). She nurtured emerging artists such as Ellsworth Kelly and Agnes Martin from her short-lived annex Section Eleven (1958–60). She continued to promote women, including Chryssa, Perle Fine, Judith Godwin, Buffie Johnson, Adaline Kent, Lee Krasner, Jeanne Miles, Aline Porter, Anne Ryan, Ethel Schwabacher, Sonja Sekula, and Ruth Vollmer.

SELECTED SOLO EXHIBITIONS
Midtown Galleries, New York (1936–38, 1945, 1948, 1957–58)
Bennington College, VT (1966)
Grand Central Moderns, New York (1967)
Betty Parsons: Paintings, Gouaches and Sculpture, 1955–1968, Whitechapel Gallery, London (1968)
Studio Gallery, Washington, DC (1971, 1973, 1975)

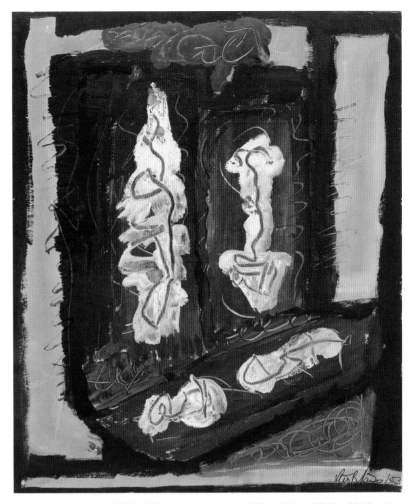

Betty Parsons, *Untitled (7124),* 1953. Gouache on paper, 16³/₄ × 14¹/₄ in. (42.55 × 36.20 cm). David Findlay Jr. Gallery, New York.

Betty Parsons Retrospective: An Exhibition of Paintings and Sculpture, Montclair Art Museum, NJ (1974)
Jill Kornblee/Jock Truman galleries, New York (1977)
Betty Parsons, Pollock-Krasner House, East Hampton, NY (1992)
Betty Parsons: A Painting Retrospective, Spanierman Gallery, East Hampton, NY (2006)

SELECTED READINGS
Lawrence Alloway, *Betty Parsons: Paintings* (Bennington, VT: Bennington College, 1966).
Lawrence Alloway, essay in *Betty Parsons: Paintings, Gouaches and Sculpture, 1955–1968* (London: Whitechapel Gallery, 1968).
Betty Parsons Retrospective: An Exhibition of Paintings and Sculpture (Montclair, NJ: Montclair Art Museum, 1974).
Lee Hall, *Betty Parsons: Artist, Dealer, Collector* (New York: Harry N. Abrams, 1991).
Ann Gibson, "Lesbian Identity and the Politics of Representation in Betty Parsons's Gallery," in *Gay and Lesbian Studies in Art History,* ed. Whitney Davis (New York: Haworth, 1994), 245–70.

Betty Parsons, c. 1951. Photograph by Erwin Blumenfeld.

PAT PASSLOF

(b. 1928, Brunswick, GA; d. 2011, New York)

Pat Passlof was raised in Queens, New York, where she studied briefly with art historian Robert Goldwater while at Queens College (1946–48). She later earned her B.F.A. degree at Cranbrook Academy of Art, Bloomfield Hills, Michigan (1951). In the summer of 1948, she attended Black Mountain College in North Carolina, where the faculty included Josef Albers, Buckminster Fuller, John Cage, Merce Cunningham, and M. C. Richards. Passlof was eager to work with the relatively unknown Willem de Kooning (a replacement for instructor Mark Tobey), who was accompanied by his wife, Elaine de Kooning. At Black Mountain, she attended de Kooning's still-life class and produced black-and-white abstractions similar to de Kooning's. In New York, Passlof took private lessons with de Kooning until 1950, and through him she met painter Milton Resnick, whom she married in 1961.

At the Eighth Street Club, Passlof organized popular yet short-lived evening sessions for younger artists and promoted the March Gallery (1957–60), one of the new cooperative galleries on Tenth Street. Passlof was a noted colorist. Her later series, exhibited from the 1970s to the 2000s, explore diverse compositions, from classicizing centaurs to the thickly painted grids of the series *Eighth House,* produced after Resnick's death in 2004.

A respected teacher, Passloff taught at Richmond College, CUNY, Staten Island, New York (1972–83), and College of Staten Island, CUNY, New York (1983–2010). She received a Guggenheim Fellowship (1999) and Award of Merit for Painting from the American Academy of Arts and Letters (2000).

SELECTED GROUP EXHIBITIONS
March Gallery, New York (two-person shows, 1957, 1959)

SELECTED SOLO EXHIBITIONS
Circle Gallery, Detroit (1952)
Green Gallery, New York (1961)
Globe Gallery, New York (1962, 1963)
Pat Passlof: Selections 1948–2011, Black Mountain College
 Museum and Arts Center, Asheville, NC (2012)
Pat Passlof: Paintings from the 1950s, Elizabeth Harris
 Gallery, New York (2014)

SELECTED READINGS
Pat Passlof, "Artist's Statement," *Artforum* (September
 1975): 30, 32.
Eleanor Heartney, "Tightening the Net: The Paintings of
 Pat Passlof," in *Pat Passlof: Selections 1948–2011*
 (Asheville, NC: Black Mountain College Museum and
 Arts Center, 2011), 1–7.

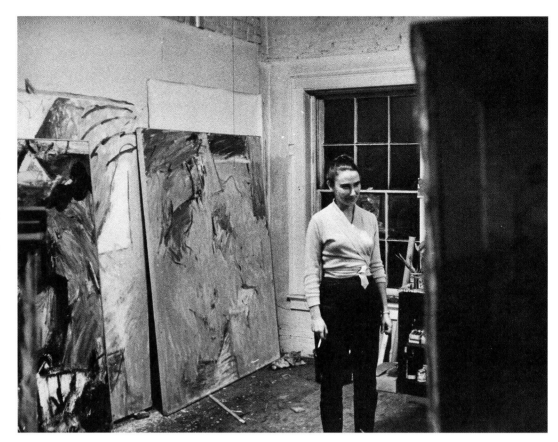

Pat Passlof in her studio. Behind her is *Score for a Bird* (fig. 2), 1958. Photograph by Jesse Fernandez.

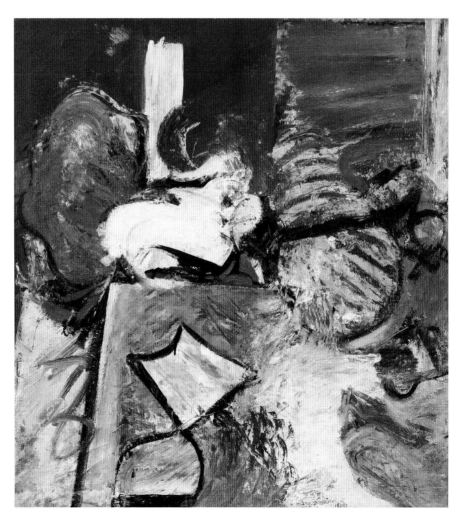

Pat Passlof, *Ionian,* 1956. Oil paint on linen, 35 × 32 in. (88.9 × 81.28 cm). The Milton Resnick and Pat Passlof Foundation; courtesy of Elizabeth Harris Gallery, New York.

VITA PETERSEN
(b. 1915, Berlin; d. 2011, New York)

Vita Petersen, c. 1940s.

Vita von Simson was born in Berlin to an aristocratic German Jewish family. Her father, Ernst von Simson, was German secretary of state in the 1920s, and her mother was a descendant of the philosopher Moses Mendelssohn. She was encouraged to pursue art by the celebrated painter Max Liebermann, a neighbor at the family's art-filled country estate on Lake Wannsee. She studied at the Munich School of Fine Arts and under Carl Hofer at the Berlin Academy. With the onset of Nazi regulations, she departed for New York in 1938. She married German-born Gustav Petersen and had a daughter in 1942. Hans Hofmann, an important teacher for Petersen, invited her to attend classes at his school, and her development was certainly influenced by his famous dictum regarding "push-pull" dynamics on the surface plane.

She met Mercedes Matter, who at that time also had a young child. Matter became a lifelong friend, and through her and her husband, Herbert, Petersen was introduced to many artists on the downtown circuit and those socializing at The Club. Nature—a primary experience from childhood—was a fundamental subject of her artwork, and she preferred to paint on a small scale, using watercolors, oil sticks, and pastels.

In the 1950s, Petersen exhibited in group shows at Tanager Gallery and Peridot Gallery, both in New York, and in 1958 had her first solo exhibition at Esther Stuttman Gallery, also in New York. In her later career, she showed at Betty Parsons Gallery, New York; Galerie von der Tann, Berlin; and Mark Borghi Fine Art, New York and Bridgehampton, New York. A revered teacher at the New York Studio School and a presence since its establishment by Matter in 1964, she was a member of its board of trustees until her death.

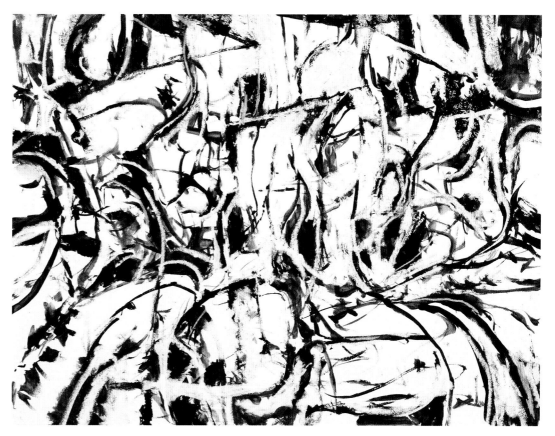

Vita Petersen, *Untitled #18,* 2011. Oil stick, pastel, and acrylic paint on paper, 12¼ × 16¼ in. (31.12 × 41.28 cm). Collection of Andrea Petersen.

LIL PICARD
(b. 1899, Landau, Germany; d. 1994, New York)

Lilli Elisabeth Benedick moved to Berlin in 1919 and married Fritz Picard in 1921 (they divorced in 1928). She befriended Berlin Dadaists and became a cultural reporter by the early 1930s for the *Berliner Tageblatt* and fashion editor for *Zeitschrift für Deutsche Konfektion.* Due to her Jewish background and the revocation of her press privileges, she immigrated to the United States in 1937. In New York, she was the owner of a custom-made millinery shop called De Lil. Her constructed hats were reproduced in the pages of *Vogue, Women's Wear Daily,* and other fashion magazines.

She began painting in 1939 and studied briefly in the summer at Hans Hofmann's school in Provincetown, Massachusetts. While many of her artworks from the 1950s stylistically emulated the expressive brushstrokes and gesturalism of Abstract Expressionism, Picard mined an autobiographical vein as well. She incorporated everyday objects (cosmetics, theater tickets) into her heavily layered, textured collages; in the 1960s, she turned to sculpture and assemblage.

In the 1950s, she resumed cultural reporting for German and American magazines such as *Die Welt, Das Kunstwerk,* and *Kunstforum International.* A pioneer of feminism in her production of "cosmetic destructions" and an early practitioner of sociopolitical performances, she staged her first public happening, *The Bed,* at Café au Go Go in New York in 1964. Her 1967 Vietnam War protest, *Construction-Destruction-Construction,* was held at Andy Warhol's Factory. She participated in more than forty group exhibitions, including those listed here.

SELECTED GROUP EXHIBITIONS
New Forms—New Media, Martha Jackson Gallery, New
 York (1960)
12 Evenings of Manipulations, Judson Gallery, New York (1967)

SELECTED SOLO EXHIBITIONS
Retrospective, Goethe House, New York (1976)
Retrospective, Neuer Berliner Kunstverein, Berlin (1978)
Retrospective, *Lil Picard and Counterculture New York,*
 organized by University of Iowa Museum of Art and
 traveled to Grey Art Gallery, New York University (2011)

SELECTED READINGS
L. C. [Lil Picard], *ARTnews* 54, no. 5 (September 1955): 52.
Kathleen A. Edwards, *Lil Picard and Counterculture New York*
 (Iowa City: University of Iowa Museum of Art, 2010).

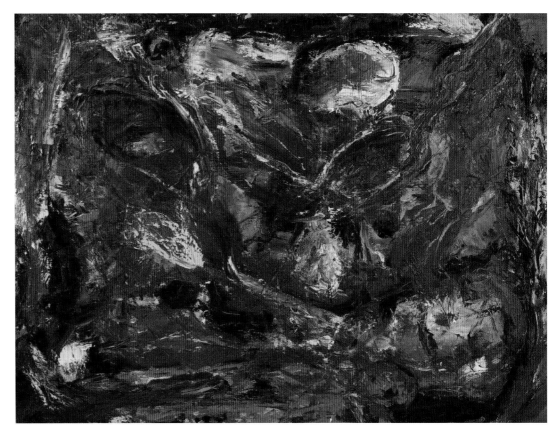

Lil Picard, *Resurrection,* 1955. Oil paint on canvas, 30 × 40 in. (76.2 × 101.6 cm). Lil Picard Collection, University of Iowa Museum of Art, Iowa City.

Portrait of Lil, c. 1970. Lil Picard Papers, University of Iowa Libraries, Iowa City. Photograph by Andy Warhol.

DEBORAH REMINGTON

(b. 1930, Haddonfield, NJ; d. 2010, Moorestown, NJ)

As a teenager, Deborah Remington enrolled in painting and drawing classes at the Philadelphia Museum School of Industrial Art (now University of the Arts, Philadelphia). She attended high school and junior college in Pasadena, California, where she befriended Wally Hedrick, John Ryan, and David Simpson. Remington enrolled briefly at the Otis Art Institute, Los Angeles (now Otis College of Art and Design). In 1947, she entered the California School of Fine Arts (B.F.A., 1955) and studied with Elmer Bischoff, Edward Corbett, David Park, Hassel Smith, Clay Spohn, and Clyfford Still. She also frequented teacher James Budd Dixon's studio in North Beach, San Francisco. Unbeknownst to many, Remington was a distant cousin of American artist Frederic Remington.

Remington was affiliated with a younger set of San Francisco Bay Area Abstract Expressionists, including Joan Brown, Jay DeFeo, Madeleine Dimond, Lilly Fenichel, and Sonia Gechtoff. The cooperative King Ubu Gallery opened on Fillmore Street in 1953; that same year, the gallery mounted *Deborah Remington/ Jorge Goya*. The space reopened in 1954 as the Six Gallery, co-founded by Remington (the only female) and Wally Hedrick, Hayward King, David Simpson, John Allen Ryan, and Jack Spicer. Located across from the East and West Gallery, Six Gallery was a receptive environment for collaboration across multiple disciplines, and the place where Beat poet Allen Ginsberg first read *Howl* in public.

From 1956 to 1958, Remington traveled to Asia. She studied Chinese and Japanese calligraphy and *sumi-e* painting in Japan and visited Cambodia, Thailand, Burma, and India. Upon her return, she experimented with gestural abstraction based on direct observations from nature, combining this with what some critics have referred to as kimono-like or heraldic imagery, as in her series of *Early Adelphi* drawings. By the mid-1960s, a notable shift occurred toward a polished and optically reflective surface. She taught art at San Francisco Art Institute (1960–65), University of California, Davis (1962), and San Francisco State College (1965). In 1965, she relocated to New York and later taught at Cooper Union (1973–97) and New York University (1994–99).

SELECTED GROUP EXHIBITIONS

Annual Drawing and Print Exhibition, San Francisco Museum of Art (1952, 1953)

Six Gallery, San Francisco, inaugural group exhibition (1954)

SELECTED SOLO EXHIBITIONS

Dilexi Gallery, San Francisco (1962, 1963 [Los Angeles], 1965)

Bykert Gallery, New York (1967, 1969, 1972, 1974)

Galerie Darthea Speyer, Paris (1968, 1971, 1973)

Retrospective, Newport Harbor Art Museum (now Orange County Museum of Art), Newport Beach, CA (1984)

SELECTED READINGS

James Monte, "Exhibition at Dilexi Gallery," *Artforum* 1 (December 1962): 48.

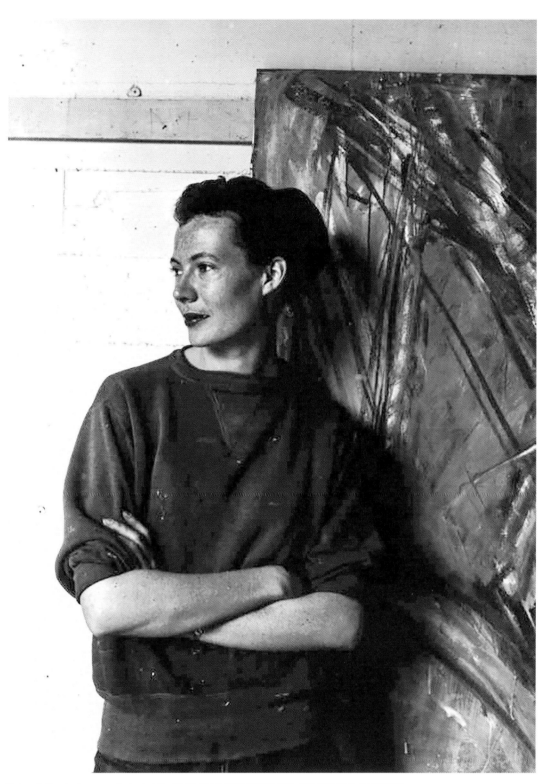

Deborah Remington as a student at the California School of Fine Arts, San Francisco, April 1955.

Constance Perkins, "Deborah Remington Shows Art with Dynamic Vitality," *Los Angeles Times,* February 11, 1963.

D. M., "Exhibition at Dilexi Gallery," *Artforum* 1 (May 1963): 48.

Deborah Remington, interview by Paul Cummings, May 29– July 19, 1973, Oral History Archives, Archives of American Art, Smithsonian Institution, Washington, DC.

Mary Fuller McChesney, *A Period of Exploration: San Francisco 1945–1950* (Oakland, CA: Oakland Museum, 1973).

Paul Schimmel and Dore Ashton, *Deborah Remington: A 20-Year Survey* (Newport, CA: Newport Harbor Art Museum, 1984).

ANNE RYAN

(b. 1889, Hoboken, NJ; d. 1954, Morristown, NJ)

After raising a family, Anne Ryan moved to New York and began painting in 1938, and in 1941 she had her first solo show at Pinacotheca Gallery and began printmaking classes at Stanley William Hayter's Atelier 17. She was known for her small-scale collages (she created about four hundred of these between 1948 and 1954), which she was inspired to produce after viewing an exhibition of collages by Kurt Schwitters at Rose Fried Gallery, New York, in 1948. Her newfound medium reflected a poetic and individual approach, a stark contrast to the heroic gestures that characterized her fellow artists associated with the New York School. Yet her compositional arrangements and networks of geometric and linear shapes; layered, textured surfaces; and planar, colored fields clearly related to abstraction's expressive potential. She emphasized the material qualities of her media, using cut and torn handmade papers by Douglass Howell, old fabric strips, and ribbon and thread, among other media.

Ryan exhibited her artwork at the Marquie Gallery, New York, in 1943, 1944, 1946, and 1948, and at two-person shows at Betty Parsons Gallery in 1950 and 1951 (the latter with Lee Krasner). She also had individual shows at Betty Parsons in 1954 and 1955. She was included in *Abstract Painting and Sculpture in America* and *Some American Prints, 1945–1950* in 1951; the *Ninth Street Show: Exhibition of Paintings and Sculpture;* Whitney Museum of American Art *Annuals* (1951, 1953–54); and *The Art of Assemblage,* Museum of Modern Art (1961). In 2010, *The Prismatic Eye: Collages by Anne Ryan, 1948–1954* was shown at the Metropolitan Museum of Art.

SELECTED READINGS

Anne Ryan, "The Ideas of Art: 11 Graphic Artists Write," *The Tiger's Eye* 1 (1949): 55–56.

Sarah Faunce, *Anne Ryan: Collages* (New York: Brooklyn Museum, 1974).

John Bernard Myers, "Anne Ryan's Interior Castle," *Archives of American Art Journal* 15, no. 3 (1975): 8–11.

Elizabeth McFadden, "Anne Ryan: A Personal Remembrance," unpublished manuscript, c. 1982–83, Archives, Metropolitan Museum of Art, New York.

Deborah Solomon, "Art: The Hidden Legacy of Anne Ryan," *The New Criterion* (January 1989): 55.

Alison Bowman, "Out of the Ordinary: Anne Ryan and Collage" (master's thesis, School of Art and Art History, University of Denver, 2010).

Anne Ryan, *Small Red Collage,* 1953. Textile collage on paper, 11⅝ × 9⅞ in. (29.53 × 25.08 cm). The Newark Museum, N.J. Gift of Elizabeth McFadden, 1956, 56.165.

Anne Ryan, c. 1949. Photograph by William Pippin.

ETHEL SCHWABACHER
(b. 1903, New York; d. 1984, New York)

Between 1918 and 1927, Ethel Kramer took classes
at the Art Students League from various instructors,
including Robert Laurent and Max Weber. She also
studied at the National Academy of Design, in 1920
and 1921, and in 1923 apprenticed with sculptor Anna
Hyatt Huntington. From 1928 to 1934, she painted
in France. In 1935, she had her first solo exhibition at
Georgette Passedoit Gallery, New York, and in the
same year married Wolfgang Schwabacher, a success-
ful lawyer; they had two children.

Between 1934 and 1936, she was a private student
of Arshile Gorky. Although Schwabacher later worked
independently, Gorky remained an important source
for critical commentary, and they developed a deep
relationship. After Gorky's death in 1948, she helped
organize his memorial exhibition at the Whitney
Museum, curated additional exhibitions at Princeton
University Art Museum and the Venice Biennale, and
in 1957 authored the first authoritative monograph
on the artist.

Schwabacher's paintings from the 1950s explore
psychological aspects of the landscape, creativity,
and maternity, informed by her own psychoanalysis.
These prominent themes relate to her life but also
represent broader psychological experiences of
womanhood and feminine identity. Her paintings
from the mid-1940s, while showing the influence of
Gorky and Surrealism, explore gardens as sites for
fantasies and childhood visions. The formal vocabulary
of Surrealism and its basis in the Freudian uncon-
scious and dream states were important influences.
Schwabacher's paintings from the late 1950s also
reveal her interest in tragic and mythic Greek themes.

SELECTED GROUP EXHIBITIONS
*Nature in Abstraction: The Relation of Abstract Painting and
 Sculpture to Nature in Twentieth-Century American Art*,
 Whitney Museum of American Art, New York (1958)
*60 American Painters, 1960: Abstract Expressionist Painting
 of the Fifties*, Walker Art Center, Minneapolis (1960)
Joint exhibition with Jeanne Reynal, Bodley Gallery, New
 York (1976)

SELECTED SOLO EXHIBITIONS
Georgette Passedoit Gallery, New York (1935, 1947)
Betty Parsons Gallery, New York (1953, 1956, 1957, 1960)
Zimmerli Art Museum, Rutgers University, New Brunswick,
 NJ (1987–88)

SELECTED READINGS
Lloyd Goodrich, *Ethel Schwabacher: Paintings and Glass
 Collages, 1951–53* (New York: Betty Parsons Gallery, 1953).
Ethel Schwabacher, "Formal Definitions and Myths in My
 Painting," *Leonardo* 6 (winter 1973): 53–55.

Ethel Schwabacher, 1950s. Photograph by Richard Pousette-Dart.

Mona Hadler, "Ethel Schwabacher and the Paradise of the
 Real," in *Ethel Schwabacher: A Retrospective Exhibition*
 (New Brunswick, NJ: Jane Voorhees Zimmerli Art
 Museum, 1987).
Judith Johnson, Jayne Walker, and Brenda Webster, "Ethel
 Schwabacher: The Lyric/Epic and the Personal," *Woman's
 Art Journal* 10 (spring/summer 1989): 3–9.
Brenda S. Webster and Judith Emlyn Johnson, eds.,
 introduction to *Hungry for Light: The Journal of Ethel
 Schwabacher*, by Ethel Schwabacher (Bloomington:
 Indiana University Press, 1993).

SONJA SEKULA

(b. 1918, Lucerne; d. 1963, Zurich)

Sonja (also known as "Sonia") Sekula (sometimes spelled "Secula") studied art in Hungary and Italy in 1934, and in 1936 she arrived in the United States with her family. She studied privately with George Grosz in 1937 and attended Sarah Lawrence College for two years before enrolling in 1941 at the Art Students League, where she studied with Morris Kantor and Raphael Soyer. She became a central figure in Surrealist émigré circles, befriending André Breton, Max Ernst, and Roberto Matta, and she contributed a drawing and text to the Surrealist magazine *VVV* (edited by David Hare). She later exhibited in the *Exposition Internationale du Surréalisme,* organized by Breton and Marcel Duchamp at Galerie Maeght, Paris.

In 1943, Sekula was included in Peggy Guggenheim's *Exhibition by 31 Women* at Art of This Century Gallery in New York (along with Hedda Sterne and Buffie Johnson), followed in the same year by *Spring Salon for Young Artists* (which also included the Abstract Expressionists Perle Fine, Hedda Sterne, William Baziotes, Robert Motherwell, Jackson Pollock, and Ad Reinhardt), and in 1945 by *The Women* (with Fine, Sterne, Janet Sobel, and Louise Bourgeois). In 1946, in her first solo exhibition at Art of This Century, she showed her *Night Paintings* and gouaches. Her paintings featured various styles and references— Paul Klee and Surrealist automatism, totems, Native American art—and labyrinthine, calligraphic surfaces. That both Matta and Motherwell were significant references underscores her penetrating combination of European Surrealism and American Abstract Expressionism.

In the mid-1940s, she made multiple trips to Mexico and in 1946 to New Mexico, and she made frequent trips to Europe throughout the 1950s. Tragically, she suffered chronic psychological breakdowns and committed suicide at age forty-five.

SELECTED GROUP EXHIBITIONS
8 and a Totempole, Galerie Neuf, New York (1946)
Betty Parsons Gallery, New York (1949, 1952, 1954, 1976)
Annual Exhibition of Contemporary American Painting, Whitney Museum of American Art, New York (1950, 1956)
Ninth Street Show, New York (1951)

SELECTED SOLO EXHIBITIONS
Betty Parsons Gallery, New York (1948–49, 1951–52, 1957)
Sonja Sekula: A Retrospective, Swiss Institute, New York (1996)

SELECTED READINGS
Sonia Sekula, "Journals," in Nancy Foote, "Who Was Sonia Sekula," *Art in America* 59 (September–October 1971): 76–78, 80.
Ann Gibson, "Universality and Difference in Women's Abstract Painting: Krasner, Ryan, Sekula, Piper, and Streat," *Yale Journal of Criticism* 8 (spring 1995): 103–32.
Dieter Schwarz and Roger Perret, *Sonja Sekula, 1918–1963* (Winterthur, Switz., and New York: Künstmuseum Winterthur and the Swiss Institute, 1996).

Sonja Sekula, *The Burning Forest,* 1949 (detail). Gouache, ballpoint pen, ink, and graphite on paper, sheet: 16¹⁵⁄₁₆ × 13³⁄₄ in. (43 × 35 cm); image: 10¹⁄₄ × 8³⁄₁₆ in. (26 × 20.8 cm). Collection Zimmerli Art Museum at Rutgers University, New Brunswick, N.J. Gift of Betty Parsons Foundation, 85.060.122.

Sonja Sekula in Northport, N.Y., c. 1945. Photograph by André de Dienes.

JANET SOBEL

(b. 1894, Ekaterinoslav, Ukraine; d. 1968,
Plainfield, NJ)

Janet Sobel (born Jennie Lechovsky) fled the pogroms
in her native Ukraine and immigrated to the United
States in 1908. She married at sixteen and raised a
family of five children in Coney Island and Brighton
Beach, Brooklyn. In 1939, at age forty-five, she began
making condensed and heavily outlined figurative
compositions and colorful landscapes. In 1943, Sidney
Janis included her in his show *American Primitive
Painting of Four Centuries,* held at the Arts Club of
Chicago. The following year, he reproduced her
painting *Music* (1944, private collection) in his book
Abstract and Surrealist Art in America, while including
her in his related show at Mortimer Brandt Gallery,
New York, along with Jackson Pollock, Mark Tobey,
and "Lenore Krassner" (Lee Krasner).

Around 1944, Sobel transitioned to greater
abstraction and received her first solo exhibition at
Puma Gallery on Fifty-Seventh Street. She was also
included in a group show at Norlyst Gallery, New York.
In 1945, Sobel participated in *The Women* at Peggy
Guggenheim's Art of This Century Gallery in New
York, followed by a solo show at the same gallery in
1946, for which Sidney Janis wrote the exhibition
brochure. In addition to painting on glass, she
combined sand with her oils and enamels (obtained
from her husband's costume jewelry business). She
achieved an "allover" distribution by rapidly pouring
or blowing her paint through a glass pipette, a
process that attracted the attention and approval of
both Pollock and critic Clement Greenberg. Critically
labeled as "primitive" or "decorative," and cautiously
granted recognition in abstract circles, Sobel was
arguably one of the first artists to apply paint through
an "automatic" and "allover" drip technique.

SELECTED READINGS

Sidney Janis, "Janet Sobel," in *Paintings by Janet Sobel*
 (New York: Art of This Century Gallery, 1946), 2–19.
Janet Sobel, interview by Bill Leonard, "This Is New York,"
 broadcast on WCBS, December 16, 1946.
Gail Levin, "Janet Sobel: Primitivist, Surrealist, and Abstract
 Expressionist," *Woman's Art Journal* 26, no. 1 (spring/
 summer 2005): 8–14.

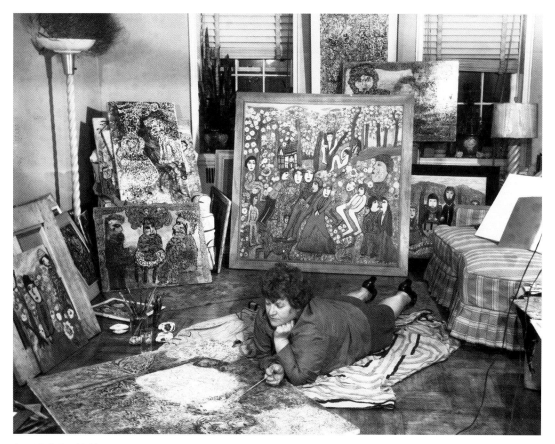

Janet Sobel, c. 1944.

Janet Sobel, *Untitled,*
c. 1946–48. Oil paint and
enamel on canvas, 18 ×
14½ in. (45.7 × 36.8 cm).
San Diego Museum of Art,
Museum purchase with
funds provided by
Suzanne Figi and Mrs.
Norton S. Walbridge.

VIVIAN SPRINGFORD
(b. 1914, Milwaukee; d. 2003, New York)

Vivian Springford moved as a child to New York, where she was educated at the Spence School before studying at the Art Students League. Although she began her career as a portraitist and illustrator, her work was familiar to artists of the New York School and championed in the late 1950s and early 1960s by critics such as Howard DeVree and Harold Rosenberg. An important relationship with Asian-American poet and abstractionist Walasse Ting, with whom she shared a studio for a decade, introduced her to Eastern philosophy and Chinese painting. This friendship was evident in her preference for rhythmic, calligraphic line on unprimed canvas, spatially balanced by the dominant injection of black. She also developed close relationships with painters Pierre Alechinsky, Sam Francis, and Karel Appel. Her "stain" paintings from the 1970s and 1980s, which seem to blossom out from one central point on the canvas, achieve a translucent aura through vivid color and amorphous shapes.

In 1960, Springford had a well-received first solo exhibition at Great Jones Gallery, New York, organized by Rosenberg. Another solo show followed at New York's Preston Gallery in 1963. Thereafter she became very private and resisted career promotion and gallery representation. Later in life, she suffered from macular degeneration, which left her legally blind by the mid-1980s. She was rediscovered when a social worker showed her work to gallerist Gary Snyder, who began exhibiting her artwork in 1998. Fortunately, she lived long enough to experience a revival of her career.

SELECTED SOLO EXHIBITIONS
Great Jones Gallery, New York (1960)
Preston Gallery, New York (1963)
Snyder Fine Art, New York (1998)
Gary Snyder Project Space, New York (2009)
Vivian Springford: A Painting Retrospective, Peyton Wright
 Gallery, Santa Fe, NM (2014)
Vivian Springford: Works from the Estate, McCormick
 Gallery, Chicago (2014)

Vivian Springford, c. 1934.

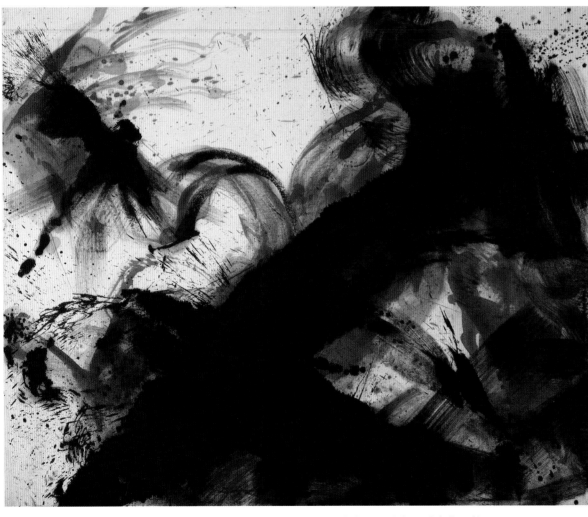

Vivian Springford, *Untitled,* 1958–59. Oil paint on canvas, 57½ × 66 in. (146.05 × 167.64 cm). McCormick Gallery, Chicago.

HEDDA STERNE

(b. 1910, Bucharest; d. 2011, New York)

Raised in a Jewish family, Hedwig Lindenberg studied art history and philosophy at the University of Bucharest before leaving for Paris in 1930, where she attended Fernand Léger's atelier. She married Fritz Stern, and after they divorced, she retained his last name but added an "e." In 1938, she submitted a collage to the *11th Exposition du Salon des Surindépendents,* Paris, after which Hans Arp and Victor Brauner brought her to the attention of Peggy Guggenheim. With the onset of World War II, she left Paris and returned to Bucharest, escaped a Nazi roundup, and arrived in the United States in 1941. She cultivated friendships with émigré artists, among them Piet Mondrian, Marcel Duchamp, and André Breton, and consequently exhibited in important exhibitions. She showed Surrealist works in the *First Papers of Surrealism* (1942) and was also included in several group exhibitions at Peggy Guggenheim's Art of This Century Gallery in New York: *Exhibition of Collage, Exhibition by 31 Women,* and *Spring Salon for Young Artists* (all 1943) and *The Women* (1945). In 1943,

Sterne met Betty Parsons through Saul Steinberg, the *New Yorker* cartoonist whom she married in 1944 (separated 1960). Parsons offered Sterne her first solo exhibition at the Wakefield Gallery and Bookshop, followed by another at Mortimer Brandt Gallery (1945), and soon thereafter at Betty Parsons Gallery (1947).

Renowned as the only female artist in Nina Leen's *Life* magazine photograph, captioned "The Irascibles" by Emily Genauer, Sterne was posed perched above a scrum of male artists associated with Abstract Expressionism, all of whom signed a protest against the policies of the Metropolitan Museum of Art (see page 155). Yet Sterne did not consider herself a member of this group. Her art included structures, patterns, and geometric abstractions, and she was criticized for working in both abstraction and figuration. Some paintings featured agricultural machines that she called "anthrographs," and she also used a commercial spray gun to make abstracted views of highways in which she attempted to depict the motion of cars (1940s–50s).

SELECTED GROUP EXHIBITIONS

Young Painters in U.S. and France, Sidney Janis Gallery, New York (1950)

Annual Exhibition of Contemporary American Painting, Whitney Museum of American Art, New York (1950, 1958)

Contemporary Painting in the United States, Los Angeles County Museum of Art (1951)

Annual Exhibition of Painting and Sculpture, Stable Gallery, New York (1954, 1955)

American Artists Paint the City, Venice Biennale, curated by Katherine Kuh (1956)

SELECTED SOLO EXHIBITIONS

Betty Parsons Gallery, New York (1953–78)

Saidenberg Gallery, New York (1956)

Retrospective, Queens Museum, NY (1985)

Retrospective, Montclair Art Museum, NJ (1997)

Retrospective, Krannert Art Museum, University of Illinois, Urbana-Champaign (2006)

SELECTED READINGS

Sarah L. Eckhardt, "Consistent Inconsistency: Hedda Sterne's Philosophy of Flux," in *Uninterrupted Flux: Hedda Sterne, A Retrospective,* by Eckhardt et al. (Urbana-Champaign: Krannert Art Museum and Kinkead Pavilion, University of Illinois at Urbana-Champaign, 2006).

Joan Simon, "Hedda Sterne," *Art in America* 95 (February 2007): 110–59.

Hedda Sterne, 1950. Photograph by Gijon Mili, *Life* magazine.

Hedda Sterne, *No. 3–1957,* 1957. Oil paint on canvas, 86⅛ × 50¼ in. (218.76 × 127.64 cm). Virginia Museum of Fine Arts, Richmond. John Barton Payne Fund.

ALMA THOMAS

(b. 1891, Columbus, GA; d. 1978, Washington, DC)

Alma Thomas's family moved to Washington, D.C., in 1907 to escape the segregation and discrimination of the South. Over her lifetime, Thomas remained in the same family residence and produced many of her artworks from her kitchen studio. In 1921, she enrolled at Howard University to study costume design. Under the guidance of her instructor and future mentor, James V. Herring, Thomas became the first graduate of the school's newly established fine arts program, earning a bachelor's degree in 1924. From 1925 until her retirement in 1960 she taught art at Shaw Junior High School in Washington, D.C., and organized the school's art club. She earned an M.A. in art education in 1934 by attending summer classes at Columbia University Teachers College.

In 1943, Herring and Alonzo J. Aden established Barnett-Aden Gallery to represent a diverse roster of artists. Thomas was a board member and the gallery's vice-president. From 1946 to 1950, she was a member of the local artists' group the "Little Paris Studio," organized by Lois Mailou Jones and Céline Tabary. She took painting classes at American University between 1950 and 1960 with Ben (Joe) Summerford, Robert Gates, and Jacob Kainen. In 1958, she traveled in Western Europe through an affiliation with the Tyler School of Art of Temple University, in Philadelphia.

After an extended period of still-life painting and study of color theory, in the 1960s she turned to abstraction and became known for her vibrant, chromatic paintings. Her works, often executed in series, are marked by concentric circles, layered geometries, and mosaic patterns drenched with color and light. Additional abstractions are inspired by observations based on the Earth, science, and space.

Thomas showed in group exhibitions in the 1950s. She received the first retrospective of work by an African American woman at the Whitney Museum of American Art (1972). Later that year, the Corcoran Gallery of Art in Washington, D.C., opened an even larger exhibition.

SELECTED SOLO EXHIBITIONS

DuPont Theatre Art Gallery, Washington, DC (1960)

Alma Thomas: A Retrospective Exhibition (1959–1966), Howard University Gallery of Art, Washington, DC (1966)

Franz Bader Gallery, Washington, DC (1968)

Alma W. Thomas: Paintings, Martha Jackson Gallery, New York (1973)

Alma W. Thomas: A Retrospective of the Paintings, Fort Wayne Museum of Art, IN (1998), and traveled

SELECTED READINGS

Howard University Gallery of Art, *Alma W. Thomas: A Retrospective Exhibition (1959–1966)* (Washington, DC: Gallery of Art, Howard University, 1966).

Harold Rosenberg, "The Art World: Being Outside," *New Yorker,* August 22, 1977, 83–86.

Merry A. Foresta, *A Life in Art: Alma Thomas, 1891–1978* (Washington, DC: Smithsonian Institution, 1981).

Alma W. Thomas: A Retrospective of the Paintings (Rohnert Park, CA: Pomegranate, in association with the Fort Wayne Museum of Art, 1998).

Alma Thomas working in her studio, c. 1968. Photograph by Ida Jervis.

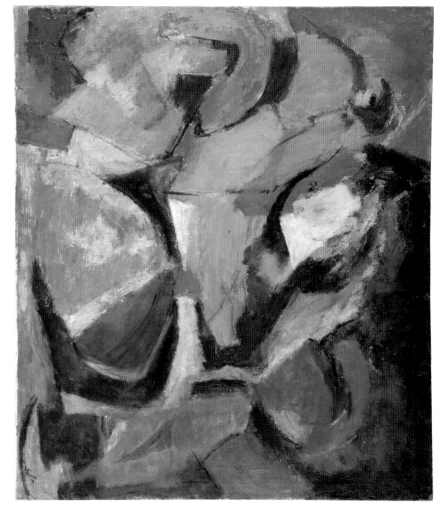

Alma Thomas, *The Stormy Sea,* 1958. Oil paint on canvas, 48¹⁄₈ × 41⁷⁄₈ in. (122.24 × 106.36 cm). Smithsonian American Art Museum, Washington, D.C. Gift of the artist.

YVONNE THOMAS

(b. 1913, Nice, Fr.; d. 2009, Aspen, CO)

Yvonne Thomas moved to the United States from southern France in 1925. In the 1930s, she left a promising career as a commercial artist and fashion illustrator to paint full time. In New York, she trained at Cooper Union, and in 1940 she attended the Art Students League and studied with Vaclav Vytlacil. Thomas also had private lessons with Dimitri Romanovsky (a Russian artist specializing in nudes and portraiture) and attended the Ozenfant School of Fine Arts. In 1948, through an introduction by Patricia Matta, wife of Surrealist painter Roberto Matta, she enrolled in the experimental Subjects of the Artist School (organized by William Baziotes, David Hare, Robert Motherwell, Barnett Newman, Mark Rothko, and Clyfford Still), a liberating and transformative experience in her development as a painter. She continued lessons with Motherwell into 1949, subsequently attending the Artists Club. In the summer of 1950, she enrolled in classes at Hans Hofmann's school in Provincetown, Massachusetts.

Preferring mid- to large-scale canvases, Thomas strongly emphasized the inherent and symbolic meaning found in color relationships, and her structured yet expansive gestural paintings are known for their puzzle-like shapes, divisions, and tensions. After visiting Aspen, Colorado, with her husband, she maintained close ties to its cultural and artistic community. In her later years, she showed in group exhibitions at Anita Shapolsky Gallery, New York.

SELECTED GROUP EXHIBITIONS
American Abstract Artists, New York (1948)
Tanager Gallery, New York (1948, 1956)
Stable Gallery *Annuals,* New York (1953–57)
Rose Fried Gallery, New York (1954, 1965)
Zabriskie Gallery, New York (1958)
*Abstract Expressionism: Second to None: Six Artists of the
 New York School,* McCormick Gallery, Chicago (2001)

SELECTED SOLO EXHIBITIONS
Tanager Gallery, New York (1956)
Esther Stuttman Gallery, New York (1960)
Journeys Part I and Part II, Cornell DeWitt Gallery,
 New York (2001)
Yvonne Thomas: New York Paintings from the 1950s,
 McCormick Gallery, Chicago (2002)

SELECTED READINGS
N. Hale, "Yvonne Thomas," *Arts Magazine* 55, no. 10 (1981): 12.
Lawrence Campbell, "Review of Exhibitions: Yvonne Thomas
 at Philippe Briet," *Art in America* 80, no. 1 (1992): 112.

Yvonne Thomas in her New York studio, 1972.

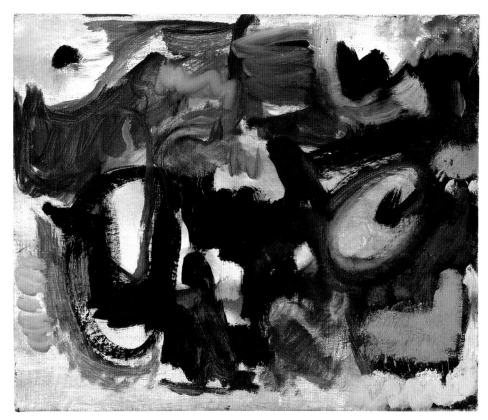

Yvonne Thomas, *Composition,* 1952. Oil paint on canvas, 14 × 17 in. (35.56 × 43.18 cm). Private collection.

MICHAEL WEST
(b. 1908, Chicago; d. 1991, New York)

Corinne Michelle West enrolled at the Art Academy of Cincinnati (1927–29) and then, in 1932, moved to New York, where she attended Hans Hofmann's classes at the Art Students League along with Mercedes Carles (Matter), Harry Holtzman, Betty Parsons, Louise Nevelson, and Irene Rice Pereira, among others. While Hofmann was an influential instructor for her, West also took courses with Raphael Soyer and Kenneth Hayes Miller. She was introduced around 1932–33 to painter Arshile Gorky and entered into an intellectual and personal relationship central to the development of both artists. Although Gorky and West considered marriage, West ultimately refused. Perhaps at Gorky's suggestion (and his own name change), West began using the name "Mikael," officially adopting by 1941 the professional and personal moniker "Michael West." West was also known to dress in male attire.

By 1935, she was living in Rochester, New York, exhibiting frequently at the Memorial Art Gallery and lecturing at the Rochester Art Club. Returning to New York in 1946, she exhibited along with Milton Avery, Adolph Gottlieb, and Mark Rothko, among others, at Pinacotheca Gallery. In 1948, she married filmmaker Francis Lee, who was active in Surrealist and Abstract Expressionist circles; they divorced in 1960.

West was a noted poet, essayist, and journal writer whose writings on art outline contemporary and individual theories on modernism. Even as her paintings up to the mid-1940s demonstrate a Cubist infrastructure, West was guided after World War II by the social, spiritual, and philosophical changes in the world and the atomic age, summarized by what she called the "New Mysticism in Painting." She was also technically driven by the direct approaches of Abstract Expressionist painters such as Jackson Pollock. To achieve a thickly raised, rough surface,

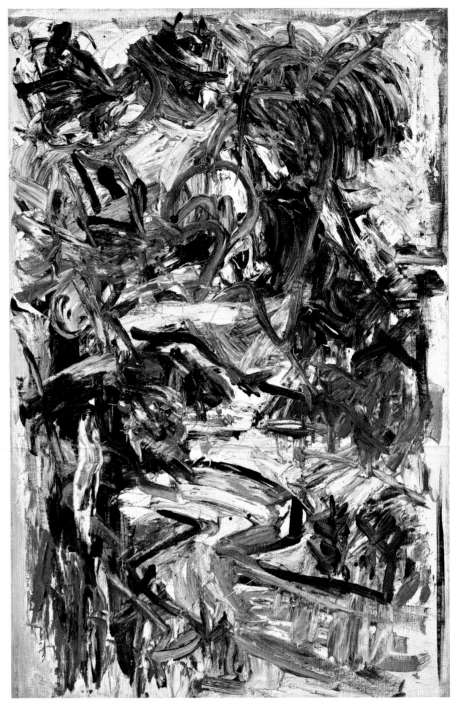

Michael West, *Road to the Sea*, 1955. Oil paint on canvas, 39 × 30 in. (99.06 × 76.2 cm). Art Resource Group, Newport Beach, Calif.

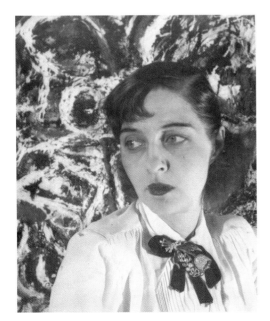

Michael West, c. late 1940s.

she frequently used a palette knife and paint directly from the tube, added found objects and sand, and occasionally painted over older canvases. In addition to friendships with Richard Pousette-Dart, sculptor Isamu Noguchi, and composer Edgard Varèse, she was influenced in the 1950s by the calligraphic approaches of Zen Buddhism and European Art Informel.

SELECTED GROUP EXHIBITIONS
Rose Fried Gallery, New York (1948)
Stable Gallery *Annual*, New York (1953)

SELECTED SOLO EXHIBITIONS
Uptown Gallery, New York (1957)
Domino Gallery, Washington, DC (1958)

Granite Gallery, New York (1963)
Michael West: Painter-Poet, Pollock-Krasner House and Study Center, East Hampton, NY (1996)

SELECTED READINGS
Suzanne Burrey, "Michael West," *Arts Digest* 32 (January 1958): 57.
Patricia Richmond, "Michael West's Paintings from the 1940s and 1950s" (master's thesis, George Washington University, Washington, DC, 1995).
Dore Ashton, "On Michael West," in *Michael West: The Automatic Paintings,* ed. José Bienvenu and Walter Maibaum (New York: 123 Watts Gallery, 1999).

JANE WILSON

(b. 1924, Seymour, IA)

Jane Wilson showed an early interest in art and studied painting at the University of Iowa (B.A., 1945; M.A., 1947). In 1948, she married John Jonas Gruen, a fellow student, composer, and writer, and the couple moved to New York the next year. She became a founding member of Hansa Gallery, an artists' cooperative, in 1952. During this period, she also worked as a fashion model, a professional choice for which the artistic community generally criticized her. She was featured with Abstract Expressionists Grace Hartigan, Helen Frankenthaler, and Joan Mitchell, along with painter Nell Blaine, in "Women Artists in Ascendance: Young Group Reflects Lively Virtues of U.S. Painting," in *Life* magazine in 1957. Wilson's circle included artists Fairfield Porter, Larry Rivers, Jane Freilicher, and poet James Schuyler. After 1960, Wilson and Gruen increasingly spent time in Water Mill, New York, where she had a studio. Her fluid transition between figuration, portraiture, and landscapes, from the mid-1950s urban Tompkins Square series to multifold versions of Long Island, reflects her childhood's Midwest geography coupled with eastern Long Island's atmosphere and light. Mark Rothko's 1961 retrospective at the Museum of Modern Art also made a significant impact on her approach to abstraction.

She showed at Tibor de Nagy Gallery (1960, 1962, 1963–66), Graham Gallery (1968, 1969, 1971, 1973, 1975), and in group exhibitions at the Museum of Modern Art from 1959 to 1961, all in New York. The Museum of Modern Art acquired her painting *The Open Scene* in 1960. Recognized for lifetime achievement by the National Academy of Design and the Guild Hall Museum in East Hampton, New York (2002), she taught at many colleges and was a professor of drawing and painting at Columbia University (1975–88). In her late career, she has been represented by Fischbach Gallery and DC Moore Gallery, both in New York.

SELECTED GROUP EXHIBITIONS
Stable Gallery *Annuals,* New York (1953–55)
New Talent, Museum of Modern Art, New York (1955–57)

SELECTED SOLO EXHIBITIONS
Hansa Gallery, New York (1953, 1955, 1957)

SELECTED READINGS
J. S. [James Schuyler], "Reviews and Previews: Jane Wilson," *ARTnews* 55, no. 9 (January 1957): 20.
F. P. [Fairfield Porter], "Reviews and Previews: Jane Wilson," *ARTnews* 58, no. 2 (April 1959): 11.
Klaus Kertess, *Jane Wilson Paintings: 1985–1995* (Southampton, NY: Parrish Art Museum, 1996).
Justin Spring, *Jane Wilson: Land, Sea, Sky* (Huntington, NY: Heckscher Museum of Art, 2001).
Elisabeth Sussman, *Jane Wilson: Horizons* (New York: Merrell, 2009).

Jane Wilson at the Hansa Gallery in New York, 1957. Photograph by Douglas Rodewald.

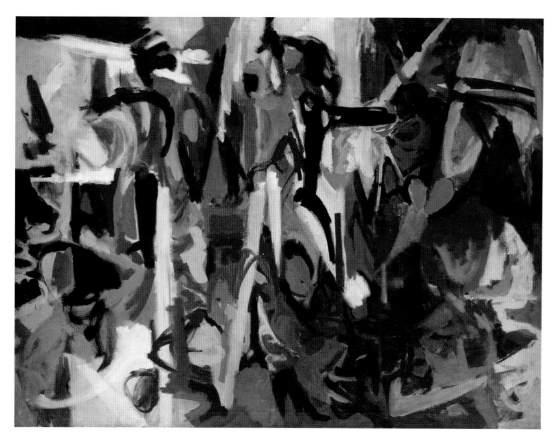

Jane Wilson, *Parade,* 1952. Oil paint on canvas, 43 × 57 in. (109.22 × 144.78 cm). Private collection.

INDEX

Illustrations and figures are indicated by "*f*" following page numbers; catalogue entries are indicated by *italic* page numbers. Artworks are under names of artists.

GWEN F. CHANZIT is curator of modern art and the Herbert Bayer Collection and Archive at the Denver Art Museum and director of museum studies in art history at the University of Denver. Chanzit has organized more than thirty Denver Art Museum exhibitions. Among her books is *From Bauhaus to Aspen: Herbert Bayer and Modernist Design in America.*

ALIZA EDELMAN is a curator and art historian who has published widely on geometric abstraction and Abstract Expressionism among women artists from the Americas. She holds a Ph.D. in modern art history from Rutgers University.

ROBERT HOBBS has held the Rhoda Thalhimer Endowed Chair of American Art at Virginia Commonwealth University since 1991 and is a visiting professor at Yale University. He has written monographs on a number of artists, including Lee Krasner, Robert Smithson, and Richard Pousette-Dart.

ELLEN G. LANDAU is Andrew W. Mellon Professor Emerita of the Humanities at Case Western Reserve University. She has organized exhibitions about, and written extensively on, Jackson Pollock and Lee Krasner. Recent books include *Reading Abstract Expressionism: Context and Critique* and *Mexico and American Modernism.*

SUSAN LANDAUER, formerly chief curator of the San Jose Museum of Art, is an independent art historian and curator. Her books include *The San Francisco School of Abstract Expressionism, Elmer Bischoff: The Ethics of Paint*, and *Richard Diebenkorn: The Ocean Park Series* (essayist).

JOAN MARTER is Board of Governors Professor of Art History, Rutgers University. She has organized many exhibitions, including *Women and Abstract Expressionism, 1945–59,* and among her numerous publications is *Abstract Expressionism: The International Context.* Marter has been editor of the *Woman's Art Journal* for the past eleven years.

JESSE LAIRD ORTEGA works at the Denver Art Museum as curatorial assistant in the New World Art department. She has an M.A. in art history and museum studies from the University of Denver and a B.F.A. in art history and Italian from the University of New Mexico.

IRVING SANDLER is a distinguished critic of Abstract Expressionism and professor emeritus of visual arts at Purchase College, State University of New York. Among his many publications are *The Triumph of American Painting: A History of Abstract Expressionism, The New York School: The Painters and Sculptors of the Fifties,* and *A Sweeper-Up after Artists: A Memoir.*

IMAGE CREDITS

The photographers and the sources of visual material other than the owners indicated in the captions are as follows. Every effort has been made to supply complete and correct credits; if there are errors or omissions, please contact Yale University Press so that corrections can be made in any subsequent edition.

Image courtesy of The Parrish Art Museum. © The James and Charlotte Brooks Foundation (fig. 1); © The Milton Resnick and Pat Passlof Foundation (fig. 2); Courtesy of McCormick Gallery, Chicago (fig. 3); Courtesy of McCormick Gallery, Chicago. Michael West Papers, courtesy of Stuart Friedman (fig. 4); Courtesy of the Estate of Shirley Goldfarb and Loretta Howard Gallery, New York (fig. 5); © 2016 Helen Frankenthaler Foundation/Artists Rights Society (ARS), New York (fig. 6); Courtesy of Smithsonian American Art Museum, Washington, DC/Art Resource, New York (fig. 7); © Aaron Siskind Foundation, Collection Center for Creative Photography, The University of Arizona (fig. 8); © Estate of Joan Mitchell (fig. 9); Reproduced from *New York School Abstract Expressionists,* p. 20, The New York School Press, 2000. ISBN: 0967799406 (fig. 10); © A. E. Artworks, LLC (fig. 11); Courtesy of Washburn Gallery, New York. Image courtesy of and © The Museum of Modern Art/Licensed by SCALA/Art Resource, New York (fig. 12); Image courtesy of McCormick Gallery, Chicago. Courtesy of Washburn Gallery, New York (fig. 13); Image courtesy of Michael Borghi Fine Art, New Jersey. Michael West Papers, courtesy of Stuart Friedman (fig. 14); Image courtesy of Michael Borghi Fine Art, New Jersey. Michael West Papers, courtesy of Stuart Friedman (fig. 15); Gordon Parks/The LIFE Picture Collection/Getty Images (fig. 16); Loomis Dean/The LIFE Picture Collection/Getty Images (fig. 17); Courtesy Center for Creative Photography, University of Arizona. © 1991 Hans Namuth Estate (figs. 18–19); Image courtesy of Robert Mann Gallery, New York. © Akademie der Künste, Berlin, Ellen-Auerbach-Archiv. © 2016 VG Bild-Kunst, Bonn/Artists Rights Society (ARS), New York (fig. 20); Photograph and digital image © Philadelphia Museum of Art. © 2016 The Willem de Kooning Foundation/Artists Rights Society (ARS), New York (fig. 21); Image courtesy of the Allan Stone Collection, New York. © 2016 The Willem de Kooning Foundation/Artists Rights Society (ARS), New York (fig. 22); Photograph by Edvard Lieber. © Elaine de Kooning Trust (fig. 23); Courtesy of National Portrait Gallery, Smithsonian Institution, Washington, DC/Art Resource, New York. (fig. 24); Image © The Metropolitan Museum of Art, New York. Image courtesy of Art Resource, New York. © 2016 The Willem de Kooning Foundation/Artists Rights Society (ARS), New York (fig. 25); Photograph by Edvard Lieber. © Elaine de Kooning Trust (fig. 26); Image courtesy of National Portrait Gallery, Smithsonian Institution, Washington, DC/Art Resource, New York. © Elaine de Kooning Trust (fig. 27); Photograph by Edvard Lieber © Elaine de Kooning Trust (fig. 28); Courtesy of Friends of Sylvia Sleigh (fig. 29); © 2016 The Willem de Kooning Foundation/Artists Rights Society (ARS), New York (fig. 30); Digital image © The Museum of Modern Art/Licensed by SCALA/Art Resource, New York. © Estate of Grace Hartigan (fig. 31); Image courtesy of Smithsonian American Art Museum, Washington, DC/Art Resource, New York (fig. 32); © The Falkenstein Foundation, courtesy of Michael Rosenfeld Gallery LLC, New York (fig. 33); Courtesy David Richard Gallery, Santa Fe. © Lilly Fenichel (fig. 34); Courtesy of David Keaton (fig. 35); Courtesy of Susie Alldredge (fig. 36); Courtesy of Susan Landauer. © William Heick (fig. 37); Courtesy of David Keaton. © The Estate of Joan Brown (fig. 38); Courtesy of Susan Landauer. © Peter and Madeleine Martin Foundation (fig. 39); Courtesy of the Deborah Remington Charitable Trust for the Visual Arts (figs. 40–41); Courtesy of Susan Landauer. © Charles Snyder (fig. 42); Courtesy of and © Bernice Bing Estate (fig. 43); Photograph by Ben Blackwell. © 2016 The Jay DeFeo Trust/Artists Rights Society (ARS), New York (fig. 44); Image courtesy of Robert Miller Gallery, New York. © 2016 Pollock-Krasner Foundation/Artists Rights Society (ARS), New York (fig. 45); Courtesy of Helen Harrison. © 2016 Pollock-Krasner Foundation/Artists Rights Society (ARS), New York (fig. 46); Photograph courtesy of Sotheby's, Inc. © 2011. © 2016 Pollock-Krasner Foundation/Artists Rights Society (ARS), New York (fig. 47); © A. E. Artworks, LLC (fig. 48); Photograph by Biff Henrich, courtesy of Albright-Knox Art Gallery/Art Resource, New York. © Estate of Joan Mitchell (fig. 49).

Courtesy of McCormick Gallery, Chicago. © Mary Abbott (cats. 1–2); © Mary Abbott (cat. 3); Image courtesy of The Jay DeFeo Trust. © 2016 The Jay DeFeo Trust/Artists Rights Society (ARS), New York (cat. 4); © 2016 The Jay DeFeo Trust/Artists Rights Society (ARS), New York (cat. 5); Photograph by Ben Blackwell. © 2016 The Jay DeFeo Trust/Artists Rights Society (ARS), New York (cat. 6); Photograph by William O'Connor. © Elaine de Kooning Trust (cat. 7); © Elaine de Kooning Trust (cat. 8); Photograph by William O'Connor. © Elaine de Kooning Trust (cat. 9); © Elaine de Kooning Trust (cats. 10–11); Courtesy of McCormick Gallery, Chicago. © A. E. Artworks, LLC (cats. 12–14); © 2016 Helen Frankenthaler Foundation/Artists Rights Society (ARS), New York. Photograph by Edward C. Robison III (cat. 15); © 2016 Helen Frankenthaler Foundation/Artists Rights Society (ARS), New York. Photo © Christie's Images/Bridgeman Images (cat. 16); © 2016 Helen Frankenthaler Foundation/Artists Rights Society (ARS), New York. Digital image © The Museum of Modern Art/Licensed by SCALA/Art Resource, New York (cat. 17); © 2016 Helen Frankenthaler Foundation/Artists Rights Society (ARS), New York. Photograph by Rob McKeever, courtesy of Gagosian Gallery, New York (cat. 18); Photograph by Howard Agriesti. © Sonia Gechtoff (cat. 19); © Sonia Gechtoff (cat. 20); Photograph by Kris Graves Projects, LLC. © Sonia Gechtoff (cat. 21); © Sonia Gechtoff (cat. 22); Photograph by Jeffrey Sturges. © Judith Godwin (cats. 23–24); Photograph by Lee Stalsworth. © Judith Godwin (cat. 25); © Estate of Grace Hartigan (cat. 26); Photograph by William O'Connor. © Estate of Grace Hartigan (cat. 27); Photograph by Dan Wayne, courtesy of ACA Galleries, New York. © Estate of Grace Hartigan (cat. 28); © Estate of Grace Hartigan (cats. 29–30); © 2016 The Pollock-Krasner Foundation/Artists Rights Society (ARS), New York (cats. 31–33); Photograph by Sheldan C. Collins. © 2016 The Pollock-Krasner Foundation/Artists Rights Society (ARS), New York (cat. 34); © 2016 The Pollock-Krasner Foundation/Artists Rights Society (ARS), New York (cat. 35); Photograph by William O'Connor. © 2016 The Pollock-Krasner Foundation/Artists Rights Society (ARS), New York (cat. 36); © 2016 The Pollock-Krasner Foundation/Artists Rights Society (ARS), New York (cat. 37);